saints

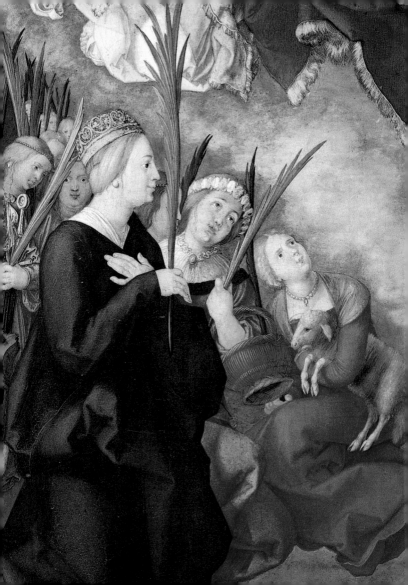

SAINTS

A YEAR IN FAITH AND ART

ROSA GIORGI

ABRAMS, NEW YORK

Cover illustration:
Fra Angelico, *Madonna of the Shadows*, detail,
1440–46 | Museo di San Marco, Florence

Opposite the title page:
Albrecht Dürer, *Adoration of the Trinity* (All Saints
Altarpiece), detail, 1511 | Kunsthistorisches Museum,
Vienna

Right:
Filippino Lippi, *The Virgin Appearing to Saint Bernard*,
detail, 1486 | Badia Fiorentina, Florence

Art Director Giorgio Seppi
Editorial direction Lidia Maurizi
Editors Veronica Buzzano, Lucia Moretti
Graphic design Chiara Forte, Frederico Magi (cover)
Picture research Elisa Dal Canto
Editing and layouts Studio Bolduri, Milan
English translation Jay Hyams
English-language typesetting Michael Shaw

Library of Congress Control Number: 2006001951
ISBN 10 0–8109–5499–0
ISBN 13 978–0810–5499–1

Printed and bound in Spain
10 9 8 7 6 5 4 3 2 1

HNA ■■■■■
harry n. abrams, inc.
a subsidiary of La Martinière Groupe

115 West 18th Street
New York, NY 10011
www.hnabooks.com

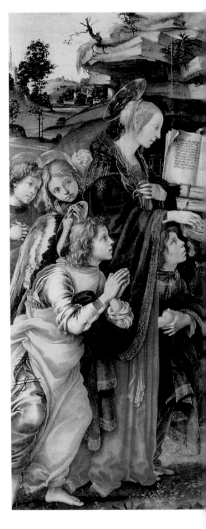

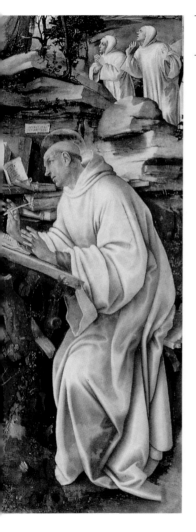

Contents

Introduction

One saint, anniversary, or remembrance for each day of the year, including the added day of the leap year. Such is the basic structure of this volume, which follows a calendar based as closely as possible on that of the Roman Catholic liturgical calendar and Church tradition, with the addition of saints drawn from popular tradition and figures for whom the process from veneration to beatification to canonization is still in progress.

Given the enormous depth and fascination of Church history, far more than one saint is available for every day of the year, so the Church has worked out levels of precedence among the various commemorations, classifying each according to its relative importance as a solemnity, feast, memorial, optional memorial, or simple commemoration. In general, that classification has been followed in the selection of saints for this book. Solemnities have been included even in those cases that do not refer to a specific saint (such as the Presentation of the Virgin in the Temple), giving precedence to Marian feasts and memorials and to the anniversaries related to them. This book also includes—daringly, in some cases—commemorations of people who are blessed or are servants of God, meaning that the process of their canonization has only just started.

Art has been a major factor in the selection of saints for this book. Since sacred images and the diffusion of such images are direct reflections of the veneration of this or that saint over time, it seemed best to include the most important such images, and not only those of importance to art history—although that was used as the primary consideration—but also those usually anonymous images that have been of importance to the history of popular art and worship.

In some cases, more than one important saint is commemorated on the same day. When only one of the two is associated with a work of art, the two appear with that one work. In those cases in which both saints are well known from outstanding works of art, both are given equal space by repeating the day.

No special effort has been made to include saints from all the regions touched by Christianity, although not doing so has meant the risk of disappointing readers because of the absence of a locally venerated saint. We believe this calendar nonetheless has the quality of universality, for it is composed of examples of sanctity expressed by men, women, and children, by adults and by the elderly, all of them treated equally in the pages of this book. Let it be said immediately that this universality is not a merit of this volume but is rather an outstanding characteristic of the call to sainthood, which is universal in the sense that it can come to anyone, to people of every age and gender and also every walk of life. The clergy and the lay, the enslaved or the free, the noble or the derelict.

The brief text dedicated to each saint is designed to give an outline of the person's life and an indication of what led him or her to a life of sanctity. A wide variety of sources has been consulted, including liturgical books of the Catholic Church, such as *The Roman Martyrology*, and in many cases also the saint's historic *passio*, meaning the narration of his or her martyrdom. Tradition has made saints the protectors or patrons of various aspects of human life, and they are invoked for particular reasons. Sometimes this is a result of actual facts (Saint Blaise is invoked for throat ailments because he saved a child from suffocation); sometimes it is based on a detail of martyrdom (several beheaded saints are invoked against headache); and some instances result from the figurative tradition (Erasmus is invoked for intestinal colics since images of his martyrdom show his intestines being wound out of his body on a windlass). Each entry also includes a note on the origin or etymology of the saint's name.

The Blessed Virgin Mary Mother of God

Solemnity

This was the first feast dedicated to Mary to be inserted in the liturgical calendar of the Western Church. The divine maternity of Mary was proclaimed church dogma at the Council of Ephesus (431); in more recent times, the Second Vatican Council (1962–65) made the meaning explicit: "that Christ should be recognized, in the truest sense, as the Son of God and the Son of Man." Before this feast was inserted in the revised Roman Catholic calendar, the first day of the year had been dedicated to remembrance of the Circumcision of the Lord, which took place eight days after his birth, as prescribed by Jewish law.

MADONNA OF THE MAGNIFICAT
Sandro Botticelli
1481–83
Galleria degli Uffizi, Florence

Saints Basil the Great and Gregory Nazianzen

BISHOPS AND DOCTORS OF THE CHURCH

Basil the Great, father of the Greek Church, struggled against the Arian heresy and was the principal monastic legislator of the East. He lived in Cappadocia (in modern Turkey) from 328 to 379. His cult was brought to the West by Greek monks as well as by Saint Benedict, who was profoundly inspired by "our holy father Basil." The Eastern Church recalls him on January 1. In art, he is depicted as a mature man with a long beard in episcopal vestments. His attributes include the book and the dove of inspiration.
NAME: Basil is from the Greek and means "king" or "royal."

Gregory grew up in a family of pious Christians, son of the bishop of Nazianus (Cappadocia). A lifelong friend of Saint Basil, he joined him in the struggle against Arianism. One of the fathers of the Greek Church, he was already bishop of Nazianzus when Emperor Theodosius sent him to Constantinople to bring that city back to orthodoxy. Greeted with stones, he eventually succeeded. He is depicted as an elder bishop, with the crosier as his attribute.
PROTECTOR: Poets.
NAME: Gregory is of Greek origin and means "watchful, alert."

THREE HIERARCH SAINTS
Central Russia, mid-19th century
Collection of the Banca Intesa, Vicenza
(Saint Basil is on the left, Saint Gregory is at the center)

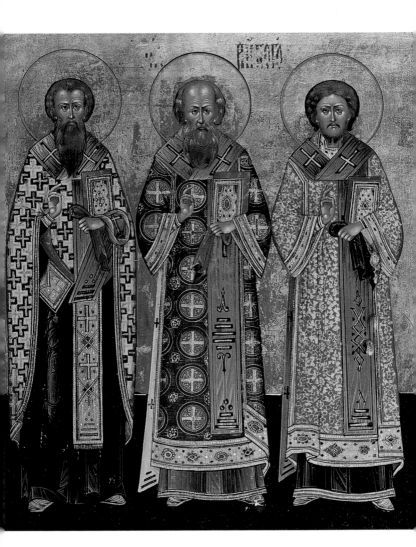

JANUARY 3

Saint Daniel of Padua

MARTYR

Daniel was probably a deacon and died a martyr during the persecutions under Diocletian in the early 4th century. His body was discovered under miraculous circumstances in the 11th century at Padua, near the oratory of Saint Prosdocimus; it was supine, covered by a block of marble, and pierced by long nails, with an inscription that identified him as the martyr Daniel. Following this discovery, the cult of the saint spread rapidly through the area of Padua. Daniel is depicted in the dress of a deacon, often holding a model of the city of Padua.

PATRON: Daniel is the patron saint of Padua.

NAME: Daniel is from the Hebrew and means "God is my judge."

Most Holy Name of Jesus

Optional memorial

This liturgical feast was instituted as a result of the great diffusion of the cult of the Holy Name of Jesus, promoted by Saint Bernardino of Siena as well as by Albert Berdini of Sarteano and Bernardino of Feltre. Devotion to the Holy Name of Jesus can be traced back to the works of Saint Paul, in particular the Epistle to the Philippians, but the Holy Name became the subject of liturgical worship only in the 14th century.

THE ADORATION OF THE NAME OF JESUS
El Greco
1577–80
Monasterio de San Lorenzo, Escorial

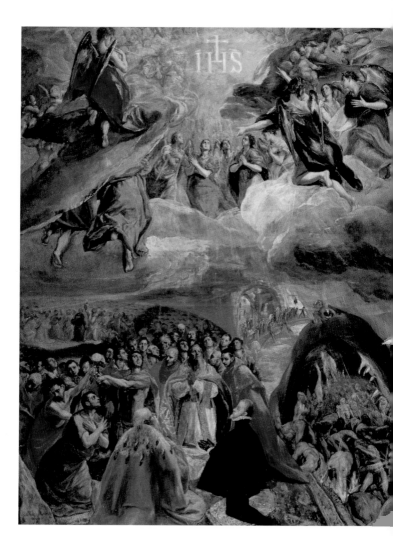

Blessed Angela of Foligno

FRANCISCAN TERTIARY

Born in 1248 in a well-to-do family, Angela spent her youth in luxury. She married and had children. Following the death of her husband, sons, and mother, all in 1291, she joined the Franciscan tertiaries. After a pilgrimage to Assisi, she had mystical experiences that led her to a painful spiritual crisis. In the constant company of Brother Arnold of Foligno, her spiritual director, she dictated the personal story of her conversion in her *Book of Visions and Instructions*. She died at Foligno in 1309. Her cult was approved early in the 18th century.

NAME: Angela *(angel)* is from the Greek and means "messenger."

BLESSED ANGELA OF FOLIGNO
(detail from the manuscript by Angela of Foligno, Codice Trivulziano n. 150, c, 1r.)
Biblioteca Trivulziana, Milan

In questo libro se contiene
da foligno persona del tol

E devote persone
da foligno vera
magiore che
el qual trase
azo che no in
mia vera e
che la predita
et dignitad
p zo che aq
no farese volgiando satisfar
mi reputo obligito ela scienzia
iqual perdo aver rezauti
pdeta amzblela aspo fedeli
storia q Tteraga guano co s
na parte alatza no semed
fare litere adurese sobra

Saint Edward the Confessor

KING

Edward lived between 1004 and 1066, reigning as king of England from 1042 to 1066. Firm in his Christian faith, he led an exemplary life. He is remembered for his profound faith, fervent prayer, and piety. His reign concluded with William of Normandy's invasion of England at Hastings. Soon after his death the cult in his honor spread both in England and in Normandy, and it intensified following the recovery of his incorrupt body, in 1102. Saint Edward is usually depicted in royal robes and bears the ring that he gave in charity to a beggar who was later revealed to have been Saint John the Apostle and who sent the ring back to him.

PROTECTOR: Kings.

NAME: Edward is of Old English origin and means "rich guard."

WILTON DIPTYCH
(detail of the left panel)
Master of the Wilton Diptych
1395–99
National Gallery, London
(Saint Edward is at the center)

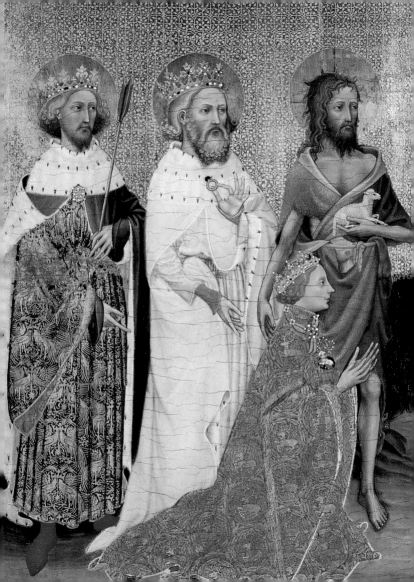

JANUARY 6

Epiphany of the Lord

Solemnity

The term *epiphany*, used for the solemn feast of the manifestation of Jesus, is of Eastern origin. In the interpretation of the fathers of the Church, the feast of the epiphany represents the call to salvation of all peoples, including pagans, as represented by the Wise Men of the East. Popular tradition has thus taken the three figures of the adoring Magi as symbols of different races and populations, considering them the descendents of Shem, Ham, and Japheth, the sons of Noah, and also as symbols of the Three Ages of Man.

ADORATION OF THE MAGI
Gentile da Fabriano
1423
Galleria degli Uffizi, Florence

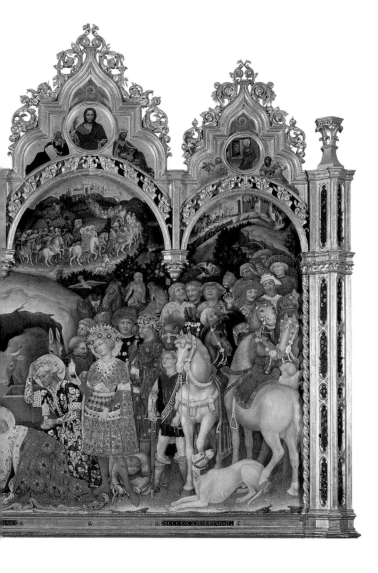

Saint Raymund of Peñafort

PRIEST

Born at Peñafort in Catalonia, Raymund lived a long life (1175–1275). He studied philosophy and canon law at Bologna, where he was noted by the bishop of Barcelona on a visit to that city; learning of the fame of sanctity that already surrounded him, the bishop called him to Spain. Raymund joined the Dominican friars in 1222 and helped Peter Nolasco in the foundation of the order of Mercedarians. Pope Gregory IX called on him to compile the *Decretals* of canon law, which were in use for nearly 700 years. His cult spread immediately after his death.

In art, he is depicted in Dominican robes, often holding a key.

NAME: Raymund *(Raymond)* is of German origin and means "advice protector."

SAINT RAYMUND PREACHING
(detail)
Carlo Saraceni
Circa 1614
Santissima Annunziata, Rome

Saint Erhard

BISHOP

Erhard lived between the 7th and 8th centuries, and little is known about his life and acts. Probably originally from Ireland, after a pilgrimage to Rome in the company of Saint Albert of Cashel (also recalled on this day), he went to Bavaria. He settled in Ratisbon (Regensburg), where he became bishop and where, immediately after his death, his cult was born and spread. Other sources identify him as an itinerant bishop ordained by Saint Boniface.

He is depicted in episcopal vestments.

NAME: Erhard is from the German and means "strong in honor."

MASS OF SAINT ERHARD
Styrian ducal workshop (attrib.)
1370–80
Narodna Galerija, Ljubljana

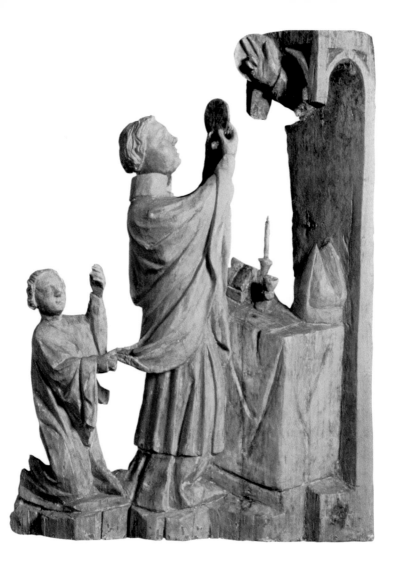

Blessed Gregory X

POPE

Born at Piacenza, Italy, around 1210, he was elected pope in 1272, taking the name Gregory X. He convoked the Second Council of Lyons, which temporarily reunited the Roman Church with the Eastern Church. The theologians Gregory summoned to the council included Thomas Aquinas, who died on his way there, and Bonaventure, who died during the council. Gregory died on his return from the council, in 1276. His cult grew immediately in popularity, and he was beatified by Pope Clement in 1713.

He is depicted in papal robes without any special attributes.

NAME: Gregory is of Greek origin and means "watchful, alert."

POPE GREGORY X RECEIVES THE POLO
BROTHERS AT ACRE
(detail from the *Livre des
Merveilles du Monde*)
School of the Boucicaut Master
Circa 1412
Bibliothèque Nationale, Paris

24

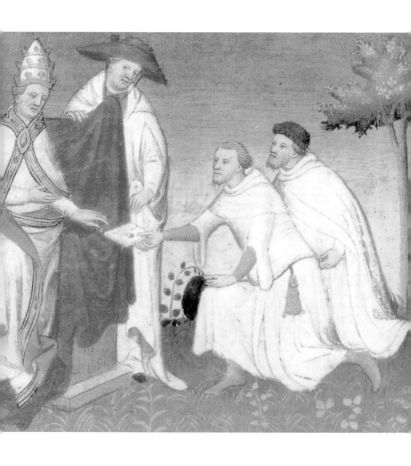

Saint John the Good

BISHOP

John Camillus, known as John the Good because of his great humility and charity, is thought to have been born at Recco in Liguria, Italy. Named bishop of Milan, probably in 641, he was the first bishop to reside in that city since the Arian Lombard invasions nearly seventy years earlier. He died in 669. His cult was created by Bishop Aribertus, who found his body, which had been believed lost.

In art, he is depicted in episcopal vestments.

NAME: John is from a Hebrew name meaning "Yahweh is gracious."

**SAINT JOHN THE GOOD
AND QUEEN THEODELINDA
(detail)**
Anonymous Lombard painter
Before 1737
Museo Diocesano, Milan

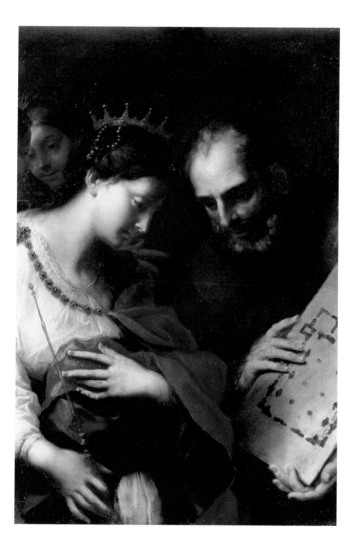

Saint Liberata

VIRGIN AND MARTYR

Daughter of the governor of Galicia and Lusitania, Liberata and her eight sisters were born on the same day in 119 while their father was away from home. Fearing that her husband would suspect her of infidelity, their mother Calsia gave the girls to their wet nurse with instructions that she should drown them. The nurse kept the babies alive, and they were baptized by Saint Ovidius and educated in the Christian faith.

With the outbreak of the persecution under Emperor Hadrian, the girls were condemned by their own father. Liberata suffered martyrdom on the cross, around 140. Her cult spread over the course of the 16th century. In art, Liberata is presented crucified and is invoked to drive away melancholy thoughts and to summon peace and serenity.

NAME: Liberata is from Latin and means "liberated."

TRIPTYCH OF THE CRUCIFIED MARTYR
(detail of the central panel)
Hieronymus Bosch
1500–04
Doge's Palace, Venice

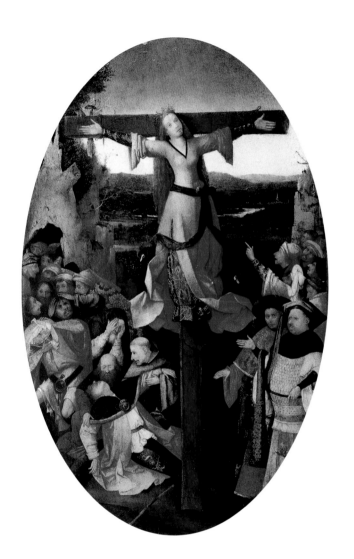

Saint Bernard of Corleone

MONK

Son of the shoemaker Leonardo Latino, Bernard was born at Corleone, Sicily, in 1605 with the name Filippo, in a habitation known in the town as the "house of the saints." Bernard's passion for weapons was nearly his undoing: he reacted to a provocation by cutting off his adversary's arm with a sword. To flee justice and expiate his crime, he asked for shelter in a Capuchin convent and was taken in. When he became a friar he took the name Bernard, and he also changed his life, conforming to the teaching of Christ and dedicating himself to works of charity and penitence. He died in 1667 and was canonized in 2001.

He is depicted in art in a Capuchin cowl in the act of penitence.

NAME: Bernard is of German origin and means "brave as a bear."

SAINT BERNARD OF CORLEONE
Popular sacred image
19th century

Saint Hilary of Poitiers

**BISHOP AND DOCTOR
OF THE CHURCH**

Hilary was born into a pagan family in Poitiers, France, around 315. He sought the truth first in philosophy and then in the Gospels; this led him to conversion and the monastic life, even though he was by then married and a father. In 350, immediately after receiving baptism, he was prolaimed bishop of Poitiers. Tireless opponent of heresy, he was banished to Phrygia in Asia Minor by the Arian emperor Constantius II. Hilary was the author of numerous theological works as well as hymns. He died in 367.

He is depicted in episcopal vestments and is invoked against serpent bites.

PROTECTOR: Exiles.

NAME: Hilary is of Latin origin and means "cheerful, happy."

SAINT HILARY OF POITIERS
(detail)
Parmigianino
1522
San Giovanni Evangelista, Parma

Blessed Odo of Novara

MONK

A Carthusian monk, Odo was born at Novara, Italy, in 1100. He undertook numerous journeys. His first took him to Yugoslavia, where he was sent to preach; he then went to Rome to seek help from Pope Clement III in settling a dispute that had arisen among the monks. He finally settled at the Benedictine monastery of Tagliacozzo, near Aquila, in central Italy, where he lived in a small cell. He died there in 1198. His local cult was approved in 1859.

He is depicted in the white Carthusian habit with a long staff in memory of his many travels.

NAME: Odo is derived from the Lombardic and means "wealth, fortune."

BLESSED ODO OF NOVARA
Daniele Crespi
1629
Certosa di Garegnano, Milan

Saint Maurus

MONK

Maurus lived in Italy in the 6th century and got his early training in the Benedictine monastery at Subiaco and also in France, where he spread the Benedictine rule. A disciple of Saint Benedict, he is famous as an example of obedience. He is presented in the black habit of the Benedictines and carries an abbatial staff, spade, crutch, or scales. He is invoked against rheumatism and, in the past, against gout.

PROTECTOR: The lame, boiler makers, coal merchants, and gardeners.

NAME: Maurus is of Latin origin and means "from Mauritania."

MOREEL TRIPTYCH
(central panel)
Hans Memling
1484
Groeningemuseum, Bruges
(Saint Maurus is on the left)

36

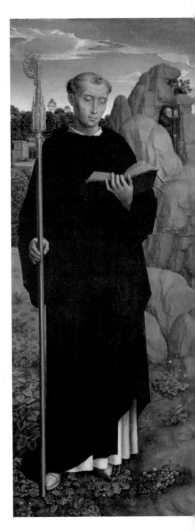

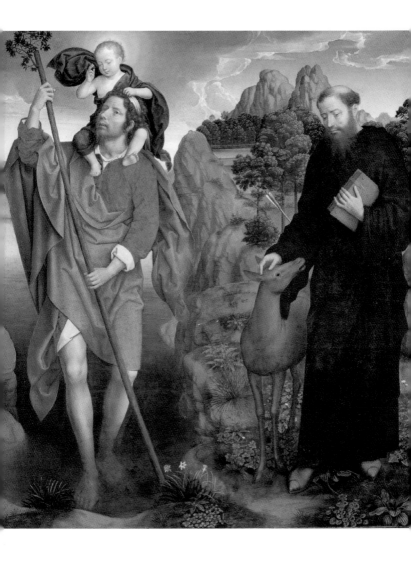

Saint Paul the Hermit

HERMIT

Born in Thebes, Paul lived in Egypt between the 3rd and 4th centuries. He went into the Theban desert to flee the persecutions under the Roman emperor Decius; fascinated by the solitude the site offered, he did not return, even after the emperor's death. He is commonly regarded as the first Christian hermit. His cult began spreading as early as the 4th century in Egypt, becoming popular throughout Europe during the 13th century. He is depicted half-naked with a long, bushy beard. He is often accompanied by a raven holding bread in its beak.

PROTECTOR: Makers of mats.

NAME: Paul is of Latin origin and means "small in stature, humble."

HERMIT SAINTS ANTHONY AND PAUL
(detail)
Giovanni Girolamo Savoldo
1520
Gallerie dell'Accademia, Venice
(Saint Paul the Hermit is on the right)

38

Saint Titian

BISHOP

Born at Eraclea in the Veneto region of northern Italy, in the second half of the 6th century, Titian (Tatian) was educated by the bishop of Oderzo, Floriano, who ordained him deacon. Forced to depart on an important diplomatic mission, Floriano declared that Titian was to be his successor should he not return within a year. Thus did Titian become bishop, and he maintained the post even after the tardy return of his predecessor. A great preacher, he was beloved for his generosity and acts of charity. He died in 632 and his cult immediately spread. He is depicted in episcopal vestments.

NAME: Titian is from the Roman family name Titianus.

SAINT TITIAN
Titian
1550
Parish church, Lentiai

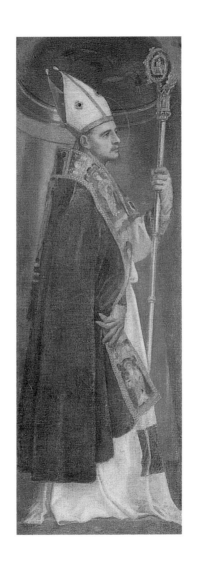

Saint Anthony

ABBOT

Anthony lived in Egypt between 251 and 356. At twenty he became a hermit, living alone and experiencing continual temptations until 306, when he dedicated himself to the numerous disciples he had attracted. He intervened in important doctrinal questions of the Church, supported persecuted Christians, and confuted Arianism. His cult was enormously widespread during the Middle Ages. In art, he is depicted in the dress of a hermit, with a T-shaped staff, a bell, and a pig. He is invoked against ergotism, the so-called St. Anthony's fire.

PROTECTOR: Butchers, salami-makers, basket-makers, and domestic animals.

NAME: Anthony is from the Roman family name Antonius.

SAINT ANTHONY ABBOT
Sassetta
Circa 1435
Metropolitan Museum, New York

42

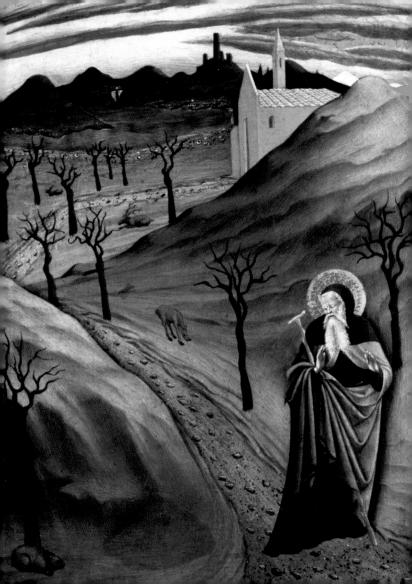

Saint Margaret of Hungary

PRINCESS AND NUN

Margaret, daughter of the Hungarian king Bela IV, was born in 1242 and died in 1270. In fulfillment of a vow her mother had made to save Hungary from the Tartars, Margaret entered a convent, where she discovered her true calling and took the veil in 1262. Among the most important mystics of the Middle Ages, Margaret died in the odor of sanctity. Her cult was first local, limited to the diocese of Transylvania and the members of the Dominican order, but it was adopted by the whole Church in 1943.

She is depicted in a Dominican habit, with a branch of flowering lily, often together with a crucifix and royal crown.

NAME: Margaret is of Greek origin and means "pearl."

SAINT MARGARET OF HUNGARY
WITH FRA' MARINO OF THE
KNIGHTS OF OUR LADY
Bartolo di Fredi (circle of)
14th century
San Nicolò, Treviso

BEATA·MAR
DA·DE·GA
FERD·

GARETA·REGI
RIE·ORDINIS
₽·DICATOℝ·

FR·STBIDV·

Saint Bassian of Lodi

BISHOP

Bassian, son of the Roman prefect of Ragusa, Sicily, was born at Syracuse around 320. He went to Rome for studies, converted to Christianity, and fled to Ravenna to avoid his father, who planned to condemn him. Bassian was ordained priest and on the death of the bishop of Lodi was named his successor. He died in that city in 409.

He is depicted in episcopal vestments accompanied by a fawn.

PATRON: Bassian is the patron saint of Lodi.

NAME: Bassian is from the Latin and means "short, stocky."

SAINT BASSIAN RECEIVES THE LAST SACRAMENT
Anonymous Lombard artist
15th century
Rocca Pallavicino, Monticelli d'Ongina

46

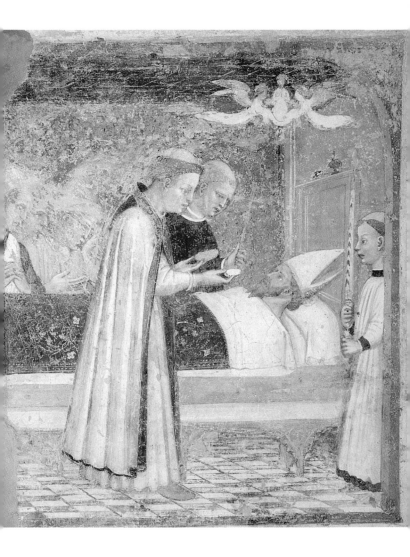

Saint Sebastian

MARTYR

Sebastian lived between the 3rd and 4th centuries between Gaul, where he was born, and Italy. He enrolled in the Roman army of Diocletian and became an officer of the imperial guard. He converted to Christianity. When he refused to sacrifice to the gods he was first shot with arrows and then clubbed to death.

In art, he is depicted pierced by arrows and is invoked against the plague.

PROTECTOR: Archers, athletes, upholsterers, and policemen.

NAME: Sebastian is of Greek origin and means "venerable."

SAINT SEBASTIAN
Antonello da Messina
1476
Gemäldegalerie, Dresden

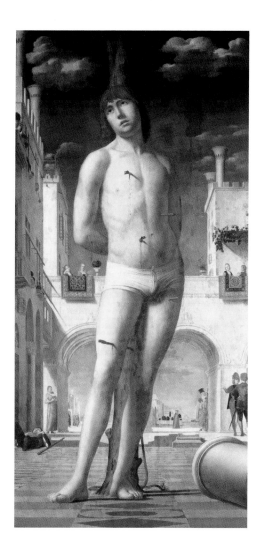

JANUARY 21

Saint Agnes

VIRGIN AND MARTYR

Agnes was just twelve years of age when she was killed, during the persecutions under Emperor Diocletian around the year 305. In the past, her feast day was the occasion for the blessing of lambs, whose wool was used by the nuns of Saint Agnes in Rome to weave the palliums of archbishops.

Her attributes are the lamb and the martyr's branch of palm. She is the subject of universal devotion.

PROTECTOR: Virgins, betrothed women (she chose Christ as her betrothed), and gardeners, since virginity is symbolized as a closed garden, the *hortus conclusus*.

NAME: Agnes is of Greek origin and means "pure, chaste."

SAINT AGNES
(detail)
Guercino
1637
Private collection

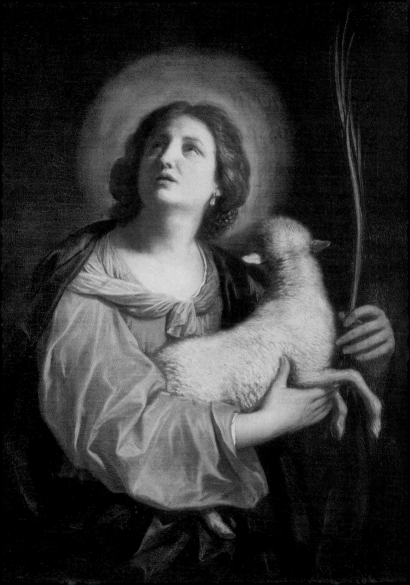

Saint Vincent of Saragossa

DEACON AND MARTYR

Martyred in the 4th century, Vincent was born in Spain, at Huesca. He became the most trustworthy collaborator of Valerius, bishop of Saragossa, and was martyred in that city in 304, during the ferocious persecutions under Diocletian, which were perpetrated in Spain by the Roman governor of Spain, Dacian. Vincent is depicted with a deacon's dalmatic and stole and the martyr's palm.

PROTECTOR: Vintners.

NAME: Vincent is from Latin and means "victorious."

MARTYRDOM OF SAINT VINCENT
Anonymous Spanish artist
15th century
Prado, Madrid

Saint Ildephonsus of Toledo

BISHOP

Ildephonsus lived in Spain between 607 and 667. A Benedictine abbot, he was elected bishop of Toledo. He wrote works of theology and treatises on the virginity of Mary. The cult in his honor spread beginning with the translation of his relics in the 7th century.

He is depicted in the dress of an abbot, usually in the presence of the Virgin Mary. Indeed, her apparitions to Ildephonsus are the primary theme of his iconography.

NAME: Ildephonsus is of Germanic origin and means "ready for battle."

THE VIRGIN CONSIGNS THE CHASUBLE
TO SAINT ILDEPHONSUS
(detail of the Saint Ildephonsus Triptych,
central panel)
Peter Paul Rubens
1630–32
Kunsthistorisches Museum, Vienna

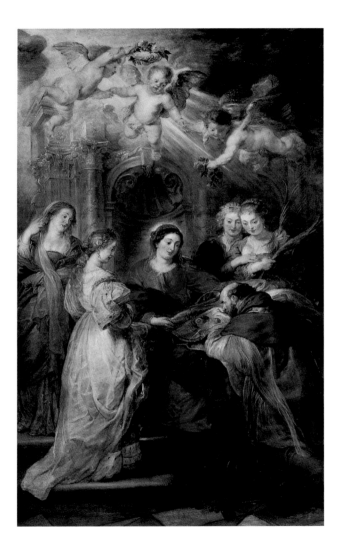

Saint Francis de Sales

**BISHOP AND DOCTOR
OF THE CHURCH**

Born at Savoy in the Château de Sales in 1567, Francis studied rhetoric, philosophy, and theology at the university of Paris, followed by law at the University of Padua, but he gave up a secular career to dedicate himself to the priesthood. Ordained in 1593, he was sent to the remote Chablais region to win Calvinists back to the faith. He earned great fame as a preacher, delivering sermons in the major cities of France, and wrote popular books on religion. In 1602, he was made bishop of Geneva. He died in 1622, was canonized in 1665, and in 1877 was declared a Doctor of the Church.

He is depicted in episcopal vestments, bald, with a thick beard.

PROTECTOR: Writers and journalists.

NAME: Francis *(Frank)* is of German origin, from the name of the people who settled in France; it has come to mean "forthright, sincere."

MADONNA AND CHILD AND
SAINT FRANCIS DE SALES
Carlo Maratta
1691
Pinacoteca Civica, Forlì

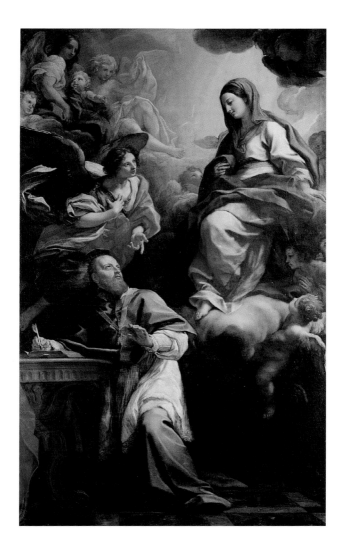

The Conversion of Saint Paul

Feast

Saul of Tarsus, who later changed his name to Paul, was a Pharisee and a fierce persecutor of Christians in the period immediately after the Resurrection of Jesus. While he was on the road to Damascus, Christ himself appeared to him, saying: "Saul, Saul, why do you persecute me?" Saul fell to the ground and lost his vision, which was restored to him by Ananias, a Christian living in Damascus (also commemorated on this day), who also baptized Saul. The feast of the Conversion of Saint Paul was celebrated as early as the 6th century.

In depictions of this episode, the saint is usually presented as a sturdy soldier who has fallen off a horse and been blinded.

NAME: Paul is of Latin origin and means "small in stature, humble."

THE CONVERSION OF SAINT PAUL
(detail)
Caravaggio
1600–01
Collezione Odescalchi, Rome

58

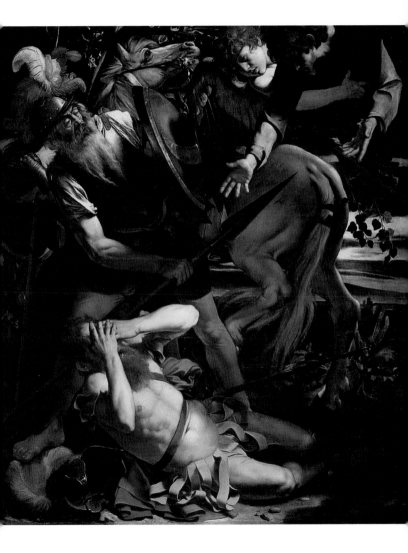

Saints Timothy and Titus

BISHOPS • Memorial

Disciples of Saint Paul, Timothy and Titus lived in the 1st century. Timothy had a pagan father and Jewish mother. His mother converted and was baptized with him. He met Paul during his second journey and was sent by him as bishop to Ephesus; he is invoked against stomach ailments.

Titus was a Greek pagan, probably converted by Paul, becoming his invaluable helper, in particular in the question of the Corinthians and at the Council of Jerusalem. He was bishop of Gortyna on Crete.

NAMES: Timothy is from the Greek and means "to honor God"; Titus is of Latin origin and may mean "defender."

Saint Paula Romana

WIDOW

A wealthy Roman noblewoman, Paula was born in 347. Widowed with five children, she turned her palace into a place of Christian learning and dedicated her life to charity, leading an ascetic life under the spiritual guidance of Saint Jerome. She died in 404 in a monastery near Bethlehem that she herself had founded, not far from a hospice, also founded by her, for the community of Saint Jerome.

She is often presented together with Saint Jerome.

NAME: Paula *(Paul)* is of Latin origin and means "small in stature, humble."

SAINT PAULA ROMANA LEAVING FOR THE HOLY LAND
Giuseppe Bottani
1745
Pinacoteca di Brera, Milan

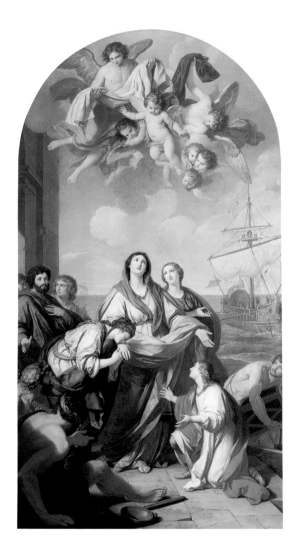

JANUARY 27

Saint Angela Merici

VIRGIN

Born at Desenzano on Lake Garda in 1474, Angela Merici was orphaned at age fifteen; she was raised by an uncle and joined the Franciscan tertiaries. Keenly interested in the education of the young and in charitable works, she founded the Company of St. Ursula (1535), best known as the Ursuline nuns, the rule of which was codified only after her death, in 1540. She was canonized in 1807.

She is depicted in a Franciscan habit or in the dress of a peasant woman.

PATRON: Angela is the patron saint of Desenzano.

NAME: Angela *(angel)* is from the Greek and means "messenger."

SAINT ANGELA MERICI
Popular sacred image
20th century

Saint Thomas Aquinas

PRIEST AND DOCTOR
OF THE CHURCH

Born at Roccasecca near Aquino (in Latium, Italy), around 1225, he was educated in the abbey of Monte Cassino, where he matured his religious calling. He became a Dominican friar and studied in Paris with Albert the Great, with further studies at Cologne. His many works include the *Summa theologica*, the most systematic attempt to give a scientific, philosophical, and theological foundation to Christian doctrine. He died in 1274 and was canonized in 1323.

He is depicted in Dominican robes with a sun on his chest, pen, and the dove of inspiration.

PROTECTOR: Academics, pencil-makers, booksellers, students, and theologians.

NAME: Thomas is from the Aramaic and means "twin."

TRIUMPH OF SAINT THOMAS AQUINAS
Lippo Memmi, Francesco Traini
1323
Santa Caterina, Pisa

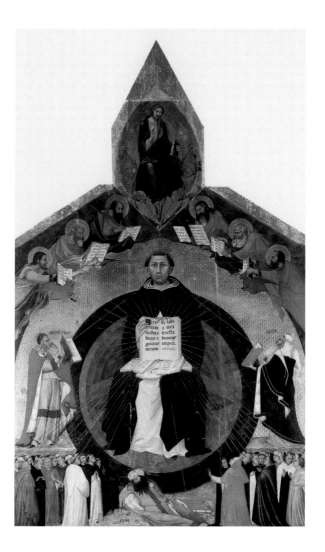

Saint Aquilinus

PRIEST AND MARTYR

Born in the 10th century at Würzburg, in Bavaria, Aquilinus formed his faith at Cologne, becoming a priest. He was offered the episcopal see several times but always refused in order to dedicate himself to charity and prayer. He went to Pavia, where he struggled against the Arian and Cathar heresies, and died around 1015, stabbed by heretics at Milan. His body was thrown in the river but retrieved by dockworkers and brought to a chapel in the basilica of San Lorenzo, which from then on was dedicated to him.

He is depicted in the robes of a priest, bearing the palm of martyrdom, with a sword through his neck.

PROTECTOR: Dockworkers.

NAME: Aquilinus is of Latin origin and means "brown, dark."

SAINT AQUILINUS
Popular sacred image
1753
Civica Raccolta delle Stampe Bertarelli, Milan

Giulio Cesare Bianchi P.t 1595

Saint Hyacintha Mariscotti

NUN

Born at Vignanello (Viterbo), Italy, in 1585, Hyacintha (Giacinta, Clarice) was put into a convent by her family in 1605, even though she sensed no true religious calling. In the convent of Poor Clares she chose the tertiary state and for many years lived at ease on the basis of her noble origins. Following a disease and the deaths of several members of her family, she experienced a profound spiritual awakening that led her to live her faith in a mystical way and to found charitable works. Her cult spread immediately after her death, in 1640, but she was canonized only in 1807.

NAME: Hyacintha *(Hyacinth)* is from the Greek and refers to the flower.

DEATH OF HYACINTHA MARISCOTTI (detail)
Marco Benefial
1758
San Lorenzo in Lucina, Rome

Saint John Bosco

PRIEST

Born at Castelnuovo d'Asti, Italy, in 1815, John Bosco was a priest dedicated to the education of the young and was a pioneer in the field of professional schools. Because of his new educational methods, he encountered opposition from the traditional clergy as well as from politicians. By the time he died, at Turin in 1888, his work had spread throughout the world. He was canonized in 1934, and in 1988, on the centennial of his death, he was declared a "Father and teacher of youth."

He is always depicted in a priest's cassock, often accompanied by youths.

PROTECTOR: Educators, youths, students, and editors.

NAME: John is from a Hebrew name meaning "Yahweh is gracious."

SAINT JOHN BOSCO
Commemorative medallion
20th century

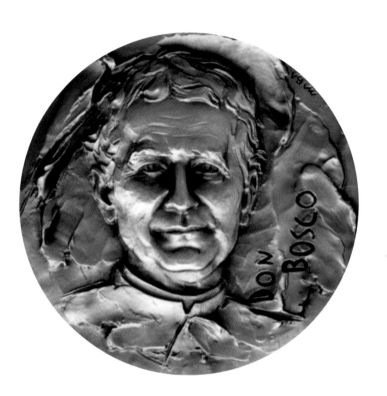

Saint Brigid of Ireland

ABBESS

Brigid (Bridget, Bride) lived in Ireland and died around 525. She chose the religious life when still very young and was the founder and abbess of the great monastery at Kildare. Her cult is strongest in Ireland, where she is second only to Patrick (who is said to have baptized her), but has spread elsewhere, with churches dedicated to her in England and Scotland as well as on the continent of Europe.

In art, she often appears wearing the white gown of a nun and the black veil of an abbess; she is sometimes accompanied by a cow, in memory of her work in a dairy as a young girl.

PROTECTOR: Milkmen, poets, blacksmiths, healers, cows, and farmyard animals.

NAME: Brigid is of Celtic derivation and means "strong, powerful, exalted."

SAINT BRIGID OF IRELAND
TRANSFORMS WATER INTO BEER
AND HEALS A BLIND MAN
(detail from the *Lives of Saints
Brigid and Barbara*)
Lorenzo Lotto
1524
Villa Suardi oratory, Trescore Balneario

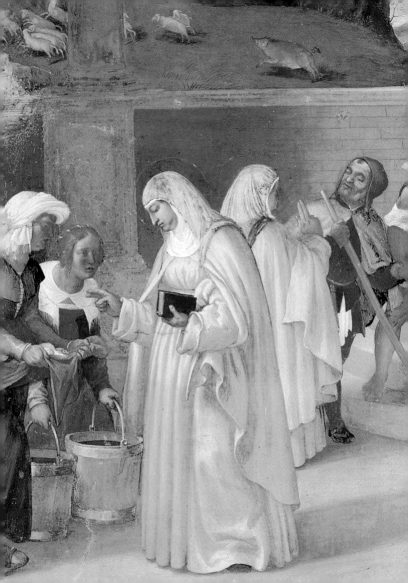

FEBRUARY 2

Presentation of the Lord

Feast

This festivity originated in the East and spread to the West in the 6th century. It was initially called the "festival of lights," inspired by the words of Simeon, "light to lighten the Gentiles" (Luke 2:32). The allusion to light led to the popular custom of blessing candles, giving the feast its popular name of Candlemas. Until the reform of the Roman Catholic calendar, the Presentation of the Lord was called the Feast of Purification, and it concludes the birth celebrations and begins the route toward Easter with the offering by the Virgin Mother of her firstborn and the prophecy of Simeon.

PRESENTATION IN THE TEMPLE
Ambrogio Lorenzetti
1342
Galleria degli Uffizi, Florence

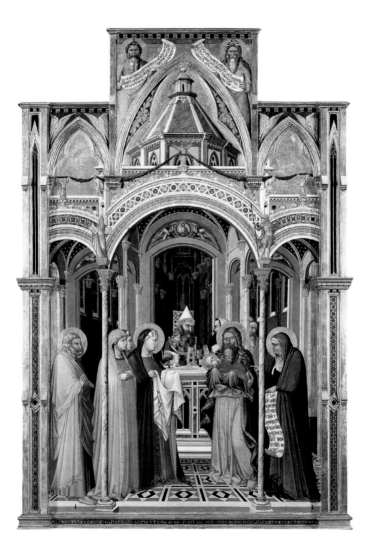

Saint Blaise

BISHOP AND MARTYR

Blaise occupied the bishop's see of Sebaste in Armenia and died, in 316, during the ferocious persecution unleashed by Emperor Licinius. Blaise was beheaded, but only after first suffering torture, his flesh being torn with metal wool combs. His cult began in the 8th century. According to tradition, he saved the life of a boy who had a fishbone stuck in his throat and was suffocating; the boy's mother later brought him food and candles in prison.

In art, Blaise is depicted in episcopal vestments with the carders' combs and the candles. He is invoked against throat diseases and hurricanes.

PROTECTOR: Pastors, farmers, wool combers, players of wind instruments, mattress-makers, and throat specialists.

NAME: Blaise is of Latin origin and means "lisping."

SAINT BLAISE
Portuguese school
1475–1500
Private collection

Saint Andrew Corsini

BISHOP

Andrew Corsini was born into a noble family in Florence in 1301. He joined the Carmelites, becoming a provincial superior in 1348, a year of plague. He did his best to care for all souls, preaching peace and amity among the citizens in the name of the Virgin Mary. In 1349, he was called to replace the bishop of Fiesole, who had died of the plague, and Pope Urban V later sent him to preach in Bologna. He died in 1373 and was canonized in 1629.

In art, he is depicted in episcopal vestments or in those of the Carmelites.

NAME: Andrew is from the Greek and means "male virility, courage."

THE ECTASY OF SAINT ANDREW CORSINI
Guido Reni
Circa 1629–33
Galleria degli Uffizi, Florence

FEBRUARY 5

Saint Agatha

VIRGIN AND MARTYR

Agatha lived during the 3rd century and was martyred at Catania, Sicily, under Emperor Decius, when she refused to sacrifice to the gods. She died as a result of her suffering in prison, but before that she had been cruelly tortured. Her breasts were torn off with pincers (but Saint Peter appeared to her at night and healed her wounds), and she was forced to walk on shards of glass and was rolled over live coals.

She is depicted in art during these tortures or with her breasts on a platter, along with a pincer.

PROTECTOR: Wet nurses, nurses, and bell-founders.

NAME: Agatha is from the Greek and means "good."

MARTYRDOM OF SAINT AGATHA (detail)
Sebastiano del Piombo
1520
Palazzo Pitti, Florence

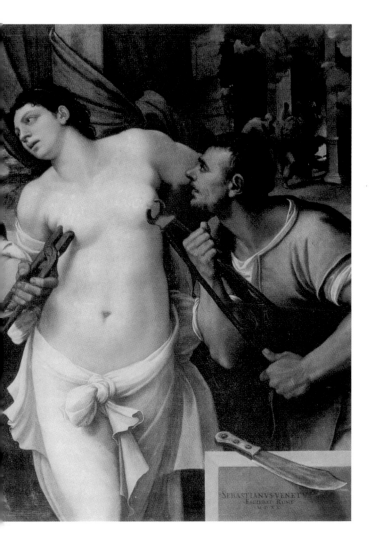

SEBASTIANVS·VENET·
FACIEBAT·ROME·
·M·D·XX·

Saints Paul Miki and Companions

MARTYRS • Memorial

Born in Kyoto, Japan, in 1556, Paul Miki was baptized at age five and entered the Jesuits. In time, he became a zealous and fatherly preacher, making good use of his profound knowledge of Buddhism. When the Jesuits were driven from Japan at the end of the 7th century, Paul stayed and continued his mission clandestinely, but he was arrested and martyred on a cross on the hill of Nagasaki together with companions in the Christian faith, Jesuits and Franciscans, on February 5, 1597. He was canonized in 1962 by Pope Pius IX.

He is usually depicted during his martyrdom.

NAME: Paul is of Latin origin and means "small in stature, humble."

THE MARTYRDOM OF THE FRANCISCAN SAINTS AT NAGASAKI
(detail)
Tanzio da Varallo
1627–32
Pinacoteca di Brera, Milan

82

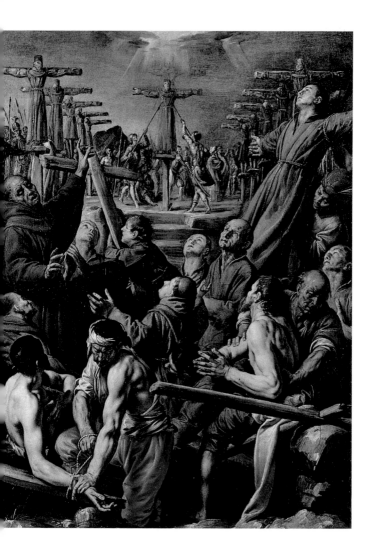

Saint Dorothy

MARTYR

Dorothy is said to have been killed in Cappadocia during the persecutions under Emperor Diocletian, early in the 4th century. According to tradition, as she was being led to her execution, a youth named Theophilus mocked her, asking her to send him flowers and fruit from Heaven. Immediately after her death, an angel appeared from Paradise, bearing fresh fruit and flowers for Theophilus. Dorothy's cult is found principally in the West. She is depicted as a young woman with a floral crown and flowers gathered in her dress or in a basket.

PROTECTOR: Gardeners, florists, brewers, and newlyweds.

NAME: Dorothy is of Greek origin and means "gift of God."

SAINT DOROTHY
Anselmo Rozio of Modena
1390
Biblioteca Estense, Modena

Saint Theodore

MARTYR

A Roman general in Anatolia in the 4th century, Theodore is among the most venerated martyr soldiers of the East. His story (often confused with that of another soldier named Theodore who also died a martyr) is based on a eulogy of him given by Gregory of Nyssa near his tomb at Euchaita, in Pontus, and on a later *passio*. His cult was initially found only in the East, but spread to the West during the 6th century.

He is depicted as a soldier, his only attribute being the cross of Christ.

PROTECTOR: Soldiers and conscripts.

NAME: Theodore is of Greek origin and means "gift of god."

SAINT THEODORE
Anonymous
Mid-14th century
Biblioteca Apostolica, Vatican

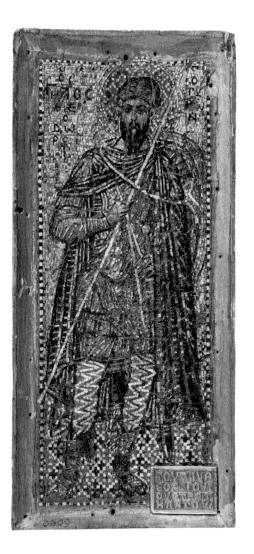

Saint Jerome Emiliani

PRIEST • Optional memorial

Jerome was born in Venice around 1486 and served in Venice's army against the League of Cambrai. Captured, he found his religious calling while in prison. Ordained priest in 1518, he dedicated himself to the care of orphaned children, along with the redeeming of prostitutes. He founded the Clerks Regular of Somasca (the Somaschi). He died in 1537 and was canonized in 1767.

In art, he appears in the cassock of the regular clergy, most often in the company of children.

PROTECTOR: Orphans and abandoned youth.

NAME: Jerome is of Greek origin and means "sacred name."

SAINT JEROME EMILIANI
Giambattista Tiepolo
1747–50
Ca' Rezzonico, Venice

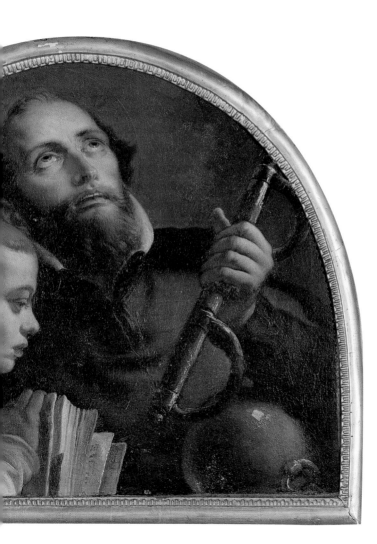

FEBRUARY 9

Saint Apollonia

VIRGIN AND MARTYR

An aged deaconess in Alexandria,
Egypt, Apollonia died a martyr in 249
during a riot against the homes of
Christians. Striking her in the face,
the heretics broke out all her teeth
and then threatened to burn her alive
on a pyre unless she renounced her
faith. Rather than do so, she herself
leapt into the flames. Her cult spread
rapidly in the West.
She is depicted as a young woman,
often with teeth or a pair of pincers;
she often bears a palm branch. She
is invoked against toothache.
PROTECTOR: Dentists.
NAME: Apollonia is of Latin origin
and is related to the god Apollo.
It may also be derived from the
aristocratic Etruscan name Apluni.

SAINT APOLLONIA
Anonymous
1550
Museo di San Francesco, Assisi

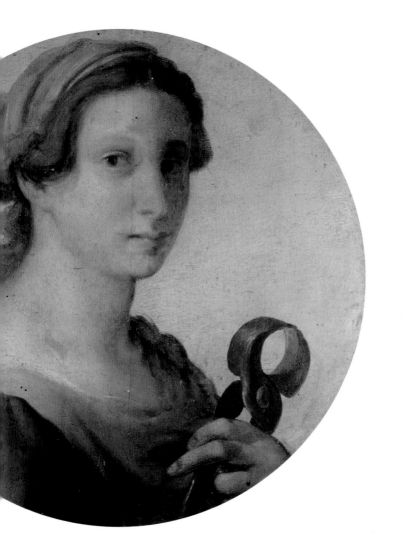

Saint Scholastica

VIRGIN

Scholastica was the sister, perhaps twin, of Saint Benedict. She was born at Norcia, Italy, and lived from roughly 480 to 547. She was a Benedictine nun in the monastery of nuns at Subiaco and later in that of Plombariola, at the foot of Monte Cassino. Her cult spread after her death initially within the order. She is depicted in art wearing the black habit of a Benedictine nun; her attributes are the dove and the book of the rule. She is invoked against storms and lightning and to obtain rain.

PROTECTOR: The Benedictine order and children who suffer convulsions.

NAME: Scholastica is from the Latin and means "teacher."

SAINT SCHOLASTICA
Anonymous
11th–12th century
Chapel of Sant'Anna, Monte Cassino

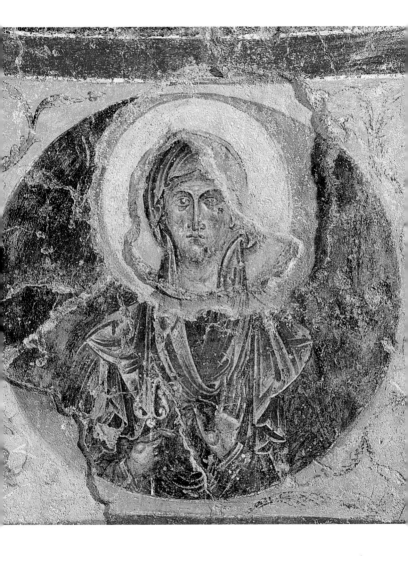

Saint Paschal I

POPE

Before being made pope, Paschal was abbot of the monastery of Santo Stefano Maggiore near the Vatican. His pontificate lasted from 817 to 824. He was the first pope to promote missions to Scandinavian countries and social interventions.
NAME: Paschal is from the Late Latin and means "relating to Easter," in turn from a Hebrew word meaning "Passover."

Our Lady of Lourdes

Optional memorial

This memorial recalls the appearance of the Virgin Mary to Bernadette Soubirous at Lourdes, near the cave of Massabielle, on February 11, 1858, and repeated until July 16 of that same year. Mary, presenting herself as the Immaculate Conception, bore a message that called for conversion, prayer, and charity. Because of these apparitions, officially recognized in 1862, Lourdes is still the site of continual pilgrimages.
The Virgin of Lourdes is usually depicted just as Bernadette saw her: young, with a white robe, a blue band at her waist, and a pure white veil over her head.

BLESSED VIRGIN MARY OF LOURDES
Popular sacred image
19th century

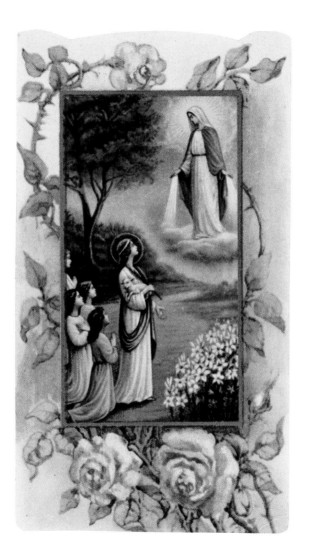

Saint Julian the Hospitaller

MARTYR

The earthly events of Julian took place between the 3rd and 4th centuries. According to tradition, he was a nobleman who through mistaken identity killed his parents and then, to expiate his sin, dedicated himself to the sheltering and care of the poor and of pilgrims. He died a martyr, together with his wife, in 304.

In art, he often appears in the clothes of a nobleman, with a falcon, deer, or the sword symbolic of his parricide.

PROTECTOR: Hoteliers, ferrymen, and travelers.

NAME: Julian is of Latin origin and comes from the Roman family name Julia.

THE HOSPITALITY OF SAINT JULIAN
Cristofano Allori
1612–18
Palazzo Pitti, Florence
(Saint Julian is the first on the right)

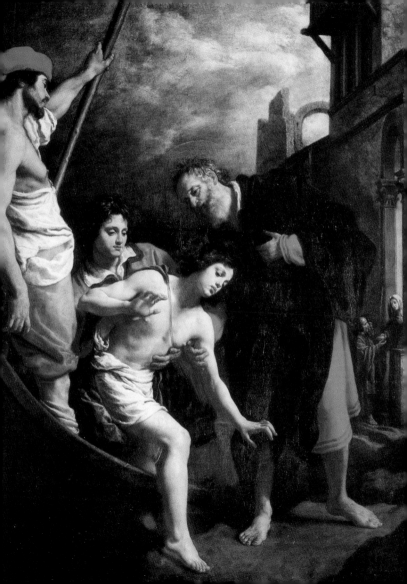

Saints Fusca and Maura

MARTYRS

Fusca was a fifteen-year-old girl in a pagan family of Ravenna, Italy, and Maura was her nurse. The girl was the first to sense the desire to join the Christian faith and convinced also her nurse. They were both baptized and then denounced by Fusca's father. Together they faced trial and suffered martyrdom by decapitation during the persecution of Decius in the 3rd century. Maura is presented as the model Christian nurse.

NAMES: Fusca is Latin and means "dark, gloomy," while Maura means "from Mauritania."

SAINT MONICA AND SAINTS REGINA, VICTORIA, MAURA, AND FUSCA (detail)
Giovanni Barbiani
1607
Santa Maria in Porto, Ravenna
(Saints Fusca and Maura are, respectively, the first and second from the right)

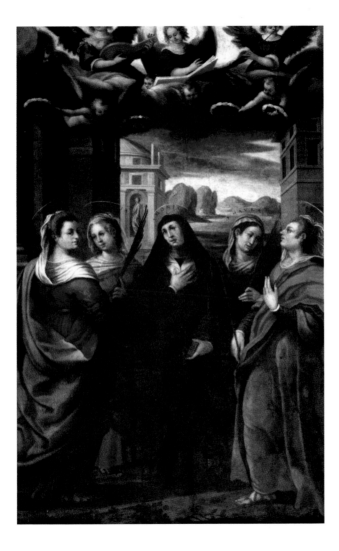

Saints Cyril and Methodius

APOSTLES TO THE SLAVS

The brothers Cyril and Methodius, born in Thessalonica early in the 9th century, chose the monastic life and brought the Gospel to the Slavic peoples. To achieve their goal they invented a new alphabet, later known as Cyrillic, with which they translated the words of the Bible for these peoples. Cyril later became a monk; Methodius was bishop of Sirmium. Canonized in 1936, the brothers were proclaimed joint patrons of Europe in 1980.

They are most often depicted together, wearing episcopal vestments and accompanied by books or scrolls bearing Cyrillic writing.

PROTECTORS: Professors.

PATRONS: Cyril and Methodius are joint patrons of Europe.

NAMES: Cyril is from the Persian and means "young king"; Methodius is of Greek origin and means "with a method."

CYRIL AND METHODIUS
Bulgarian school
19th century
Archaeological Museum, Veliko Turnovo
(Saint Cyril is to the left, Methodius to the right)

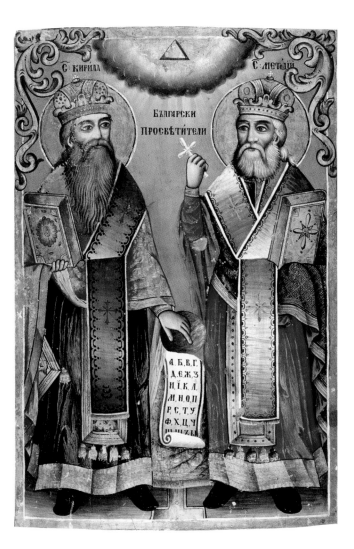

С: КИРИЛЛ

С: МЕТОДІИ

БЪЛГАРСКИ
ПРОСВѢТИТЕЛИ

А, Б, В, Г,
Д, Е, Ж, З,
И, Ї, К, Л,
М, Н, О, П,
Р, С, Т, У,
Ф, Х, Ц, Ч,
Ш, Щ, Ю, Я

Saint Valentine

MARTYR

The ancient *Roman Martyrology*, the compendium of martyrs at Rome, lists two 3rd-century martyrs named Valentine for this day, and they can probably be identified as the same person. One was a priest in Rome, the other a bishop of Terni. The first healed the daughter of a prefect and converted the entire family to Christianity; the second is known for his gifts at miracle-working. Victims of anti-Christian persecutions, both were martyred and buried in Rome. The depiction of this saint in art reflects this double history, for he can appear dressed as a bishop or a priest. His attributes are the pastoral staff, the palm, or an epileptic child. He is invoked against stomach pains.

PROTECTOR: Lovers, the betrothed, and epileptics.

NAME: Valentine is from the Latin and means "strong and healthy."

SAINT VALENTINE BAPTIZING SAINT LUCILLA
Jacopo Bassano
Circa 1575
Museo Civico, Bassano del Grappa

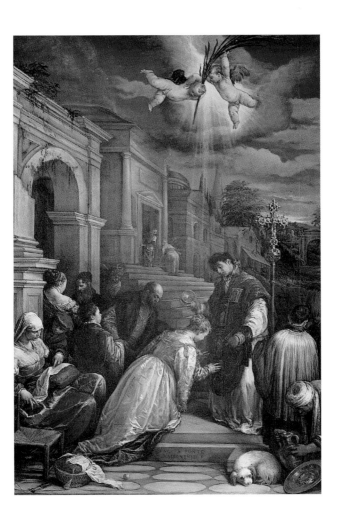

Saints Faustinus and Jovita

MARTYRS

Faustinus and Jovita, brother and sister, lived between the 1st and 2nd centuries, during the reigns of the emperors Trajan and Hadrian. Their stories are without historical merit, and the two saints have been dropped from the current Catholic Church calendar. They may have been Roman soldiers at Brescia who suffered numerous tortures before their martyrdom, which was done by decapitation. Their cult, while very old, always has been primarily local. Despite the difference in their sex, both are depicted as soldiers or one is dressed as a presbyter, the other a deacon. Both bear the palm of martyrdom.

PATRONS: Faustinus and Jovita are the patron saints of Brescia.

NAMES: Faustinus is a diminutive of the Latin *Faustus*, meaning "favorable, lucky"; Jovita is derived from the name of the god Jove.

MADONNA AND CHILD WITH SAINTS
FAUSTINUS AND JOVITA
Vincenzo Foppa
Circa 1505–10
Pinacoteca Tosio Martinengo, Brescia

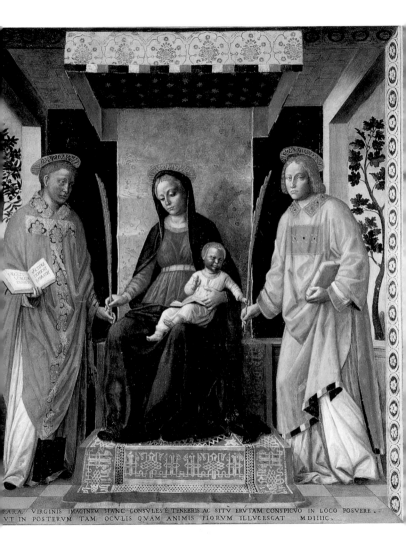

PARA. VIRGINIS IMAGINEM HANC CONSVLES E TENEBRIS AC SITV ERVTAM CONSPICVO IN LOCO POSVERE.
VT IN POSTERVM TAM OCVLIS QVAM ANIMIS PIORVM ILLVCESCAT M DIIIIC.

Saint Juliana of Nicomedia

MARTYR

Early in the 4th century, during the persecutions of Diocletian, this young woman suffered martyrdom. According to legend, her family forced her into marriage with a pagan, but she denied him, intending to convert him. Her husband, however, had her locked up and called on her to abjure her faith. While she was in prison the devil pestered her, trying to get her to obey her husband, and she struck him with her chains. In the end she was beheaded.

In art, she is often depicted with a winged devil or dragon near her or chained to her feet. She is invoked against contagious diseases.

PROTECTOR: Women in childbirth.

NAME: Juliana is of Latin origin and comes from the Roman family name Julia.

SAINTS PARASKEVA, BARBARA, AND JULIANA
Pskov school
14th century
Tretyakov Gallery, Moscow
(Saint Juliana is on the right)

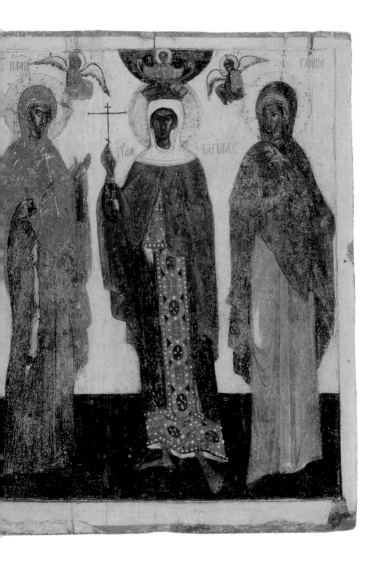

The Seven Servite Founders

CONFESSORS • Optional memorial

Their names were Buonfiglio Monaldi, John Buonagiunta, Benedict dell'Antela, Bartholomew degli Amidei, Geraldino Sostegni, Ricovero Uguccione, and Alexis Falconieri. Devout Florentines, they formed an order devoted to the Virgin Mary. In 1245, they set off from Florence to live a life of fraternity, penitence, and contemplation while caring for the poor. The order of friars they founded, known as the Servants of the Blessed Virgin Mary, or Servites, followed the rule of Saint Augustine. They were canonized in 1888.

They are usually depicted together in adoration of the Virgin, wearing the black habit of their order.

PROTECTORS: Those who plan something good together.

NAMES: Buonfiglio is a name of favorable auspices, and Buonagiunta means "welcome"; Benedict means "blessed," Bartholomew, from the Latin, means "loves God"; Geraldino, also Latin, means "brave"; Ricovero is a variant of Hugh and means "heart, spirit"; Alexis is from the Greek and means "defender."

APPARITION OF MARY TO THE SEVEN SERVITE FOUNDERS
Popular sacred image
20th century

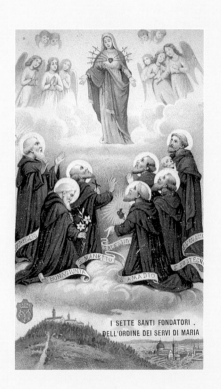

I SETTE SANTI FONDATORI .
DELL'ORDINE DEI SERVI DI MARIA

Beato Giovanni Fra Angelico

DOMINICAN

Born at Vicchio, Italy, in 1387, Fra Angelico was already a well known painter when his religious calling led him to the convent of Fiesole, where he took the name Giovanni. By means of his art, he preached as a friar of the order of Dominicans. Indeed, he painted only religious subjects. He was active in Tuscany and at the Vatican; when Pope Nicholas V offered him the bishop's see of Florence he adamantly refused it. He died at Rome in 1455 and although never officially beatified has always been known as Beato Fra Angelico.

In art, he is depicted in a Dominican cowl, and rarely is he shown in the act of painting.

PROTECTOR: Painters and artists.

NAME: Giovanni *(John)* is from a Hebrew name meaning "Yahweh is gracious."

BEATO FRA ANGELICO
(detail of the *Disputation*)
Raphael
1509–11
Stanza della Segnatura, Vatican

Saint Mansuetus

BISHOP

Mansuetus was bishop of the city of Milan from 676 to 685. He preached against the Eastern heresy of Monotheletism, which held that Christ had two natures, human and divine, but a single divine will. Fierce supporter of Dyothelitism, which on the contrary supposed the presence in Christ of both divine and human will, he wrote homilies and treatises and took part in the Lateran Council. He is depicted in art in episcopal vestments.

NAME: Mansuetus is of Latin origin and means "docile."

SAINT MANSUETUS
Anonymous Lombard artist
Before 1737
Museo Diocesano, Milan

Saint Eleutherius

BISHOP

Born around 456 at Tournai, in modern Belgium, Eleutherius was the first bishop of the city of his birth. He set himself the difficult task of converting the Franks of King Clovis who, ten years after his nomination as bishop, accepted baptism in mass after their victory over the Alemanni; this important event did not mean the conversion of all of France, however. Eleutherius died around 531.

He is depicted in episcopal vestments.

NAME: Eleutherius is from the Greek and means "free, independent."

SAINT ELEUTHERIUS
14th century
Tournai Cathedral

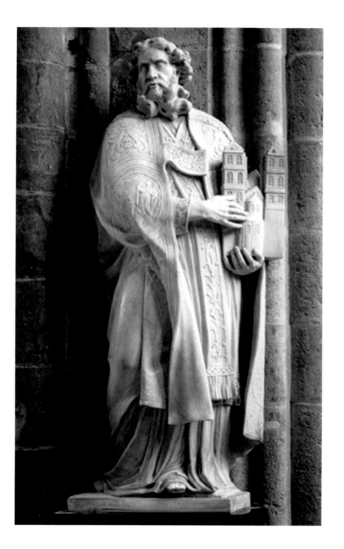

Saint Peter Damian

BISHOP AND DOCTOR
OF THE CHURCH

Born at Ravenna, Italy, in 1007, he was raised by an older brother, Damianus (whose name he took). He excelled in his studies and taught at the University of Piacenza, but preferred the life of a hermit in the Camaldolensian monastery of Fonte Avellana. He was called by the bishop of Ravenna and then by Pope Leo IX to battle the problems afflicting the Church with written works and sermons. He was named bishop, then cardinal. He died at Faenza in 1072. His official cult was approved only in 1828. He is depicted in the habit of a Camaldolensian monk or in episcopal vestments. He is invoked against migraine headaches.

NAME: Peter is from the Greek and means "rock, stone."

SAINT PETER DAMIAN
Master of Saint Peter Damian
15th century
Museo d'Arte della Città, Ravenna

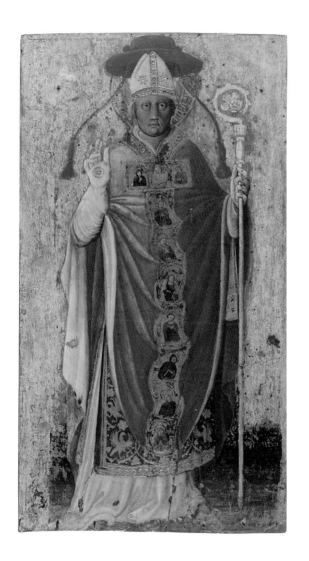

The Chair of Saint Peter

Feast

The feast of the Chair of Saint Peter emphasizes the importance of the mission that Jesus entrusted to this saint, who was teacher and shepherd of the church that was founded upon him. This feast was formerly celebrated on two different days, one for the chair at Antioch (before Peter's trip to Rome and his martyrdom) and one for that of Rome.

NAME: Peter is from the Greek and means "rock, stone."

SAINT PETER RECEIVES
THE KEYS FROM CHRIST
Guercino
1618
Pinacoteca Civica, Cento

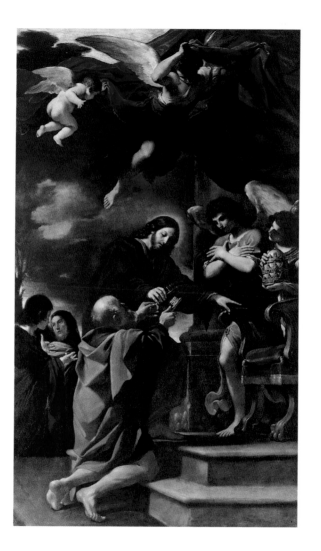

Saint Margaret of Cortona

PENITENT

Margaret was born into a poor farm family at Laviano, Italy, around 1274. Her mother died when she was seven, her stepmother mistreated her, and soon enough she left her father's home to live with a nobleman named Arsenio in his castle at Montepulciano. But Arsenio was mysteriously murdered—his dog returned alone and pulled on Margaret's dress and then led her to Arsenio's dead body. In vain she begged to be allowed back into her father's home and instead was taken into the home of two pious women. Not long after that she began her life of penitence as a Franciscan tertiary. She died in 1297. Her cult spread immediately in the diocese of Cortona, but her canonization came only in 1728.

In art, she appears in a Franciscan habit, often with a small dog and the symbols of the penitent.

PROTECTOR: Penitent women.

NAME: Margaret is of Greek origin and means "pearl."

SAINT MARGARET OF CORTONA
Jacopo Alessandro Calvi
Late 18th century
Private collection

Saint Polycarp

BISHOP AND MARTYR • Memorial

Polycarp was a disciple of the apostles at Smyrna, between the 1st and 2nd centuries, and according to tradition was made bishop of that city at the insistence of John the Apostle. He traveled to Rome to confer with Pope Anicetus on questions concerning the uniform dating of Easter. On his return to Smyrna he fell victim to an anti-Christian uprising and was taken to the amphitheater, where he was called on to abjure his faith in front of the proconsul Statius Quadratus. When he refused he was burned on a pyre. This was in the year 155, when he was eighty-six years old.

NAME: Polycarp is from the Greek and means "giving much fruit."

SAINT POLYCARP
Popular sacred image
20th century

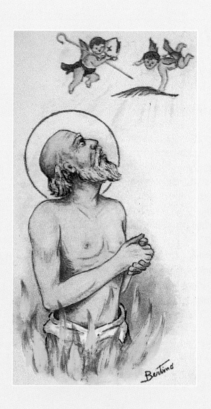

Blessed Constantius of Fabriano

DOMINICAN

Constantius was born at Fabriano, Italy, early in the 15th century, and at fifteen he entered the Dominicans, becoming a preaching friar thanks to the guidance of excellent teachers. He did his utmost to favor the internal reform of the order and strove for peace, trying to eliminate all discord among the families in the cities—Fabriano, Perugia, and Ascoli—where he was an active preacher. He died in Ascoli in 1481.

In art, he is depicted in the white habit and black mantle of the Dominicans.

NAME: Constantius is from the Latin and means "constant, steadfast."

BLESSED CONSTANTIUS
OF FABRIANO
Popular sacred image
19th century

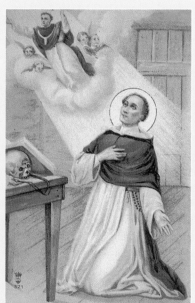

BEATO COSTANZO DA FABRIANO
CONFESSORE DOMENICANO

Saint Walburga

ABBESS

Walburga, daughter of King Richard of Saxony and sister of Saints Willibald and Winebald, was born in England around 710. She entered a monastery as a child and was called by Saint Boniface to bring the Gospel to Germany with several other monks and nuns. She later became abbess of the male and female monastery of Heidenheim, ruling with great zeal. By the time she died, in 776, word of her many miracles was spreading. In art, she appears in a white habit and black veil and carries the pastoral staff of an abbess. She is invoked against ulcers and rabies.
NAME: Walburga is from the ancient German and means "rule of the fortress."

MIRACLE OF SAINT WALBURGA
Peter Paul Rubens
1610
Museum der Bildenben Künste, Leipzig

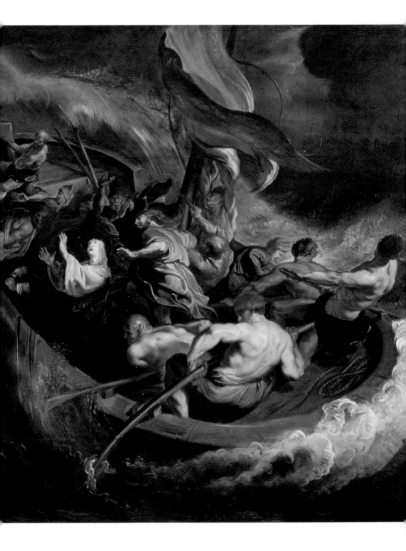

Saint Nestor of Magydos

BISHOP AND MARTYR

Nestor occupied the bishop's see at Magydos in Asia Minor in the region of Pamphylia during the period of the persecutions under Decius, in the middle of the 3rd century. According to what is said in a Greek *passio*, Nestor sought to save the entire Christian community by placing it outside the city, while he alone remained in prayer. He was found, arrested, and condemned to crucifixion for refusing to abjure his faith and sacrifice to the idols.

He is depicted in episcopal vestments, sometimes during his martyrdom on the cross.

NAME: Nestor is of Greek origin and means "homecoming."

SAINT NESTOR OF MAGYDOS
Popular sacred image
20th century

Saint Leander of Seville

BISHOP

Born at Cartagena around 545, he chose the religious life, as did his brothers Isidore and Fulgentius and his sister Florentina, and battled the Arianism professed by the Visigoths then ruling Spain. Following important conversions in the royal family, he was expelled and took refuge in Constantinople, where he met the future pope Gregory the Great. Recalled to Spain, he was made bishop of Seville. He convened the Third Council of Toledo, which confirmed the conversion of the Visigoth kingdom to Catholicism. He died around 600.

He is depicted in episcopal vestments and is invoked against rheumatism.

NAME: Leander is from the Greek and means "lion of a man."

SAINT LEANDER
(detail)
Bartolomé Esteban Murillo
1655
Seville Cathedral

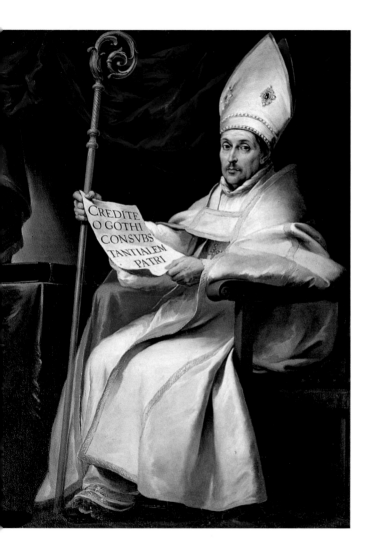

Venerable Carlo Gnocchi

PRIEST

Carlo was born at San Colombano al Lambro, Italy, in 1902. Ordained priest in 1925, he had his first pastoral experiences as a parish priest and as chaplain of the Gonzaga Institute of Milan. He was military chaplain of the Alpini, first in Greece and then in Russia. He came away from these experiences suffering such a profound spiritual crisis that, on his return, he dedicated all his efforts to the care of orphans, children mutilated by bombardments, and the disabled. He died in 1956. He is on the way toward canonization, having been declared venerable in 2002.

In iconography Don Gnocchi is depicted in the dress of an Alpino or with the cassock and together with children.

NAME: Carlo *(Charles)* is from the German and means "man, or free man."

VENERABLE CARLO GNOCCHI
Marco Melzi
20th century
Fondazione Don Carlo Gnocchi, Salice Terme

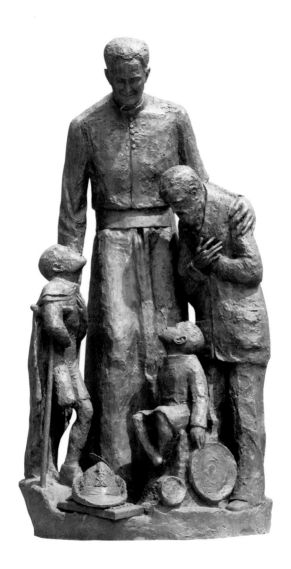

FEBRUARY 29

Saint Hilary

POPE

Originally from Sardinia, Hilary (Hilarus) was born at Cagliari and was among the Roman archdeacons during the pontificate of Leo the Great (440–61), serving as that pope's representative at the Council of Ephesus and succeeding him on the throne. His pontificate was distinguished by his battle against heresies and by the diplomatic skills he revealed in the relations between the Church of Rome and the Church of Constantinople. He died on February 29, in the leap year 468. He is depicted in papal robes and in normal years is commemorated on February 28.

PROTECTOR: Librarians.
NAME: Hilary is of Latin origin and means "happy."

SAINT HILARY
19th century
San Paolo fuori le Mura, Rome

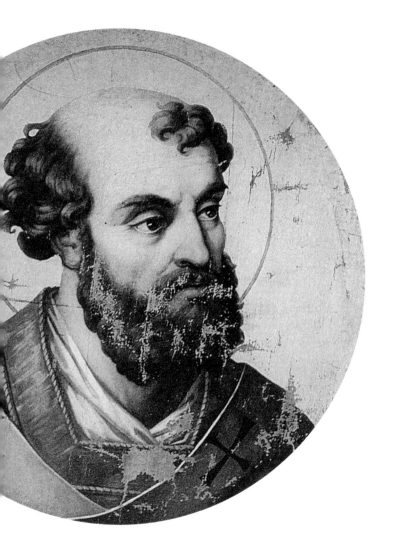

Saint Albinus of Vercelli

BISHOP

Albinus became bishop of Vercelli, Italy, in 452. He had to have the city's cathedral rebuilt, for it had been destroyed during the bloody struggle against the Goths and Huns that had ended with the victory of the Romans led by Aetius in 451. Although no other specific historical information exists about this bishop saint, the cult dedicated to him is quite ancient.

He is depicted in episcopal vestments with a crosier.

NAME: Albinus is from the Latin and means "white."

MADONNA AND CHILD ENTHRONED AND SAINTS AMELIUS, LAURENCE, ALBINUS, AND AMICUS
Paolo da Brescia
1458
Galleria Sabauda, Turin
(Saint Albinus is the second from right)

136

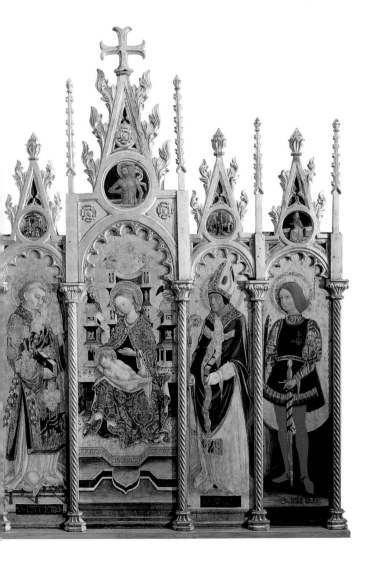

Saint Quintus the Thaumaturge

CONFESSOR

Native of Phrygia, in Asia Minor, Quintus moved with his family to Aeolia, where he dedicated himself to works of charity. His activities attracted the ire of pagans, and he was denounced, tried, but then released by the prefect Rufus, whom Quintus had healed of a demonic obsession. Newly arrested, he was this time tried by a different prefect and was put to many tortures, which he suffered with Christian spirit. After the miraculous healing of his legs, which had been broken, he was allowed to return to his preaching. He died around 285.

NAME: Quintus is of Latin origin and means "fifth," as in "fifth child."

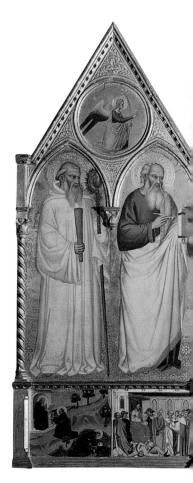

THE VIRGIN APPEARS TO SAINT BERNARD AND SAINTS
Master of the Rinuccini Chapel
14th century
Accademia, Florence
(Saint Quintus is the second from right)

138

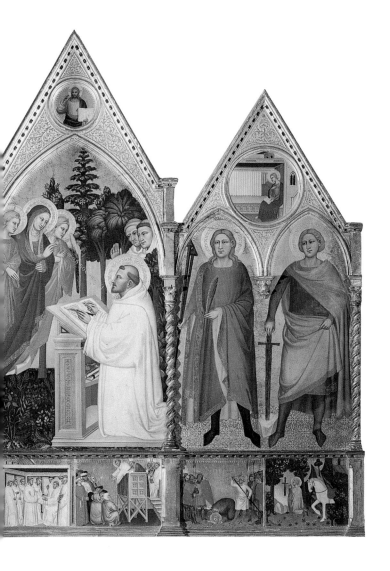

Saint Cunegund

EMPRESS

Born around 978, daughter of Siegfried, first earl of Luxembourg, and Hedwig of Germany, Cunegund was given in marriage to Henry, duke of Bavaria, shortly after elected emperor of the Holy Roman Empire. Together with her husband she conducted an exemplary life and, at his death, she retired as a Benedictine nun, laying aside all symbols of power to join the convent of Kaufungen, which she had founded. She died around 1040. The cult of Saint Cunegund was approved by Innocent III in 1200.

She is depicted in regal clothes and often holds a model of the cathedral of Bamberg; on occasion she appears in a monastic habit.

PATRON: Cunegund is the patron saint of Luxembourg.

NAME: Cunegund is from the German and means "brave in war."

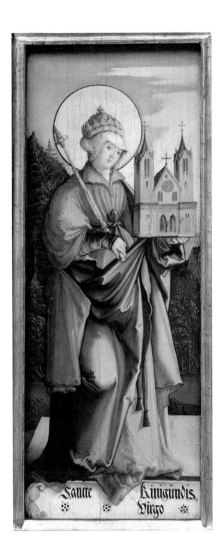

Sancte Kunigundis
Virgo

Saint Casimir

PRINCE

Casimir was born in 1458, son of King Casimir IV of Poland and Elizabeth of Austria. He fled the life of ease and privileges, and when the Hungarians deposed their king Matthias Corvinus in 1461 and offered him the crown, he refused it. He spent his brief life (he died at age twenty-five) following ascetic ideals and assisting his father in the rule of the kingdom. He was canonized in 1521.

He is depicted as a youth in regal clothes, often with a royal crown nearby. He is invoked against illnesses caused by chills and against carnal temptations.

PROTECTOR: The youth of Lithuania.

PATRON: Casimir is the patron saint of Lithuania.

NAME: Casimir is of Polish origin and means "to destroy peace."

SAINT CASIMIR
Carlo Dolci
Circa 1671
Palazzo Pitti, Florence

Saint Adrian of Caesarea

MARTYR

Adrian was martyred in the 4th century at Caesarea and is recalled in the writings of Eusebius, who related the events of Adrian to those of Ebulus. The two arrived at Caesarea with the precise aim of joining and assisting the Christians living there. They were soon discovered, arrested, and tried. Refusing to abjure their faith, they were condemned to death during the games in the amphitheater. Adrian was torn apart by wild beasts and then beheaded on March 5 or 7 of the year 309.

NAME: Adrian is from the Latin and means "born at Adria."

THE MARTYRDOM OF SAINT ADRIAN
(detail)
Peter Paul Rubens
Rubenshuis, Antwerp

Saint Rose of Viterbo

VIRGIN

Born at Viterbo, Italy, in 1235, Rose had a vision when still a child and was very young when she entered the Franciscan tertiaries. At age ten, having been healed of an illness, she began preaching in the streets of Viterbo against the emperor Frederick II, enemy of the pope. Deemed dangerous, she was exiled from the city, returning only after the emperor's death. She herself died at age eighteen, consumed by the tireless exercise of charity. Her cult began immediately after her death. Her relics were translated to the church of Santa Maria delle Rose on September 4, an event that is still celebrated with a procession.

She is depicted in the robe of a tertiary, and her attributes are roses and lilies.

PROTECTOR: Since 1922, Rose has been the protector of the young female members of Catholic Action.

NAME: Rose is from the Latin and indicates the flower.

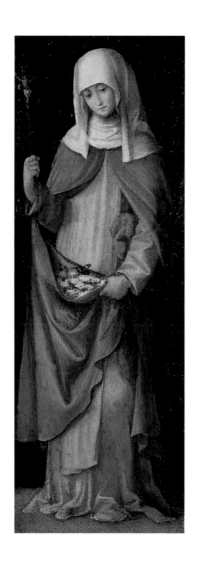

Saints Perpetua and Felicity

MARTYRS

Perpetua, a noblewoman and mother of a nursing child, and her slave Felicity, far advanced in pregnancy, died at Carthage in the amphitheater during the persecutions of Septimus Severus in the 3rd century. They had been imprisoned before being baptized. Perpetua herself wrote a description of the prison, and her words were collected by Tertullian. The two women died tied to a net, torn in pieces by a bullock.

In art, they are usually depicted together, sometimes with the animal.

PROTECTOR: Felicity is the protector of women in childbirth.

NAMES: Both names are of Latin origin. Perpetua indicates eternal faith in Christ; Felicity means "happiness."

SAINT PERPETUA
(detail of a vault mosaic)
6th century
Archbishop's Palace, Ravenna

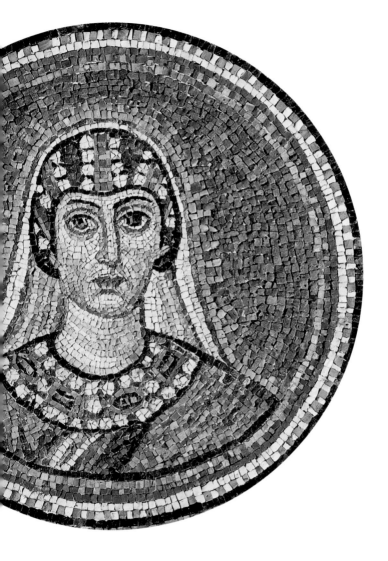

Saint John of God

FOUNDER

John was born in Portugal at Montemor-o-Novo in 1495. Before his conversion, at age forty, he was a soldier, shepherd, and bookseller. In 1537, he felt himself called to do charitable works and began giving to the poor and sick, even transforming his house in Granada into a hospital. He died in 1550 and was canonized in 1690.

He is depicted in a cassock while healing the sick.

PROTECTOR: The sick, nurses, doctors, people with heart problems, booksellers, bookbinders, and hospitals.

NAME: John is from a Hebrew name meaning "Yahweh is gracious."

SAINT JOHN OF GOD TENDING
A SICK MAN
(detail)
Bartolomé Esteban Murillo
17th century
Hospital de la Caridad, Seville

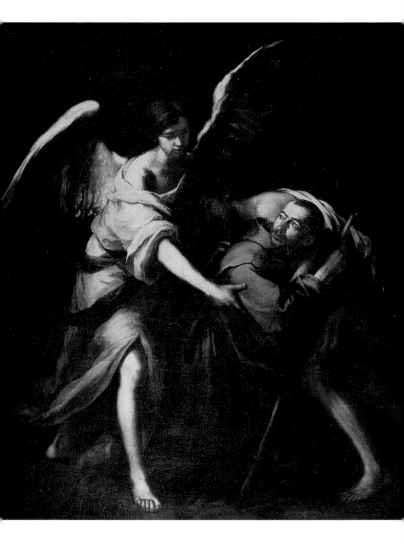

Saint Frances of Rome

FOUNDRESS

Born at Rome in 1384, Frances was an exemplary wife and mother and dedicated her life to prayer and the assistance of the poor. She founded the Congregation of the Oblates of Mary. She died in Rome in 1440 and was canonized in 1608.

She is depicted in the black cassock and white veil of the Benedictines while distributing bread to the poor; she is often accompanied by a guardian angel. She is invoked against the plague and for the liberation of souls in Purgatory.

PROTECTOR: Car drivers and widows.

NAME: Frances *(Frank)* is of German origin, from the name of the people who settled in France; it has come to mean "forthright, sincere."

**SAINT FRANCES OF ROME
GIVING ALMS**
Baciccio
Circa 1675
J. Paul Getty Museum, Los Angeles

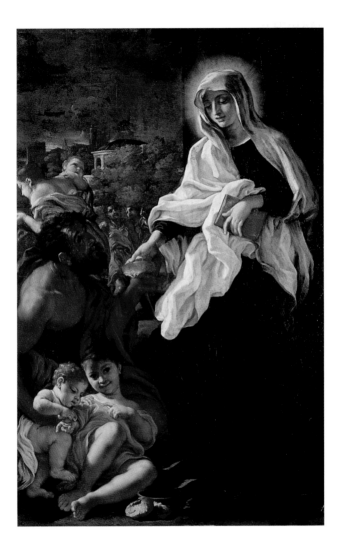

Saint John Ogilvie

MARTYR

John Ogilvie was born in Scotland in 1579. At fourteen he was sent to be educated in Belgium and Germany. There he converted to Catholicism and entered the novitiate of the Jesuits at Brünn, in Moravia. He was ordained a priest in 1610. In 1613, he returned to Scotland, where Catholics were being persecuted, so he operated clandestinely. In 1614, he was arrested and tortured; the next year he was executed for high treason at Glasgow. He was canonized in 1976.

He is depicted wearing a cassock and black mantle.

NAME: John is from a Hebrew name meaning "Yahweh is gracious."

SAINT JOHN OGILVIE
Popular sacred image
19th century

Saint Rosine of Wenglingen

VIRGIN MARTYR

Rosine is a saint from the 4th century whose worship is primarily a local cult. The story of her life cannot be reconstructed in detail because so many elements have become confused with the lives of other saints from the early centuries. A virgin, she was probably a martyr, for she has been depicted with a sword and palm branch since antiquity; it seems probable she spent a long period in a hermitage. Wenglingen, near Augsburg, has been the center of her cult since the 12th century, as is indicated by her frequent appearance in the local iconography.

NAME: Rosine *(Rose)* is from the Latin and indicates the flower.

SAINT ROSINE OF WENGLINGEN
Popular sacred image
20th century

Saint Fina of San Gimignano

VIRGIN

Born at San Gimignano, Italy, in 1238, she died at fifteen, already in the odor of sanctity. Her family was poor, and she was soon immobilized by a deathly sickness, laid out on an oaken plank. With her great devotion she suffered the terrible disease and the pain, using prayer and always thinking of the Passion of Jesus and the Virgin. Her cult began immediately after her death.
She is depicted as a young woman, often with flowers.
PATRON: Fina is the patron saint of San Gimignano.
NAME: Fina is an abbreviated form of Seraphina, Hebrew for "fiery one," in reference to an order of angels.

APPARITION OF SAINT GREGORY
TO SAINT FINA
(detail from the *Stories of Saint Fina*)
Domenico Ghirlandaio
1475
Collegiate Church, San Gimignano

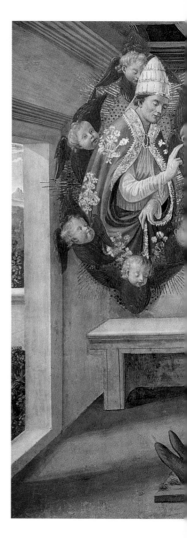

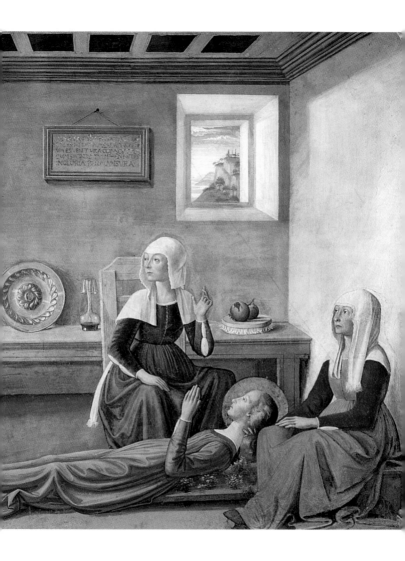

Saint Roderigo of Córdoba

PRIEST AND MARTYR

Roderigo lived in the 9th century, during the period in which Spain was deeply divided between Christians and Muslims, often even within the same family. In fact, Roderigo, a Christian priest, had one brother who was Christian and one who was Muslim and often found himself called upon to settle their harsh religious disputes. In 837, during a persecution of Christians, Roderigo was arrested and called upon to publicly renounce his faith in Christ, on pain of death. When he refused he was decapitated (together with Saint Solomon, also remembered on this day). He is depicted in a priest's robes bearing a palm branch.

NAME: Roderigo *(Roderick)* is of German origin and means "famous in glory."

SAINT RODERIGO
Bartolomé Esteban Murillo
1650
Gemäldegalerie, Dresden

160

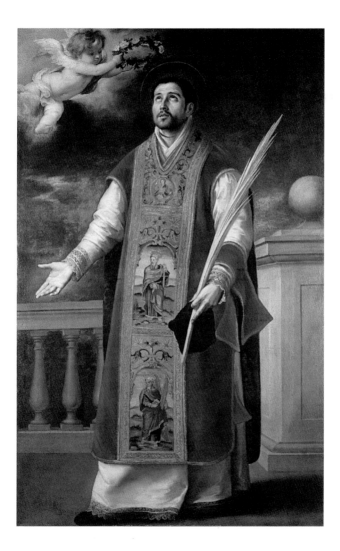

Saint Matilda

QUEEN

Matilda was born around 895 in Saxony and raised in the monastery of Erfurt, where her grandmother Maude was abbess. She was married to Henry I the Fowler, king of Germany, and led an exemplary life as wife, mother, and queen, distinguishing herself for her prayer and assistance to the poor, whom she often visited in disguise. She founded several monasteries, including that of Quedlinburg, where she died in 968.

She is depicted in regal dress.

NAME: Matilda is from the German and means "strong in war."

CORONATION OF DUKE HENRY
AND DUCHESS MATILDA
Evangeliary of Henry
Circa 1173
Herzog August Bibliothek, Wolfenbüettel

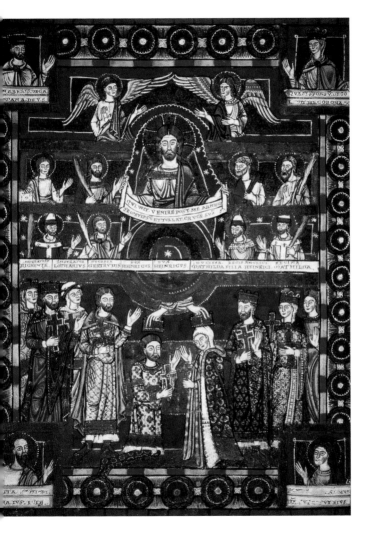

Saint Longinus

MARTYR

Longinus is identified with three different people: the Roman centurion who recognized Christ as his savior during the Passion; the Roman soldier who pierced the side of the crucified Christ with a lance; and the leader of the group of soldiers sent to guard the tomb. According to tradition (both Greek and Latin) he converted after the experience. He became a disciple of the apostles, worked to help spread Christianity, and died a martyr in Cappadocia.

He is depicted as a Roman soldier, often with the lance, often under the cross; sometimes he bears a palm branch. He is invoked against wounds from edged weapons.

NAME: Longinus is from Latin by way of Greek and means "long."

CRUCIFIXION
(detail)
Andrea Solario
1503
Louvre, Paris

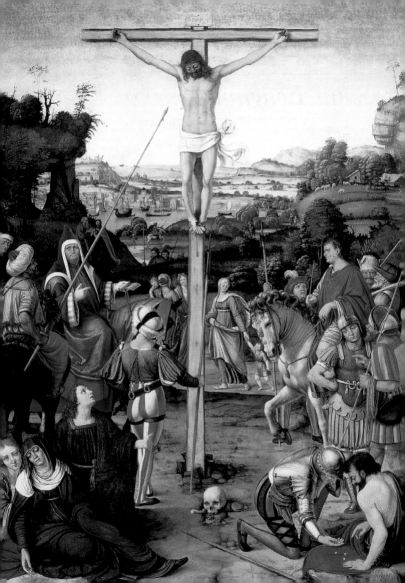

Saint Agapitus of Ravenna

BISHOP

Agapitus was bishop of the dioceses of Ravenna, Italy, between the 3rd and 4th centuries. According to certain sources, he took part in the Council of Rome in 340. He was buried in the cemetery of the basilica of San Probo in Classe, but in 963 the archbishop Peter IV translated his relics to the basilica of the Resurrection of Our Lord. His cult arose in the 11th century with the spread of the legend that the first twelve bishops of Ravenna had been miraculously chosen following the sign of a dove that landed on them.

NAME: Agapitus is from the Greek and means "beloved."

CHRIST AND SAINTS
(detail)
833
Apse vault, St. Mark's, Rome
(Saint Agapitus is the second from right)

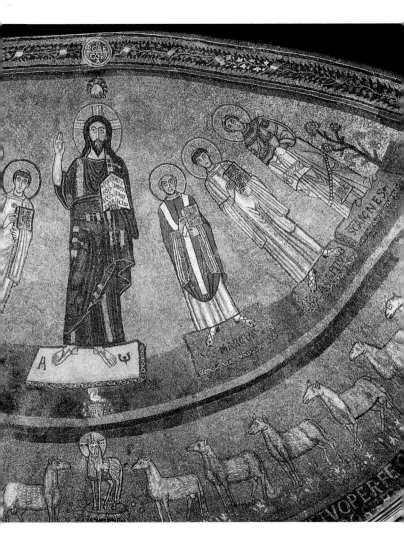

Saint Patrick

BISHOP

Born in Britain around 385, Patrick was still a child when he was carried off by Irish raiders who took him to Ireland as a slave. He later fled, returned to his home, and was educated and instructed as a priest. He decided to dedicate himself to the spread of Christianity in the places of his slavery, and in 432 he was sent to Ireland as a missionary bishop. He died in 461 (according to legend in 493, at more than 100 years of age). His cult is universal.

He is depicted in bishop's clothes, sometimes with a clover as attribute. He is invoked for liberation from Hell, for the souls in Purgatory, and against rabies.

PROTECTOR: Miners.

PATRON: Patrick is the patron saint of Ireland.

NAME: Patrick is of Latin origin and means "nobleman."

MIRACLE OF SAINT PATRICK
Giambattista Tiepolo
Circa 1746
Museo Civico, Padua

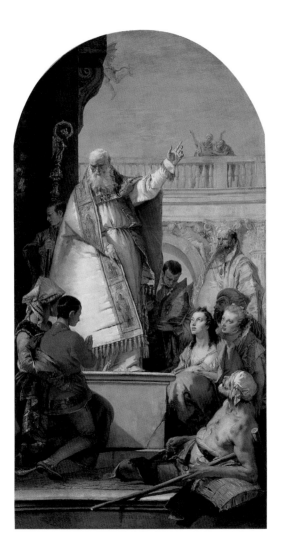

Saint Cyril of Jerusalem

BISHOP AND DOCTOR
OF THE CHURCH

Cyril was born in Jerusalem in 315. As a young priest he demonstrated such great doctrinal learning that he was entrusted with preparing candidates for baptism. To this end he wrote his *Catecheses*, which earned him immediate renown. When still only thirty-five he was made bishop of Jerusalem. Thanks to his doctrinal rigor he was soon hated by the Arians, who several times opposed him and exiled him. Reestablished by the emperor Theodosius, he exercised the ministry until his death, around 386.

He is depicted in episcopal vestments.

NAME: Cyril is of Persian origin and means "young lord."

SAINT CRYIL OF JERUSALEM
Popular sacred image
20th century

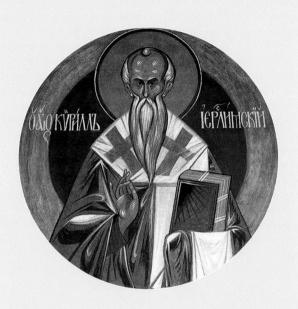

Saint Joseph

HUSBAND OF THE VIRGIN MARY • Solemnity

Joseph, of the house of David, lived at Nazareth and was a carpenter. He married Mary and was the putative father of Jesus. He is cited in the Gospels only in reference to the infancy of Jesus and probably died before Jesus began his public life. The cult of Saint Joseph spread around the 9th century and entered the liturgy in the 15th.

He is depicted as an older man with a flowering staff and the tools of a carpenter. He is invoked for a good death and by the homeless and the exiled.

PROTECTOR: Artisans, carpenters, woodworkers, supply officers, workingmen, fathers of families, and attorneys.

NAME: Joseph is from the Hebrew and means "he will add."

SAINT JOSEPH AND THE CHILD
Guido Reni
1638–40
Arcivescovado, Milan

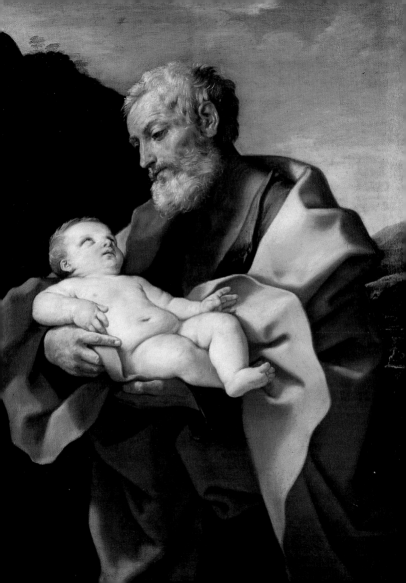

Saint John Nepomucene

MARTYR

Born at Nepomuk in Bohemia in 1330, John was the preacher of King Wenceslaus IV and confessor of his queen, Joanna of Bavaria. He died in 1383, thrown into the Vltava River on the orders of the king for refusing to reveal the queen's confession (Wenceslaus suspected she was guilty of infidelity).

He is depicted in a cassock and may bear the palm and five stars. He is invoked against the dangers of rivers and the sea, to obtain rain, and against slander.

PROTECTOR: Seafarers, canons, the slandered, officials in charge of a diocesan curia, good fame, and bridges.

NAME: John is from a Hebrew name meaning "Yahweh is gracious."

SAINT JOHN NEPOMUCENE HEARS THE CONFESSION OF THE QUEEN OF BOHEMIA
Giuseppe Maria Crespi
1743
Galleria Sabauda, Turin

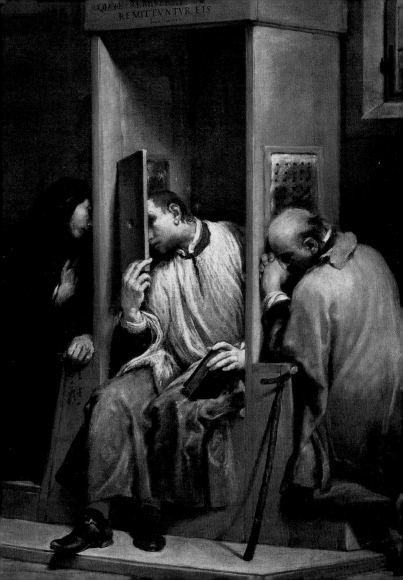

Saint Giustiniano of Vercelli

BISHOP

Perhaps a disciple of Martin of Tours, Giustiniano was bishop of Vercelli, Italy, from 435 to 452. He probably died before the ferocious Huns of Attila fell on Milan and Pavia, spreading death and destruction in the outlying cities as well. According to ancient documents, Giustiniano was the fourth bishop of the city after Eusebius. He directed the diocese with zeal, was loved like a father, and was a guide for the clergy and the monks. He seems to have died of natural causes.

NAME: Giustiniano is from the Latin and means "honest, just."

SAINT GIUSTINIANO OF VERCELLI
Popular sacred image
19th century

Saint Lea of Rome

WIDOW

Lea was a Roman matron, widowed when still young. The consul Vettius Agorius Praetextatus hoped to marry her, but she decided against a second marriage and, on the advice of Saint Jerome, turned instead to the religious life of a convent, joining the one that was already home to Paola and Marcella. The only information about her comes from a letter from Saint Jerome to Marcella, dated 384, the year of Lea's death. The saint eulogized her virtues and her life, which had been completely dedicated to prayer and charity.

Lea rarely appears in art, and when she does it is as a woman in prayer.

NAME: Lea is of Latin origin and means "lioness."

SAINT LEA OF ROME
Popular sacred image
19th century

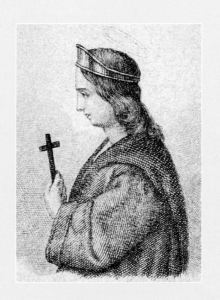

Saint Turibius of Mogrovejo

BISHOP

Turibius Alphonsus de Mogrovejo was born near León, Spain, around 1538. A layman professor at the University of Salamanca, he was appointed president of the court of the inquisition at Granada by King Philip II. In 1580, he was nominated to the archbishopric by the pope; he received the orders of priesthood and was sent to Lima, Peru. He dedicated himself completely to his enormous diocese, helping the indigenous peoples, supporting the faithful, and encouraging the clergy to not succumb to the conquistadors. He died in 1606 and was canonized in 1726.

He is depicted in episcopal vestments.

PROTECTOR: Missionary bishops.
PATRON: Saint Turibius is the patron saint of Peru.
NAME: Turibius is Celtic and means "of the tribe of the Taurini."

SAINT TURIBIUS
Anonymous
17th century
Astorga Cathedral

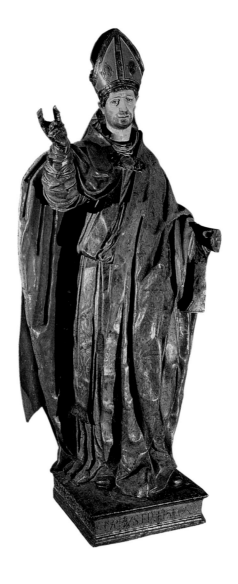

Blessed Diego Joseph of Cádiz

CAPUCHIN FRIAR

Born at Cádiz in Andalusia, Spain, in 1743, Diego (Didacus, Diaz) lost his mother at nine. He entered the novitiate of the Capuchin friars of Seville and was ordained priest at Carmona. He performed missionary work in his homeland, and his sermons brought many conversions. He left various apologist and spiritual writings. He died at Ronda on March 24, 1801. He was proclaimed blessed in 1894.

He is depicted as an elderly man with a long beard in the cowl of a Capuchin, often in adoration of the crucifix.

NAMES: Diego is from the Greek and means "teaching," but as a diminutive of Jago it means James, which is from the Aramaic and means "follower of God." Joseph is from the Hebrew and means "he will add."

DIEGO JOSEPH OF CÁDIZ
Anonymous
20th century
Cádiz Cathedral

The Annunciation of the Lord

Solemnity

The solemnity of the Annunciation is placed in the calendar exactly nine months before Christmas. Recording the visit of the archangel Gabriel to Mary of Nazareth, it celebrates the conception of Jesus by way of the Holy Spirit. In the most common depictions of the event in Western art, the Virgin receives the announcement while in prayer at a reading stand; the angel speaks to her sometimes kneeling, sometimes standing, sometimes while still in flight, and often bears a branch of flowering lily as an attribute. A dove, symbol of the Holy Spirit, descends from above.

ANNUNCIATION
Fra Angelico
1433–34
Museo Diocesano, Cortona

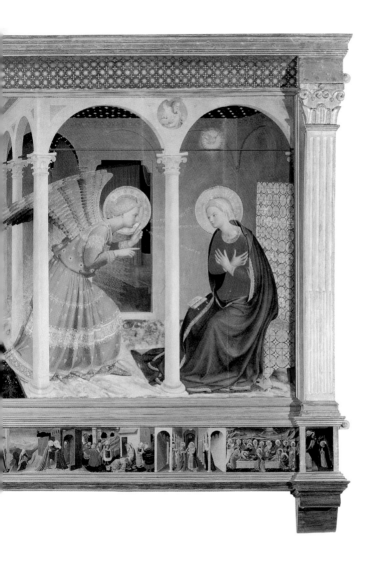

Saint Lucia Filippini

VIRGIN

Lucia was born at Tarquinia, Italy, in 1672. While still a child she lost first her mother, then her father, and at sixteen she entered the monastery of Santa Chiara at Montefiascone. There she dedicated herself to the education of the devout, with the advice of Cardinal Barbarigo and the help of the blessed Rose Venerini, leading to the foundation of the Pious Matrons, created to help in the education of young girls. She died in 1732 and was canonized in 1930.

NAME: Lucia is Latin and means "luminous, shining."

SAINT LUCIA FILIPPINI
Popular sacred image
19th century

Saint Rupert

BISHOP

Rupert was born into a noble family of Irish origin, related to the Merovingians, at the end of the 7th century. After receiving a monastic education, he set about the evangelization of the Salzburg region and the Tyrol. He was the bishop, at first itinerant, of Salzburg, and acted to promote the development of the local salt mines. He died on March 27, 718. His relics are today in Salzburg cathedral.

He is depicted in episcopal vestments, often near a barrel of salt.

PATRON: Rupert is the patron saint of Salzburg.

NAME: Rupert *(Robert)* is from the Saxon and means "bright glory."

RUPERT BAPTIZING KING THEODONE
Massimiliano Schmaltz
Early 20th century
San Gioacchino in Prati, Rome

Saint Conon

BASILIAN MONK

Conon was born at Naso, near Messina, Sicily, during the age of King Roger II, between 1130 and 1154. Following his calling, he became a Basilian monk and undertook a pilgrimage to Jerusalem. While he was away both of his parents died, so on his return he decided to lead the life of a hermit, which led him to sanctity. He died in 1236. Tradition attributes many miracles to him. He is depicted with the dress of a monk and is invoked against diseases of the nose and ears.
NAME: Conon is of Greek origin and means "cone."

SAINT CONON ABBOT
1961
Santa Maria delle Grazie, San Cono

Saint Secundus

MARTYR

Secundus lived in the 2nd century. Born into a pagan family, he was struck by the heroism of Christian martyrs and visited them in prisons at Asti, Italy. He joined the faith thanks to Saint Calocerus of Brescia and probably received baptism from Saints Faustinus and Jovita. In his turn he was imprisoned and executed (perhaps in 119) for having buried the martyred bishop Martian and for having refused to abjure his faith. His cult and the legendary information that surrounds him date to the 9th century.

He is depicted as a soldier or knight, sometimes with a model of the city of Asti.

PATRON: Secundus is the patron of Asti and Ventimiglia.

NAME: Secundus is from the Latin and means "second," as in a "second-born child."

SAINT SECUNDUS AND ANGEL
(detail)
Bernardo Strozzi
1640
Hermitage, St. Petersburg

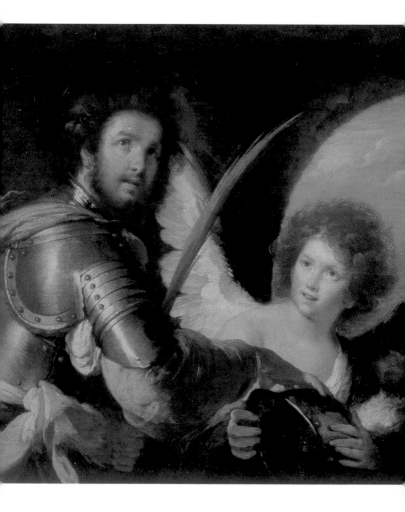

Saint John Climacus

ABBOT

Born around 579, John chose the monastic life when very young and lived in both a cenobite community and a hermitage. He became abbot of the monastery at Mount Sinai when he was about seventy and wrote an important work on the ascetic life, known as the *Ladder to Paradise*, from which he got the name *Climacus*, Greek for "he of the ladder." He died on Mount Sinai around 649.

He is depicted in monastic robes or while indicating to his disciples the mystical ladder.

NAME: John is from a Hebrew name meaning "Yahweh is gracious."

SAINTS JOHN CLIMACUS, GEORGE,
AND BLAISE OF SEBASTE
Anonymous
Second half 18th century
Russian Museum, St. Petersburg
(Saint John Climacus is at the center)

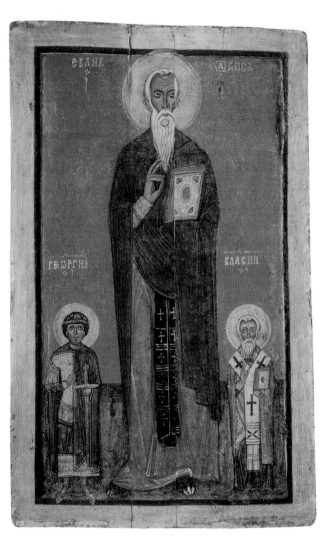

MARCH 31

Saint Amos

PROPHET

Amos preached in the northern kingdom of Israel, in particular in the schismatic sanctuary of Betel, during the period of Jeroboam II (793–53 B.C.). Before being called to undertake his mission as a prophet, Amos was a shepherd. The book of his prophecies is chronologically the earliest of the books of the Minor Prophets. In his book Amos invites people to believe in the Lord and inveighs against social injustices, hypocritical worship, and human selfishness.

He is depicted in the robes of antiquity and bears a scroll, but otherwise is without specific attributes.

NAME: Amos is from the Hebrew and means "strong."

ANGELS AND THE PROPHET AMOS
(detail)
Melozzo da Forlì
1480
Vault of the Sacristy of St. Mark,
basilica of the Holy House, Loreto

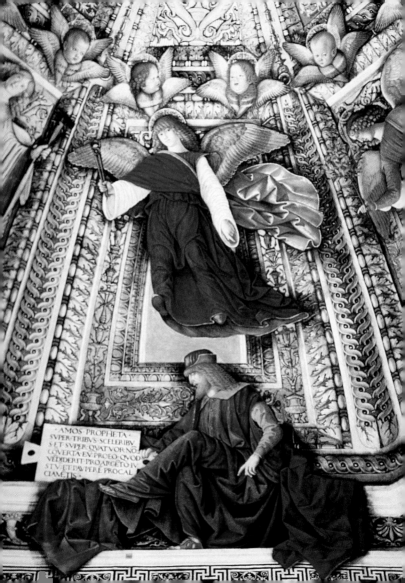

· AMOS · PROPHETA ·
SVPER · TRIBVS · SCELERIBV
S · ET · SVPER · QVATVOR · NO
COVERTA · EV · PROEO · QVOD
VEDIDERIT · PRO · ARGETO · IV
STV · ET · PAVPERE · PROCAL
CLAMETIS ·

Saint Hugh of Grenoble

BISHOP

Born into a noble family at Château-neuf d'Isère, France, in 1053, Hugh chose the religious life, becoming a canon in Valence. In 1080, when only twenty-seven and not yet ordained, he was made bishop of Grenoble. Strongly attracted to solitude, he would have preferred life as a monk, but his several requests to be relieved of his duties as bishop were turned down. He gave invaluable assistance to Saint Bruno, helping him in the foundation of the first Carthusian community at Chartreuse, which was located in his diocese. After fifty-two years as bishop, he died at Grenoble, in 1132. Two years later he was canonized by Pope Innocent II.

He is depicted in episcopal vestments over a white scapular.

NAME: Hugh is from the German and means "heart, spirit."

SAINT HUGH BISHOP
Daniele Crespi
1618
Certosa di Garegnano, Milan

Saint Francis of Paola

HERMIT • Optional memorial

Francis was born at Paola (Calabria), Italy, in 1416. After three years in a convent of the Friars Minor, he left to withdraw to a cave by the sea, where he led a life of prayer, fasting, work, and mortification. He was joined by many followers, leading to the formation of the Hermits of St. Francis, later called the Minims (*Minimi fratres*, "least brethren"), with a rule approved in 1506. Francis was called to France by Louis XI and died there in 1507. He was canonized in 1519. He is depicted with a long beard and wears a brown habit; the word *charitas* inscribed within a sun can appear at the top of a cane or on the cover of a book. He is invoked against sterility.

PROTECTOR: Hermits, seafarers.
NAME: Francis *(Frank)* is of German origin, from the name of the people who settled in France; it has come to mean "forthright, sincere."

SAINT ANTHONY OF PADUA AND
SAINT FRANCIS OF PAOLA
Simone Cantarini
1637–45
Pinacoteca Nazionale, Bologna
(Saint Francis of Paola is on the right)

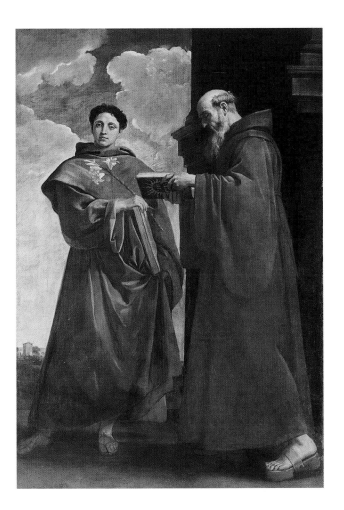

Saint Mary the Egyptian

PENITENT

Mary lived in the area between Egypt and Palestine in the 5th century. According to tradition, she was a prostitute at Alexandria but joined a group of pilgrims to reach Jerusalem, where instead of plying her trade she converted, the result of a miraculous event. She spent the remainder of her life at a cave, visited once a year by a monk named Zosimus, who brought her Easter Eucharist. Her cult was particularly popular during the Middle Ages.

She is most often depicted with such long hair that it covers her entire body.

PROTECTOR: Penitents and the repentant.

NAME: Mary is from the Egyptian and means "beloved"; in the Hebrew (from Miriam) it means "lady."

COMMUNION OF SAINT MARY
THE EGYPTIAN
Antonio Pollaiolo
Circa 1460–70
Parish church of Santa Maria, Staggia Senese

Saint Sixtus I

POPE

Sixtus was born into a family of shepherds toward the end of the 1st century. He was pope from 115 to 125, the year of his death. Since there is no certain information concerning his martyrdom he was not inserted in the new universal calendar of the Church; he does appear, however, in the representation of the martyrs in the basilica of Sant'Apollinare at Ravenna.

NAME: Sixtus is of Latin origin and means "sixth."

CORTEGE OF MARTYRS
(detail)
4th century
Sant'Apollinare, Ravenna
(Saint Sixtus is the second from right)

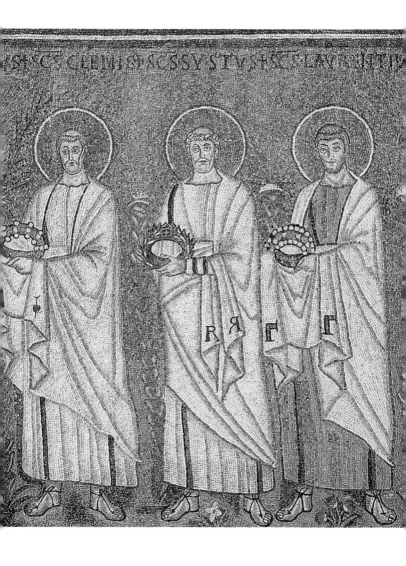

S · SC̄S · CLEMES · SC̄S · SY · STVS · SC̄S · LAVRENTIVS

Saint Isidore of Seville

BISHOP AND DOCTOR OF THE CHURCH • Optional memorial

Isidore was born in Seville around 560 into a noble family from Cartagena; his older brother Leander also became a saint. Educated in the monastic life, he was bishop of Seville after his brother Leander and directed the diocese for thirty-six years. His ministry saw the conversion of the Arian Visigoths and the organization of the Spanish Church. He presided over several councils and wrote many works, including the *Etymologies*, an encyclopedia of the knowledge of his time. He died in 636 and was canonized in 1598.

He is depicted in episcopal vestments.

NAME: Isidore is from the Greek and means "gift of Isis."

SAINT ISIDORE
Bartolomé Esteban Murillo
1655
Seville Cathedral

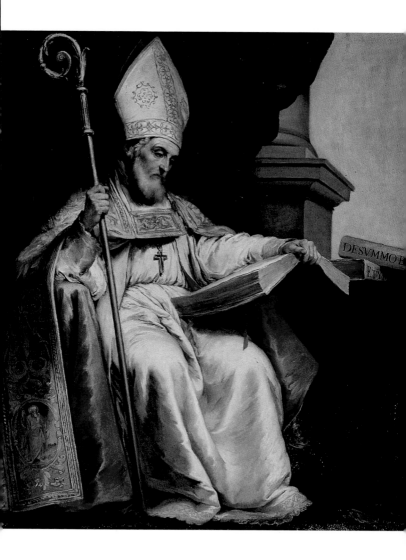

Saint Vincent Ferrer

PRIEST • Optional memorial

Born at Valencia in 1350, Vincent
Ferrer was a Dominican friar and
preacher. He worked tirelessly for the
unity of the Church during the period
of the Great Schism, when there was
a pope at Rome and another in
Avignon. He converted Cathars and
Waldensians and made efforts to
end the Hundred Years War. He died
at Vannes, in Brittany, in 1419.
He is depicted in the habit of a
Dominican, holding a book or flame;
he often points an index finger
skyward. He is invoked against
lightning, earthquakes, and epilepsy.
PROTECTOR: Preachers.
NAME: Vincent is from the Latin
and means "victorious."

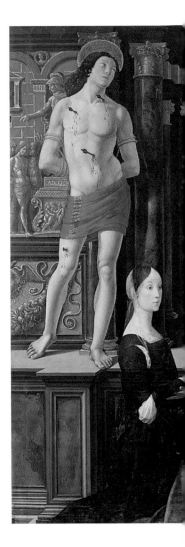

SAINT VINCENT FERRER ALTARPIECE
(detail)
Domenico Ghirlandaio
1493–97
Museo della Città, Rimini

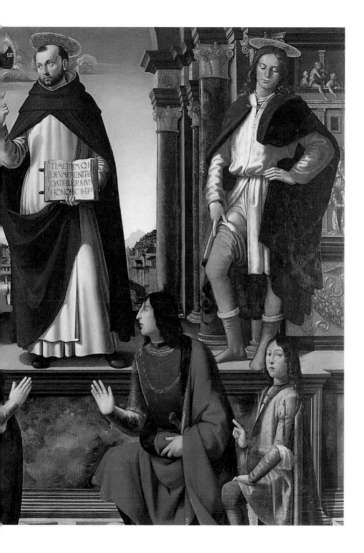

Saint Celestine I

POPE

Celestine was pope from 422 to 432,
and his pontificate was very active.
In terms of doctrinal disputes, he
worked energetically against the
heresies of Pelagius and Nestorius.
He was in contact with Saint
Augustine as early as 390 and,
one year before Augustine's death,
defended his teachings. He wrote
numerous pastoral letters and the
Decretals, which gave shape to
canon law. He died in Rome in 432.
In art, he is depicted in papal robes
but is not associated with any
particular iconography.
NAME: Celestine is of Latin origin
and means "from the sky."

SAINT CELESTINE
Popular sacred image
20th century

John Baptist de La Salle

PRIEST • Memorial

John Baptist was born at Rheims, France, in 1651. He earned degrees in literature and philosophy before being ordained priest, in 1678. He dedicated his life to the education of the poor and made his greatest contribution in the training of teachers. To that end he founded the Brothers of the Christian Schools (also called the Christian Brothers or the De La Salle Brothers), achieving his goals in the face of criticism and obstacles from civil authorities and even from the clergy. He died at Saint-Yon, in 1719, and was canonized in 1900.

He is depicted in a priest's cassock with white cape and black mantle.

PROTECTOR: Teachers.

NAME: John is from a Hebrew name meaning "Yahweh is gracious."

SAINT JOHN BAPTIST DE LA SALLE
Popular sacred image
1846
Civica Raccolta delle Stampe Bertarelli, Milan

Saint Julian of Toledo

BISHOP

Julian was born around 620 and died in 690. His parents were Christians of Jewish origin, and after having him baptized they had him educated in the cathedral, which he entered as an oblate when still a child. After completing his studies, he became a priest in the diocesan clergy and was elected bishop after the death of the metropolitan Quiricus. He exercised his ministry with zeal and passion, discretion, and also with courage, always dedicating particular attention to the poor. He left numerous written works.

In art, he is depicted in episcopal vestments and may have a basket of bread.

NAME: Julian is of Latin origin and comes from the Roman family name Julia.

THE VIRGIN AND SAINT JULIAN
Andrés de Vargas
Second half 17th century
Cuenca Cathedral

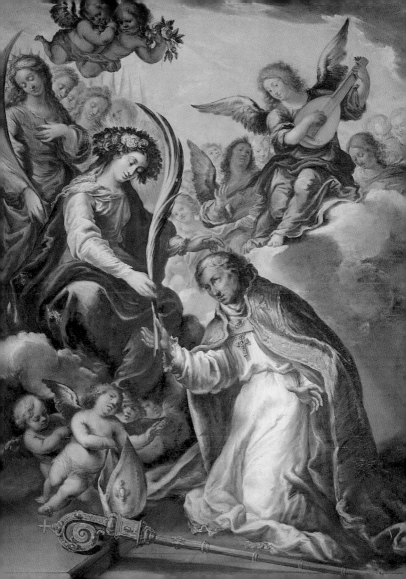

Saint Casilda of Toledo

VIRGIN

Casilda, young daughter of the emir of Toledo, was brought up in the Muslim faith but out of pity secretly visited Christians in prison, bringing them food. When she fell ill of a disease no Arab doctor could cure, she visited the shrine of San Vincenzo in Burgos; cured by its famous healing waters, she converted to Christianity and lived as a hermit in a cell near the spring. She died, perhaps at age 100, around 1050.

She is usually depicted in regal dress, with roses hidden in her clothing. She is invoked against conjugal sterility and hemorrhages.

NAME: Casilda is of Latin origin and is the feminine form of Cassius, the name of a Roman family.

SAINT CASILDA
Francisco de Zurbarán
1640–45
Museo Thyssen-Bornemisza, Madrid

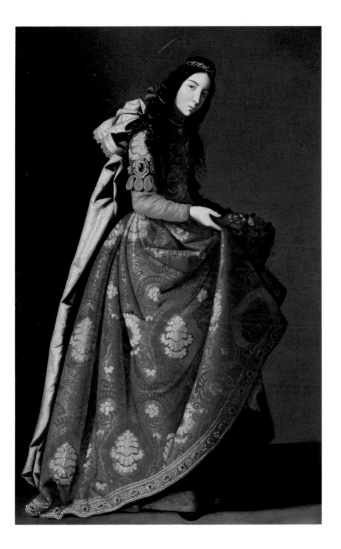

Saint Ezekiel

PROPHET

Ezekiel, priest and prophet, lived in Israel in the 6th century B.C. After the victory of Nebuchadnezzar, Ezekiel, then about twenty-five, was deported to Babylon. Following a vision, he began preaching and tore down the false hopes of the exiles, prophesizing that the deportation would lead to doom. The destruction of Jerusalem by the Babylonians in 586 is the historical proof of this. He then announced new hope to the Jews, based on God's grace and faith in God, as confirmed by the return to the homeland after the edict of Cyrus the Great in 538.
He is depicted as an elderly man with a long white beard and may bear the scroll of his prophecies or the double-winged wheel of his vision.
NAME: Ezekiel is of Hebrew origin and means "strong with the help of God."

Saint Terence

MARTYR

During the persecutions of Decius, around 250, Terence and thirty-nine companions at Carthage opposed the obligation to sacrifice to the idols and to renounce Christ. Before the prefect Fortunantius, Terence is said to have held forth courageously, in the name of all, repeating words from the Gospels. As punishment, his companions were tortured and then beheaded one by one before his eyes. The same fate was then his. His relics were later translated to Constantinople.
He is depicted as a youth bearing a palm branch.
NAME: Terence is from the ancient Sabine and means "delicate, tender."

SAINT TERENCE
Giovanni Antonio Bellinzoni of Pesaro
1447–48
Museo Civico, Pesaro

Saint Stanislaus

BISHOP AND MARTYR
Memorial

Stanislaus was born at Krakow in 1030 into a well-to-do family. After studies in Paris, he returned to Krakow, was ordained priest, and in 1072 was elected bishop. A great preacher and man of charity, he battled the immoral behavior of the ruler, King Boleslaus II. The king turned a deaf ear to the bishop's many entreaties, and in the end Stanislaus excommunicated him. In response, the king had Stanislaus murdered while celebrating the Mass. Stanislaus was canonized in 1253.

He is depicted in episcopal vestments, often while performing an act of charity.

PATRON: Stanislaus is the patron saint of Poland.

NAME: Stanislaus is of Polish origin and means "glory of the state."

MIRACLE OF SAINT STANISLAUS
(detail)
Puccio Capanna
1337
Lower Basilica of St. Francis, Assisi

Saint Zeno

BISHOP

Originally from Africa, where he was born early in the 4th century, Zeno arrived in Verona, Italy, and founded the first church in that city, of which he was bishop for ten years. He struggled against lingering elements of paganism, battled Arianism, and according to tradition fished in the Adige River (the fish being symbolic of the souls he baptized). He died at Verona in 372.

By the 5th century his cult was widespread.

He is depicted in episcopal vestments with a fish or fishing rod. He is invoked to help infants speak and walk and against floods.

PROTECTOR: Fishermen.

PATRON: Saint Zeno is the patron of Verona.

NAME: Zeno is from the Greek and means "from Jupiter."

MADONNA AND CHILD WITH SAINTS
JOHN THE BAPTIST AND ZENO
Jacopo Bassano
1538
Parish church, Borso del Grappa
(Saint Zeno is on the left)

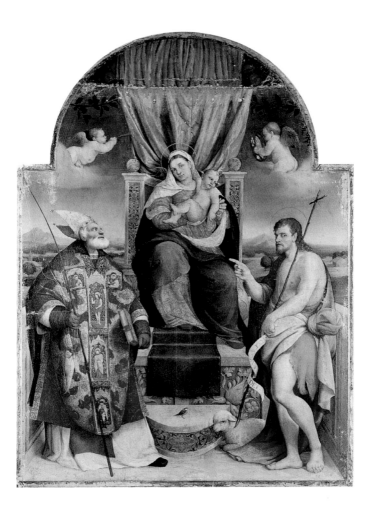

Saint Hermengild

MARTYR

The Visigoth prince Hermengild lived in the 6th century, son of the king of Spain. Although educated in the Arian faith, he married the orthodox Catholic princess Ingonda; to avoid problems, his father exiled him to Seville. There he received Catholic baptism from Saint Leander. He opposed his father and sought to overthrow him, allying himself with the Byzantines. Imprisoned, he refused communion from the hands of an Arian priest and was beheaded. Gregory the Great listed him among the martyrs. He is depicted in regal robes with the palm of martyrdom.

NAME: Hermengild is from the Visigoth language and means "great sacrifice."

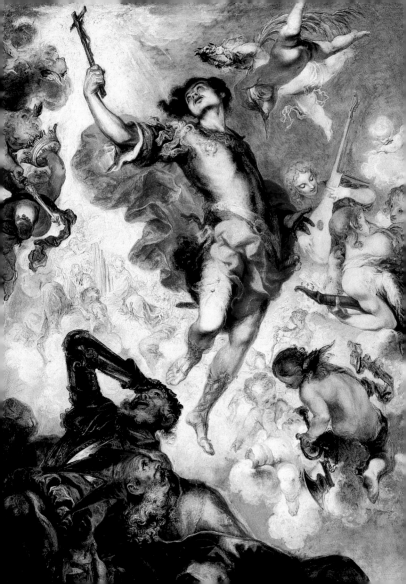

Saints Tiburtius, Valerius, and Maximus

MARTYRS

Valerius was a pagan who converted to Christ thanks to his chaste wife, Cecilia (Cecily). He in turn converted his brother Tiburtius. Both were condemned for having buried the bodies of other martyrs and were decapitated, together with the prefect Maximus, whom they had also converted, in 266. Their cult in Rome dates back to as early as the 5th century.

The three protagonists of this tragedy are often presented together with the palm of martyrdom and a crown of flowers.

NAMES: All three names are of Latin origin. Tiburtius means "of Tivoli" (*Tibur*, in Latin); Valerius "belonging to the Valeria family"; Maximus means "great."

THE MARTYRS CECILY, VALERIUS, AND TIBURTIUS VISITED BY AN ANGEL
Orazio Gentileschi
Circa 1607
Pinacoteca di Brera, Milan

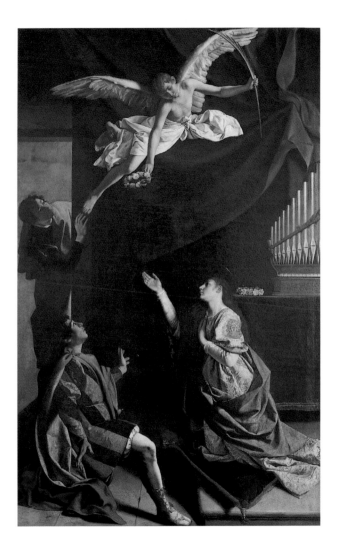

Saint Peter González (also called Saint Telmo)

DOMINICAN

Peter González was born at Astorga, Spain, in 1190. Nephew of the bishop of Palencia, he was soon made a deacon of the cathedral, but he continued to live a life of ease with many amusements. The day came, however, when he fell from a horse. The scornful derision heaped upon him by all those present revealed to him the emptiness of worldly life. He decided to enter the Dominican order and threw himself into tireless activities as a preacher and peacemaker, famously preaching to sailors. He died at Santiago de Compostela in 1246. His cult was confirmed in 1741.

He is depicted in a Dominican habit, sometimes with a small ship in his hand, and is invoked against storms at sea.

NAMES: Peter is from the Greek and means "rock, stone"; González is from the Teutonic and means "victor in battle."

MONUMENT TO SAINT TELMO
20th century
Fromista (Palencia)

Saint Bernadette Soubirous

VIRGIN

Bernadette was born at Lourdes, France, on January 7, 1844. At the age of fourteen, near a cave at Massabielle, she witnessed the first of eighteen apparitions of the Virgin Mary, who identified herself as "the Immaculate Conception." At twenty-two, Bernadette chose to withdraw to the convent of Saint-Gildard, mother house of the congregation of the Sisters of Charity of Nevers. She stayed there until her death, in 1879. She was canonized on December 8, 1933, and is depicted in the dress of a shepherd or nun.

NAME: Bernadette *(Bernard)* is of German origin and means "brave as a bear."

SAINT BERNADETTE SOUBIROUS
Popular sacred image
20th century

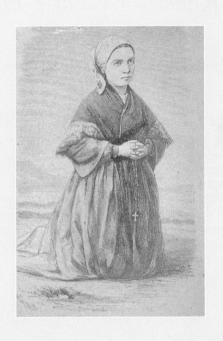

Saint Robert of Chaise-Dieu

ABBOT

Robert de Turlande was born around 1000 into a noble family in the Auvergne region of France. He was educated at the church of Saint Julian's at Brioude, in the Upper Loire, where he became a priest. Full of charity and love for the poor and ill, he had a hospice built at his own expense. Hoping for a monastic life, he sought in vain to enter the community of Cluny, but was not accepted. Despite the enthusiastic embrace of the people of Brioude, he did not give up his attempts to become a monk. Following a pilgrimage to Rome, he was able to achieve his goal, founding a community called the Chaise-Dieu ("Chair of God") and becoming its beloved abbot. He died in 1067 and was canonized three years later.

He is depicted in the robes of an abbot.

NAME: Robert is from the German and means "shining in glory."

SAINT ROBERT
Popular sacred image
Late 19th century

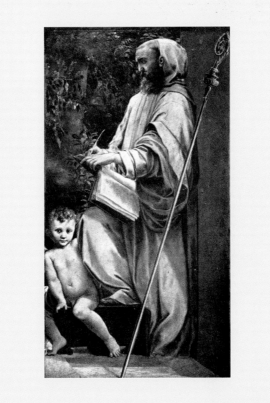

Saint Galdinus

BISHOP

Galdinus was born at Milan in 1096. In 1160, he was named archdeacon at the cathedral alongside the bishop Hubert, together with whom he supported the nomination of Pope Alexander III against the antipope Victor IV, supported by Frederick Barbarossa, the Holy Roman emperor. After the destruction of Milan by the emperor in 1162, Galdinus was named cardinal and was included in the retinue of Alexander III. Following the death of Hubert, the pope named Galdinus bishop of Milan, so he returned to that city. He was active and charitable in the reconstruction of the city and the Catholic community. He died in 1176, immediately after giving a sermon against heresies.

He is depicted in episcopal vestments.

NAME: Galdinus is from the French and means "to dominate, to rule."

SAINT GALDINUS
Anonymous Lombard painter
Before 1737
Museo Dioscesano, Milan

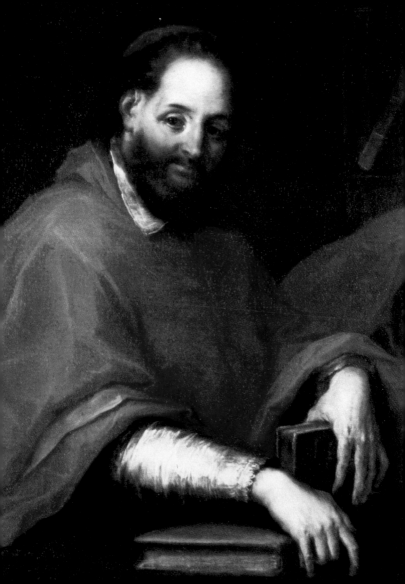

Saint Leo IX

POPE

A German named Bruno, born in Alsace, in 1002, his ascent was rapid: first canon, then deacon, then bishop of Toul when only twenty-four. His election to the throne of Saint Peter in 1049 was favored by Emperor Henry III, and he immediately attracted the enthusiasm of the people of Rome. He labored to promote the reformist ideals of the Cluniac monks and to combat simony. His reign saw the beginning of the schism between East and West. He died in Rome in 1054. He is depicted in papal robes.

NAME: Leo is of Latin origin and means "lion."

POPE LEO IX CONSECRATES THE ABBEY OF SAINT ARNOUD AT METZ
Miniature from the 9th century
Burgerbibliothek, Bern

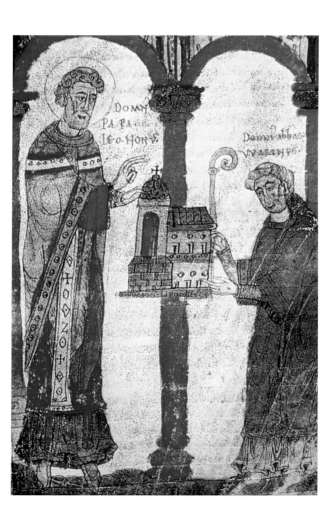

DOMN
PA PA
LEO HORE

DOMN ABBAS
WARANUS

Saint Agnes of Montepulciano

VIRGIN

Agnes was born between 1268 and 1274 into a noble family at Gracciano, near Montepulciano, Italy. At nine she entered the monastery of the Dominicans at Montepulciano. Because of the great sanctity she demonstrated, the young mystic was elected abbess of the monastery of Procedo when only fifteen, and shortly afterward she was also made abbess of Santa Maria Novella at Montepulciano. By the time of her death in 1317, her cult was already widespread and was soon given Church recognition.

She is depicted in Dominican robes with a lily, lamp, and crucifix.

NAME: Agnes is of Greek origin and means "pure, chaste."

APPARITION OF THE VIRGIN TO THE DOMINICAN SAINTS ROSE OF LIMA, CATHERINE OF SIENA, AND AGNES OF MONTEPULCIANO
(detail)
Giambattista Tiepolo
1748
Santa Maria dei Gesuati, Venice
(Saint Agnes is the first on the right)

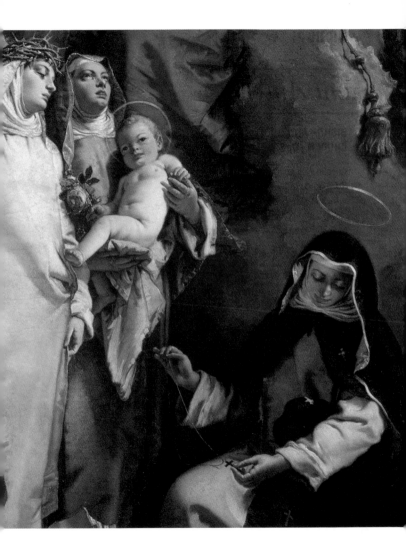

Saint Anselm

BISHOP AND DOCTOR OF THE CHURCH • Optional memorial

Anselm was born in 1033 at Aosta. He yearned to take the Benedictine robe, but faced with his severe father's prohibition, he fled to the monastery of Bec in Normandy. He became archbishop of Canterbury and always demonstrated great charity and wisdom in mediating between the power of the king of England and the rights of the Church. Among the great theologians of his time, he was the author of important philosophical texts. He died in 1109 at Canterbury. In 1720, he was declared a Doctor of the Church. He is depicted in episcopal vestments.

NAME: Anselm is from the ancient German and means "protected by God."

THE VIRGIN MARY AND SAINTS
Pier Francesco Foschi
Second half 16th century
Santo Spirito, Florence
(Saint Anselm is the second from the left)

Saint Caius

POPE

The pontificate of Caius (283–96) experienced only the first signs of the great persecution of Diocletian, to whom Caius may have been related. He was born in Dalmatia, from where he moved to Rome. He is remembered for having confirmed the orders of the ecclesiastical hierarchy, but he does not seem to have died a martyr, for he is referred to as a confessor in antique documents. Most probably he died of natural causes around 296.

In art, he is depicted in papal robes and is not associated with any particular iconography.

NAME: Caius is of Latin origin and means "gay."

SAINT CAIUS
Lorenzo Monaco
Early 15th century
Galleria dell'Accademia, Florence

Saint George

MARTYR • Optional memorial

Worshiped as a soldier-saint at his presumed birthplace of Lydda (modern Lod, near Jerusalem), George lived between the 3rd and 4th centuries. The legend of the knight battling the dragon to free a princess dates to the Middle Ages, while the saint's cult, approved by Pope Gelasius I in 494, spread to England at the end of the 7th century and grew stronger with the Crusades.

George is depicted as a knight fighting a dragon. He is invoked against the plague, venereal diseases, and skin ailments. **PROTECTOR:** Halberdiers, arms-makers, knights, horses, soldiers, Boy Scouts, lepers, and husbands. **PATRON:** George is the patron saint of England and also of the cities of Genoa and Ferrara. **NAME:** George is of Latin origin and means "farmer."

SAINT GEORGE AND THE DRAGON
Raphael
1505
Louvre, Paris

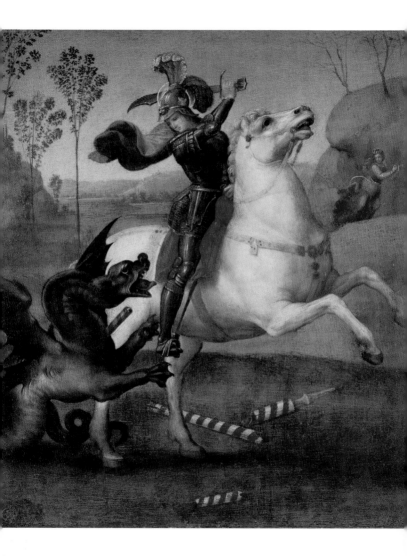

Saint Fidelis of Sigmaringen

PRIEST AND MARTYR
Optional memorial

Born Mark Rey at Sigmaringen, Germany, in 1578, Fidelis studied law and philosophy and was active as a lawyer and tutor on behalf of the poor—known as the poor man's lawyer—when he entered the Capuchin order at Fribourg. He became a preacher and was sent to the Grisons area to bring the Christians there, followers of the Swiss religious reformer Zwingli, back into reconciliation with Rome. He was killed there in 1622 by heretics and was canonized in 1746. He is depicted with the cowl of a Capuchin friar, the palm, and the instruments of his martyrdom: swords and a spiked club.

NAME: Fidelis is of Latin origin and means "faithful."

SAINT FIDELIS OF SIGMARINGEN
AND THE BLESSED JOSEPH OF
LEONISSA TRAMPLING HERESY
(detail)
Giambattista Tiepolo
1752–58
Pinacoteca Nazionale, Parma
(Saint Fidelis of Sigmaringen is on the left)

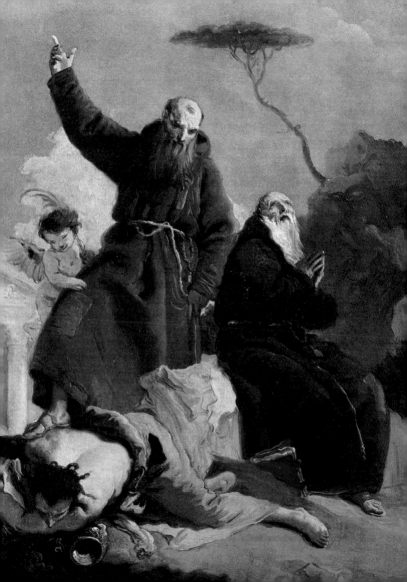

Saint Mark

EVANGELIST • Feast

Mark was a disciple of Jesus and an evangelist; he preached at Cyprus and Alexandria, where he founded the first Christian church and where he was martyred by being tied up and dragged through the city. The principal sites of his cult are Alexandria and Venice.

He is depicted at a mature age, often while writing his Gospel; his attribute is the winged lion. He is invoked for harvests and against scabies.

PROTECTOR: Notaries, opticians, glaziers, breeders, pharmacists, painters, shoemakers, tanners, secretaries, and interpreters.

PATRON: Mark is the patron saint of the cities of Venice and Pordenone.

NAME: Mark is of Latin origin and was derived from the name of the god Mars.

SAINT MARK EVANGELIST
Lorenzo Veneziano
1371
Gallerie dell'Accademia, Venice

Saint Marcellinus

POPE

Successor to Pope Caius, Marcellinus occupied the papal throne from 296 to 304. He died during the persecution of Christians decreed by Emperor Diocletian. Marcellinus died a martyr, but whether he was decapitated or died in prison following torture is unclear. He was distinguished for his zeal and charity.

Having no specific iconography, he is depicted in papal robes.

NAME: Marcellinus is a diminutive of Marcello, which in turn is a diminutive of Mark, of Latin origin and derived from the name of the god Mars.

POLYPTYCH
(detail)
Pietro Lorenzetti
1320
Parish church of Santa Maria, Arezzo
(Saint Marcellinus is in the middle of the upper row)

· S· IACOBVS ITE · · SF· MARCELLID · · SF· AGVSTINVS ·

Saint Zita

VIRGIN

Zita was born into a poor family at Monte Sagrati, Italy, in 1218. At the age of twelve she was sent to work as a maid for the wealthy Fatinelli family at Lucca. She remained there until her death, in 1278, scrupulously performing her chores as a domestic servant and earning the trust of her patrons, who entrusted her with the direction of the house. Disliked and mistreated by the rest of the servants, she always exchanged bad for good, cultivating Christian virtues with her simplicity. She was canonized in 1969. She is depicted dressed as a maid, sometimes holding a bunch of keys or a lily.

PROTECTOR: Domestic servants and bakers.

NAME: Zita is from the Persian and means "virgin."

MIRACLE OF SAINT ZITA
Bernardo Strozzi
Circa 1620
Private collection

252

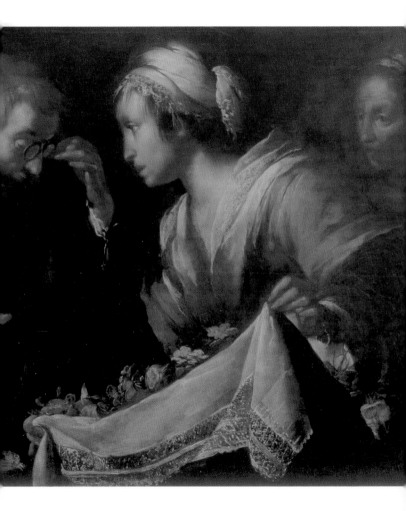

Saint Vitalis

MARTYR

Vitalis lived in the 3rd century, married Saint Valleria, and was father of the twin saints Gervase and Protase. The surviving information about him is thought to be part legendary. Vitalis is said to have undergone various tortures to make him abjure his faith. In the end he was thrown into a ditch and heaped over with stones and dirt. His tomb was immediately worshiped by the Christians of Ravenna.

He is depicted with the palm of martyrdom or while being thrown into the ditch.

NAME: Vitalis is of Latin origin and means "vigorous, full of life."

MARTYRDOM OF SAINT VITALIS (detail)
Federico Barocci
1583
Pinacoteca di Brera, Milan

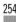

254

Saint Catherine of Siena

**VIRGIN AND DOCTOR
OF THE CHURCH • Feast**

Caterina di Giacomo di Benincasa was born in Siena, Italy, in 1347. A tertiary sister of the Dominican order, she initially led a life of prayer and penitence. She later became involved in the problems of the Church, performing an active role in the Great Schism and successfully exhorting Gregory XI to leave Avignon and return to Rome. Catherine died in Rome in 1380. Canonized in 1461, she was proclaimed the patron saint of Italy in 1939 and was made a Doctor of the Church in 1970. She is depicted in Dominican robes with the stigmata and may hold a cross, lily, or book. She is invoked against the plague, migraines, and to obtain a good death.

PROTECTOR: Nurses.

PATRON: Catherine is the patron saint of Italy.

NAME: Catherine is of Greek origin and means "pure."

SAINT CATHERINE OF SIENA
(detail)
Andrea Vanni
Circa 1390
San Domenico, Siena

Saint Peter of Verona

MARTYR

Peter (Saint Peter Martyr) was born at Verona around 1205 and joined the Dominicans, perhaps receiving the habit directly from Saint Dominic himself. Known as a miracle worker, he became an inquisitor and died a martyr on April 6, 1252, at the hands of heretics who ambushed him on the road from Como to Milan: they cracked his skull with a cleaver and stabbed him. He was proclaimed a saint one year after his death.

He is depicted in a Dominican habit with the cleaver imbedded in his head or the sign of the wound or with a dagger in his chest. He sometimes bears the palm and is invoked against headaches.

PROTECTOR: Dominicans and inquisitors, shoemakers, fabric merchants, and brewers.

NAME: Peter is from the Greek and means "rock, stone."

SAINT PETER OF VERONA WITH
SAINTS NICHOLAS AND BENEDICT
Cima da Conegliano
1505–06
Pinacoteca di Brera, Milan
(Saint Peter of Verona is at the center)

258

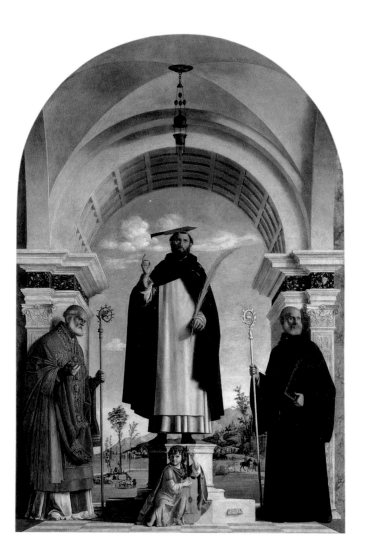

Saint Pius V

POPE • Optional memorial

Born at Bosco Marengo, Italy, in 1504, Michele Ghislieri entered the Dominican order in 1518. Elected pope in 1566 with the name Pius V, he carried out many of the reforms promoted by the Council of Trent. He saw to the secular clergy, battled simony and nepotism, spread devotion to the Madonna of the Rosary, and lived in great austerity. He oversaw completion of the Roman catechism and exhorted Christians in the struggle against the Turks that culminated in the victory at Lepanto. He was canonized in 1712.

He is depicted in papal robes.

PROTECTOR: Congregation of the doctrine of the Church.

NAME: Pius is from the Latin and means "religious, devout."

APOTHEOSIS OF SAINT PIUS V
Giovenale Dongiovanni
1746–49
Mondovi Cathedral

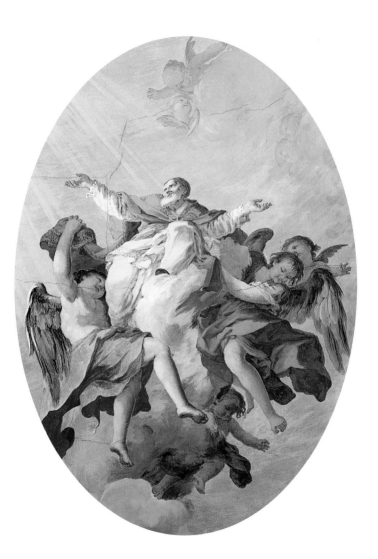

Saint Joseph

WORKER • Optional memorial

The feast of Saint Joseph, putative father of Jesus, is celebrated on March 19, but in 1955 Pope Pius XII inserted this memorial to Joseph as a worker in the liturgical calendar. To emphasize the dignity of human labor, the Christian ideals of work, and the example of Joseph as a worker, he made the day coincide with May Day, the day on which much of the world celebrates labor. The Second Vatican Council explicated this, saying that "workers continue the work of the Creator and make themselves useful to their brethren."

Joseph is depicted as an elderly man with a flowering staff and carpenter's tools.

NAME: Joseph is from the Hebrew and means "he will add."

Saint Sigismund

KING AND MARTYR

Sigismund, king of Burgundy, was the first ruler of Gaul to convert to Christianity. He was a primary force behind the spread of the faith and was active in the foundation of monasteries. He brought shame on himself for a horrendous crime—having his son killed for suspicion of conspiring against him—and fled to the monastery of Aguane. He was captured in 524 and thrown into a well, where he died in 539. He was declared a martyr by Gregory of Tours. He is depicted in royal robes and is invoked against malaria.

NAME: Sigismund is of German origin and means "who protects with victory."

SAINT SIGISMUND
AND SIGISMONDO MALATESTA
(detail)
Piero della Francesca
1451
Tempio Malatestiano, Rimini
(Saint Sigismund is the figure seated)

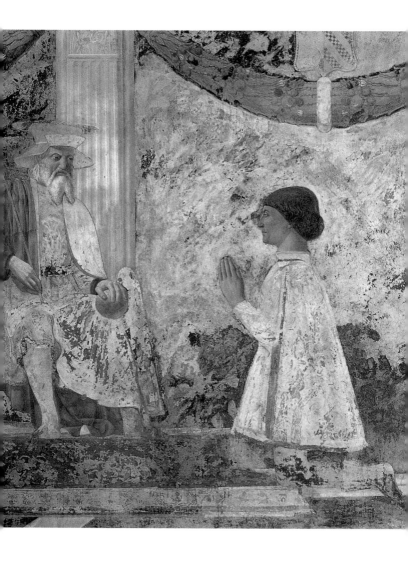

Saint Athanasius

BISHOP AND DOCTOR OF
THE CHURCH • Memorial

Athanasius was born at Alexandria around 295. Elected bishop of that city in 328, he was a strenuous supporter of Catholicism against Arianism, which had been condemned by the Council of Nicea (325) but remained the cause of doubt and division in the Eastern Church. Athanasius was stalwart in his defense of Christian orthodoxy against the Arian heresy and thus made himself the target of attacks by heretics. He was sent into exile and was able to return only under the emperor Valens. He died in 373.

Athanasius appears more often in Eastern art than Western and is depicted in episcopal vestments, holding a book.

NAME: Athanasius is from the Greek and means "immortal."

THE TRINITY, MADONNA, ARCHANGELS, AND SAINTS AUGUSTINE AND ATHANASIUS
Luca Signorelli
1510
Galleria degli Uffizi, Florence
(Saint Athanasius is on the lower right)

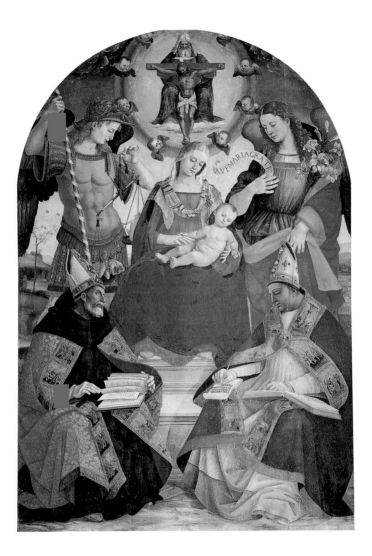

Saint Philip

APOSTLE • Feast

Philip, Galilean from Bethsaida, was one of the twelve apostles chosen by Jesus. In the Gospels it is Philip who asks the Messiah to procure food for the crowd before the miracle of the multiplication of the loaves and fish. Philip said to Jesus (John 14:8–9), "Show us the Father," receiving the response, "He that hath seen me hath seen the Father." The rest of Philip's story has been handed down in the apocryphal Acts and collected in *The Golden Legend*, according to which Philip died a martyr at Hierapolis, stoned and then crucified. He is depicted in art with a tunic and pallium, sometimes with a cross or dragon.

NAME: Philip is from the Greek and means "lover of horses."

LAST SUPPER
(detail)
Leonardo da Vinci
1495–97
Refectory of the convent of Santa Maria delle Grazie, Milan

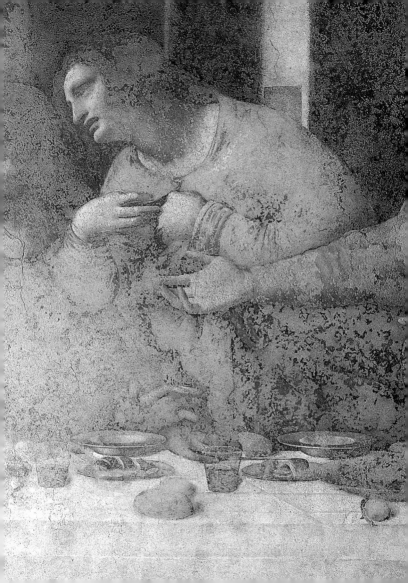

Saint James the Less

APOSTLE • Feast

James the Less, probably a son of Alpheus, was one of Christ's twelve apostles. He assumed an important role after the Ascension of Jesus and was the first bishop of Jerusalem. Peter went immediately to James after being miraculously freed from prison, and Paul did the same after his conversion. He is said to have died a martyr after the year 60, but under uncertain circumstances drawn only from apocryphal sources.

He is depicted in a tunic and pallium, sometimes with a staff. He is invoked against the sufferings of the dying.

PROTECTOR: Hatters and pharmacists.

NAME: James is from the Aramaic and means "follower of God."

THE APOSTLE JAMES THE LESS
Master of St. Francis
1250–75
National Gallery of Art, Washington, D.C.

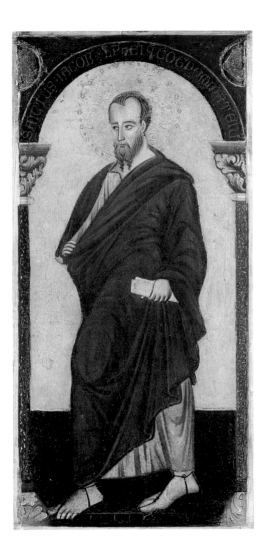

Saint Florian

MARTYR

Florian lived between the 3rd and early 4th centuries. He was a veteran of the Roman army and lived at Mantem, near Krems, Austria. According to tradition, he saved a town from burning down by throwing a single bucket of water on the flames. He moved to Lorch during the persecution of Diocletian to share the fate of the Christians there. In 304, he was arrested and because of his faith was thrown into the Enns River with a millstone around his neck. His cult is popular in Austria and Bavaria.

He is depicted dressed as a soldier, sometimes with the millstone or the bucket of water.

PROTECTOR: Firemen.

NAME: Florian is from the Latin and means "follower of the goddess Flora."

SAINT FLORIAN POLYPTYCH
Andrea Bertolotto, known as Bellunello
1480
San Floriano, Forni di Sopra
(Saint Florian is at the center)

Saint Gothard of Hildesheim

BISHOP

Gothard (Godard, Gotthard) was born in 960 at Reichersdorf in the diocese of Passau, in Bavaria. A Benedictine monk, he was an early reformer, following the rule of Saint Benedict and the Cluniac reform. At the desire of Emperor Henry II, he was made bishop of Hildesheim. He carried out his duties for eighteen years, founding new churches, instructing the faithful, and seeing to the discipline of the clergy. He died in 1038 and after nearly a century was declared saint.

He is depicted as an elderly man in episcopal vestments and is invoked against fevers, dropsy, rheumatism, and hail.

PROTECOR: Women in childbirth.

NAME: Gothard *(Godehard)* is of German origin and means "strong through God." The Saint Gotthard Pass bears this saint's name.

SAINT GOTHARD
Anonymous German artist
active in the Veneto
Circa 1440
Seminario Gregoriano, Belluno

.sanctus.
.gotardus.

Saint Dominic Savio

ADOLESCENT

Dominic was born in 1842 at Riva di Chieri in the diocese of Turin, Italy. A young student of Don Bosco, at the time of his first communion he decided to always lead a life of sanctity, praying and performing works of charity. He organized the Company of the Immaculate Conception. He died at the age of fifteen during a cholera epidemic, after giving assistance to the sick. He was canonized in 1954. He is depicted as a devout youth, sometimes together with Don Bosco.
PROTECTOR: Children's choirs, altar boys, and pregnant women.
NAME: Dominic is from the Latin and means "sacred to the Lord."

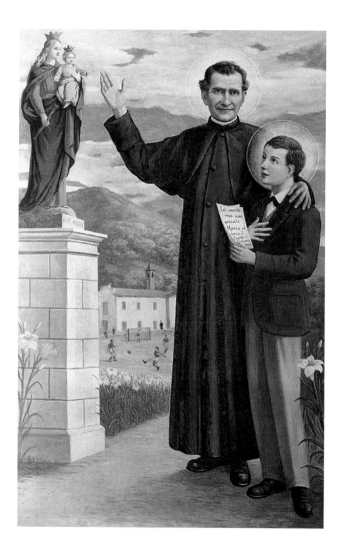

Saint Flavia Domitilla

MARTYR

Flavia Domitilla belonged to the Roman aristocracy and was probably martyred during the persecutions under the Roman emperor Diocletian. Little of her story can be gleaned from historical sources. It seems she was the niece of the Roman consul Titus Flavius Clemens and was banished along with other Christians to the island of Ponza, where she was martyred. A 5th-century *passio* associates Flavia Domitilla with the martyrs Nereus and Achilleus, indicating that they converted Domitilla to preserve her virginity shortly before her marriage to a youth named Aurelian. For this both were decapitated.

NAMES: Both names are of Latin origin. Flavia means "blonde," and Domitilla refers to a member of the Roman Domitia family.

SAINT GREGORY THE GREAT
WITH SAINTS MAURUS, PAPIANUS,
AND DOMITILLA
Peter Paul Rubens
1606
Gemäldegalerie, Berlin

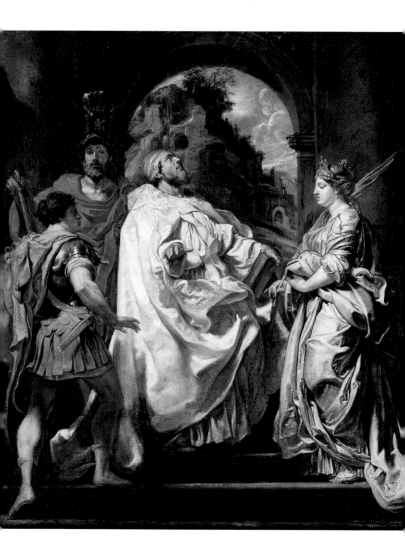

Saint Acacius

MARTYR

Acacius was a Roman soldier who preferred martyrdom to denial of his faith. He was crucified or impaled along with ten thousand companions on Mount Ararat in the 2nd century. From this episode, related in the Acts of Martyrdom of the 12th century, his cult spread to Switzerland and Germany during the period between the Crusades and the early 15th century.

He is depicted in the dress of a soldier or knight with a crucifix, often during the mass martyrdom.

PROTECTOR: Those in the throes of death.

NAME: Acacius is derived from a name for the locust, the thorny plant with which he was whipped before being martyred.

THE MARTYRDOM OF
THE TEN THOUSAND
(detail)
Albrecht Dürer
1508
Kunsthistorisches Museum, Vienna

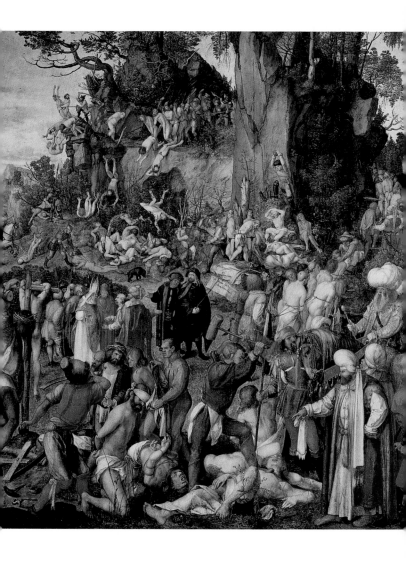

Saint Pachomius

ABBOT

Pachomius was born in 287 in Upper Egypt, son of pagan parents. A soldier in the Roman army, he was taken prisoner at Thebes. He vowed that if released by the god of the Christians he would dedicate himself to the service of others. He was indeed freed and was true to his vow. He converted, and after several years of living as an anchorite, he founded the first Christian monastic community. On his death, in 347, his example was followed by many disciples in nine male communities and at least one female and proved of fundamental importance to both Eastern and Western monasticism. He is depicted in antique robes and may bear the pastoral staff of an abbot.

NAME: The meaning of Pachomius is unknown.

SAINT PACHOMIUS
Popular sacred image
20th century

Saint Job

WISE MAN

Job lived around 1500 B.C. in the land of Huss, to the north of Arabia. When he had reached the height of prosperity, with seven sons and three daughters, many fields and heads of cattle, he was beset by unspeakable calamities that deprived him of all his possessions, his children, and his health. Job succeeded in bearing these adversities because they were the will of God. His cult spread in the 1st century, promoted by Saint Clement. He is depicted as an old man covered with sores and is invoked by lepers and hypochondriacs.

PROTECTOR: Breeders of silk worms.

NAME: Job is of Hebrew origin and means "the persecuted who supports adversity."

SAN GIOBBE ALTARPIECE
(detail)
Giovanni Bellini
1470–80
Gallerie dell'Accademia, Venice
(Saint Job is the third from the left)

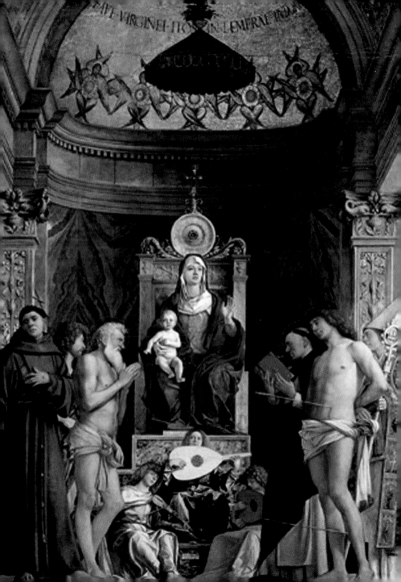

Saint Ignatius of Laconi

CAPUCHIN FRIAR

Ignatius Vincent Peis was born at Laconi in Sardinia in 1701. At eighteen, during a serious illness, he vowed to become a Capuchin friar if healed, but he did not respect the promise. Two years later, after a serious fall from a horse, he remembered his vow and presented himself at the convent of Buoncammino at Cagliari. He became a humble and obedient laybrother, taking the name of Ignatius. He died at eighty, loved by all and already worshiped as a saint. He was canonized in 1951.

He is depicted as an old man with the cowl of the Capuchins and an alms sack.

NAME: Ignatius is from the Roman family name Egnatius, perhaps from the Latin word for "fire."

SAINT IGNATIUS OF LACONI
Popular sacred image
19th century
Civica Raccolta delle Stampe Bertarelli, Milan

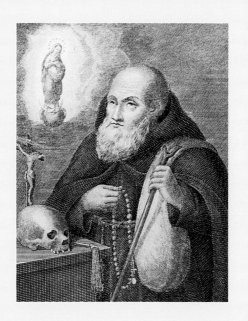

Saints Nereus and Achilleus

MARTYRS • Optional memorial

Nereus and Achilleus were martyred under Nero, Domitian, or Trajan. The information about them is scarce and legendary, but their cult is ancient, dating back to at least the 4th century, and the discovery of bodies on the site of their tomb attests to their historicity. The tradition according to which they were the servants of Flavia Domitilla or were Praetorian soldiers is unfounded.

They are usually depicted dressed as soldiers.

NAMES: Both names are of Greek origin. Nereus means "great swimmer," Achilleus means "brown, dark."

THE MARTYRDOM OF NEREUS
AND ACHILLEUS
(detail)
Ottavio Vannini and Domenico Passignano
Circa 1630
Santa Maria Maddalena de' Pazzi, Florence

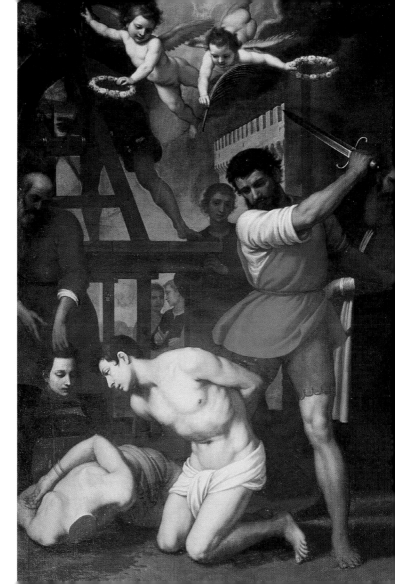

Our Lady of Fatima

Optional memorial

This is the commemoration of the first appearance of the Virgin Mary to three shepherdesses at Fatima, Portugal, in 1917. Those present were Lucia dos Santos and her cousins Francisco and Jacinta. When the youngest failed to keep the secret, many people came to the later apparitions, and the children were arrested by the authorities. All this did not prevent the Virgin from appearing again (in all, six times) and performing miracles. During the last appearance, on October 13, she announced the coming end of the world war.

She is depicted while appearing to the three shepherdesses.

Saint Peter Nolasco

FOUNDER

Peter Nolasco was born around 1180, probably at Barcelona. Dedicated to helping the Christian slaves held by the Moors, who then controlled much of Spain, he founded the order of Our Lady of the Ransom (Mercedarians), con-firmed in 1235 and based on the rule of Saint Augustine. By the end of the Christian reconquest of Spain, Peter's order spread across the peninsula. He yearned to visit the tomb of his namesake apostle but did so only in a vision. He died at Barcelona around 1256. His cult was approved in 1628. He is depicted in the white cloak with scapular and the coat of arms of the order.

NAME: Peter is from the Greek and means "rock, stone."

APPARITION OF SAINT PETER
TO SAINT PETER NOLASCO
(detail)
Francisco de Zurbarán
Prado, Madrid

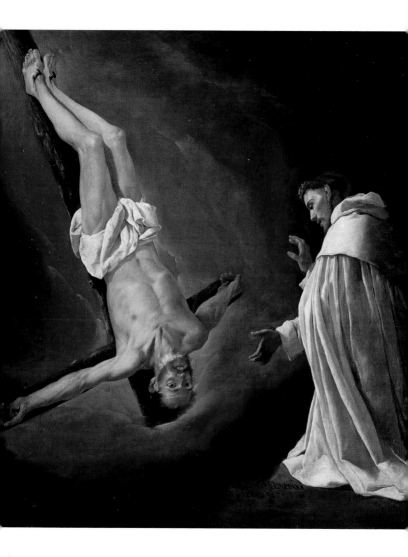

Saint Matthias

APOSTLE • Feast

Chosen by lot to become the new twelfth apostle, in place of Judas Iscariot, Matthias was probably among the seventy-two disciples sent by Jesus to preach in pairs in every city. According to the Acts of the Apostles, he was chosen after the Ascension from among those who had been followers of Jesus since his baptism in the Jordan River. He is known to have preached at Jerusalem, but nothing certain is known of his martyrdom. He may have been stoned to death.

In art he is often presented with such weapons as halberds. He sometimes holds a book, the generic symbol of an apostle.

PROTECTOR: Engineers and butchers.

NAME: Matthias is from the Hebrew and means "gift of the Lord."

SAINT GREGORY THE GREAT
AND SAINT MATTHIAS
Masolino da Panicale
1428–29
National Gallery, London
(Saint Matthias is on the right)

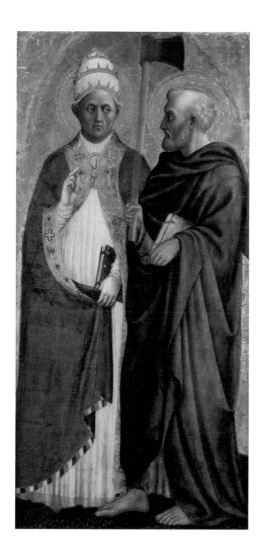

Saint Isidore the Farmer

FARMER

Isidore was born in Madrid around 1080. A poor farm laborer, he was a devout Christian and patiently supported the vexations of his companions. According to tradition, he spent hours absorbed in prayer while angels performed his chores in the fields. He died around 1130 and was canonized in 1622 by Pope Gregory XV.

He is depicted in peasant clothes with agricultural tools, sometimes accompanied by angels who plow for him while he prays.

PROTECTOR: Farmers, laborers, and husbandmen.

PATRON: Isidore is the patron saint of Madrid.

NAME: Isidore is from the Greek and means "gift of Isis."

SAINT ISIDORE
Pietro Bernardi
1600–25
Santa Maria della Scala, Verona

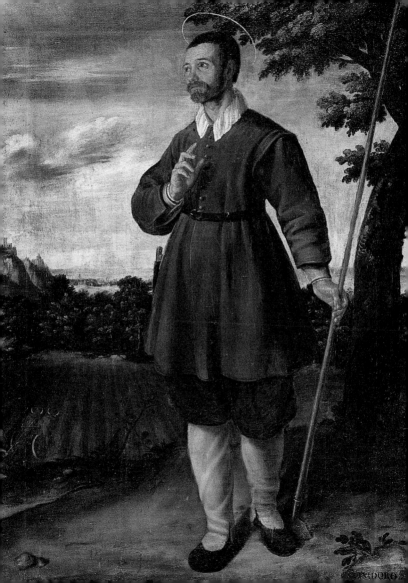

Saint Simon Stock

CARMELITE FRIAR

Perhaps originally from Kent in England, Simon Stock lived in the 13th century. Following a pilgrimage to the Holy Land, he joined the hermit order of the Carmelite friars. He was of great importance to the consolidation of the order, which at the middle of the 13th century went from being a hermit order to one of mendicant friars, and Simon Stock was its prior general at London. He died at Bordeaux, in 1265. Initially local, his cult spread during the 14th century.

He is depicted wearing the Carmelite habit; his conventional attributes are a flame (an allusion to Purgatory) and the scapular he received from the Madonna during a vision.

PROTECTOR: The Carmelite order.
NAME: Simon is of Hebrew origin and means "God has answered."

THE MADONNA OF CARMEL WITH
CARMELITE SAINTS AND THE SOULS
IN PURGATORY
(detail)
Giambattista Tiepolo
1721–22
Pinacoteca di Brera, Milan
(Saint Simon Stock is on the right)

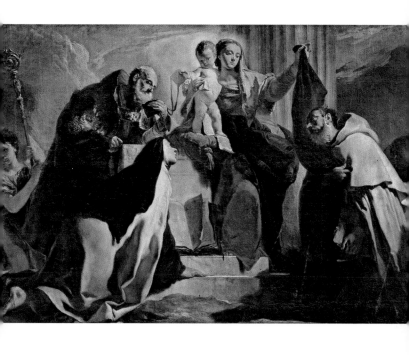

Saint Paschal Baylon

FRANCISCAN FRIAR

Paschal was born in 1540 in Spain at Torre Hermosa, in a humble peasant family. He was first a shepherd, then asked to be taken into the Franciscan order. When he was admitted to vows at the convent of Monfort at Valencia in 1564, out of humility he refused the priesthood and remained a laybrother. He was a mendicant friar, obedient and fervent in his adoration of the Eucharist. He died in 1592 and was canonized in 1690. He is depicted in the Franciscan habit, often in adoration of the Eucharist.

PATRON: Eucharistic conferences and organizations.

NAME: Paschal is from the Late Latin and means "relating to Easter," in turn from a Hebrew word meaning "Passover."

SAINT PASCHAL BAYLON
(detail)
Giambattista Tiepolo
Circa 1769
Prado, Madrid

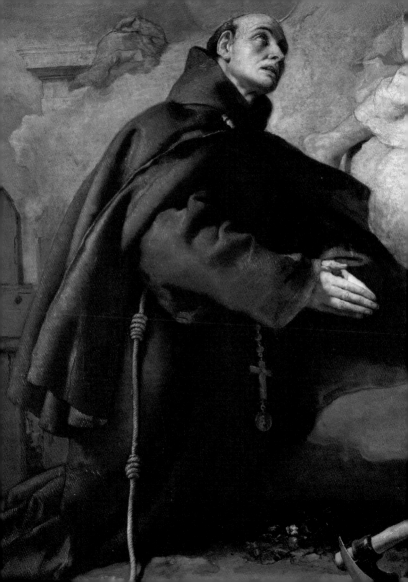

Saint Felix of Cantalice

CAPUCHIN LAYBROTHER

Felix was born at Cantalice, near Rieti, Italy, in 1515. Until the age of thirty he worked as a farmer, but then he joined the Capuchin order, realizing a long-cherished desire, and moved to Rome. He became a mendicant friar nicknamed by everyone "Brother Deo gratias" because of the response he gave everyone, whether or not they made an offering. He was known and highly regarded by Saint Philip Neri, who often sought his advice, and he was especially attentive to young people, teaching them the praise of the Lord. He died in 1587 and was canonized in 1712.

He is depicted in art with the Capuchin habit, often carrying a beggar's wallet.

NAME: Felix is from the Latin and means "happy, content."

MADONNA AND CHILD WITH
SAINTS JOHN THE BAPTIST, FELIX OF
CANTALICE, ANDREW, AND CATHERINE
OF ALEXANDRIA
(detail)
Pietro da Cortona
1630
Pinacoteca di Brera, Milan
(Saint Felix is at the bottom left)

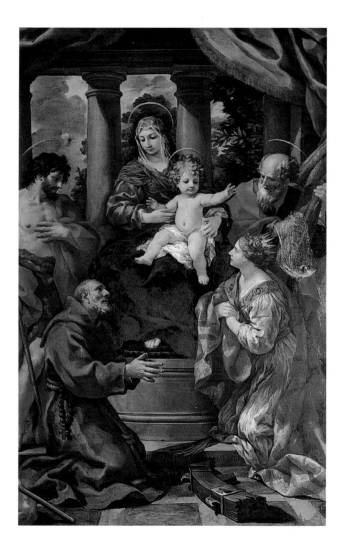

Saint Celestine V

POPE

Pietro Angelerio was born near Isernia, Italy, in 1215. A Benedictine monk, he spent many years as a hermit on Mount Morrone; his disciples later became part of the Benedictine order, the Celestines. In 1294, when after two years the cardinals had failed to find a successor to Pope Nicholas IV, Peter sent them a message that God was not pleased with their delay. In response, they chose him as pope, and he became Celestine V. After five months he realized he was being used as a tool in political maneuverings and abdicated the papal throne. Boniface VIII had him imprisoned until his death, in 1296. He was canonized in 1313.

PROTECTOR: Bookbinders.
NAME: Celestine is of Latin origin and means "from the sky."

Saint Yves

PRIEST

Yves (Ivo) was born in 1253 at Kermartin in Brittany, where he studied theology and canon law. After activity in the law courts of Rennes and Tréguier, he became a priest and led an ascetic life until his death, in 1303.
He is depicted as a scholar, judge, or cleric holding a scroll of petitions or a book.

PROTECTOR: Lawyers, judges, jurists, magistrates, notaries, procurators, bailiffs, the poor and abandoned, widows, and orphans.
NAME: Yves is from the German and means "yew."

SAINT YVES, PROTECTOR OF WIDOWS AND ORPHANS
Jacopo da Empoli
1617
Palazzo Pitti, Florence

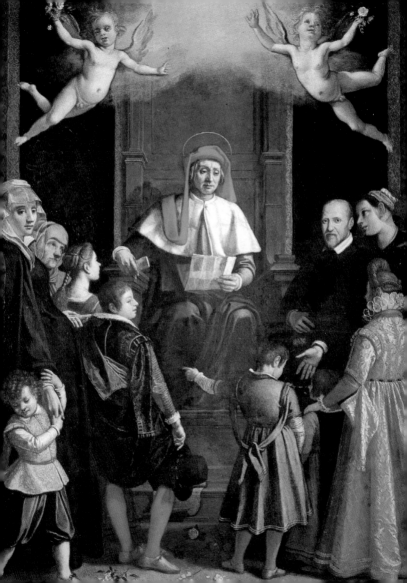

Saint Bernardino of Siena

PRIEST • Optional memorial

Bernardino degli Albizzeschi was born at Massa Marittima, Italy, in 1380. A Franciscan priest, he was a firm preacher of penitence, condemning gambling, usury, superstition, and political strife. He spread devotion to the Holy Name of Jesus as a symbol of the Lord and three times refused the nomination as bishop. He died in 1444 and was canonized in 1448. He is depicted in a Franciscan habit and has a weary face; his attribute is the monogram of the name of Jesus (IHS), and he is often shown with three miters at his feet, symbolic of his three refusals of the post of bishop. He is invoked against hemorrhages and hoarseness.

PROTECTOR: Preachers, publishers, woolworkers, weavers, and boxers.

NAME: Bernardino *(Bernard)* is of German origin and means "brave as a bear."

SAINT BERNARDINO OF SIENA
AND ANGELS
(detail)
Andrea Mantegna (attrib.)
1469
Pinacoteca di Brera, Milan

Saint Constantine

EMPEROR

Constantine the Great is not listed in *The Roman Martyrology* but is worshiped on this day by the Eastern Church and by that of the West in areas of Eastern influence. He recognized the great spread of Christianity and conceded freedom of worship to Christians by the Edict of Milan, in 313. According to legend, before the battle at Milvian Bridge, Christ appeared to him in a dream, promising him victory under the sign of the Cross. He was baptized on the point of death in 337. He is depicted in the robes of an emperor, often in the company of his mother, Helen.

NAME: Constantine *(Constant)* is of Latin origin and means "tenacious."

SAINT CONSTANTINE
AND SAINT HELEN
(detail)
Palma Vecchio
1520–28
Pinacoteca di Brera, Milan

Saint Rita of Cascia

WIDOW AND NUN • Optional memorial

Rita was born around 1381 at Cascia, Italy. Giving in to her parents' request she married. Her husband, an abusive man, was eventually murdered, victim of a family feud. When her two sons expressed the desire to avenge his death, Rita prayed to God to kill them to keep them from staining their hands with blood. She then lived in a convent of Augustinian nuns in penitence and caring for the suffering. As a sign of her particular devotion to the Passion, a wound appeared on her forehead that was similar to that caused by a crown of thorns. She died in 1457 and was canonized in 1900. She is depicted in the Augustinian habit; there is the wound in her forehead and she adores the crucifix amid roses. The "patron saint of impossibile causes and situations," she is invoked against smallpox and natural calamities and by women desiring to have children.

PROTECTOR: Grocers and salami vendors.

NAME: Rita is a diminutive of Marguerite, which is of Greek origin and means "pearl."

SAINT RITA
(detail of the saint's sarcophagus)
1457
Monastery of Saint Rita, Cascia

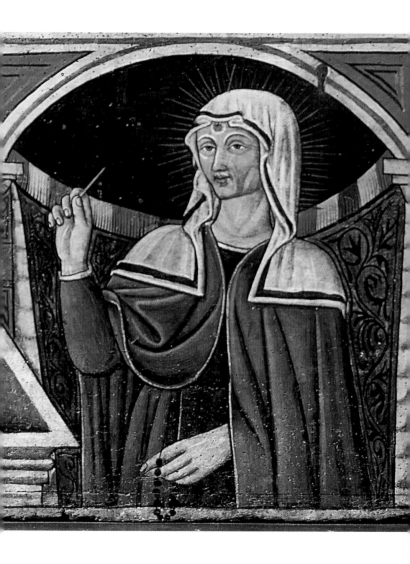

Servant of God
Girolamo Savonarola

DOMINICAN REFORMER

Born at Ferrara, Italy, in 1452, he studied philosophy and medicine before turning to the religious life of the Dominican friars. He was a great preacher and denounced the immoral behavior and corruption of his times, in particular that of the Church. His open criticism of Pope Alexander VI caused his excommunication, capture, and condemnation to the pyre as a heretic, in 1498. The movement for his beatification was initiated in 1977.

He is depicted in the Dominican habit, the black hood always raised, with his characteristic profile and hooked nose.

NAME: Girolamo *(Jerome)* is of Greek origin and means "sacred name."

GIROLAMO SAVONAROLA
Fra Bartolomeo
Circa 1499–1500
Museo di San Marco, Florence

Saint Amelia

MARTYR

Amelia was martyred at Tavo in
Galatia, a region of central Turkey,
in the second half of the 3rd century.
According to a *passio*, the young
woman stoically endured the
torments inflicted on her by her
persecutors and continued to call
out the name of Christ, firmly and
loudly, until her death.
She is depicted with a palm branch
and, sometimes, with the lily.
NAME: Amelia is from the
Ostrogoth and means "active,
energetic."

SAINT AMELIA
Popular sacred image
Early 20th century

Saint Bede the Venerable

MONK AND DOCTOR OF THE CHURCH • Optional memorial

An English Benedictine, Bede was born near Wearmouth around 672. From the age of seven he studied with Benedict Biscop; later he was at Jarrow, where he completed his religious training and spent the rest of his life. A great biblical scholar, he wrote one of the first Anglo-Saxon histories and left numerous writings that earned him the title of Doctor of the Church. He died in 735 and was canonized in 1899. He is depicted in the black habit of the Benedictines, usually posed as a scholar or scribe.

PROTECTOR: Scholars.

NAME: Bede is from the Hebrew, but its meaning has been lost.

SAINT BEDE WRITING
English miniature from the *Vita Sancti Cuthberti*
12th century
British Library, London

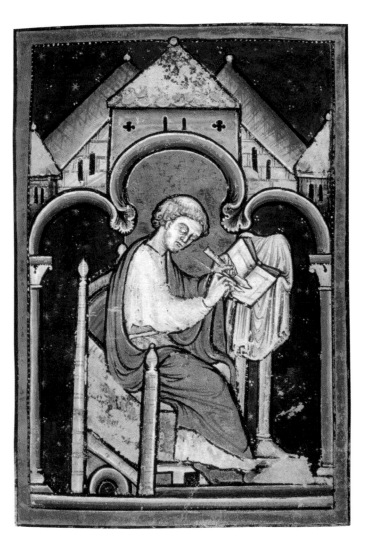

Saint Philip Neri

PRIEST • Memorial

Born in 1515 at Florence, Philip demonstrated such good character as a child that he was nicknamed "Philip the good." He became a priest in 1551 and dedicated himself to the education of the young of the city, using a new method that joined theater and music to the catechism. With the support of Pope Gregory XIII, he founded the Congregation of the Oratory in 1575. He died in Rome in 1595 and was canonized in 1622. He is depicted with a long face and white beard, a black habit or chasuble, while adoring the Virgin Mary. He is invoked against rheumatism and earthquakes.

PROTECTOR: The young.
NAME: Philip is from the Greek and means "lover of horses."

MADONNA AND CHILD
AND PHILIP NERI
(detail)
Guido Reni
1619
Santa Maria in Vallicella, Rome

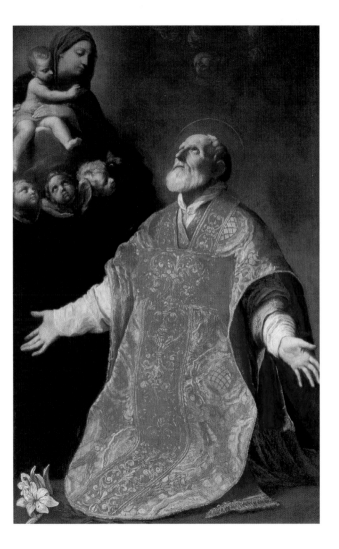

Saint Augustine of Canterbury

BISHOP • Optional memorial

Born in the second half of the 6th century, Augustine was a Benedictine monk in the abbey of Sant'Andrea at Rome when he was chosen by Pope Gregory I to lead a group of missionary monks to heathen England. Consecrated archbishop in Gaul at the end of the century, Augustine was welcomed with all honors by the king of Kent. He set himself up at Canterbury, and from there his monks carried out their mission of evangelization. He died in 604.

He is depicted in episcopal vestments.

NAME: Augustine is from the Latin and means "great, venerable."

THE VIRGIN AND SAINTS
(detail)
Pier Francesco Foschi
Second half 16th century
Santo Spirito, Florence

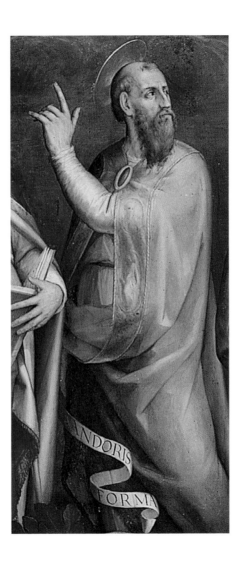

Saint Germanus of Paris

BISHOP

Born in Burgundy, Germanus lived during the 6th century. An unwanted child, he was raised, against her will, by an aunt. He chose the religious life, which he practiced in accordance with the austere rules of Eastern monasticism. He was named bishop of Paris and led the diocese until his death, in 576. His exemplary life earned him the affection of the people and the favor of the king, who conceded him a convent in which he could unite his community of monks. This was the origin of Saint-Germain-des-Prés.

He is depicted in episcopal vestments.

PROTECTOR: Prisoners.

NAME: Germanus is from the Latin and means "brother."

SAINT GERMANUS BISHOP OF PARIS
Popular sacred image
1830

Saints Sisinnius, Alexander, and Martyrius

PROTOMARTYRS OF TRENT

Sisinnius was a deacon, and both Alexander and Martyrius were church readers. Originally from Cappadocia, they were sent by Saint Ambrose to Vigilius, bishop of Trent, to spread the Gospel in the Tyrolean Alps, where pagan cults were still holding on. They built a small church but were burned alive in 397, the wood for the pyre being taken from the remains of the church. Their cult is still alive in the dioceses of Trent.

They are usually shown together, in the tunics of deacons and subdeacons.

NAMES: The meaning of Sisinnius is unknown; Alexander and Martyrius are from the Greek and mean, respectively, "protector of men" and "witness."

SAINT VIGILIUS BISHOP AND SAINTS SISINNIUS, MARTYRIUS, AND ALEXANDER
Paolo Naurizio
1583
Museo Diocesano Tridentino, Trent
(The three saints are at the center of the picture, the fourth, fifth, and sixth from the left)

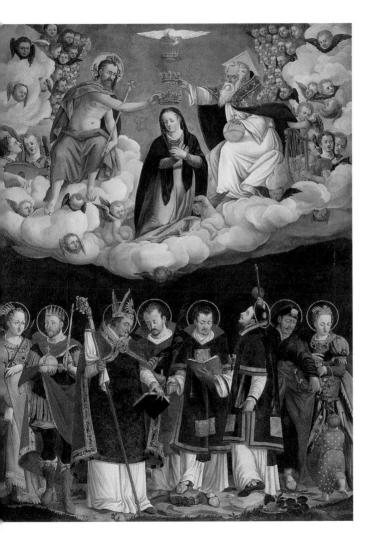

Saint Joan of Arc

VIRGIN

Joan was born at Domrémy, France, around 1412. An illiterate peasant, from the age of thirteen she heard the voices of saints calling on her to free France, at the time involved in the Hundred Years War (1339–1453). She thus went into battle against the army of the English, for on the basis of holdings on French soil the English claimed rights to the throne. In fact, Joan succeeded in having Charles VIII crowned at Rheims. Betrayed and tried as a heretic, Joan was sent to the pyre in 1431. Pope Calixtus III ordered the trial annulled in 1455; Joan was fully rehabilitated and finally canonized in 1920.

She is depicted in armor bearing a standard.

PROTECTOR: Telegraph and radio operators.

PATRON: Joan is the patron saint of France.

NAME: Joan *(John)* is of Hebrew origin and means "Yahweh is gracious."

JOAN OF ARC AT THE CORONATION OF CHARLES III IN THE CATHEDRAL OF RHEIMS
Jean-Auguste-Dominique Ingres
1851
Louvre, Paris

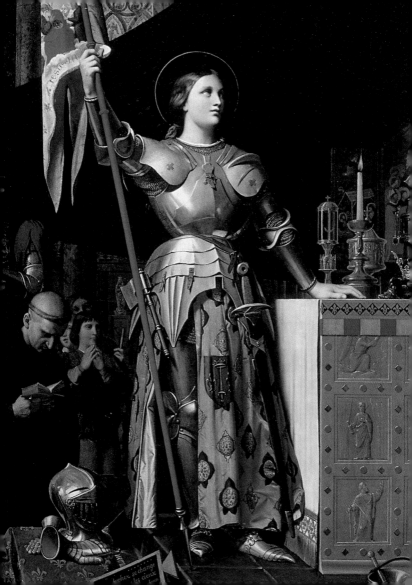

The Visitation of the Blessed Virgin Mary

Feast

According to the Gospel of Luke, following the Annunciation Mary went from Nazareth to Judaea to visit her older cousin Elizabeth, who was then pregnant with John the Baptist. Elizabeth, feeling the child in her womb leap, sensed the great mysteries surrounding Mary and exclaimed, "Blessed art thou among women, and blessed is the fruit of thy womb." Mary responded with the beautiful hymn of the *Magnificat*. The Visitation, a feast of Franciscan origin, used to be celebrated on June 2, but today it concludes the Marian month.

Depictions of the event show the encounter of the two women and their delicate embrace.

VISITATION
Pontormo
1528–29
Parish church of San Michele, Carmignano

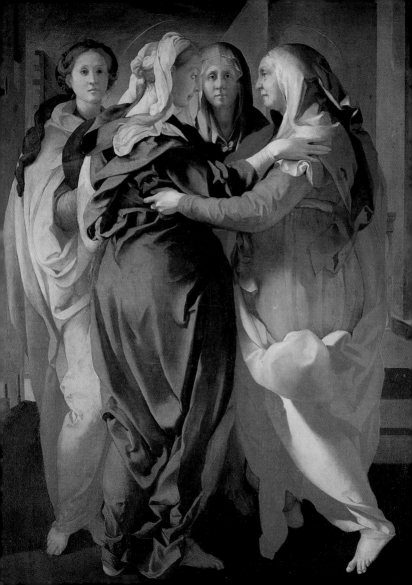

Saint Petronilla

MARTYR

According to inscriptions found in the catacombs of Domitilla, Petronilla was a martyr of that family; even so, popular tradition has made her into a daughter of Saint Peter. A variety of sources offer information that only confuses the story. She probably lived in Rome in the 4th century, but some sources claim she arrived there with Saint Peter and that to save her from improper attentions he gave her a fever each time a visitor arrived. Her cult spread between the 4th and 6th centuries.

She is depicted with keys, the same attribute as Saint Peter.

NAME: Petronilla is from the Latin by way of the Greek and means "rocky place."

BURIAL AND GLORY OF SAINT PETRONILLA
Guercino
1622–23
Musei Capitolini, Rome

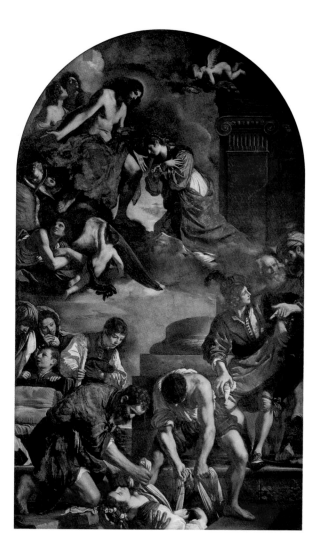

Saint Justin

MARTYR • Memorial

Born at Nablus in Samaria early in the 2nd century, child of parents of Greek origin, Justin sought the truth by studying the Greek philosophers before turning to the prophets of the Bible. In that way he arrived at Christianity and in 130 was baptized at Ephesus. He used philosophical arguments in preaching the Gospel and opened a school of Christian philosophy in Rome. He was arrested and beheaded for his faith during the reign of Marcus Aurelius. The Second Vatican Council made reference to his teachings.
He is depicted in ancient dress, with a scroll as his attribute.

PROTECTOR: Philosophers.

NAME: Justin is from the Latin and means "honest, upright."

SAINT JUSTIN
Popular sacred image
20th century

Saint Erasmus

BISHOP AND MARTYR

Originally from Antioch, Erasmus took the bishop's see of Formiae, Italy. To flee persecutions he fled to Mount Lebanon, where he was fed by a raven, but he was discovered, captured, and tortured. Sent to Diocletian, he was freed by an angel and carried out many more conversions. Taken prisoner again, he was killed around 303. According to a late tradition, before martyrdom he was tortured by having his intestines wound out of his body on a windlass. His cult spread in Italy and then in Germany in the 15th century.

He is depicted in episcopal vestments accompanied by a windlass or during the torture itself. He is invoked against intestinal colics and the pains of childbirth.

PROTECTOR: Sailors and fishermen of the Mediterranean.

NAME: Erasmus is of Latin origin and means "desired, lovable."

MARTYRDOM OF SAINT ERASMUS
Sebastian Ricci (attrib.)
Circa 1694
Pinacoteca di Brera, Milan

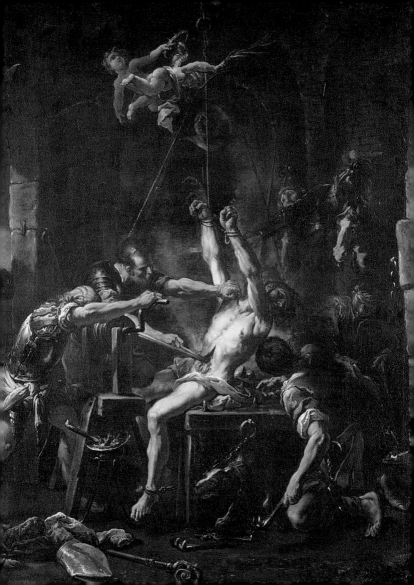

Saints Charles Lwanga and Companions

MARTYRS • Memorial

The first martyrs in Africa were Charles Lwanga and twelve other youths who were servants of Mwanga, king of Buganda, a region in today's Uganda. Having converted to Christianity, they were killed at Kampala in 1886 because they declared themselves willing to pray until death. After them another nine companions suffered the same fate. The persecutions continued until 1887, with much loss of life. They were canonized in 1964.

NAME: Charles is of Germanic origin and means "man, or free man."

Saint Clotilda

QUEEN

Daughter of Chilperic, king of Burgundy, Clotilda was born around 474 at Lyons. A Catholic, she married Clovis, the pagan king of the Franks. She obtained baptism for her sons and, with the help of Bishop Remigius of Rheims, she converted the king. On the death of Clovis, she had to witness the fratricidal struggles of her sons, thirsty for power, although she gave them Christian warnings and advice. She died at Tours in 545 and was immediately considered a saint.

She is depicted in royal dress and is invoked for the conversion of husbands and against fever, sudden death, and leg ailments.

PROTECTOR: The lame.

NAME: Clotilda is from the ancient French and means "illustrious in battle."

SAINT CLOTILDA, QUEEN OF THE FRANKS
Popular sacred image
19th century

Ste CLOTILDE REINE De FRANCE PRIEZ POUR NOUS.

Saint Quirinus

BISHOP

Quirinus was bishop of Siscia (now Sisak in Croatia). The earliest information about him comes from Eusebius of Caesarea, who in 309 mentions him among the martyrs during the persecution under Diocletian. An ancient *passio* relates the events: he was arrested and interrogated, and on refusal to sacrifice to the gods, he was whipped and imprisoned. In prison, however, he performed more conversions.

After further interrogations he was condemned to death and thrown into the Sava River with a stone tied around his neck. His body, first tended by the Christians of Savaria (an ancient area in western Hungary), was finally taken to Rome. He is depicted in episcopal vestments without any specific iconography.

NAME: Quirinus is of Latin origin and means "armed with a lance."

SAINT QUIRINUS OF SISCIA
Popular sacred image
20th century

Saint Boniface

BISHOP AND MARTYR • Memorial

Boniface was born in England around 672. A Benedictine monk, he left his homeland to spread the Gospel in the still-pagan regions of Europe. With the encouragement of Pope Gregory II, he brought the Gospel to the Germanic lands. Named bishop, he was also the organizer of the growing Church, designating bishops and founding monasteries, including his favorite at Fulda. He died in 754 in Friesland, struck down by pagan hands.

He is depicted in episcopal vestments and may hold a Bible pierced by a sword.

PATRON: Boniface is the patron saint of Germany.

NAME: Boniface is from the Latin and means "who has good fortune."

BAPTISM OF THE TEUTONS AND MARTYRDOM OF SAINT BONIFACE (detail from a miniature in a sacramentary from the church of the Holy Savior, Fulda)
975
Universitätsbibliothek, Göttingen
(Saint Boniface is shown baptizing on the left, being martyred on the right)

Saint Norbert

BISHOP • Optional memorial

Born in 1080 at Xanten, Germany, into a noble family, he led a worldly, carefree life during his youth. For reasons of prestige he was named imperial chaplain. Then, during a thunderstorm in 1115, he only narrowly escaped death by lightning: the event changed his life. He took vows and conducted an upright and righteous life. Pope Gelasius authorized him and several companions to found a religious community at Prémontré, France, which developed into the order of the Premonstratensian Canons, approved in 1126. That same year Norbert was chosen archbishop of Magdeburg, Germany. He died there in 1134 and was canonized in 1582 by Pope Gregory XIII.

He is depicted with the white robe of the Premonstratensians, usually holding a monstrance.

PROTECTOR: Women in childbirth.

NAME: Norbert is of German origin and means "splendor of the north."

SAINT NORBERT
Miniature
12th century
Staatsbibliothek, Munich

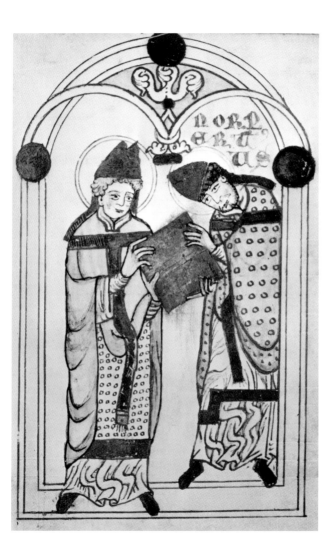

Saint Robert of Newminster

ABBOT

Born at Gargrave, England, around 1100, Robert studied in Paris and on his return to Gargrave was ordained priest and named rector. Having joined the Benedictines at Whitby, he was among the founders of Fountains Abbey, in 1132. He was named abbot of Newminster in 1138 and was responsible for giving new life to that abbey. He had the gift of prophecy, dedicated himself to acts of charity, and made prayer his primary weapon in his battles against evil. He was in contact with Saint Bernard. He died around 1159.

He is depicted as an abbot.

NAME: Robert is from the German and means "shining in glory."

SAINT ROBERT OF NEWMINSTER
Popular sacred image
20th century

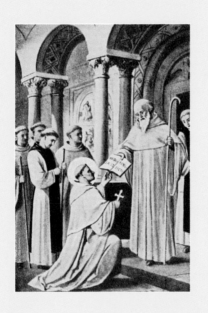

Saint Médard

BISHOP

Médard was born around 470 in Picardy, France, and studied near present-day Saint-Quentin, where he became friends with Eleutherius of Tournai and made himself known for his dedicated care of the poor. He was made bishop of Saint-Quentin and is famous for having given shelter to Queen Radegund, who had fled the cruelties of her husband, the Merovingian king Clotaire; he also started the queen on her religious life. Médard died around 560, and on instructions from the same king Clotaire his remains were translated to Soissons.

He is depicted in episcopal vestments. Mostly during the Middle Ages, it was customary to present him smiling and laughing, for which reason he is invoked against toothache.

NAME: Médard is of German origin and means "honored, daring."

S^t MEDARD

A Paris chez AUBRY, N.º 31 Estampe, Rue S.t Jacques N.º 51

Leipzig

JUNE 9

Saint Ephrem

DEACON AND DOCTOR OF THE
CHURCH • Optional memorial

Ephrem was born at Nisibis in
Mesopotamia around 306. At
eighteen he was baptized and was
instructed in the cathedral school.
He was made deacon, and when his
city was conquered by the Persians
he withdrew to Edessa. There he
composed important poetry and
hymns that earned him the name
"harp of the Holy Spirit." He was
the first to use the female voice in
hymns. He died at Edessa, in 373,
was canonized in 1920 and declared
a Doctor of the Church.
He is depicted in the dress of an
Eastern monk bearing a book or
scroll of his poems.
NAME: Ephrem is from the Hebrew
and means "he who bears fruit."

THE DORMITION OF SAINT EPHREM
(detail)
1457
Byzantine Museum, Athens

Saint Getulius

MARTYR

Getulius was martyred together with Amantius, Caerealis, and Primitivus during the reign of Emperor Hadrian and was the first Sabine to be martyred. According to legend, he was born in the city of Gabii and died not far from there. The *passio* that relates the story of his martyrdom and that of his companions speaks of torture, such as whipping and fire, which they underwent but escaped unharmed. They were then clubbed and decapitated.

He is depicted as a soldier with as attributes the club and the palm.

NAME: Getulius is from the Latin and means "belonging to the Gaetuli," a tribe of north Africa.

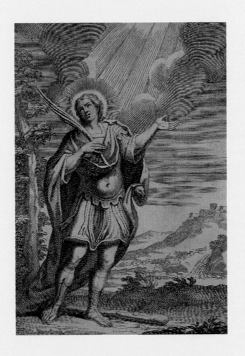

Saint Barnabas

APOSTLE • Memorial

A Jew of the tribe of Levi, born on Cyprus, he was known as Joseph until the apostles changed his name to Barnabus. An early Christian disciple, he was among the first to sell all his belongings and give the money to the nascent Church. It was Barnabas who presented Paul to the community of Damascus, and together with Paul he evangelized the Gentile community, after activity at Antioch and Cyprus. He was then active in the preaching of Mark. According to apocryphal tradition, he was stoned to death on Cyprus around 60.

He is depicted with tunic and pallium, sometimes bears a palm branch or the attributes of a bishop, and is invoked against hail.

NAME: Barnabas is from the Aramaic and means "son of encouragement."

SAINT BARNABAS
Giulio Cesare Procaccini
1605–06
Civiche Raccolte d'Arte Antica, Castello Sforzesco, Milan

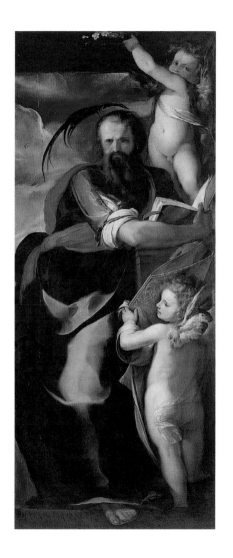

Saint Onuphrius

HERMIT

Onuphrius lived between the 4th and 5th centuries. Perhaps of noble origin, after having lived in the monastery of Hermopolis, at sixty he chose the hermit's life in the nearby Theban desert. Until his death around 400, he lived in complete solitude, receiving communion every Sunday from an angel. The abbot Paphnutius, passing through that land, was witness to his death and saw to his burial.

He is depicted as a hermit, often covered only by his own long hair. Together with the attributes of the penitent he is sometimes shown with symbols of his royal birth.

PROTECTOR: Weavers and sellers of fabric.

NAME: Onuphrius is of Coptic origin and means "who is good."

SAINT ONUPHRIUS
José Ribera
1637
Hermitage, St. Petersburg

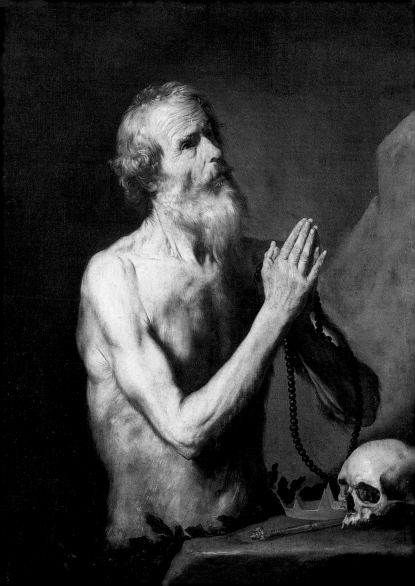

Saint Anthony of Padua

**PRIEST AND DOCTOR OF
THE CHURCH • Memorial**

Born at Lisbon in 1195, Anthony entered the order of Austin Canons but became a Franciscan in 1220, struck by the martyrdom of several Franciscan friars in Morocco. He was a preaching friar, greatly gifted at oratory, and taught in several European universities. He settled in Padua, where he dedicated himself exclusively to preaching. He died in 1231 and was canonized in 1232, only eleven months after his death. In 1946, he was declared a Doctor of the Church.

He is depicted in a Franciscan cowl with a book, bread, flame, heart, lily, and the Christ Child. He is invoked in finding all lost things and by women seeking husbands.

PROTECTOR: Orphans, prisoners, shipwrecked persons, pregnant women, sterile women, sick children, glaziers, and conscripts.

NAME: Anthony is from the Roman family name Antonius.

MADONNA AND CHILD
AND SAINT ANTHONY OF PADUA
(detail)
Anthony van Dyck
1630–32
Pinacoteca di Brera, Milan

352

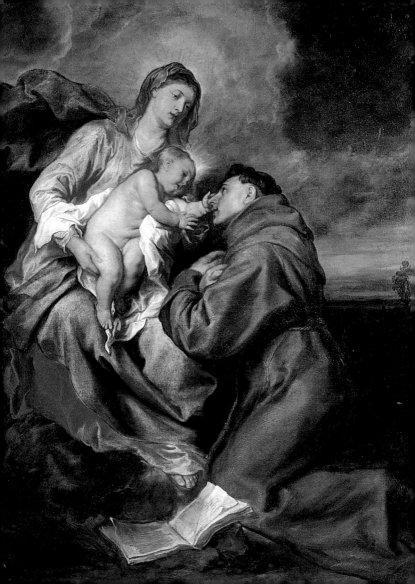

Saint Elisha

PROPHET

Elisha, a rich landowner, was plowing a field with twelve yoke of oxen when the prophet Elijah threw his mantle over him and asked him to follow him. He obeyed, became a disciple of Elijah, and continued his work. He was not a writing prophet but a miracle worker, and his many miracles are related in the Bible. His history is narrated in the two books of Kings. He died around 790 B.C. Celebrations of his feast began within the Carmelite order in 1399. He is depicted with the scroll of his prophecies and in various episodes of his life.

NAME: Elisha is from the Hebrew and means "God saves."

ELISHA MULTIPLIES THE LOAVES
Tintoretto
1577
Scuola Grande di San Rocco, Venice

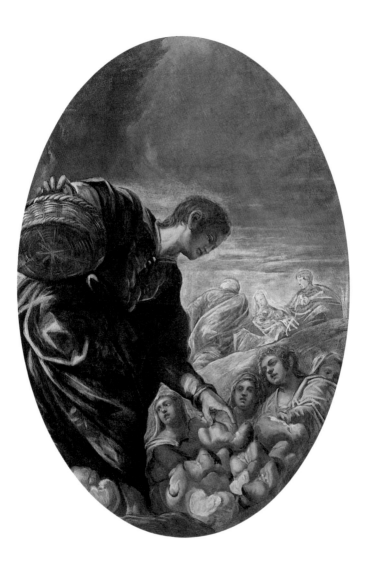

Saint Vitus

ADOLESCENT MARTYR

This young Christian of the 4th century, perhaps originally from Sicily, worked miracles even in his youth. According to legend, he was assisted by two angels, his tutor Modestus and his nurse Crescentia. He healed the son of Diocletian from epilepsy but was tortured all the same and killed for his refusal to sacrifice to the gods. His cult is widespread in Italy, Germany, and Bohemia.

He is depicted as a youth or child with a white rooster or the palm branch, sometimes dressed as a soldier. He is invoked against lethargy, the bite of poisonous animals, and Saint Vitus's dance.

PROTECTOR: Actors, dancers, epileptics, and tinsmiths.

NAME: Vitus is of Latin origin and means "full of vitality."

MADONNA AND CHILD WITH
SAINTS VITUS AND MODESTUS
AND THE REDEEMER IN GLORY
Lorenzo Lotto
First quarter 16th century
Gallerie dell'Accademia, Venice
(Saint Vitus is on the left)

356

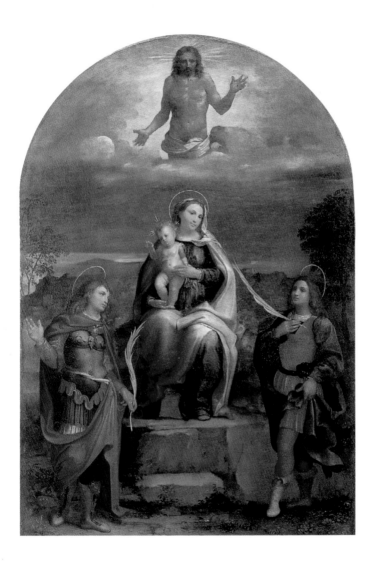

JUNE 16

Saints Cyricus and Julitta

MARTYRS

According to legend, these were a mother and son killed under Diocletian, perhaps in Tarsus, in Cilicia (Turkey), in the 4th century. Cyricus (Quiricus), only three years old, died—all the while professing his faith—when he was thrown violently to the ground by the magistrate who was interrogating them; his mother, having witnessed this, was then beheaded. Their cult was widespread in Europe, and since the Middle Ages they usually have been depicted together.

PROTECTOR: Cyricus is a protector of children.

NAMES: Cyricus is from the Greek and means "lord"; Julitta is Latin and means "content."

SAINT CYRICUS SCRATCHES THE JUDGE
(detail from the *Scenes of the Life of Saint Cyricus and Saint Julitta*)
Master of Saint Cyricus and Saint Julitta
15th century
Courtauld Institute of Art, London

Saint Adulf

BISHOP

Adulf was born into a Christian English family, probably noble, in the 7th century. He was sent by his parents to study in Belgium, together with his brother Botulf; Botulf became a Benedictine and returned to England, but Adulf remained and may have become bishop of Utrecht. Both brothers are mentioned in a biography written in 1068 by the abbot Folcard. Their relics were translated in 972 to the abbey of Thorney. Both are worshiped, most of all in Britain at Boston in Lincolnshire.

Adulf is depicted in episcopal vestments.

NAME: Adulf is from the German and means "young wolf."

SAINT ADULF
Popular sacred image
19th century
Civica Raccolta delle Stampe Bertarelli, Milan

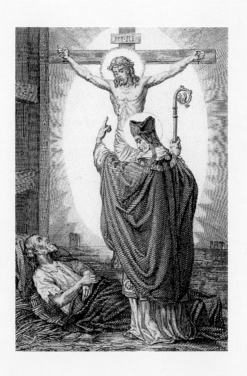

Saint Gregory Barbarigo

BISHOP AND CARDINAL

Born in 1625 in Venice, Gregory was initially taught by his senator father and after legal studies in Padua undertook a diplomatic career. He was at Münster at the ratification of the Peace of Westphalia, ending the Thirty Years War, and shortly after his return became a priest. In 1656, Pope Alexander VII called him to Rome to assist the sick during the plague. He was named bishop of Bergamo, and in that position he carried out the reforms of the Counter-Reformation. He was then made bishop of Padua and later cardinal. He founded colleges, seminaries, and libraries. He died in 1697, was beatified in 1761, but was canonized only in 1960 by John XXIII. He is depicted in cardinal's robes.

NAME: Gregory is of Greek origin and means "watchful, alert."

THE BLESSED GREGORY BARBARIGO
(detail)
Francesco Cappella
18th century
Bergamo Cathedral

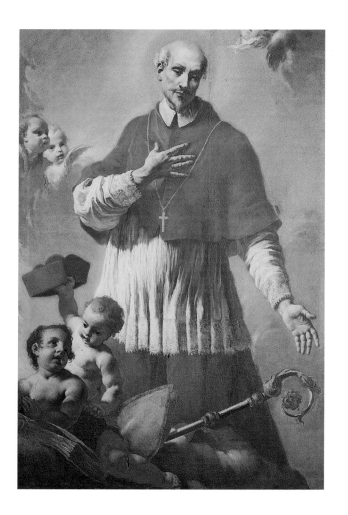

Saint Romuald

ABBOT • Optional memorial

Born around 950 at Ravenna, Italy, he chose the religious life, becoming a Benedictine monk. He felt a strong need to join eremitical experience to that of the monastic community; he achieved his goal in the founding of the monastery at Camaldoli in 1012, which he gave a new rule, stricter than the Benedictine. He died in the Castro valley in 1027 and was canonized in 1595.

He is depicted with a long beard, wearing the white cloak of the reformed Benedictines. His attributes are the Bible, the tempting devil, and a ladder he saw in a dream on which monks climbed into the sky.
PROTECTOR: The Camaldolesian order.
NAME: Romuald is of Lombard origin and means "forceful commander."

SAINT ROMUALD
(detail)
Guercino
17th century
Pinacoteca Comunale, Ravenna

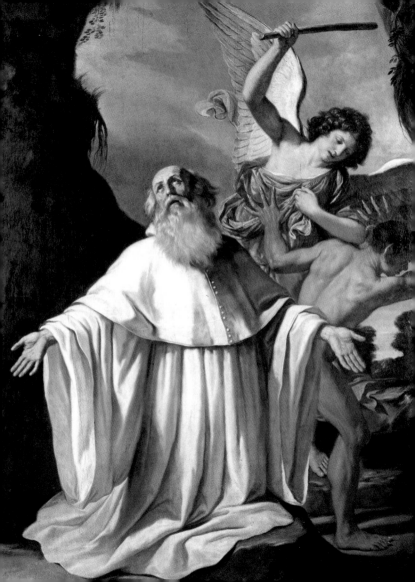

Saint Lucan

BISHOP

Lucan (Lugan) lived in the 5th century and may have been bishop of Sabiona in the Isarco valley in northern Italy. According to legend, in a period of terrible famine he permitted his faithful to eat dairy products during Lent, for which he was denounced to the pope. He set off for Rome to explain his actions to the pope but performed so many miracles along the way that he was immediately pardoned on his arrival. When he returned to his mountains, Lucan led a hermit's life in the Fiemme valley, perhaps to flee the persecution of the Arians. His cult became particularly popular in the 13th century. He is depicted in episcopal vestments.

NAME: Lucan is of Latin origin and means "of Lucania."

Saint Aloysius Gonzaga

PRIEST • Memorial

Aloysius (Luigi), son of Ferrante Gonzaga, marchese of Castiglione delle Stiviere, was born in 1568. Educated in Spain, at ten he made a vow of chastity and renounced his hereditary rights to enter the order of the Jesuits. He died in Rome of the plague in 1591. His cult was approved in 1621, and he was canonized in 1726.

He is depicted as a youth dressed as a priest, with a tunic over a black cassock. His attributes are the crucifix, the lily, a skull, and a whip.

PROTECTOR: Youths, scholars, and students.

NAME: Aloysius is a French form of the German *Ludwig*, meaning "famous warrior."

SAINT ALOYSIUS GONZAGA
Giandomenico Tiepolo
1760
Pinacoteca di Brera, Milan

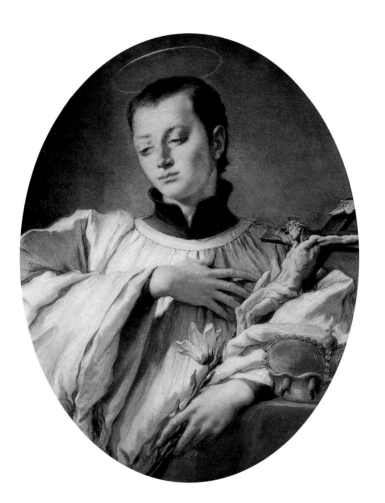

Saint Thomas More

MARTYR • Optional memorial

Thomas More was born into a noble family in London in 1478 and studied law. He enjoyed great fortune with the ascent of Henry VIII, who used him for diplomatic missions, had him knighted in 1521, and made him lord chancellor. He came to oppose the king, however, and refused to support him as the head of the English Church against the Roman Catholic Church. In 1534, he was accused of treason, imprisoned, and beheaded. A celebrated man of letters, More was the author of *Utopia*, among other works. Beatified in 1886, he was canonized in 1935 by Pope Pius XI.

He has been famously portrayed in a fur-trimmed coat.

PROTECTOR: Lawyers.

NAME: Thomas is from the Aramaic and means "twin."

THOMAS MORE
(detail)
Peter Paul Rubens
(after the portrait by Hans Holbein the Younger)
1630
Prado, Madrid

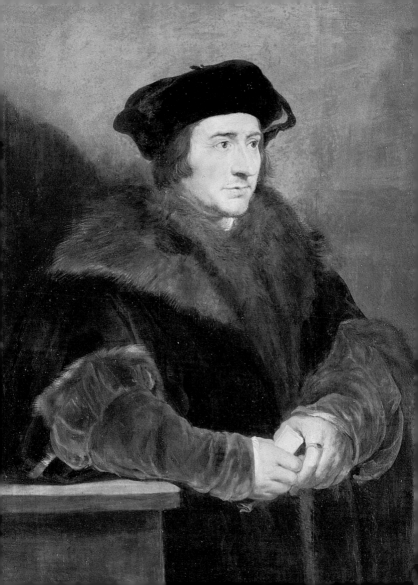

Saint Joseph Cafasso

PRIEST

Joseph Cafasso was born at Castelnuovo d'Asti in 1811. Ordained priest, he followed and carried on the pastoral work of the theologian Luigi Guala, directed at the young, laborers, and prisoners. He brought comfort to those condemned to death and was involved in the work of Don Bosco, who referred to him as a "model of priestly life." He died in Turin in 1860 and was canonized in 1947.

He is depicted in a priest's robes, often while assisting the imprisoned.

PROTECTOR: Prisoners and those condemned to death.

NAME: Joseph is from the Hebrew and means "he will add."

372

SAINT JOSEPH CAFASSO
Popular sacred image
20th century

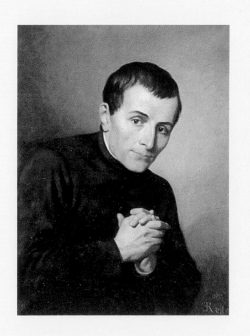

The Birthday of Saint John the Baptist

SOLEMNITY

Son of Elizabeth and Zacharias, both already advanced in years and childless, John was born about six months before Jesus. This birth had been announced by the archangel Gabriel to Zacharias, who was struck dumb by the message. Eight days after the birth, having to be circumcised, the child needed a name, and Zacharias succeeded in writing "John," following the indications of the angel; his tongue loosened in the hymn of the *Benedictus*.

In representations of the birth of the Baptist, Mary is usually also present, assisting her cousin Elizabeth, while Zacharias is most often shown in the act of writing. **NAME:** John is from a Hebrew name meaning "Yahweh is gracious."

BIRTH OF THE BAPTIST
(detail)
Giovanni Baronzio
Circa 1330–40
National Gallery of Art, Washington, D.C.

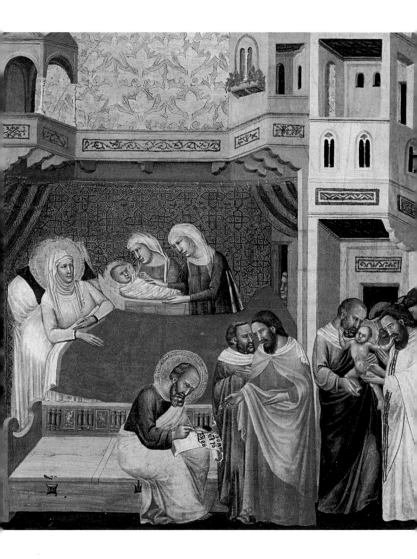

Saint Prosper of Reggio

BISHOP

Prosper occupied the episcopal see of Reggio Emilia in Italy in the 5th century. His cult is ancient and very popular; it began spreading in the 11th century. No solid biographical information is available about him, only several 10th-century documents concerning the translation of his relics.

He is depicted in episcopal vestments, often holding a book.

NAME: Prosper is of Latin origin and means "happy, fortunate, favorable."

SAINT PROSPER OF REGGIO
(detail of the preparatory drawing
for *Christ Dying among Mourners
and Saint Prosper*)
Guercino
1624
Royal Library, Windsor Castle

JUNE 26

Saint Vigilius

BISHOP AND MARTYR

Vigilius was active in bringing the Gospel to the mountain areas of northern Italy and was bishop of Trent between the 4th and 5th centuries. He was in contact with Ambrose of Milan, who sent him Sisinnius, Martyrius, and Alexander to help in his mission. Vigilius met his death while preaching the Gospel to the peoples of the remote Rendena valley. When he overturned a statue of Saturn, the idolaters killed him, according to tradition striking him to death with their clogs.

He is depicted in episcopal vestments, sometimes holding a clog.

NAME: Vigilius is from the Latin and means "vigilant."

SAINT VIGILIUS ALTARPIECE
(detail)
Giuseppe Alberti
1673
Museo Diocesano Tridentino, Trent

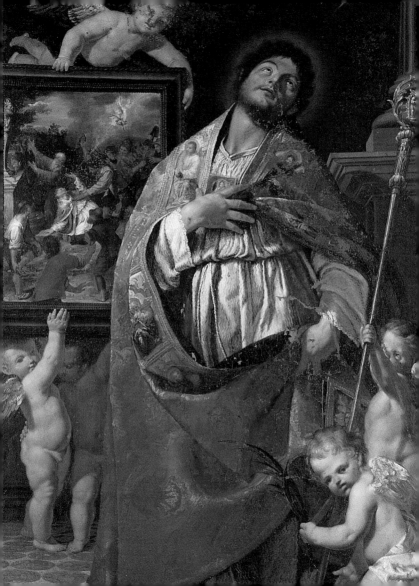

Saint Cyril of Alexandria

BISHOP AND DOCTOR
OF THE CHURCH

Born at Alexandria, Egypt, between 370 and 380, Cyril lived as a hermit until a patriarch uncle convinced him to return to the religious community. In 412, he became in turn patriarch of Alexandria, in which post he demonstrated unwavering authority, battling heresies, in particular the Nestorian, which brought him into doctrinal conflict with Nestorius, patriarch of Constantinople. Among the leading theologians and exegetes of the East, Cyril, nicknamed "seal of the Fathers," died in 444.

He is depicted in episcopal vestments.

PATRON: Cyril is the patron saint of Alexandria, Egypt.

NAME: Cyril is from the Persian and means "young king."

SAINT BISHOP CYRIL OF ALEXANDRIA
(detail)
1189
Church of the Annunciation of Arkali,
Novgorod

Saint Irenaeus of Lyons

BISHOP AND MARTYR • Memorial

Irenaeus was born around 130, perhaps at Smyrna (today's Izmir, Turkey), where he was a disciple of Saint Polycarp. Following studies in Rome, he was ordained priest and called to Lyons, being named bishop around 178. He preached against heresies and asked the intervention of Pope Victor I on the question of the date of Easter. An important theologian, Irenaeus was the author of several works. He died around 208, perhaps as a martyr.

He is depicted in episcopal vestments.

NAME: Irenaeus is of Greek origin and means "peaceful."

BAPTISM OF SAINT IRENAEUS
(detail of the Saint Piat Tapestry)
Pierrot Feré
1402
Treasury of the Cathedral, Tournai

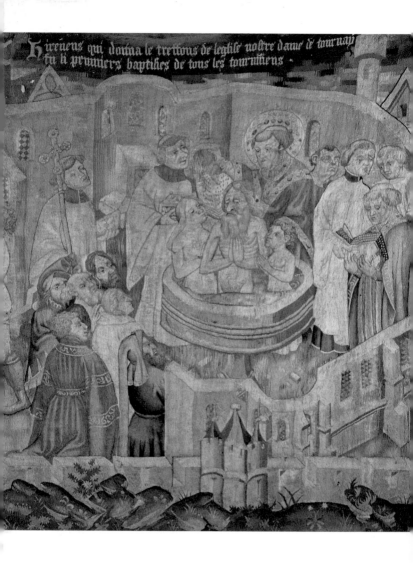

Hireneus qui donna le tresfons de leglise nostre dame de tourn[ay]
fu li premiers baptizies de tous les tournisiens

Saint Peter the Apostle

Solemnity

Simon, called Peter, was a fisherman on the Sea of Galilee; he was chosen by Jesus to be the "rock" on which he would build the church. He became the leader of the apostles and traveled, preaching, to Rome, where he became the first bishop of Rome and where he died during the reign of Nero, between 64 and 67. According to tradition, he was crucified with his head downward.

He is depicted wearing tunic and pallium or, sometimes, in papal robes. He has short curly hair, a short beard, and rough-hewn features. His attributes are keys, a book, a cock, and sometimes a boat.
PROTECTOR: Fishermen, fish mongers, cobblers, key-makers, harvesters, watchmakers, and porters.
NAME: Peter is from the Greek and means "rock, stone."

SAINT PETER
(detail of the Griffoni Polyptych)
Francesco del Cossa
Circa 1473
Pinacoteca di Brera, Milan

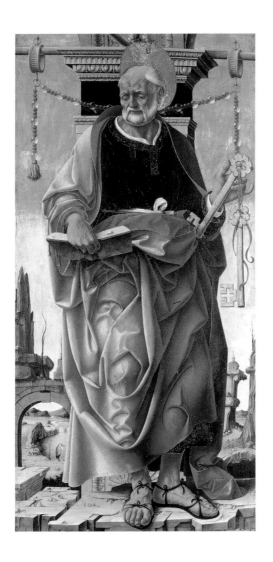

Saint Paul the Apostle

Solemnity

Paul, a Jew born at Tarsus, was a Pharisee and a tent-maker. He took part in the persecution of Christians until, while traveling on the road to Damascus to persecute Christians there, he had a vision that led him to convert. From then on, baptized by the disciple Ananias, he began preaching, founded several communities, and lived in Rome for three years. He died in Rome during the reign of Nero, around the year 65, according to tradition beheaded with a sword. He is depicted in a tunic and pallium, with dark hair and a long beard, usually holding a book and a sword.

PROTECTOR: Theologians and the Catholic press.

NAME: Paul is of Latin origin and means "small in stature, humble."

SAINT PAUL
(detail of the Pisa Altarpiece)
Masaccio
1426
Museo Nazionale di San Matteo, Pisa

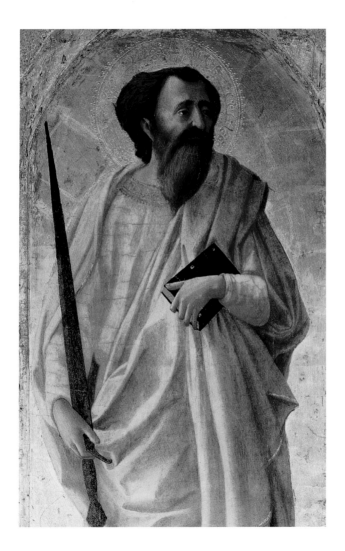

The Martyrs of Rome under Nero

MARTYRS • Optional memorial

This memorial recalls the nameless saints who died fearsome deaths, tortured during the persecutions unleashed by the Roman emperor Nero between the years 64 and 67. According to historians of the time, the Christians were accused of every disgrace or calamity, including the great fire that had raged across Rome, devastating entire city quarters. So terrible was the brutality unleashed against the Christians that the Romans themselves—usually tolerant of other religions—were shocked. Christians were burned alive, torn to pieces by wild beasts, crucified, and decapitated.

PERSECUTION OF CHRISTIANS
(detail)
Anonymous
1909
Westfälisches Schulmuseum, Dortmund

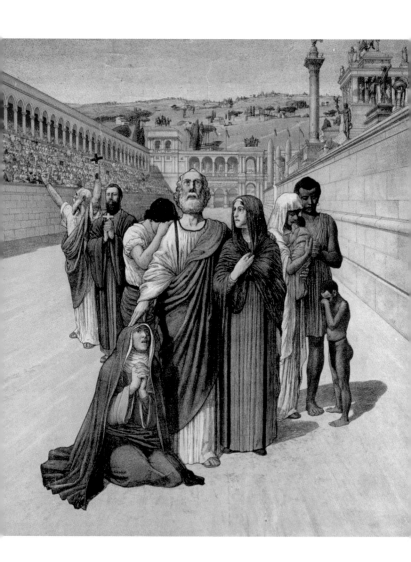

JULY 1

Saint Aaron

BROTHER OF MOSES

Aaron lived in Egypt in the 13th
century B.C. He was the brother of
Moses who, being a stutterer, made
use of Aaron's great eloquence to
speak with the pharaoh and with the
people. He participated in the exodus
from Egypt but, having doubted in
God, he could not reach the Promised
Land. He was the first high priest of
the Chosen People and his descen-
dants include Saint John the Baptist.
He is depicted in the dress of a
Jewish priest.
PROTECTOR: Button-makers.
NAME: Aaron is of Hebrew origin
and means "illuminated."

AARON WITH THE THURIBLE
(detail from the *Trinity, Virgin, Angels,
Sibyls, Prophets, Adam and Eve*)
Giovanni Serodine
1620–30
Church of the Conception of Mary, Spoleto

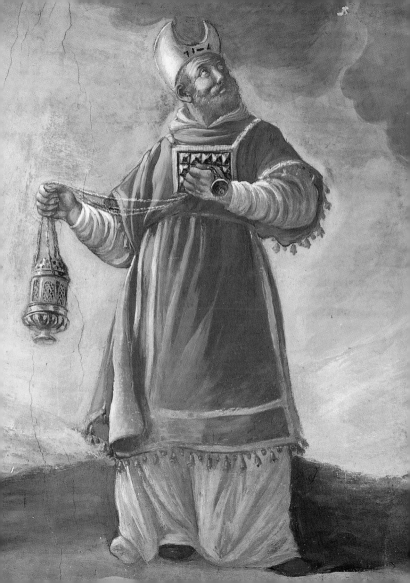

Saints Processus and Martinian

MARTYRS

Processus and Martinian were warders in the Mamertine prison where, according to tradition, Peter and Paul were kept before their martyrdom. Both were converted by Peter's preaching and asked to be baptized; Peter miraculously made the water necessary for their baptism flow from the stone. Alerted to this conversion, the judge Paulinus sought in vain to dissuade them in every way with horrendous tortures. Finally he had them decapitated on the Aurelian Way.

They are usually depicted while undergoing torture.

PROTECTORS: Warders, jailers, and prison police.

NAMES: Both names are of Latin origin. Processus means "who proceeds," Martinian means "related to Mars."

MARTYRDOM OF SAINTS PROCESSUS
AND MARTINIAN
(detail)
Valentin de Boulogne
1629
Pinacoteca Vaticana, Vatican

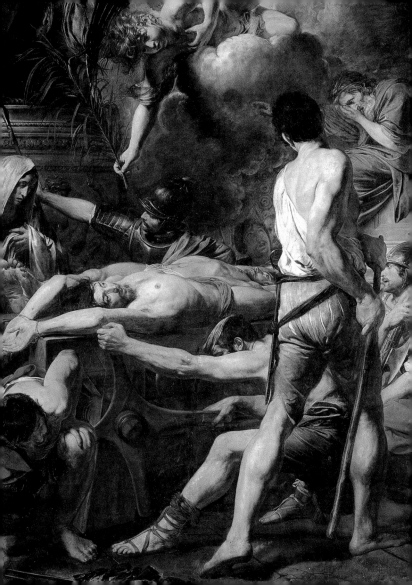

Saint Thomas the Apostle

Feast

An apostle of Jesus, Thomas lived in Palestine in the 1st century and, according to an apocryphal tradition, died in India as a martyr, killed by a spear. Thomas is famous for his doubting, for he refused to believe in the Resurrection until Jesus appeared to him and invited him to touch the wound in his side, at which Thomas declared, "My Lord and my God." His cult spread from India to Asia Minor and Europe. He is depicted with a builder's square or a spear or lance, sometimes with a belt or girdle in hand, and is invoked against eye disorders.

PROTECTOR: Architects, artists, carpenters, engineers, judges, builders, and stonecutters.

NAME: Thomas is from the Aramaic and means "twin."

THE INCREDULITY OF SAINT THOMAS
(detail)
Caravaggio
1600–01
Schlossgalerie, Potsdam

Saint Elizabeth of Portugal

QUEEN • Optional memorial

Daughter of King Peter III of Aragon, she married King Diniz of Portugal when only twelve years old. She lived from 1271 to 1336. She was a very religious queen, always patient with her husband, despite his continuous infidelities. An exemplary mother and woman of peace, she reconciled her husband with their son Alfonso, who had led a revolt against him.

When King Diniz died, in 1325, she entered a convent and dedicated the rest of her life to prayer and care for the poor. Beatified in 1516, she was canonized in 1625 by Pope Urban VIII.

She is depicted in regal dress or Franciscan robes.

NAME: Elizabeth is of Hebrew origin and means "God is abundance."

SAINT ELIZABETH
Francisco de Zurbarán
1640
Prado, Madrid

Saint Anthony Zaccaria

PRIEST • Optional memorial

Born at Cremona, Italy, in 1502, Anthony Zaccaria was first a doctor and then a priest. To make up for the shortcomings of the Church, he formed spiritual groups of laymen and founded the Congregation of St. Paul (later known as the Barnabites). He died at Cremona on July 5, 1539, and was canonized in 1897.

He is depicted most often wearing the black cassock of the regular clergy; his attributes are the flowering lily and the crucifix.

NAMES: Anthony is from the Roman family name Antonius; Zaccaria is from the Aramaic and means "God remembers."

SAINT ANTHONY ZACCARIA
Popular sacred image
18th century
Civica Raccolta delle Stampe Bertarelli, Milan

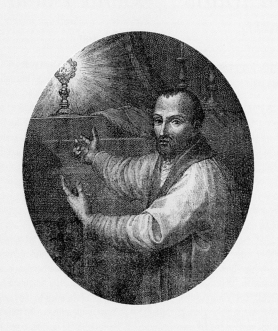

Saint Maria Goretti

VIRGIN AND MARTYR • Optional memorial

Maria was born in 1890 in a poor family at Corinaldo, Italy, and at seven followed her parents in search of work in the Pontine Marshes. When her father died, ten-year-old Maria took care of the house and her brothers. Pestered by the amorous advances of a young neighbor, she resisted him, even when he threatened her. He finally stabbed her, and she died, maintaining intact her virginity. Beatified in 1945, she was canonized in 1950.

PROTECTOR: Young women.
NAME: Maria *(Mary)* is from the Egyptian and means "beloved"; in the Hebrew (from Miriam), it means "lady."

Saint Isaiah

PROPHET

Son of Amoz, Isaiah was born around 770 B.C. and received the call to prophesy during a vision in 739 B.C. He preached in the kingdom of Judah and at Jerusalem under the kings Uzziah, Jotham, Ahaz, Hezekiah, and Manasseh. Under the last-named he was condemned to death and, according to tradition, sawed in half. Tirelessly proclaiming the need to live in the faith, he had a profound influence on theology throughout Israel, prophesying that only those who remained faithful to Yahweh would survive the consequences of disobedience. His prophecies made frequent reference to the coming of Christ, with allusions to the Passion. He is depicted holding a scroll.

NAME: Isaiah is from the Hebrew and means "God is salvation."

SAINT ISAIAH
Raphael
1511–12
Sant'Agostino, Rome

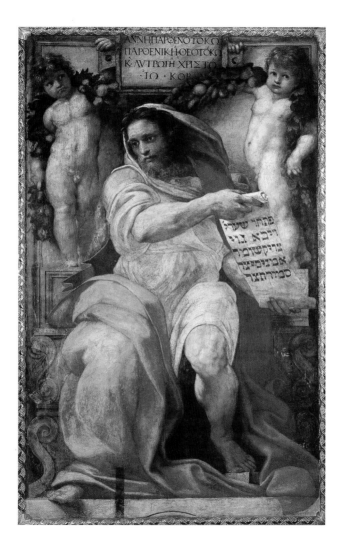

Saint Willibald

MONK

Willibald, famous as a traveling monk, was a native of Wessex, in southern England, and lived between 700 and around 786. He made a pilgrimage to the Holy Land and stopped at Rome on his return. Pope Gregory III directed him to revive the community of monks at Monte Cassino, which had been destroyed by the Lombards of Zotone in 577. He was then sent to Germany and ordained priest; in 741, Gregory III named him bishop of Eichstätt, where he was active as both pastor and missionary. He died in the odor of sanctity.

He is depicted dressed as a monk.

NAME: Willibald is of German origin and means "very ardent."

SAINT WILLIBALD ASKS THE BLESSING OF POPE GREGORY III BEFORE LEAVING TO EVANGELIZE THE SAXONS
(detail)
Francesco Solimena
Early 18th century
Pinacoteca di Brera, Milan

Saint Procopius

MARTYR

According to what is handed down
by the Church historian Eusebius of
Caesarea, Procopius was the first
Christian of Caesarea to be martyred
during the persecution under Emperor
Diocletian, in 303. Originally from
Aelia, near Jerusalem, Procopius was
a Church reader and interpreter in
Syriac. He had always led a virtuous
life, dedicated to fasting, meditation,
and prayer. He was taken before the
magistrate Flavian; refusing to sacri-
fice to the gods and the emperors,
he was beheaded.
He is sometimes depicted as a
soldier, with the palm of martyrdom.
NAME: Procopius is of Greek origin
and means "who promotes."

ELIJAH, PROCOPIUS, AND GEORGE
Ivory plaque
970
Private collection, Munich
(Saint Procopius is in the center)

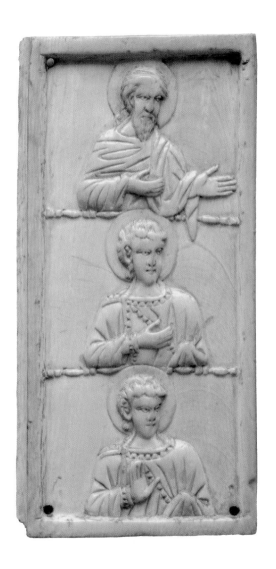

Saint Veronica Giuliani

VIRGIN

Born in 1660 at Urbino, Italy, and baptized as Ursula, she took the name Veronica when she entered the convent of Capuchin nuns at Città di Castello in Umbria, at the age of seventeen. She was a great mystic, and on the orders of her spiritual director, she diligently transcribed her numerous revelations for thirty years in a diary that was published much later, entitled *Diary of the Passion*. She received the stigmata and died in 1727. She was canonized in 1839.

She is depicted with the robes of the Clares in adoration of the crucifix with the crown of thorns and the instruments of the Passion.

NAME: Veronica is from the Greek and means "victorious."

BLESSED VERONICA GIULIANI
SURROUNDED BY ANGELS
(detail)
Michele Fanolli
1832
Cittadella Cathedral

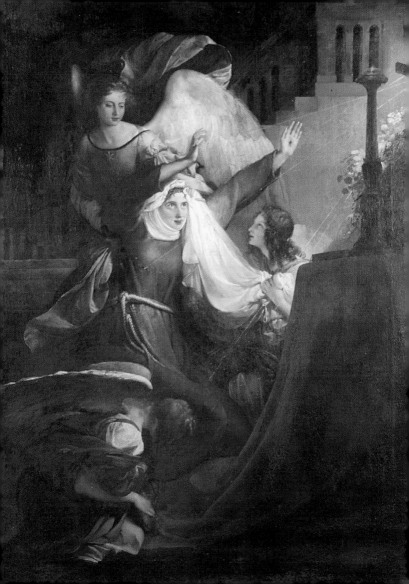

Saints Secunda and Rufina

MARTYRS

According to tradition, Secunda and Rufina were Christian sisters in Rome, promised in marriage to two young men of the same faith. When persecutions broke out, the men renounced their faith, but the sisters made vows of chastity and were denounced. Their martyrdom took place around 260, during the reign of Emperor Valerian, on the Cornelian Way: Rufina was decapitated, Secunda was clubbed to death. The cult of the two virgins was widespread in the 4th century.

They are usually depicted during their martyrdom. Their attribute is the palm.

NAMES: Both names are of Latin origin. Secunda means "second"; Rufina means "tawny."

THE MARTYDOM OF SAINTS SECUNDA AND RUFINA
Cerano, Pier Francesco Morazzone, and Giulio Cesare Procaccini
1625
Pinacoteca di Brera, Milan

Saint Benedict

ABBOT • Feast

Benedict was born at Norcia in Umbria, Italy, around 480. He founded the order of the Benedictines, based on liturgical prayer and manual labor and well known for its Latin motto: *Ora et labora* ("Pray and work"). Benedict is thus considered the father of Western monasticism. He died in the abbey of Monte Cassino, which he had founded, in 547.

He is depicted in black robes with a book, an abbot's crosier, a raven with bread in its beak, a broken cup, a rod, or a bundle of rods.

PROTECTOR: Farmers, Italian architects, chemists, peasants, engineers, and speleologists.

PATRON: Benedict has been the patron saint of Europe since 1964.

NAME: Benedict is of Latin origin and means "he who is blessed."

SAINT BENEDICT
(detail of the Portinari Triptych)
Hans Memling
1487
Galleria degli Uffizi, Florence

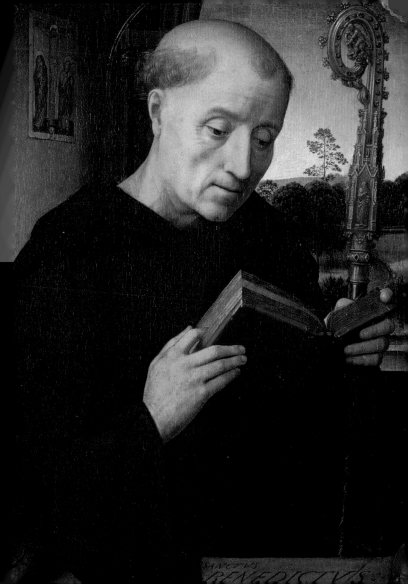

SANCTVS
BENEDICTVS

Saints Nabor and Felix

MARTYRS

Like Saint Victor, Nabor and Felix were Moorish soldiers from northern Africa. They arrived in Milan around the end of the 3rd century, part of the imperial troops of Maximian Herculeus. They converted to Christianity and were decapitated at Lodi during the persecution unleashed by Emperor Diocletian in 303. Their bodies were taken to Milan and placed in a tomb; the small basilica over it is known as the Naboriana. The cult had the favor of Saint Ambrose but waned over the course of the later Middle Ages to be revived in the 14th century by the Franciscans.

They are depicted as soldiers with palm branches.

NAMES: Nabor is of Hebrew origin and means "light of the prophet"; Felix is from the Latin and means "happy, content."

CHRIST AS KING BETWEEN SAINTS NABOR AND FELIX
(detail of the Shrine of the Three Kings)
Nicholas of Verdun
Circa 1181
Cologne Cathedral

Saint Henry II

EMPEROR • Optional memorial

Henry was born in Bavaria in 973 and was crowned Holy Roman Emperor in 1014. Feeling responsible for his subjects in terms of their faith, he had a strong influence on Church matters and favored the spread of monasticism. He died in 1024. He was buried in the cathedral of Bamberg, which he had founded, and was canonized in 1146.

He is depicted in imperial robes.

PROTECTOR: Benedictine oblates.

NAME: Henry is from the ancient German and means "home ruler."

KING HENRY II
Johann David Passavant
1840
Kaiseraal, Römer, Frankfurt am Mein

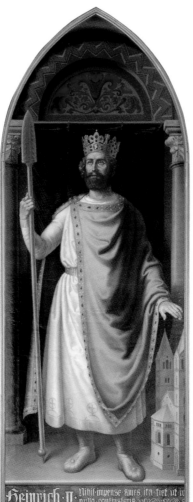

Heinrich · II · Nihil impense · ames · ita · fiet · ut · in
nullo · contristeris ❧❦❧❦

Saint Camillus de Lellis

PRIEST • Optional memorial

Camillus was born at Bucchianico, Italy, in 1550, and after a stormy youth he lived as a soldier of fortune until he fell ill with a leg ailment that forced him to seek help in a hospital. To pay for his treatment he was required to serve as a nurse, but he proved untrustworthy and was thrown out. He went into the service of Capuchin friars and asked to join the order but again ended up in the hospital, and this time changed his outlook and chose a new mission for himself, that of caring for the sick. In 1585, he founded a congregation of male nurses (Ministers of the Sick) and was a pioneer in the proper care of the infirm. He died at Genoa in 1614 and was canonized in 1746. He is depicted in black robes with a red cross.

PROTECTOR: Nurses, the sick, and hospitals.

NAME: Camillus is of Phoenician origin and means "priest officiating at special sacrifices."

CAMILLUS DE LELLIS TENDS THE WOUNDED IN THE HOSPITAL OF SANTO SPIRITO IN ROME DURING THE FLOODING OF THE TIBER IN 1598 (detail)
Pierre Subleyras
1745
Palazzo Braschi, Museo di Roma, Rome

Saint Bonaventure

BISHOP, CARDINAL, AND DOCTOR OF THE CHURCH • Memorial

Born around 1218 in Bagnoreggio, near Orvieto, Italy, Giovanni di Fidanza took the name Bonaventure when he entered the Franciscan order, in 1243. Elected minister general of the order, he played a decisive role, coming to be called the "second founder of the order" and nicknamed the "Seraphic Doctor." In 1273, he was named cardinal and bishop of Albano. He died in 1274.

He was canonized in 1482 and declared a Doctor of the Church in 1588.

He is depicted in cardinal's robes over a Franciscan habit, with a book, crucifix, angel, and monstrance.

PROTECTOR: Theologians, messengers, porters, and weavers.

NAME: Bonaventure is of Latin origin and means "good fortune."

SAINTS CLARE AND BONAVENTURE
(detail of the Polyptych of the Graces)
Vincenzo Foppa
1483
Pinacoteca di Brera, Milan

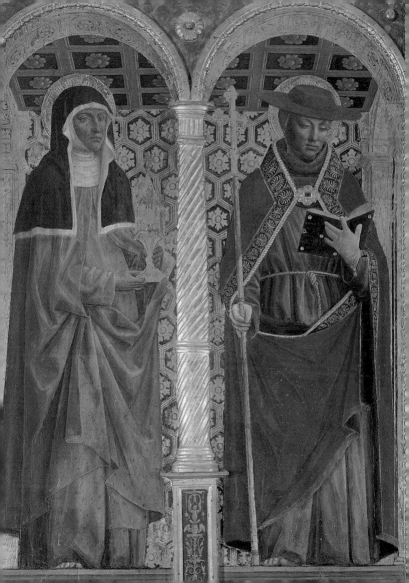

Blessed Virgin of Mount Carmel

Optional memorial

This feast was instituted in the 18th century following the approval of the new rule of the Carmelite order. The intention was to recall the Madonna of Mount Carmel and to celebrate the rule, recalling the ancient origin of Carmelite spirituality.

On Mount Carmel, in fact, Elijah had the vision of a cloud that, bringing rain, ended the great drought, an image that exegetes thought must prefigure Mary. And it was on that mountain in the 12th century that many hermits joined in praise of God under the protection of the Virgin Mary.

THE MADONNA OF CARMEL
(detail)
Monetto da Brescia
1520–22
Gallerie dell'Accademia, Venice

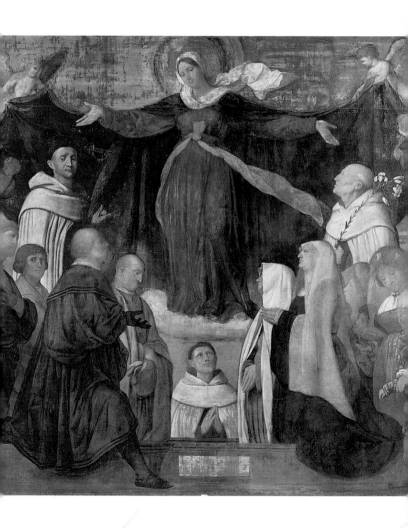

Saint Alexis

MENDICANT

In the 5th century, the Roman patrician Alexis, after getting married, left his wife untouched and set off on a pilgrimage to Syria, where he lived as a beggar. Word of his sanctity spread, but when he returned to Rome he was unrecognized by his parents. For seventeen years he lived as a servant in his father's home, sleeping under the stairs, and died begging in front of the house. His identity was revealed by Pope Innocent I (401–17), who had a vision that led to the discovery of a sheet of paper that Alexis held in his fist. On it was written his name.

He is depicted as a beggar or pilgrim, near a staircase. Sometimes he holds the letter. He is invoked by the dying.

PROTECTOR: Beggars and porters.
NAME: Alexis is of Greek origin and means "protector."

DEATH OF SAINT ALEXIS
(detail)
Pietro da Cortona
1638
Church of the Girolamini, Naples

Maternus of Milan

BISHOP

Maternus was the seventh bishop of Milan, after Mirocle, in the 4th century. He led the Milanese Church for nearly twelve years. Saint Charles Borromeo found his relics in 1571.

He is depicted with the attributes of a bishop. The oldest image of Maternus, in a chapel of San Vittore of Ciel d'Oro in Milan, presents him wearing a dalmatic.

NAME: Maternus is from the Latin and means "devoted to the mother."

SAINT MATERNUS
Anonymous Lombard artist
Before 1737
Museo Diocesano, Milan

Blessed Pietro Cresci of Foligno

CONFESSOR

Pietro, son of Pietro of the Cresci family, was born around 1243 at Foligno, Italy. At about thirty he decided to give all his belongings to the poor and live as a penitent. He even sold himself, becoming a slave, but his owner immediately freed him, asking in exchange only prayer. Pietro, therefore, made his home the cathedral. He was always ready to perform a service and lived in absolute poverty. He dressed in sackcloth, wore no shoes, and spent his time in intense prayer, turned toward the sun as the image of Christ, the "true sun." Many took him for crazy, and the Inquisition interrogated him several times, but no heresy could be found in him, nor any proof of insanity. He died in the odor of sanctity at Foligno in 1323.

NAME: Pietro *(Peter)* is from the Greek and means "rock, stone."

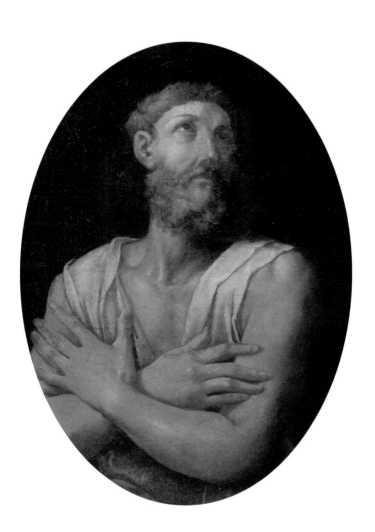

Saint Apollinaris

BISHOP AND MARTYR • Optional memorial

The first bishop of Ravenna, Italy, Apollinaris may have died in the year 200. What little is known of his life and acts is part of a tradition that dates to at least the 7th century, for which reason he is often considered legendary. There are several sources, however, that attest that he was originally from Antioch. His cult was highly popular during the 5th century, which can be assumed to reflect an important level of pastoral activity and missionary work on his part. He is depicted in ancient episcopal vestments in the gesture of preaching.

NAME: Apollinaris is from the Latin and means "sacred to Apollo."

SAINT APOLLINARIS IN GLORY
Giacomo Manzoni
1900–01
Parish church of Sant'Apollinare, Frosinone

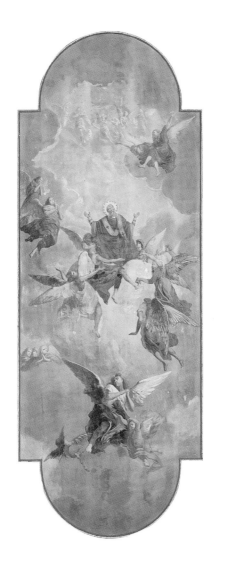

JULY 21

Saint Daniel

PROPHET

Of noble origins, Daniel was born
into the tribe of Judah. In 605 B.C.,
when he was still very young, he
was deported to Babylon following
the first destruction of Jerusalem.
Along with other aristocrats he
served as a page at the court of
Nebuchadnezzar. Educated in the
Babylonian culture, he distinguished
himself as an interpreter of dreams,
thanks to which he reached high
levels. He always remained faithful
to the Jewish religion, thus making
many enemies and risking death.
He is depicted as a young prophet
bearing a scroll or book, sometimes
surrounded by lions or protecting
Susanna.
NAME: Daniel is from the Hebrew
and means "God is my judge."

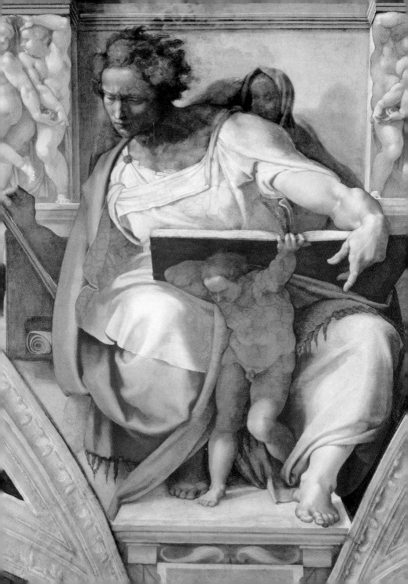

Saint Mary Magdalen

DISCIPLE • Memorial

In Gregory the Great's interpretation, Mary Magdalen was the repentant prostitute who anointed Jesus' feet and asked him to forgive her sins, becoming his disciple. She was present at the crucifixion and was the first witness of the Resurrection. In the apocryphal tradition, she evangelized Provence and died there. From there, her cult spread throughout Europe.

She is sometimes depicted in elegant dress; sometimes she is disheveled, perhaps covered only by her own long hair. Her primary attribute is the ointment jar, to which can be added the symbols of a penitent.

PROTECTOR: Gardeners, perfume-makers, glove-makers, and the penitent.

NAMES: Mary is from the Egyptian and means "beloved"; in the Hebrew (from Miriam), it means "lady." Magdalen is from the Hebrew and means "from Magdala."

SAINT MARY MAGDALEN
(detail)
Piero della Francesca
1460
Arezzo Cathedral

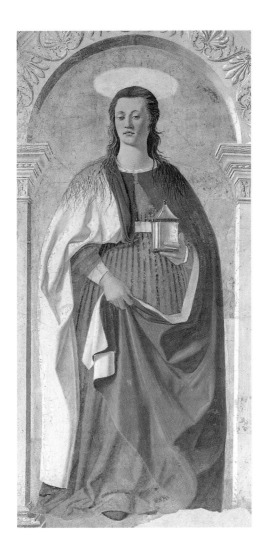

Saint Bridget of Sweden

FOUNDRESS • Feast

Born near Uppsala in 1303, at fourteen she married the nobleman Ulf Gudmarsson, with whom she had eight children. When he died, she dedicated herself to an ascetic and contemplative life. She was a Franciscan tertiary and founded the Order of the Holy Savior (Bridgettines), primarily for women but also for men. She died at Rome in 1373. In art, she is depicted as a widow, pilgrim, noble, or abbess with the cross of the Daughters of Bridget, a heart or cross, the monogram of Christ (IHS), a burning candle, book, pen, or inkwell.
PROTECTOR: Pilgrims and travelers.
PATRON: Bridget is the patron saint of Sweden.
NAME: Bridget is of Celtic derivation and means "strong, powerful, exalted."

MADONNA AND CHILD WITH SAINT BRIDGET AND SAINT MICHAEL
Giovanni di Francesco
1440
J. Paul Getty Museum, Los Angeles
(St. Bridget is on the left)

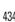

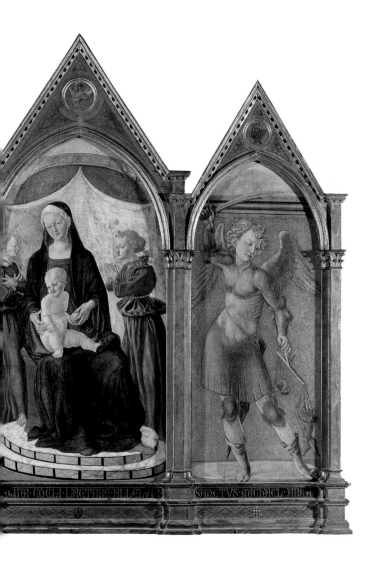

...INE COELI ELAE... ...CLAE... SANCTVS MICHAEL ARO...

Saint Christina of Bolsena

MARTYR

According to tradition, Christina was most probably a saint of Tyre martyred during the persecution under Diocletian in 287. Legend tells us that she heroically survived various terrible tortures and finally died when pierced by a lance. The first iconographic presentations of her date to the 6th century; the young martyr appears at Ravenna in mosaics of the church of Sant'Apollinare Nuovo in the procession of the virgins.

She is depicted as a young woman with various instruments of martyrdom: a knife, arrow, or millstone.

NAME: Christina is from *Christus*, a Latin term from the late period.

SANTA CRISTINA AL TIVERONE
ALTARPIECE
(detail)
Lorenzo Lotto
1504–06
Santa Cristina al Tiverone, Quinto di Treviso

Saint James the Greater

APOSTLE • Feast

Son of Zebedee and brother of John the Evangelist, James was an apostle of Jesus, one of the witnesses of the Transfiguration of Christ and his agony in the garden of Gethsemane. He was martyred under Herod Agrippa around 42. The discovery of his relics at Compostela in the 9th century contributed to the spread of his cult. He was originally depicted as a pilgrim; his image on horseback battling Moors spread only after his apparition at the battle of Clavijo in 844. He is invoked against rheumatism and for good weather.

PROTECTOR: Milliners, pharmacists, druggists, sock-makers, and pilgrims.

PATRON: James is the patron saint of Spain and Guatemala.

NAME: James is from the Aramaic and means "follower of God."

SAINT JAMES
(detail of the Belforte Polyptych)
Giovanni Boccati
1445–80
St. Eustachio, Belforte sul Chienti

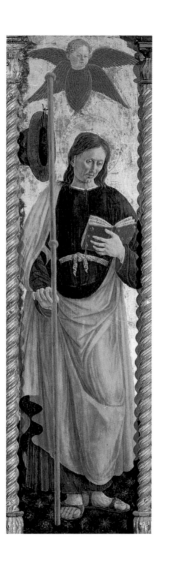

Saint Christopher

MARTYR

A Canaanite of gigantic stature, Christopher desired to serve the most powerful prince in the world. A hermit suggested he would do better to serve the needy, so he decided to help travelers cross a river. When he carried a child who revealed himself as Christ, he converted. He died a martyr, probably during the rule of the Roman emperor Decius, around 250. His cult is attested to in Bithynia in the 5th century.

He is depicted as a giant with a long staff carrying the Christ Child on his back and is invoked against the plague, sudden death, hurricanes, and hail.

PROTECTOR: Car drivers, boatmen, railway workers, mountain climbers, porters, loaders, pilgrims, travelers, athletes, fruit vendors, and gardeners.

NAME: Christopher is from the Greek and means "Christ-bearer."

SAINT CHRISTOPHER
(detail of the Saint Vincent Ferrer Polyptych)
Giovanni Bellini
1472
Santi Giovanni e Paolo, Venice

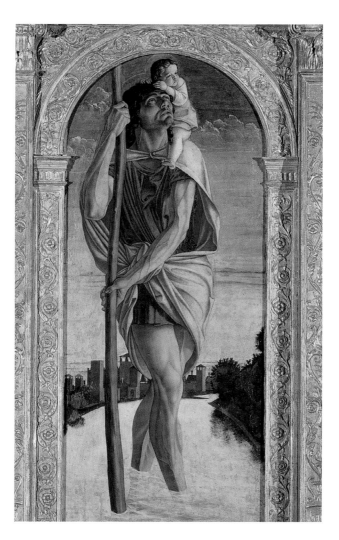

Saints Anne and Joachim

PARENTS OF THE VIRGIN MARY
Memorial

Anne and Joachim, known from apocryphal texts, were the parents of Mary. They were old and childless, but in the end the Omnipotent gave them a child, from whom would be born the Messiah. The cult of Anne is known from the 6th century, that of Joachim from the 14th. The most common image depicts them at the Golden Gate of Jerusalem.

PROTECTORS: Joachim is the protector of grandparents, Anne of sculptors, rag-sellers, lace-makers, launderers, embroiderers, seamstresses, navigators, miners, makers of socks, gloves, and brooms, carders, and gold workers.
NAMES: Both names are of Hebrew origin. Anne means "who has mercy"; Joachim means "God makes strong."

MEETING OF JOACHIM AND ANNE
AT THE GOLDEN GATE
(detail)
Giotto
1304–06
Scrovegni Chapel, Padua

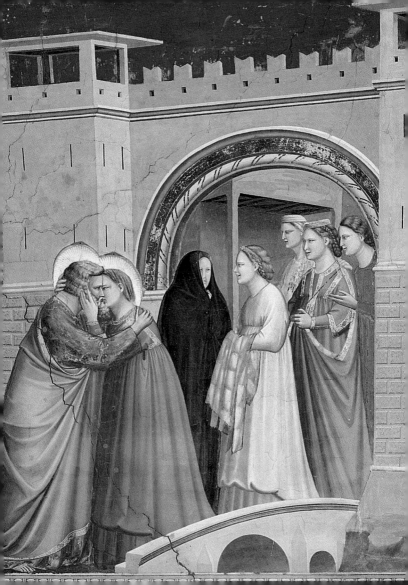

Saint Pantaleon

DOCTOR AND MARTYR

According to a legendary *passio*, Pantaleon, who appears even in the oldest martyrologies, was a doctor so highly respected that he was summoned to the court of the emperor Maximanus early in the 3rd century. He was a native of Nicomedia in Bithynia and had been led to the profession of doctor by his pagan father. He converted to Christianity and opposed the priests of Aesculapius, tending the sick and curing the ailing in the name of Christ. For this he was denounced, tortured in many ways (some sources say six), and finally beheaded.

He is depicted with the attributes of a doctor and is invoked against strabismus.

PROTECTOR: Doctors, wet nurses, and nursing mothers.

NAME: Pantaleon is from the Greek and means "the all-compassionate."

SAINT PANTALEON HEALS A CHILD
Paolo Veronese
16th century
San Pantaleone, Venice

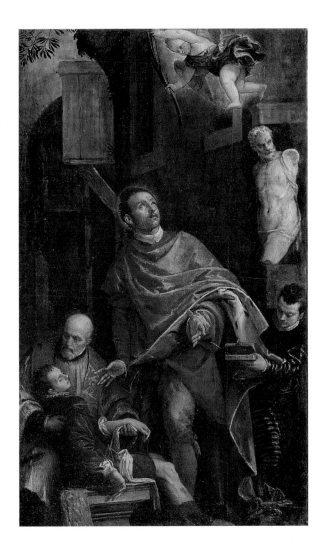

Saints Nazarius and Celsus

MARTYRS

These martyrs have been worshiped in Milan since the miraculous discovery of their relics by Saint Ambrose, in 395. Two new basilicas were founded over their tombs, and the cult spread, notably through the West. They were martyred perhaps in the 1st century, although some legends place them during the persecutions of Diocletian (3rd–4th century). According to that same tradition Celsus was a nine-year-old child baptized by Nazarius, an evangelizer of regions of Gaul. **NAMES:** Nazarius is of Hebrew origin and means "consecrated"; Celsus is from the Latin and means "elevated."

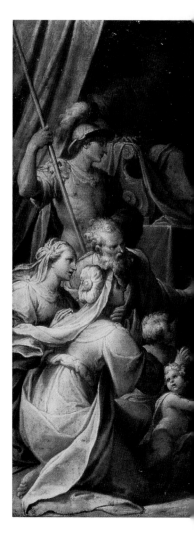

MARTYRDOM OF SAINTS NAZARIUS AND CELSUS
Camillo Procaccini
Circa 1618
Museo Diocesano, Milan

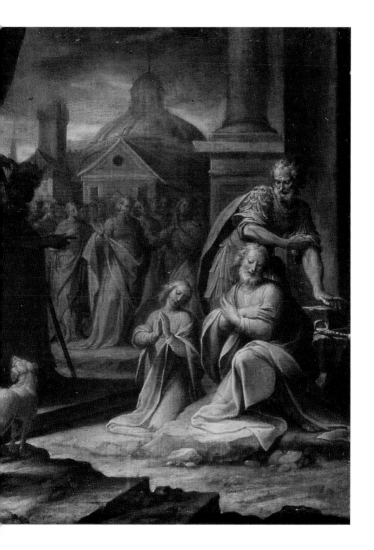

Saint Martha

Memorial

Sister of Lazarus and Mary (traditionally identified as Mary Magdalen), Martha was a disciple of Jesus, who visited her several times in her home in Bethany. The Gospels refer to her three times: the episode of the raising to life of Lazarus; when she complained that Mary, intent on listening to words of Jesus, was not helping with the domestic chores; and just before the Passion, when she and Mary entertained Jesus at dinner. Her cult was born in Provence with the finding of her presumed relics in 1187. She is depicted with a bucket and aspergillum or with utensils for the care of the home.

PROTECTOR: Housewives, maids, servants, cooks, and hospital dieticians.

NAME: Martha is from the Aramaic and means "mistress, lady."

CHRIST IN THE HOME OF MARTHA
AND MARY
Jan Vermeer
Circa 1656
National Gallery of Scotland, Edinburgh
(Martha is the standing figure)

Saints Abdon and Sennen

MARTYRS

Killed together in Rome in the perse-cutions during the reign of Decius in the 3rd century, Abdon and Sennen may have been originally from Persia. They were condemned to be devoured by wild beasts in the amphitheater but succeeded in taming the animals and thus saving themselves from that fate, although they were then beheaded. Their relics, placed in the cemetery of Pontian, were translated by Pope Sixtus IV (in the 15th century) to Rome's church of Saint Mark. They are depicted together, some-times in Oriental dress, with the swords of their martyrdom as their attribute. Abdon is invoked by those fearful of losing their vision.

NAMES: Both names are of Hebrew origin. Abdon means "servile"; Sennen means "treasure of ivory."

SAINTS ABDON AND SENNEN
Jaume Huguet
1459–60
Santo Maria, Tarrasa

Saint Ignatius of Loyola

PRIEST AND FOUNDER • Memorial

Iñigo López was born in the castle of Loyola in the Basque region in 1491. He was brought up to be a soldier but was wounded in battle. During his convalescence he read a life of Christ and a book about the saints, which led to his conversion. He changed his name to Ignatius, spent a long time living as a hermit, and studied philosophy. Together with several followers he took vows of poverty and chastity and promised to serve the Church, eventually founding a new order, the Society of Jesus (Jesuits), which was approved in 1540. He died at Rome in 1556. He is depicted in priestly robes and has his heart pierced by spines and the monogram of Christ (IHS). He is invoked against evildoers and wolves.

PROTECTOR: Jesuits and soldiers.

NAME: Ignatius is from the Roman family name Egnatius, perhaps from the Latin word for "fire."

MIRACLES OF SAINT IGNATIUS
(detail)
Peter Paul Rubens
Circa 1619
Church of the Gesù, Genoa

Saint Alphonsus de' Liguori

**BISHOP AND DOCTOR
OF THE CHURCH • Memorial**

Born near Naples in 1696, Alphonsus began a legal career, but gave it up to dedicate himself to God. He was ordained priest in 1726 and did mission work among the lower classes of Naples. He founded the congregation of the Holy Redeemer, known as the Redemptorists, dedicated to preaching to the rural poor and common people. In 1762, he was named bishop; he died in 1787 and was canonized in 1839. Since 1871 he has been a Doctor of the Church. He is depicted in priest's or episcopal vestments, always in an attitude of prayer.

PROTECTOR: Theologians.
NAME: Alphonsus is from the German and means "valorous, noble."

SAINT ALPHONSUS DE' LIGUORI
Popular sacred image
19th century
Civica Raccolta delle Stampe Bertarelli, Milan

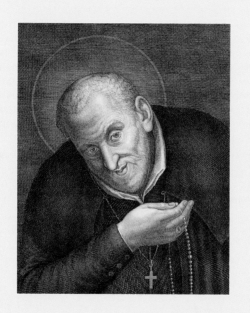

AUGUST 2

Saint Stephen I

POPE

Stephen succeeded Lucius I as pope during the reign of Emperor Valerian. During his three-year pontificate (254–57) he faced the problem of the readmission of the *lapsi*, "lapsed" Christians who had renounced their faith out of fear and now asked to return to the Church. He also dealt with liturgical matters and the question of vestments, ruling that these should be worn only in the Church. On his death he was buried in the Calixtus Cemetery on the Appian Way. Shortly after his death, Emperor Valerian began persecuting Christians, which may be why Stephen is sometimes called a martyr.

Stephen is depicted in papal robes but does not possess any specific attributes.

NAME: Stephen is of Greek origin and means "crowned."

MADONNA AND CHILD WITH SAINTS
(detail)
Pietro da Cortona
1627
Accademia Etrusca, Cortona
(Saint Stephen is the second from the right)

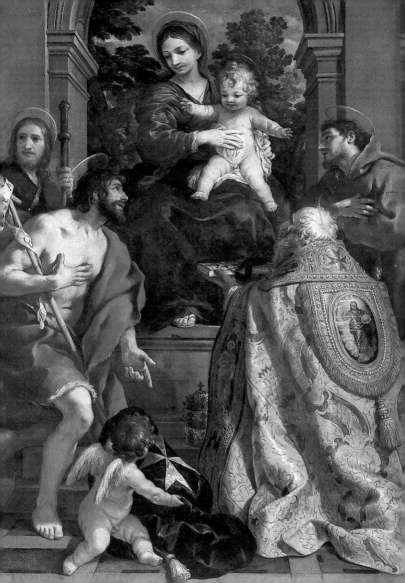

Saint Nicodemus

MEMBER OF THE SANHEDRIN

Nicodemus is cited in the Gospel
of John; member of the Sanhedrin,
he prohibited the arrest of Jesus,
opposing the other Pharisees, and
after the crucifixion he helped Saint
Joseph of Arimathea bury Jesus.
Tradition holds that he was baptized
by the apostles Peter and John and
that he was martyred together with
Stephen. The commemoration falls
on the day of the translation of his
relics.
He is depicted among the figures in
scenes of the Deposition (Descent
from the Cross).
NAME: Nicodemus is of Greek
origin and means "winner among
the people."

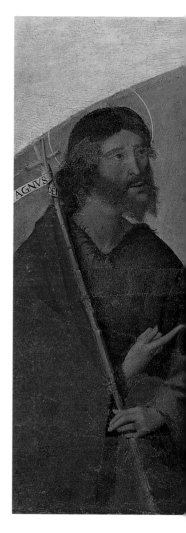

DEAD CHRIST SUPPORTED BY
NICODEMUS, WITH SAINT JOHN
THE BAPTIST AND SAINT LUCY
(detail)
Domenico Panetti
1506
Pinacoteca dell'Accademia dei Concordi,
Rovigo

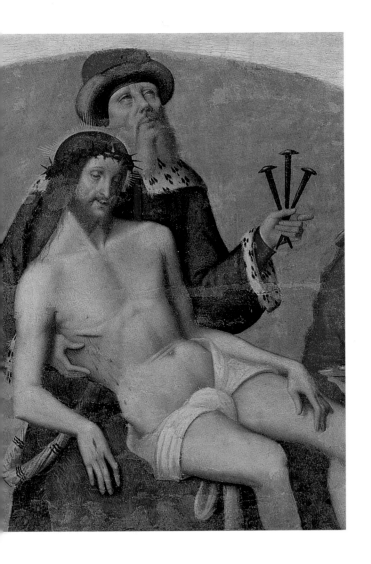

Saint John Vianney

PRIEST • Memorial

Jean-Marie Vianney was born into a peasant family in Dardilly, France, in 1786. With difficulty he reached the ordination of priest at age thirty-two and, in 1818, he was appointed parish priest of Ars-en-Dombes, a remote town that had lapsed in its faith, which he brought back to the Church using only prayer, mortification, and example. The town became a pilgrimage site, where the "holy curate" heard confession for long hours each day. He died in 1859 and was canonized in 1925.

He is often depicted near a confessional with the surplice, the stole, and the cross.

PROTECTOR: Parish priests.

NAME: John is from a Hebrew name meaning "Yahweh is gracious."

SAINT JOHN VIANNEY
Popular sacred image
19th century
Civica Raccolta delle Stampe Bertarelli,
Milan

Dedication of the Basilica of Santa Maria Maggiore

Optional memorial

The basilica of Santa Maria Maggiore on Rome's Esquiline Hill is thought to be the oldest Marian sanctuary in the West; its foundation began in 432, under Pope Sixtus III, who named it for Mary to celebrate the truth recognized by the Council of Ephesus: the solemn proclamation of the Virgin as "Mother of God." In the past, the basilica was also called the Liberian because legend held that the Virgin had appeared in a dream to Pope Liberius (352–66) and to a pair of Roman patricians, telling them to erect a church on the site where the next morning, August 6, they would find snow.

THE FOUNDATION OF
SANTA MARIA MAGGIORE
(central panel of the
Santa Maria Altarpiece)
Masolino da Panicale
1428
Museo Nazionale di Capodimonte, Naples

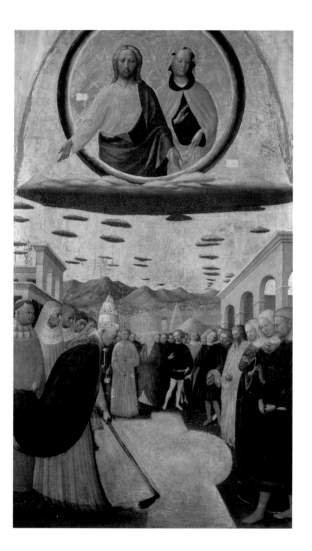

AUGUST 6

Transfiguration of the Lord

FEAST

This evangelical episode narrated by Matthew, Mark, and Luke presents the vision of the glory of Christ, transfigured atop a high mountain (identified as Mount Tabor), where he had gone to pray with Peter, John, and James. Jesus appeared with a luminous face like the sun and his clothes were white and shining. He was in dialog with Moses and Elijah. The glorious manifestation was confirmed by the words of God, speaking from the sky: "This is my beloved son: hear him." The feast is of Eastern origin and entered the universal calendar under Pope Calixtus III in 1457.

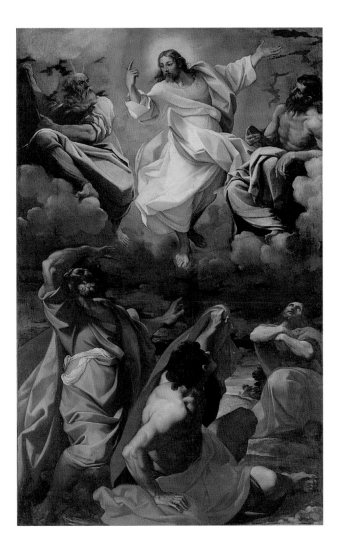

Saint Cajetan

PRIEST • Optional memorial

Tommaso de Vio Cajetan (Gaetano) was born in 1480 at Vicenza, Italy. He studied law at the University of Padua and became a member of the clergy. In an effort to restore to the clergy the values of the authentic apostolic life, he founded a congregation of ecclesiastics, the Theatine Clerks, so-called for their association with the bishop of Chieti, a town whose Latin name is Theate. With the approval of Pope Clement VII, Cajetan founded houses of the congregation at Naples and Venice, promoting charitable works and dedicating himself to his mission among the poor. He died in Naples, in 1547, and was canonized in 1671. He is depicted in the dress of a clergyman; his attribute is a winged heart.

PROTECTOR: The congregation of the Theatines.

NAME: Cajetan is of Latin origin and means "from Gaeta."

MADONNA AND CHILD
WITH SAINT CAJETAN
Andrea Celesti
1690
Palazzo della Carità Apostolica, Brescia

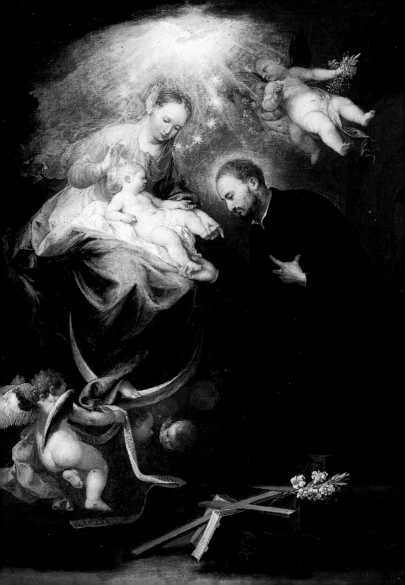

Saint Dominic

PRIEST • Memorial

Dominic was born in Caleruega, Spain, around 1170. In 1204, when he was already one of the canons of Osma Cathedral, he went on a trip with his bishop. At Toulouse he encountered Albigensian heretics and understood the importance of reconciling them with the Church. He then founded the Order of Preachers, once known as the Black Friars and best known as the Dominicans, and dedicated himself to the creation of communities that would be true centers of sacred culture. He died at Bologna, in 1221, and was canonized in 1234. He is depicted in a white habit and black mantle, a star on his forehead, symbol of wisdom, and a lily in his hand; sometimes he is accompanied by a dog bearing a torch in its mouth.

PROTECTOR: Astronomers, orators, and seamstresses.

NAME: Dominic is from the Latin and means "sacred to the Lord."

SAINT DOMINIC
(detail)
Claudio Coello
Circa 1683
Prado, Madrid

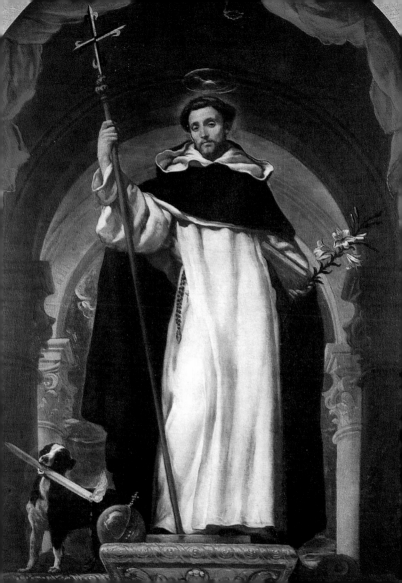

Saint Teresa Benedicta of the Cross

MARTYR • Memorial

Edith Stein was born at Breslau, Poland, in 1891 into a Jewish German family. Although raised in the Jewish tradition, at fourteen Edith declared herself an atheist. She studied philosophy at Göttingen and Freiburg with fine results and was drawn to the Catholic faith; she converted and received baptism in 1922. Her career as a teacher was interrupted by the racist Nuremberg Laws, and she entered the Carmelite convent at Cologne, taking the name Teresa Benedicta of the Cross. In 1942, she was deported to the extermination camp of Auschwitz, where she died in a gas chamber. She was canonized in 1998.
She is depicted in the Carmelite habit.

PATRON: Teresa has been a patron saint of Europe since 1999, along with Saints Brigid of Sweden and Catherine of Siena.

NAME: Teresa is of Greek or German origin; in the first it means "huntress," in the second, "strong and amiable woman."

SAINT TERESA BENEDICTA
OF THE CROSS
Popular sacred image
20th century

Saint Laurence

MARTYR • Feast

According to legend, Laurence was born in Spain and was called by Pope Sixtus II to become a deacon of Rome. When the city prefect ordered him to hand over the Church's valuables, he collected the poor and sick and presented them, saying, "Here is the Church's treasure." He was arrested in 258, during the persecution of Valerian, and was put to death by being roasted on a gridiron. According to tradition, when on the point of death he said to the emperor, "Let my body be turned; one side is broiled enough." And when turned: "It is cooked enough. You may eat!"

He is depicted in a dalmatic, with a book, alms box, the gridiron, and a palm. He is invoked against fires and lumbago.

PROTECTOR: Rotisserie operators, restaurant owners, cooks, librarians, booksellers, pastry chefs, firemen, and glaziers.

NAME: Laurence is from the Latin and means "from Laurentum."

SAINT LAURENCE
Gian Lorenzo Bernini
1618
Galleria degli Uffizi, Florence

Saint Clare of Assisi

VIRGIN • Memorial

Clare was born of a noble family in Assisi, Italy, in 1194. Deeply moved by the acts of Francis of Assisi, she decided to follow his example. She founded the order of the Poor Clares, giving it a rule that was approved in 1228 by Pope Gregory IX and was confirmed by Innocent IV in 1253, the year of Clare's death. She was canonized in 1255.

Clare is depicted in the black-and-brown habit of her order, with the lily, cross, and sometimes the staff of an abbess. Her attribute is a monstrance.

PROTECTOR: Television, embroiderers, launderers, gilders, ironers, and the blind.

NAME: Clare is of Latin origin and means "clear, luminous."

SAINT CLARE
(detail of the lunette of the San Francesco al Monte Altarpiece)
Lorenzo Lotto
1526
Pinacoteca Civica, Jesi

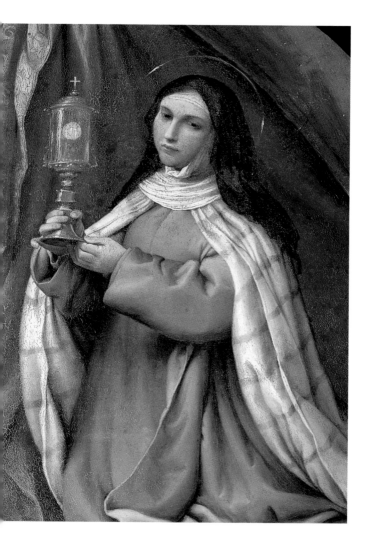

Saint Jane Frances de Chantal

FOUNDRESS • Memorial

Jane was born at Dijon, France, in 1572. At twenty she married Baron Christophe de Chantal, with whom she had six children. Widowed eight years later, she felt the desire to dedicate herself to a religious life. Her confessor was Saint Francis de Sales, who led her to found the Order of the Visitation, named for the Visitation of Saint Mary and dedicated to the assistance of the infirm. She died at Moulins in 1641 after having opened seventy-five houses of the congregation. She was canonized in 1767.
She is depicted in the black habit of the consecrated.

NAMES: Jane *(John)* is from a Hebrew name and means "Yahweh is gracious." Frances *(Frank)* is of German origin, from the name of the people who settled in France; it has come to mean "forthright, sincere."

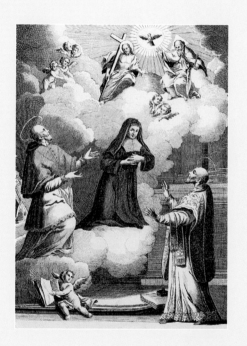

Saint Hippolytus

MARTYR • Optional memorial

Hippolytus was a priest and martyr, together with Pope Pontian, during the reign of Roman Emperor Alexander Severus (222–35). He fell into heresy and was condemned to forced labor, during which he was reconciled with the Church and was martyred. In terms of iconography, his figure has become confused with that of the legendary jailer of Saint Laurence, also known as Hippolytus, and also martyred of the 3rd century, according to *The Golden Legend,* by being torn in pieces by horses. Hippolytus is depicted in the dress of a soldier, holding the bridle and fittings of a horse.

PROTECTOR: Horses and jailers.
NAME: Hippolytus is from the Greek and means "loosed horse."

SAINT HIPPOLYTUS AND SAINT AFRA
(detail of the wing of the polyptych of
Saint Thomas)
Master of the Altar of Saint Bartholomew
1490–1500
Wallraf-Richartz-Museum, Cologne

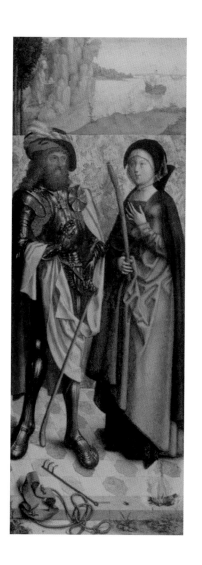

Saint Maximilian Kolbe

PRIEST AND MARTYR
Memorial

Raimund Kolbe was born in Poland in 1894. He studied in the college of the Franciscans in Rome and entered the novitiate with the name Maximilian Maria. Ordained priest in 1918, he founded the Militia of Immaculate Mary for the conversion of men by way of their unconditional dedication to the Virgin Mary, an order that was distinguished for its intense work. He was deported to the concentration camp of Auschwitz, where he offered his life in exchange for that of a man who had a wife and children and died of starvation on August 14, 1941. He was canonized in 1982.

He is depicted in the habit of a minor conventual friar or, sometimes, with the uniform of the deported.

NAME: Maximilian is from the Latin and is composed of words meaning "great" and "competitor."

SAINT MAXIMILIAN KOLBE
Popular sacred image
20th century

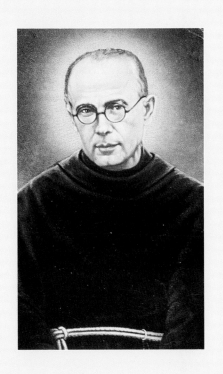

Assumption of the Blessed Virgin Mary

Solemnity

The event of the Assumption directly into Heaven of Mary with her mortal body concludes the earthly events of her life, bearing her to a higher dimension. The Assumption of Mary, as explained in the catechism of the Catholic Church, presents a particular involvement in the Resurrection of Jesus Christ and anticipates the resurrection of all Christians. This concept has been clear since the earliest period of the Church, for which reason it often appears in apocryphal literature; it was defined in dogmatic terms only in 1950 by Pope Pius XII.

THE ASSUMPTION
Titian
1518
Santa Maria Gloriosa dei Frari, Venice

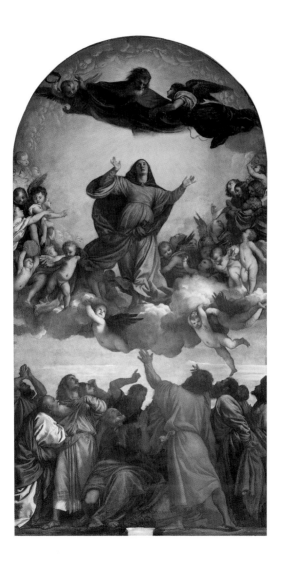

Saint Stephen of Hungary

KING • Optional memorial

Born at Esztergom around 970, Stephen was Hungary's first Catholic king. Despite resistance from the royal court and the remaining pagans, he devoted most of his energies to the political and religious unity of Hungary and summoned many Cistercian missionaries to help in the conversion of the country. His reign obtained the recognition of Pope Sylvester II, who sent him a royal crown so he could be crowned as an "apostolic king" and an example of tireless charity. He died in 1038, and his cult was recognized in 1083.

PATRON: Stephen is the patron saint of Hungary.

NAME: Stephen is of Greek origin and means "crowned."

Saint Roch

HERMIT

Roch (Rock) of Montpellier, France, lived in the 14th century. A hermit, he undertook a pilgrimage to Rome, where he cared for plague victims. On the way home, sick and alone and expecting to die, he was miraculously healed by an angel and nourished by a dog. He died, perhaps in prison, having been arrested as a spy. His cult spread immediately.

He is depicted dressed as a pilgrim and usually lifts his robe to reveal the mark of the plague on his thigh; a dog is usually nearby. He is invoked against the plague.

PROTECTOR: Surgeons, grave-diggers, pharmacists, pavers, pilgrims, travelers, the sick, and prisoners.

NAME: Roch is of Germanic origin with an uncertain meaning.

SAINT ROCH AND THE ANGEL
(detail)
Bartolomeo Vivarini
1480
Sant'Eufemia, Venice

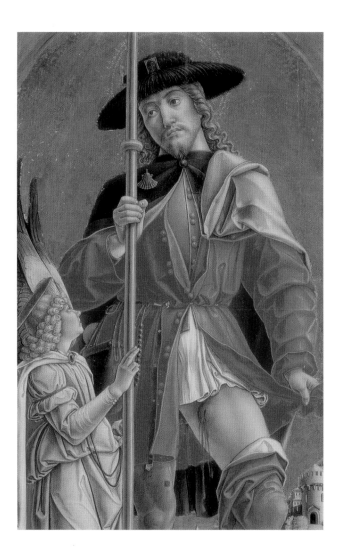

Saint Clare of Montefalco

ABBESS

Born at Montefalco, Italy, in 1268, into a well-to-do family, Clare showed devotion to the Passion of Christ from an early age, and at fifteen withdrew, as had her sister Joan, to a small hermitage. In 1290, this place of withdrawal and prayer became a convent dedicated to the Holy Cross, following the August-inian rule. Clare became its abbess in 1291; she lived in continual penitence and had extraordinary visions. She died with the fame of sanctity in 1308 and was canonized in 1881. She is depicted in the habit of the Dominicans.

NAME: Clare is of Latin origin and means "clear, luminous."

CHRIST APPEARS TO CLARE
OF MONTEFALCO
(detail)
Sebastiano Conca
Circa 1742–51
Sant'Agostino, Rome

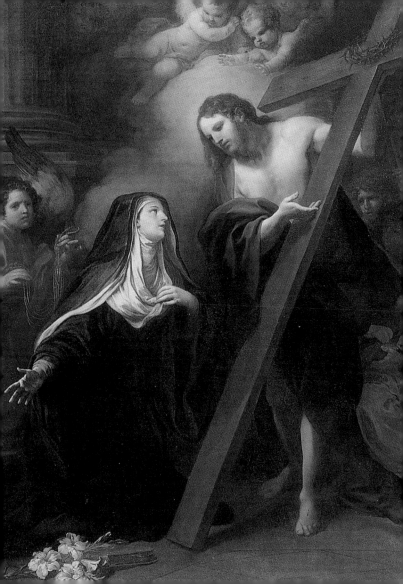

Saint Helen

MOTHER OF CONSTANTINE

Helen (Helena, Ellen), mother of the emperor Constantine, was born in Bithynia, an ancient region of Asia Minor, around 250. Around 312 she converted to Christianity. During a pilgrimage to the Holy Land she found the cross of Christ and ordered construction of the church of the Nativity and the Holy Sepulcher. She died in 330. Saint Ambrose was the first to present Helen's important role in the finding of the true cross.

She is depicted in imperial robes with a cross. She is invoked against storms and fire and by those in search of lost objects.

PROTECTOR: Dyers and makers of needles and nails.

NAME: Helen is from the Greek and means "torch."

SAINT HELENA
(detail)
Cima da Conegliano
Circa 1495
National Gallery of Art, Washington, D.C.

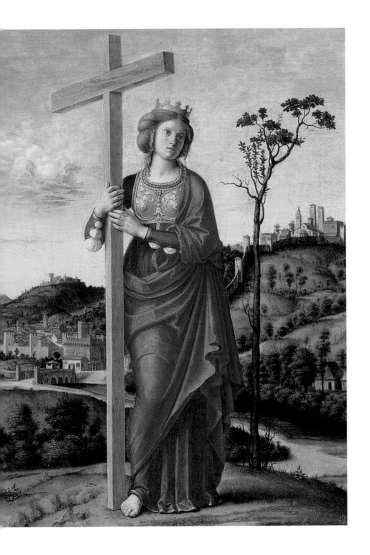

Saint Louis of Anjou

BISHOP

Son of Charles of Anjou, Louis was born in 1274. Heir to the king of Naples, he renounced the throne in favor of his brother in order to embrace the religious life. Ordained priest in 1296, he was made bishop of Toulouse and dedicated himself to the assistance of the poor and needy. He died in 1297 and was canonized in 1317.

He is depicted as a youth, with the vestments of a bishop over the Franciscan habit and with royal attributes, along with the lily of France. He is invoked against nervous breakdowns, lung diseases, and tuberculosis.

NAME: Louis is a French form of the German *Ludwig*, meaning "famous warrior."

SAINT LOUIS OF ANJOU
(detail)
Sebastiano del Piombo
Circa 1508
San Bartolomeo a Rialto, Venice

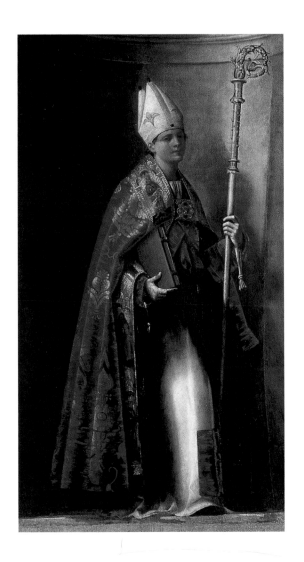

Saint Bernard

ABBOT AND DOCTOR OF THE CHURCH • Memorial

Bernard was born near Dijon, France, in 1090. At twenty-two he entered the Benedictine abbey of Cîteaux, where he founded the Cistercian order. In 1115, he was named abbot of a new monastery at Clairvaux, which gave origin to many other foundations. During his life, he was the most powerful religious influence in Europe, known for his holy life, miraculous cures, and teaching. He died in 1153, and his cult immediately spread.

He is depicted in the white habit of the Cistercians, with an abbot's pastoral staff, a miter at his feet, the host, a chained demon, white dog, a book (since he was a Doctor of the Church), and a beehive, emblematic of his great eloquence (he was known as the "Mellifluous Doctor").

PROTECTOR: Beekeepers, candlemakers, and skiers.

NAME: Bernard is of German origin and means "brave as a bear."

THE VIRGIN APPEARING
TO SAINT BERNARD
(detail)
Filippino Lippi
1486
Badia Fiorentina, Florence

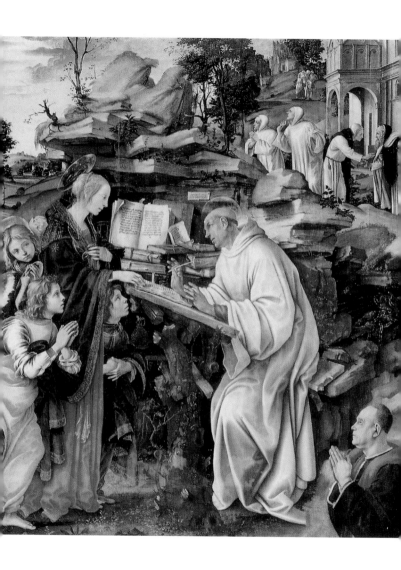

AUGUST 21

Saint Pius X

POPE

Giuseppe Sarto was born near Treviso, Italy, in 1835. A man of humble origins, he became a priest, then bishop of Mantua, and then, in 1893, was elected cardinal and patriarch of Venice. He set in motion the reform of ecclesiastical legislation and promoted Eucharistic communion for children, considering participation in holy mysteries an indispensable basis for a true Christian life. He worked out a new catechism and promoted the liturgical reform of sacred music. He died a few months before the outbreak of World War I, on August 21, 1914. He was beatified in 1951 and canonized in 1954.

NAME: Pius is from the Latin and means "religious, devout."

POPE PIUS X
Anonymous
20th century
Palazzo Braschi, Museo di Roma, Rome

AUGUST 22

Queenship of the Virgin Mary

MEMORIAL

The feast of the Queenship of the Virgin Mary was instituted by Pope Pius XII in 1955 on May 31, as the conclusion to the Marian month. With the reform of the liturgical calendar it was moved a few days from the Assumption, as a conclusion to the earthly events of Mary. Her regality does not imply the possession of the power to dominate but, in accordance with scriptural precedents, is a result of her relationship to Christ as mother and collaborator.

THE VIRGIN MARY
(detail of the Polyptych with the Adoration of the Lamb)
Jan and Hubert van Eyck
1432
Cathedral of St. Bavo, Ghent

Saint Rose of Lima

VIRGIN • Optional memorial

Isabel de Flores y del Oliva, known as Rose, was born at Lima, Peru, in 1586, to parents of Spanish origin. She entered the Dominicans as a tertiary and, since there were no convents in Peru, she kept her vows in a hut in the garden of her home, in a state of destitution and mortification characterized by ecstatic experiences. She died in 1617 and was canonized in 1671, the first person in the Americas to be canonized a saint.

She is depicted as a youth, in the habit of the Dominicans; her attributes are roses and the Christ Child. She is invoked against fever, dropsy, and stomachache.

PROTECTOR: Gardeners and Dominican nuns.

PATRON: Rose is the patron saint of South America and the Philippines.

NAME: Rose is from Latin and indicates the flower.

SAINT ROSE OF LIMA
Bartolomé Esteban Murillo
Circa 1670
Museo Lázaro Galdiano, Madrid

Saint Bartholomew

APOSTLE AND MARTYR • Feast

Apostle of Jesus, identified with Nathanael (Bartholomew is a patronymic), according to *The Roman Martyrology* he preached in India and in Armenia, where he was martyred. *The Golden Legend* relates that he was flayed alive before being crucified.

He is depicted in a tunic and cloak, often with the knife with which he was flayed; in some versions he bears his skin draped over his arm. In Spanish iconography he holds a chained demon.

PROTECTOR: Plasterers, tailors, furriers, binders, butchers, glovemakers, stewards, house painters, and tanners.

PATRON: Bartholomew is the patron of Armenia.

NAME: Bartholomew is from the Aramaic and means "son of Tolmai."

SAINT BARTHOLOMEW
Carlo Crivelli
1475–80
Civiche Raccolte d'Arte Antica,
Castello Sforzesco, Milan

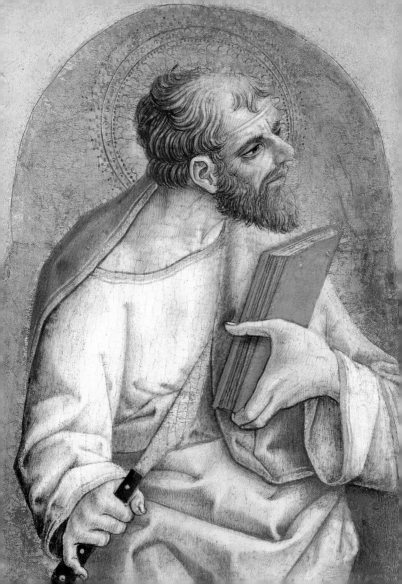

Saint Louis of France

KING • Optional memorial

Son of Louis VIII of France, Louis was born at Poissy in 1214 and ruled with great justice, leading a pious life, in many senses a model of sanctity and a model Christian king. He died of typhoid fever in 1270 at Tunis during the eighth Crusade. His cult began to spread immediately. He is depicted in royal robes with the lily of the French monarchy and has as specific attribute the crown of thorns, a relic that he brought from the Holy Land.

PROTECTOR: Carpenters, barbers, distillers, marble-workers, haberdashers, hairdressers, embroiderers, Franciscan tertiaries, the Military Order of Saint Louis, and the French Academy.

PATRON: Louis IX is the patron saint of France.

NAME: Louis is a French form of the German *Ludwig*, meaning "famous warrior."

SAINT LOUIS
(detail of the Saint Ambrose Polyptych)
Bartolomeo Vivarini
1477
Gallerie dell'Accademia, Venice

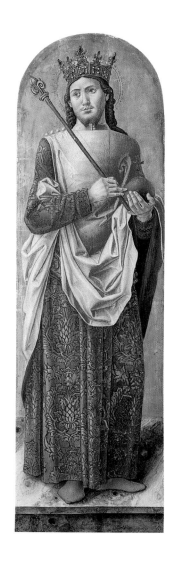

Saint Alexander of Bergamo

MARTYR

Alexander lived between the 3rd and 4th centuries. A Christian soldier, standard bearer of the Theban Legion commanded by Saint Maurice, he fled the massacre of Agaunum in the Valais, taking shelter first at Milan, then at Como, and finally at Bergamo, where he was publicly beheaded in 303 after having preached and brought about many conversions.

He is depicted as a Roman soldier with a standard that bears the white lily of the Theban Legion.

PATRON: Alexander is the patron saint of Bergamo.

NAME: Alexander is of Greek origin and means "protector of men."

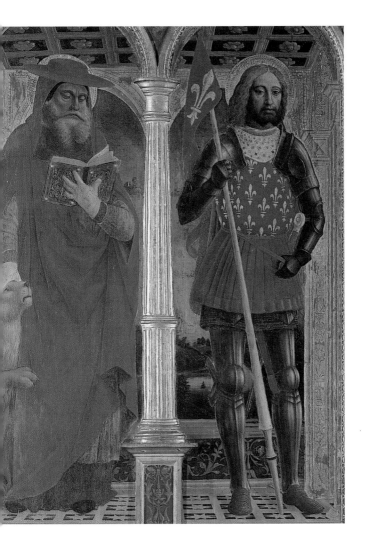

Saint Monica

MOTHER OF SAINT AUGUSTINE
Memorial

Born around 332, Monica was the model Christian mother. Her dissolute and violent husband caused her much suffering, but with patience and dedication she succeeded in bringing him to baptism. She always looked after her son Augustine and after she died at Ostia, in 387, he was baptized. Her cult spread in the 10th century. She is depicted in the black habit of an Augustinian nun; her attributes are the book of the rule and the crucifix. She is invoked as propitiatory of births.
PROTECTOR: Mothers and widows.
NAME: Monica may be of Latin origin with the uncertain meaning of "mother, bride."

SAINT MONICA
(detail)
Alvise Vivarini
1485–90
Gallerie dell'Accademia, Venice

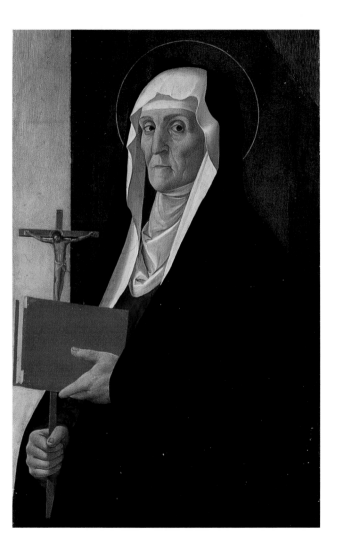

Saint Augustine

**BISHOP AND DOCTOR OF
THE CHURCH • Memorial**

Augustine was born at Thagaste, in what is now Algeria, in 354. He studied rhetoric and philosophy and renounced the Christian faith he had been brought up in to follow the principles of Manichaeism. He taught grammar, rhetoric, and philosophy at Thagaste, Carthage, Rome, and Milan. In Milan, he heard the preaching of bishop Ambrose, who led him to convert and to be baptized in 386. He returned to Africa to live in a religious community in 388, and in 391 he was ordained priest. He became bishop of Hippo in 396. He died in 430. He is depicted in the robes of a bishop, usually busy studying.

PROTECTOR: Printers and theologians.

NAME: Augustine is from the Latin and means "great, venerable."

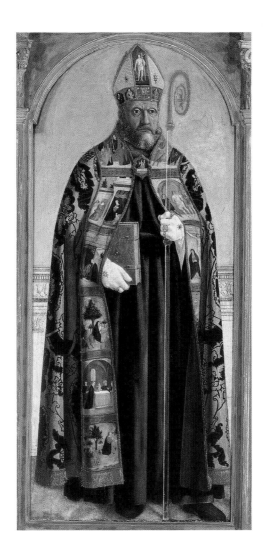

The Passion of John the Baptist

Memorial

John, the forerunner of Christ, ended his life in martyrdom. Preaching and baptizing, he called upon the people to convert. When he strongly rebuked the moral conduct of King Herod Antipas, who lived with Herodias, the wife of his dead brother, the king locked him in the fortress of Machaerus by the Dead Sea. He was beheaded during a banquet during which Herodias's daughter, Salome, danced with such grace that the enchanted king promised to give her anything she asked for. At the instigation of her mother, she asked for John's head on a silver platter. The memory of the martyrdom of Saint John the Baptist has been celebrated since the 5th century.

BEHEADING OF THE BAPTIST
Stefano de' Fedeli
Second half 15th century
Monza Cathedral

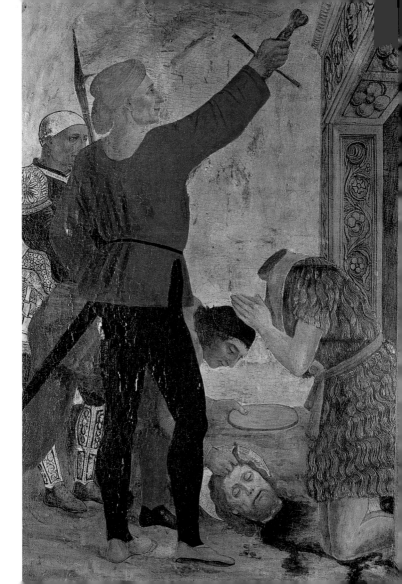

Blessed Ildephonsus Schuster

BISHOP

Born at Rome in 1880, Ildephonsus was ordained priest in 1904 and in 1918 became abbot ordinary of San Paolo fuori le Mura. In 1929, he was made archbishop of Milan. Modeling himself on his great predecessor Saint Charles Borromeo, he showed assiduous and tireless dedication to his pastoral duties. Of greatest importance to him was the defense of the purity of the faith and the salvation of souls. He carried this out by way of pastoral visits, letters, exhortations, and the training of the clergy. He died in 1954 in the seminary of Venegono, the construction of which he had promoted. He was beatified in 1996. He is depicted in episcopal vestments. **NAME:** Ildephonsus is from the ancient German and means "ready for battle."

BLESSED ILDEPHONSUS SCHUSTER
(detail)
Pietro Zegna
1992
Santa Giustina, Milan

512

Saint Abundius of Como

BISHOP

Where Abundius was born is unknown, as is the date of his birth. It seems unlikely that he was a native of Como, Italy, but he was made bishop of that city in 440, after having worked closely with the predecessor, Amanzius. He was part of the papal delegation sent by Pope Leo I to Constantinople to end the long conflict over the nature of Christ awakened by Nestorianism and Eutychianism. On his return to Como, he dedicated himself to his apostolate and to pastoral activities in that area. He died at Como between 469 and 499. He is depicted in episcopal vestments.

PATRON: Abundius is the patron of Como.

NAME: Abundius is from the Latin and means "bountiful."

SAINT ABUNDIUS
(detail of the Saint Abundius Altarpiece)
Giovan Angelo del Maino
1514
Como Cathedral

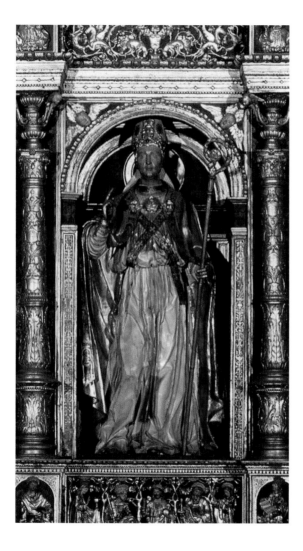

Saint Giles

ABBOT

Giles was probably born in the first half of the 7th century at Athens. He went to Provence and founded a monastery at what is today Saint-Gilles, near Arles. He died there around 710. According to legend, when he first arrived in Provence he lived as a hermit and was nourished by a deer with its milk. One day the deer was pursued by the Gothic king Wamba and his huntsmen. It took refuge in Giles's cave, and when the king shot an arrow at it, the arrow hit Giles instead. To make up for this the king gave him all the surrounding territory, in which Giles made a prosperous community of monks of which he was abbot. Giles was among the most popular saints of the Middle Ages, and his shrine was a place of pilgrimage.

He is depicted in a Benedictine habit with the deer and the arrow. He is invoked against fear.

PROTECTOR: Cripples, lepers, and wet nurses.

NAME: Giles is from the late Latin and means "kid."

SAINTS CHRISTOPHER AND GILES
(detail of the central panel of the
Moreel Triptych)
Hans Memling
1484
Groeningemusuem, Bruges
(Saint Giles is on the right)

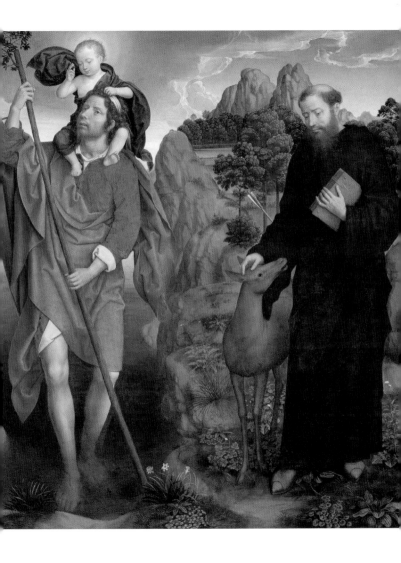

Saint Elpidius

ABBOT

Elpidius lived in the 4th century, probably at Piceno, Italy. What little is known of him is confusing. He may have been a hermit of Jericho or Cappadocia who arrived in Italy. Other sources indicate he was a disciple of Saint Basil. Medieval biographies of this saint are not believable, but the sheer size of the devotion to him seems to confirm his actual existence.

In art, he appears dressed variously as a solider or abbot.

NAME: Elpidius is from the Greek and means "hope."

SAINT ELPIDIUS
(detail of the polyptych of the
Coronation of the Virgin with Saints)
Vittore Crivelli
Second half 15th century
Pinacoteca Civica Vittore Crivelli,
Sant'Elpidio a Mare

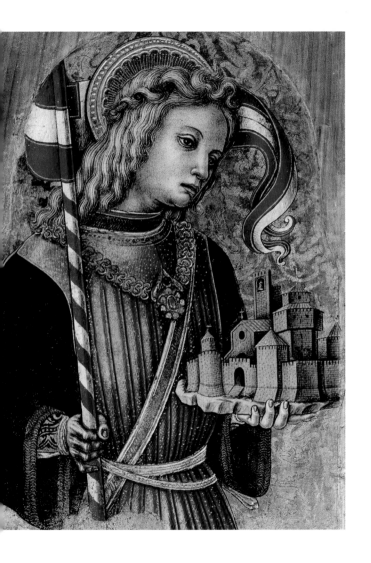

Saint Gregory the Great

POPE AND DOCTOR OF
THE CHURCH • Memorial

Born around 540 into a powerful, aristocratic Roman family, Gregory completed law studies before entering the service of the state. After a few years he chose the monastic life, founding monasteries and dedicating himself to the needy. Made pope in 590, he was active in works of charity and missions. He contributed to the development of the Roman liturgy as well as to church music, most especially Gregorian chant. He left important pastoral, moral, and spiritual works. He died in 604, and his cult spread immediately. He is depicted in papal robes with the dove of inspiration and a book and is invoked against the plague and gout.

PROTECTOR: Musicians, singers, makers of ribbons, braid, and buttons, teachers, and popes.

NAME: Gregory is of Greek origin and means "watchful, alert."

SAINT AUGUSTINE
AND SAINT GREGORY THE GREAT
(detail of the Fathers of the Church Altar)
Michael Pacher
1480
Alte Pinakothek, Munich
(Saint Gregory is on the right)

Saint Rosalia

VIRGIN HERMIT

According to legends, Rosalia was the daughter of Duke Sinibaldus and lived in the 12th century. Perhaps to flee a marriage imposed on her by her father, she lived in penitence and prayer as a virgin hermit in a cave on Mount Pellegrino in Sicily. Her cult, already popular in the 13th century, was greatly revived in the 17th century when her relics were discovered. She is often depicted with a crucifix and a skull and roses, the flowers fitting attributes because of her name. She is invoked against the plague.

PATRON: Rosalia is the patron saint of Palermo.

NAME: Rosalia *(Rose)* is from the Latin and indicates the flower.

MADONNA AND CHILD
ENTHRONED WITH SAINTS
ROSALIA, PETER, AND PAUL
(detail)
Anthony van Dyck
1629
Kunsthistorisches Museum, Vienna

Saint Lorenzo Giustiniani

BISHOP

Lorenzo was born at Venice in 1381 into a noble family. He renounced every privilege and entered the Augustinian monastery of San Giorgio on the isle of Alga. In 1404, he was ordained priest and was later made superior of the monastery. In 1433, he became bishop of Castello, and when the new diocese of Venice was created in 1451,

Lorenzo was its first patriarch. In that post he worked tirelessly for the Church and for spiritual activities, delegating to others all administrative roles. He died in 1455 and was canonized in 1690.
He is depicted in episcopal vestments.
NAME: Lorenzo is of Latin origin and means "from Laurentum."

BLESSED LORENZO GIUSTINIANI
Gentile Bellini
1465
Gallerie dell'Accademia, Venice

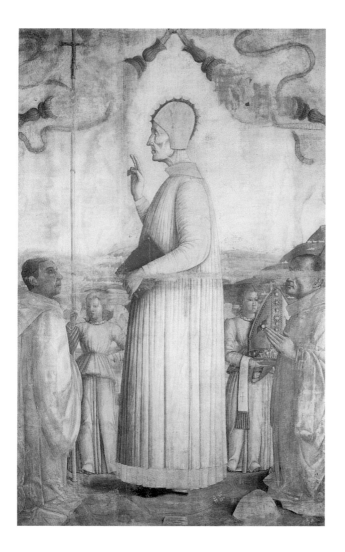

Saint Zechariah

PROPHET

Zechariah, belonging to the tribe of Levi, was born at Galaad in the 6th century B.C. His numerous prophecies and frequent nocturnal visions testify to his mystical union with God. On the return from exile in Egypt, he exhorted the Jews to rebuild the Temple, always demonstrating a passionate love for God and Israel. He was also very active in relations with pagan peoples. He was probably very old when he died and was buried beside the prophet Haggai in Palestine.

He is usually depicted as an elder with a scroll or book.

NAME: Zechariah is from the Aramaic and means "God remembers."

MADONNA OF SAINT ZECHARIAH
(detail)
Parmigianino
1530
Galleria degli Uffizi, Florence

Saint Gratus of Aosta

BISHOP

Gratus was bishop of Aosta, in northern Italy, from 450 to 470. What little is known about him indicates that he almost certainly took part in a provincial council convoked by the bishop of Milan. He was much loved by the faithful and by all the church of Aosta. A biography of him was written in the 13th century, based primarily on legendary elements.

He is depicted in episcopal vestments, sometimes in the act of venerating the head of Saint John the Baptist, and is invoked against lightning, storms, animals that damage crops, and to obtain rain.
PROTECTOR: Vineyards.
PATRON: Gratus is the patron saint of Aosta.
NAME: Gratus is of Latin origin and means "thankful."

SAINT GRATUS OF AOSTA
Popular sacred image
18th century
Civica Raccolta delle Stampe Bertarelli,
Milan

528

SEPTEMBER 8

The Birthday of Our Lady

Feast

The Birth of the Virgin Mary is not narrated in the Gospels, but has been handed down in such apocryphal texts as the Protevangelium of James along with *The Golden Legend*, the source of much iconographic tradition. The celebration of the birthday of the Mother of Christ was introduced in the 7th century by Pope Sergius I, who thus brought to the West a tradition already present in the Eastern Church, and was fixed on September 8. The birth of Mary is the announcement, promise, and preparation for the birth of the Messiah.

BIRTH OF THE VIRGIN
(detail)
Domenico Ghirlandaio
1486–90
Santa Maria Novella, Florence

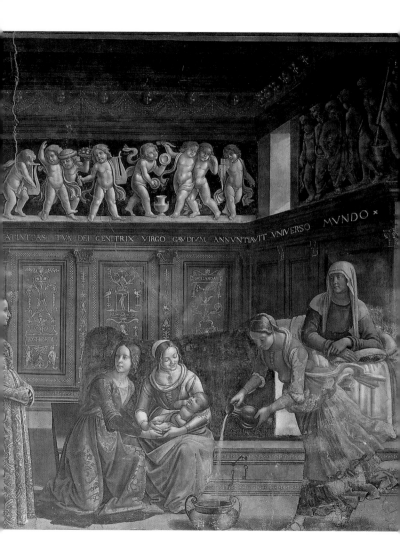

Saint Peter Claver

PRIEST • Optional memorial

Born in Catalonia at Verdú in 1580, Peter studied with the Jesuits, later becoming a Jesuit himself. Before being ordained he set sail for Colombia with the intention of helping the indigenous peoples. At Cartagena he was ordained priest and made a special vow to evangelize and give all possible assistance to the African slaves. For almost forty years he served them, comforting, sustaining, and bringing them food and the word of God. He died of plague at Cartagena in 1654.

He is depicted in Jesuit's robes in the company of slaves.

PROTECTOR: Slaves and missionaries among African peoples.

NAME: Peter is from the Greek and means "rock, stone."

SAINT PETER CLAVER
Popular sacred image
19th century
Civica Raccolta delle Stampe Bertarelli, Milan

Saint Nicholas of Tolentino

PRIEST

Nicholas was born near Fermo, Italy, in 1245. Augustinian friar and preacher, he assisted the outcast and the sick. He settled at Tolentino, not far from his birthplace in the March of Ancona, mediated in the conflict between Guelphs and Ghibellines, and obtained numerous conversions. He died in 1305 and was canonized in 1446.

He is depicted as a youth in the black habit of the Augustinians; his attributes include the flowering lily, a star in the middle of his chest, the book of the rule, and a crucifix. He is invoked against the plague and fevers and for the liberation of souls in Purgatory.

PROTECTOR: The oppressed, infancy, maternity, and Augustinian monks.

NAME: Nicholas is of Greek origin and means "victorious among the people."

Blessed Ludwig IV

LANDGRAVE OF THURINGIA

Born in the year 1200, son of the landgrave of Thuringia, at twenty Ludwig wed Elizabeth of Hungary, with whom he had three children. He was a devoted and exemplary husband, always supporting his wife in her acts of charity and asceticism. He died of malaria at Otranto in 1227, about to set off on the fifth Crusade. Hagiographic sources have exalted his figure as a prince, even attributing several miracles to him. He is depicted together with Elizabeth.

NAME: Ludwig is of German origin and means "famous warrior."

BLESSED LUDWIG IV
LANDGRAVE OF THURINGIA
(detail)
Moritz von Schwind
1853
Staatliche Kunstsammlungen, Weimar

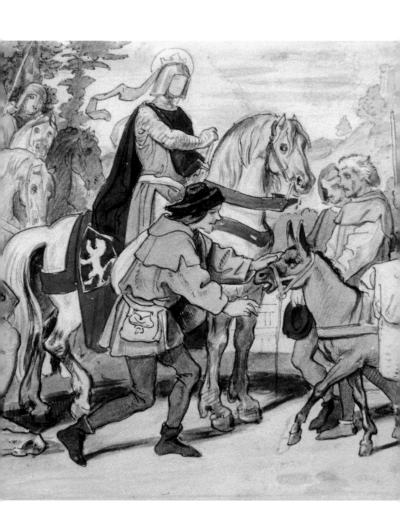

The Holy Name of Mary

Optional memorial

This day was chosen to honor the Holy Name of Mary. The feast was first granted in 1513, but only in the diocese of Cuenca, Spain; it was then suppressed by Pius V and revived by Sixtus V. It was extended to the Kingdom of Naples and Milan in 1671 and became a universal feast on September 12, 1683, at the will of Pope Innocent XI, as thanks for the victory over the Turks who besieged Vienna and threatened Christianity. The feast recalls the significance of Mary, she that is the bearer of light, light that illuminated her soul and that has become the light for many other souls.

MADONNA WITH GREEK INSCRIPTION (MADONNA GRECA)
Giovanni Bellini
1460–64
Pinacoteca di Brera, Milan

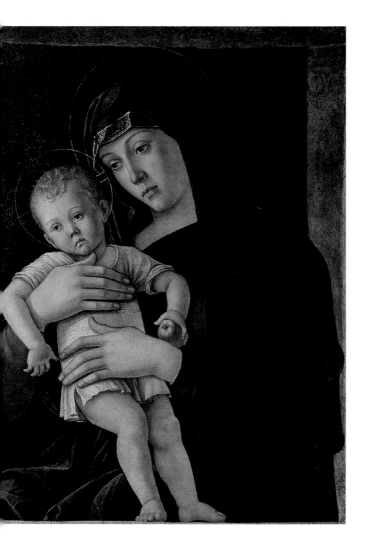

Saint John Chrysostom

**BISHOP AND DOCTOR OF
THE CHURCH • Memorial**

John was born in Antioch around 350. On the death of his mother, he retired for six years to live as a hermit, but so severe was the rule he followed that he got ill and was forced to return to Antioch. In that city he was ordained deacon, then priest, and soon had become a famous and admired preacher. As bishop of Constantinople he proved an intransigent critic of the behavior of the Byzantine court and the arrogance of the powerful. For this reason he ran up against strong opposition and was forced into exile several times. He died at Pontus, on the Black Sea, in 407. Most of the images of him come from the East and depict him in episcopal vestments.

PROTECTOR: Exiles and preachers.

NAME: John is from a Hebrew name meaning "Yahweh is gracious"; Chrysostom is Greek and means "mouth of gold."

SAINT JOHN CHRYSOSTOM
Andrey Rublyov, Daniil Chorny
1408
Tretyakov Gallery, Moscow

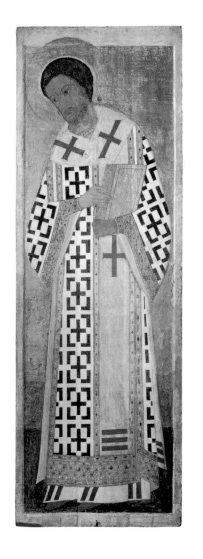

SEPTEMBER 14

Exaltation of the Cross

Feast

This feast is ancient, having been initially celebrated in the East in the 4th century. It was adopted in the West about three centuries later and commemorates the recovery of the precious relic of the cross on which Jesus died. The exaltation of the agony that led to the death of Christ and that permitted Christ's glorification involves an element of irony that was difficult for the early Christians to comprehend. From the instrument used in that most infamous death, the cross has been transformed into a symbol of the Christian faith. In early images the cross is shown gemmed and shining, not so much a means of death as a sign of undying glory.

EXALTATION OF THE CROSS
(detail from the *Legend of the True Cross*)
Piero della Francesca
1452–62
Main chapel, San Francesco, Arezzo

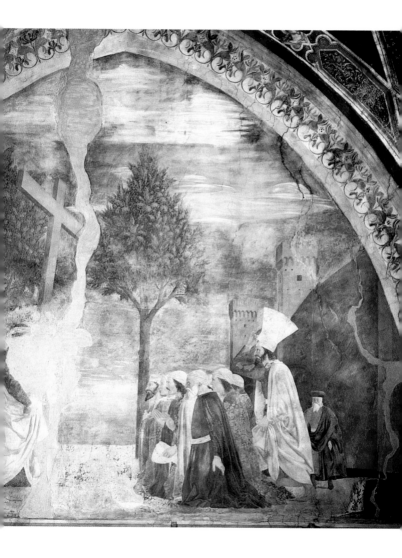

Our Lady of Sorrows

Memorial

The cult of Our Lady of Sorrows is of devotional origin. In all probability it derives from the sacred depictions of Holy Week. It was introduced to the Roman calendar during relatively recent times, in 1814, by Pope Pius VII. The veneration of Our Lady of Sorrows is associated with the Passion of Christ and the maternity of Mary, which assumes universal dimensions when associated with the cross of Jesus.

In depictions of Our Lady of Sorrows, the Virgin is presented pierced in her chest by one or seven swords; sometimes her heart is visible.

SORROWING VIRGIN
José de Mora
Second half 17th century
Church of La Victoria, Osuna

544

Saints Cornelius Pope and Cyprian Bishop

Memorial

Cornelius and Cyprian lived in constant communion without ever meeting. Cornelius was pope, elected in 251. Opposed by dissident priests, he had the support of Cyprian, bishop of Carthage, who authoritatively defended his legitimacy. In 253, during the persecution ordered by the Emperor Gallus, Cornelius was exiled to Civitavecchia, where he died, while Cyprian died a martyr under Valerian in 258.

Cornelius is depicted in papal robes, sometimes with a horn; Cyprian, invoked against the plague, is depicted in episcopal vestments with the palm.

PROTECTOR: Cornelius is protector of bovines.

NAMES: Both names are of Latin origin. Cornelius is from the name of the Cornelia family; Cyprian means "of Cyprus."

SAINTS ANTHONY ABBOT, CORNELIUS, AND CYPRIAN WITH A PAGE
(detail)
Paolo Veronese
1567
Pinacoteca di Brera, Milan
(Saint Cornelius is at the center top; Saint Cyprian is to the right)

Saint Hildegard of Bingen

ABBESS

Hildegard was born at Bermersheim, Germany, in 1098. She was a Benedictine nun and mystic. Abbess from 1136, she founded several monasteries, including that of Rupersberg, near Bingen, where she lived a long time and died, in 1179. She left an enormous literary production related to her visions, as well as commentaries on the Gospels, the rule of Saint Benedict, and the lives of various saints. Her treatise *Liber Scivias* (*sci vias Domini:* "know the ways of the Lord"), a collection of revelations, was approved by the pope with the support of Saint Bernard.

In traditional iconography she is depicted as a Benedictine nun writing.

PROTECTOR: Esperantists and philologists.

NAME: Hildegard is from the German and means "fearless in battle."

THE INSPIRATION OF SAINT HILDEGARD OF BINGEN
(detail)
Woodcut from the *Legend of Saint Hildegard*
1524

Saint Joseph of Copertino

PRIEST

Joseph Desa was born at Copertino, Italy, in 1603. He was taken into religious life by Franciscan conventual friars at Grottella in 1625, and in 1628 he was ordained priest. The intense desire for union with Christ manifested itself in ecstatic moments and episodes of levitation that aroused suspicions in the Inquisition. The Holy Office tried him in 1634 and in the end declared him innocent. He died at Osimo in the Marches in 1663 and was canonized in 1767. He is depicted in flight, in the habit of the conventual friars.

PROTECTOR: Aeronautics, astronauts, candidates for examinations, and students.

NAME: Joseph is from the Hebrew and means "he will add."

SAINT JOSEPH OF COPERTINO IN
ECTASY ON SEEING THE SANCTUARY
OF LORETO
(detail)
Ludovico Mazzanti
1754
Basilica of the Sanctuary of Saint Joseph of Copertino, Osimo

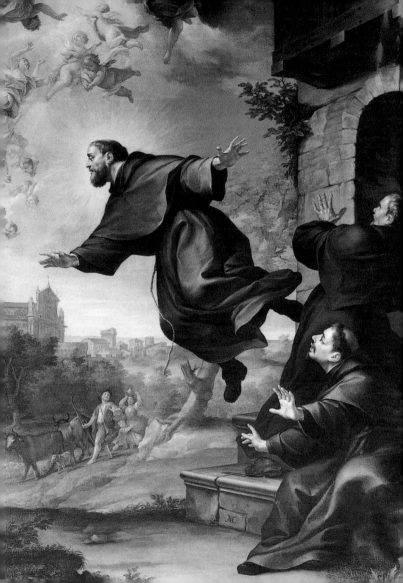

SEPTEMBER 19

Saint Januarius

BISHOP AND MARTYR • Optional memorial

Januarius (Gennaro) was born in the 3rd century in Naples or Benevento, where he was bishop. During the persecutions of 303 he was condemned to be torn apart by lions, but the beasts spared him. He was then thrown into a flaming furnace but exited unscathed. So he was beheaded. His blood was saved in two vials. His cult dates to the 5th century. He is depicted in episcopal vestments with the palm, vials, and lions and is invoked against eruptions of Mount Vesuvius.

PROTECTOR: Blood donors and goldsmiths.

PATRON: Januarius is the patron saint of Naples.

NAME: Januarius is of Latin origin and means "January," the month dedicated to the god Janus.

THE GLORY OF SAINT JANUARIUS
Battistello Caracciolo
1632
Certosa di San Martino, Naples

Martyrs of Korea

MARTYRS • Memorial

Andrew Kim Taegon was born in 1881 into a Christian family. At fifteen he went to China, where he was ordained priest. He returned clandestinely to Korea (Korea's first native priest) and was discovered, arrested, and beheaded in 1846. Paul Chong Hasang was a heroic Korean layperson. Born in 1795, he saw his father and brother die as martyrs. His family was deprived of all its possessions, and he shared the prison and persecution. He was beheaded for his faith in 1839. Andrew and Paul, together with another 101 Korean martyrs, were canonized in 1984.

Saint Eustace

MARTYR

Eustace was a Roman general of the 3rd century, originally named Placidas. According to legend, during a hunt he saw a stag with a luminous crucifix between its antlers, which said to him, "I am Jesus who you honor without knowing it." He converted and was baptized, taking the name Eustace. He was tortured in many ways, finally suffering the fate of being roasted inside a bronze bull. He is depicted in the dress of a nobleman together with the stag with a crucifix between its horns. He is invoked against fire.

PROTECTOR: Forest rangers, hunters, and those in difficult situations.

NAME: Eustace is from the Greek and means "fruitful."

VISION OF SAINT EUSTACE
(detail)
Pisanello
Circa 1430
National Gallery, London

SEPTEMBER 21

Saint Matthew

APOSTLE AND EVANGELIST
Feast

Matthew (Levi, according to Mark and Luke) was a Jew who worked for the Romans as tax collector and as such was disliked by the population. Jesus saw him while he was seated in the customs house and called to him. Matthew gave up everything and followed. He wrote his Gospel during the second half of the 1st century, probably in Syria, where he went to evangelize the local population. According to apocryphal sources, he died a martyr in Ethiopia.

He is depicted while writing his Gospel, inspired by an angel. His attributes are the book and the halberd, the instrument of his martyrdom.

PROTECTOR: Bankers, tax collectors, accountants, and bookkeepers.

NAME: Matthew is of Hebrew origin and means "gift of God."

SAINT MATTHEW INSPIRED
BY THE ANGEL
Rembrandt
1661
Louvre, Paris

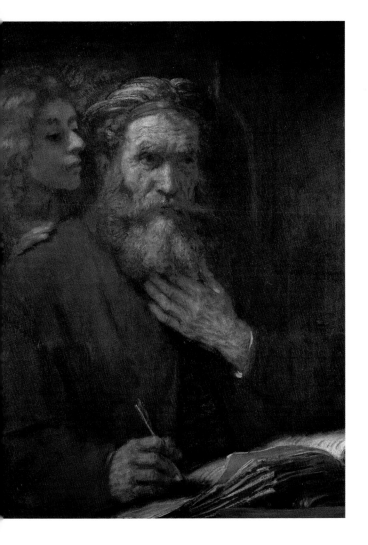

Saint Maurice

MARTYR

Maurice was commander of the Theban Legion. The legion crossed the Valais region during a persecution ordered by Diocletian at the beginning of the 4th century, and Maurice was martyred with six thousand of his soldiers when they refused to sacrifice to the gods near Agaunum (today's Saint Moritz). His cult spread at first in Switzerland, most of all in the Valais canton.

He is represented, sometimes as a black African, in the dress of a soldier, with a standard, sword, and palm, and is invoked by those sick with gout.

PROTECTOR: Mountain climbers, soldiers, Swiss Guards, weavers, and dyers.

NAME: Maurice is of Latin origin and means "from Mauritania."

SAINTS ERASMUS AND MAURICE
Matthis Grünewald
1525
Alte Pinakothek, Munich
(Saint Maurice is on the right in the foreground)

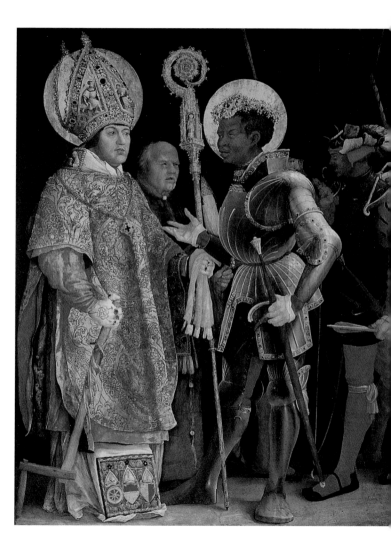

Saint Pius of Pietreclina

CAPUCHIN • Memorial

Francesco Forgione was born at Pietreclina, northeast of Naples, in 1887. He became a Capuchin in 1903, choosing to call himself Pius (Fra Pio: he is famous as Padre Pio). Ordained priest in 1910, in 1916 he was transferred to the convent of San Giovanni Rotondo, where he spent the rest of his life. He was active in caring for the needy and revealed gifts as a miracle worker. He received the stigmata in 1918, sign of communion with the Passion of Christ. He died in 1968 and was canonized in 2002.

He is depicted in the habit of a Capuchin friar.

NAME: Pius is from the Latin and means "religious, devout."

Saint Thecla of Iconium

MARTYR

Thecla was probably a Jew converted to Christianity by Saint Paul, of whom she then became a disciple. The certainty of her historical existence is based on the fact that her cult was widespread even in the most ancient times. The events of her martyrdom are surrounded by numerous apocryphal versions that agree that she miraculously escaped death several times. She is depicted in the robes of a martyr, with the palm, sometimes with lions at her feet, and is invoked by those sick of bone cancer.

NAME: Thecla is of Greek origin and means "shining."

SAINT THECLA FREES ESTE
FROM THE PLAGUE
(detail)
Giambattista Tiepolo
1759
Este Cathedral

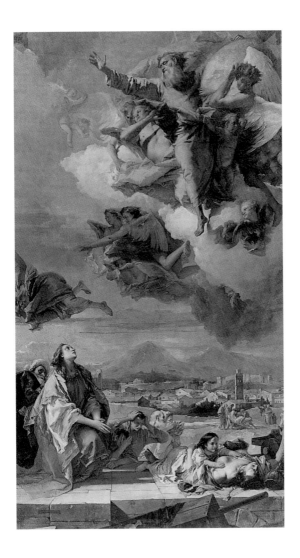

Saint Gerard of Csanad

APOSTLE OF HUNGARY

Born in Venice to a Dalmatian family around 980, he was baptized with the name George. When he entered the Benedictine monastery of San Giorgio Maggiore he chose to call himself Gerard in memory of his father, who had only recently died. After several years, he left on a pilgrimage to the Holy Land, but having reached the seaport of Zadar, in Croatia, he traveled instead to Hungary. King Stephen I (Saint Stephen) welcomed him, and he gave up his intention to become a hermit and instead evangelized Csanad and became its first bishop. He was killed at Pest, on the right bank of the Danube, in 1046; his cult was approved in 1083.

He is depicted in episcopal vestments.

NAME: Gerard is from the ancient German and means "strong lance."

TRIUMPH OF SAINT GERARD
Gerolamo Pellegrini
1674
San Francesco della Vigna, Venice

Saint Nicholas of Flüe

HERMIT

Nicholas was born in the Swiss region of Obwalden, in 1417. The married father of ten children, he lived as a devout Christian until, after twenty years of matrimony, he felt called to the life of a hermit, which he undertook with his wife's consent. He took up residence in a cell built for him in a ravine at Ranft, and for many years ate only communion wafers. He preached peace and was involved in the achievement of Swiss unity, for which reason he came to be called *"pater patriae."* He was also known as Brother Klaus. He was canonized in 1947.

He is depicted in the dress of a mountain hermit.

PATRON: Nicholas is the patron saint of Switzerland.

NAME: Nicholas is of Greek origin and means "victorious among the people."

THE HERMIT NICHOLAS OF FLÜE
Popular sacred image
1860

Saints Cosmas and Damian

MARTYRS • Optional memorial

The brothers Cosmas and Damian lived in Cilicia (southern Turkey) between the 3rd and 4th centuries. Both brothers were doctors who treated the sick without asking payment, and both died as martyrs during the persecution of Emperor Diocletian. Their cult had immediate diffusion, in part because several people who had invoked them experienced miraculous cures.

They are always depicted together, with containers of drugs and medical instruments. They are invoked against the plague, glandular inflammations, kidney problems, gallstones, and distemper.

PROTECTORS: Doctors, surgeons, dentists, pharmacists, midwives, barbers, and hairdressers.

NAMES: Both names are from the Greek. Cosmas means "well ordered"; Damian means "tamer."

MADONNA WITH FOUR SAINTS (MEDICI MADONNA)
Rogier van der Weyden
1450–51
Städelsches Kunstinstitut, Frankfurt
(Saints Cosmas and Damian are on the right)

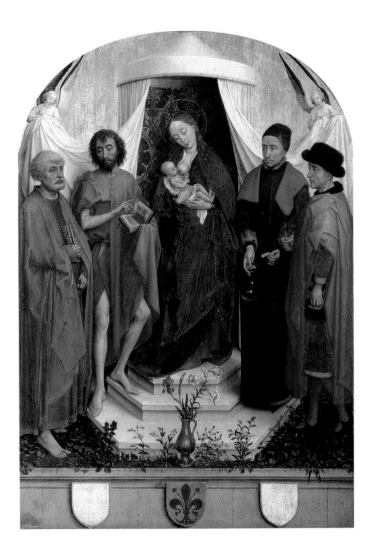

Saint Vincent de Paul

PRIEST • Memorial

Born in 1581 at Pouy, near Dax, in Gascony, he was ordained priest at age nineteen. He dedicated his long life to tireless works of charity, caring for the poor and the suffering. He taught numerous helpers and founded the congregation of the Priests of the Mission, called Lazarists or Vincentians, and together with Saint Louise de Marillac founded the Sisters of Charity. He died at Paris in 1660 and was canonized in 1737.

He is often depicted in black habit and mantle, black skullcap, and is shown most often with the poor. In some cases he wears a surplice and alb.

PROTECTOR: Charitable groups.

NAME: Vincent is from the Latin and means "victorious."

SAINT VINCENT DE PAUL
Andrea Pozzi
1820
San Giuseppe, Lendinara

SEPTEMBER 28

Saint Wenceslaus

MARTYR • Optional memorial

Son of the duke of Bohemia,
Wenceslaus was born around 907
and was educated in Christianity by
his grandmother, Saint Ludmila. In
921, he succeeded his father and
struggled for freedom of worship
against the pagan nobility and his
brother Boleslas. He led a pious life.
He escaped an ambush set by his
brother but was murdered in 929.
He was immediately venerated as
a saint and was canonized in the
next century.
PROTECTOR: Brewers, prisoners,
and altar boys.
PATRON: Wenceslaus is the patron
of the Czech Republic and Poland.
NAME: Wenceslaus is from the
Polish and means "greater glory."

**SAINTS VITUS, WENCESLAUS,
AND SIGISMUND**
School of Prague
1385
Staatsgalerie, Stuttgart
(Saint Wenceslaus is at the center)

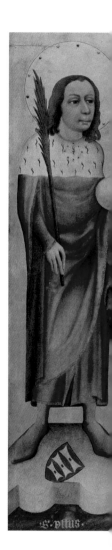

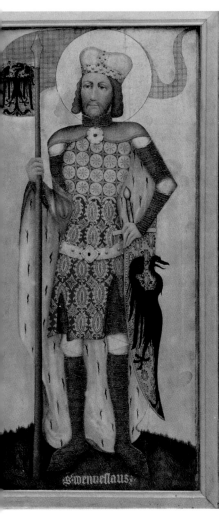

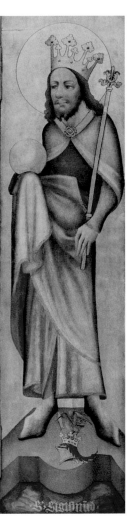

§wenceslaus·

§·Sigismud·

Saints Michael, Gabriel, and Raphael

ARCHANGELS • Feast

Three archangels are cited in the canonical texts: Michael is the leader of the celestial ranks and the conqueror of Satan; Gabriel, the divine herald, announces the birth of John to Zacharias and that of Jesus to Mary; Raphael accompanies Tobias on his journey. Michael is depicted as a warrior, often holding scales, and is invoked for a good death; Gabriel is depicted with a lily; Raphael usually appears with Tobias.

PROTECTORS: Gabriel of postal workers, ambassadors, newsvendors, and couriers; Raphael of the blind and adolescents; Michael of grocers, paratroopers, and police.

NAMES: All are of Hebrew origin. Michael means "who is like God?"; Gabriel means "force of God"; Raphael "God has healed."

THE THREE ARCHANGELS
Francesco Botticini
Circa 1470
Galleria degli Uffizi, Florence

572

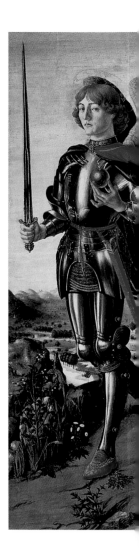

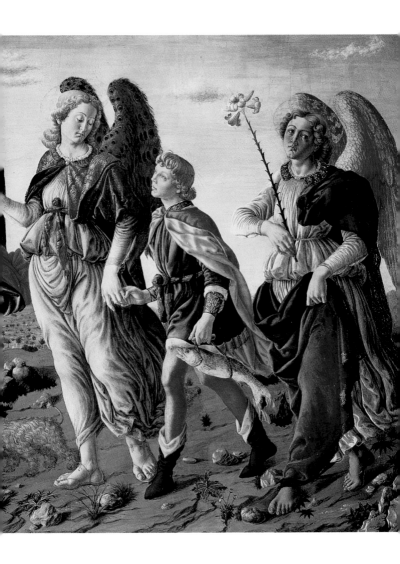

Saint Jerome

**PRIEST AND DOCTOR OF
THE CHURCH • Memorial**

Born in Dalmatia around 347, he studied at Rome, Aquileia, and Trier. Shortly after his baptism in 366 he chose the religious life, becoming a monk and hermit. He wrote the Vulgate, the Latin translation of the Bible, originally requested by Pope Damasus. He retired to a monastery at Bethlehem, where he died in 420, nearly eighty years in age. Sometimes he is depicted half-naked and striking his chest with a stone while contemplating a crucifix; sometimes he is shown reading or writing, wearing a cardinal's robes. His attributes include the lion, skull, and book. He is invoked by those with failing eyesight.

PROTECTOR: The learned, students, archaeologists, book sellers, pilgrims, librarians, and translators.

NAME: Jerome is of Greek origin and means "sacred name."

SAINT JEROME
(detail of the Gualdo Tadino Polyptych)
Girolamo di Giovanni
Mid-15th century
Pinacoteca di Brera, Milan

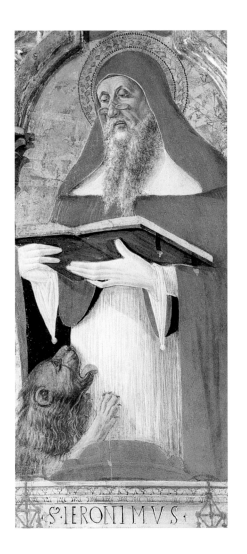

S·IERONIMVS·

Saint Thérèse of Lisieux

Saint Bavo of Ghent

VIRGIN AND DOCTOR OF THE CHURCH • Memorial

Thérèse Martin was born at Alençon, France, in 1873. From an early age she decided to dedicate herself fully to God and at sixteen entered the Carmelite convent of Lisieux, where two of her sisters already lived. On the directions of her superior, she began writing a diary of her child-hood, which became *The Story of a Soul* and reflects a spirituality characterized by simplicity and faith in the love and mercy of God. She fell ill in 1895 and died two years later.
PROTECTOR: Missions.
NAME: Thérèse is of Greek or German origin; in the first it means "huntress," in the second, "strong and amiable woman."

HERMIT

Bavo (Allowin) was born in 589 into a noble family of the Brabant in the Low Countries. He abandoned a life of ease and dissolute behavior to serve the poor and to preach. In the end he turned to the life of the hermit, setting up home in a hollow tree in the forest near Ghent. He died around 659.
In art, he is sometimes depicted in the clothes of a hermit near a hollow tree, along with the stone he used as a pillow; or, to indicate his noble birth, he is dressed as a nobleman with sword and falcon. He is invoked against whooping-cough and rheumatism.
NAME: Bavo is from the ancient German and means "from Bavaria."

SAINT BAVO
(detail of the external wings of the triptych of the Last Judgment)
Hieronymus Bosch
Circa 1510
Gemäldegalerie der Akademie der Bildenden Künste, Vienna

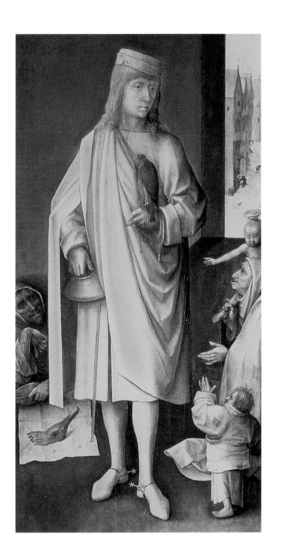

Guardian Angels

Memorial

According to biblical sources (Job, Tobias, Matthew), every human being is accompanied from birth to death by an angel who protects, advises, and intercedes. The insertion of this feast in the calendar, promoted by Pope Paul V in 1615, favored the spread of a particular devotion. Initially celebrated September 29, it was moved to October 2 by Pope Clement X in 1670.

The iconography of this memorial shows an angel taking a child by the hand, teaching a child to pray, pointing to the sky, or protecting the child with a shield from the snares and deceits of demons.

GUARDIAN ANGEL
Filippo Vitale
Circa 1617
Church of the Pietà dei Turchini, Naples

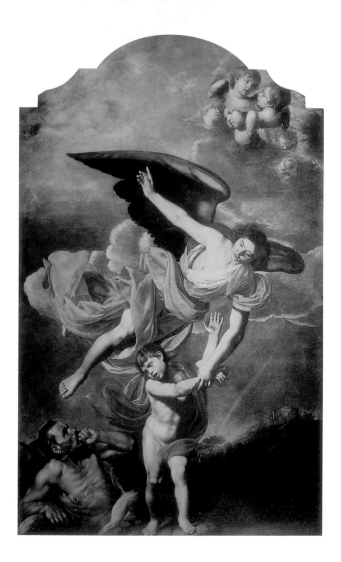

Saint Dionysius the Areopagite

DISCIPLE OF SAINT PAUL

Dionysius was known as the Areopagite because he was a member of the Areopagus, the tribunal of Athens, and was among the few that converted after hearing Saint Paul. Later sources indicate that he was the first bishop of Athens. According to *The Roman Martyrology*, he suffered many torments during the persecution under Hadrian. He died around 95. Rarely depicted in art, he sometimes appears in narrations of events in the life of Saint Paul. He then appears in episcopal vestments.

NAME: Dionysius means "from Dionysius."

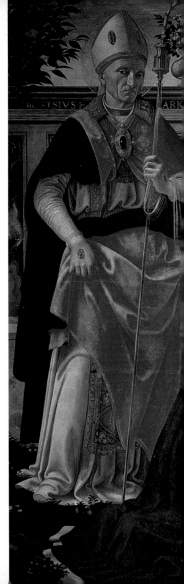

MADONNA AND CHILD, ANGELS, AND SAINTS
(detail)
Domenico Ghirlandaio
Circa 1480
Galleria degli Uffizi, Florence
(Saint Dionysius is at the lower right)

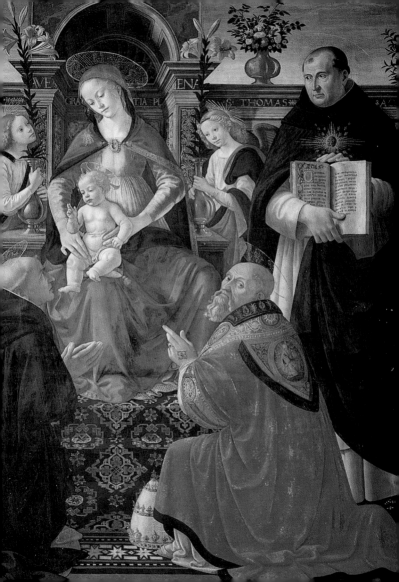

Saint Francis of Assisi

CONFESSOR • Feast

Son of a merchant, Francis was born at Assisi, Italy, in 1181. He spent a carefree, easygoing youth, dreaming of becoming a soldier, but after a vision he gave up everything to follow God in poverty. In 1208, he began preaching penitence, dressed in sackcloth and living from begging; he was soon joined by his first companions. He founded the order of Friars Minor, approved by Pope Innocent III. In 1224, he received the stigmata. Sick and nearly blind, he composed the *Canticle of the Sun.*

He died on October 3, 1226, and was canonized in 1228.

He is depicted with a brown habit and a cord at his waist and often reveals the stigmata.

PROTECTOR: Merchants, rope-makers, ecologists, florists, traders, upholsterers, and poets.

PATRON: Francis is the patron saint of Italy.

NAME: Francis *(Frank)* is of German origin, from the name of the people who settled in France; it has come to mean "forthright, sincere."

THE SERMON TO THE BIRDS
(detail)
Giotto
1297–1300
Upper Basilica of St. Francis, Assisi

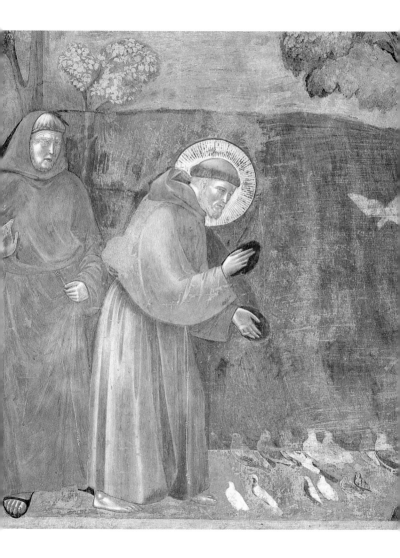

Saint Placid

MONK

Placid, the son of a Roman patrician, lived in the 6th century. Together with Maurus, he was a disciple of Saint Benedict. Gregory the Great relates that Maurus saved Placid from drowning (walking on water to do so) and that Placid was an obedient, even exemplary disciple. According to a late, unfounded tradition, Placid died in Sicily, martyred by Saracens. Placid is depicted as a youth in the Benedictine habit (black, or white if reformed), sometimes with a palm branch.

PROTECTOR: Novices and the shipwrecked.

NAME: Placid is from the Latin and means "sweet, docile."

SAINT BENEDICT BLESSES MAURUS AND MAURUS SAVES PLACID FROM DROWNING
(from *Stories from the Legend of Saint Benedict*)
Spinello Aretino
1390
San Miniato al Monte, Florence

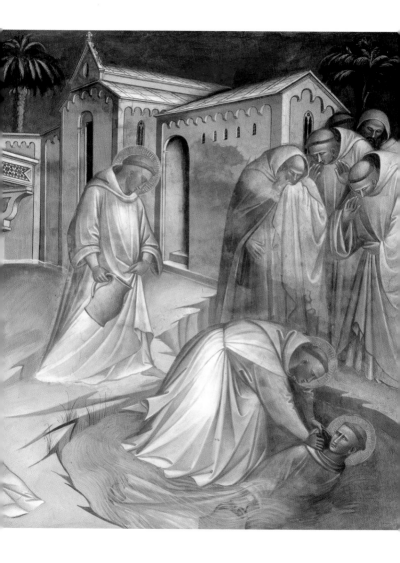

Saint Bruno

PRIEST AND MONK • Optional memorial

Bruno was born at Cologne around 1032. First a canon, he became a monk and then, encouraged by Hugh of Grenoble, he founded the order of Carthusian monks at Chartreuse (which gives its name to their monasteries; in English it becomes *charterhouse*). He died in Calabria in 1101. His cult was extended to the entire church in 1674.

He is depicted in the white Carthusian habit while treading upon a globe, a sign of his disdain for worldly things. He can have a shaft of the cross sprouting green leaves; seven stars; or a miter at this feet. He is invoked against the plague.

PROTECTOR: The order of the Carthusians.

PATRON: Bruno is the patron saint of Cologne.

NAME: Bruno is of Germanic origin and means "brown in color."

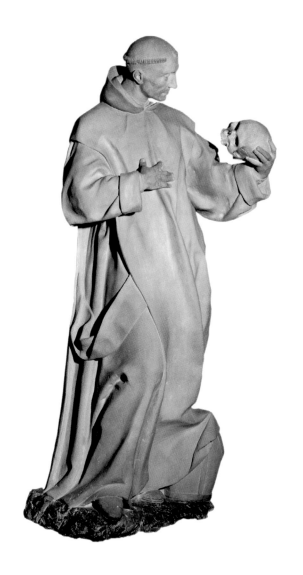

Our Lady of the Rosary

Memorial

This feast was instituted following the Christian victory over the Turks at the battle of Lepanto, on October 7, 1571, which occurred while the Confraternity of the Rosary was celebrating a solemn procession in the streets of Rome. Pope Pius V attributed the victory to the intercession of the Virgin, "Mary, succor of Christians," for which reason the feast was celebrated for many years with the name Our Lady of the Victory.

The image of the Blessed Virgin of the Rosary presents Mary and the Child, who is giving the rosary to Saint Dominic or other saints. The word *rosary*, with its reference to roses, comes from the floral homage offered in honor of the Virgin.

APPARITION OF THE VIRGIN
TO SAINT DOMINIC AND
MYSTERIES OF THE ROSARY
Guido Reni
1596
Sanctuary of the Madonna of San Luca,
Bologna

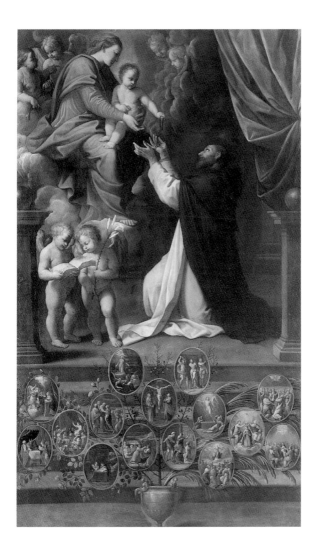

Saint Palatias

MARTYR

Palatias was martyred during the persecution of Diocletian, between the 3rd and 4th centuries. The existence of the saint, whose life is strictly tied to that of her slave, Laurentia, is attested by a very ancient cult and by the veneration of relics translated from Fermo, where she died, to Ancona. The details of her story, quite similar to that of other virgin martyrs, blend elements from the hagiographic literature of her *passio* with literary motifs from the period.
She is usually depicted in prayer.
NAME: Palatias is from the Latin and means "inhabitant of Palatium."

SAINT PALATIAS
(detail)
Guercino
1658
Pinacoteca Civica "Francesco Podesti,"
Ancona

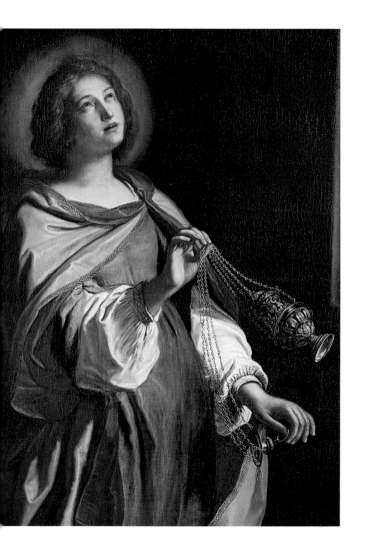

Saint Denis

BISHOP AND MARTYR • Optional memorial

Denis (Dionysius) was born early in the 3rd century, probably in Italy, where he was made priest and bishop. He was later sent to preach in Gaul, together with two companions, the priest Rusticus and the deacon Eleutherius. On their arrival in Paris, they set up a Christian center on an island in the Seine, but they were persecuted, imprisoned, and ultimately beheaded, their bodies thrown in the river, around 250, under Emperor Decius. The cult of Denis enjoyed great popularity in the 9th century.

He is depicted in episcopal vestments holding his head in his hands and is invoked again migraines.

NAME: Denis *(Dionysius)* is of Greek origin and means "from Dionysius."

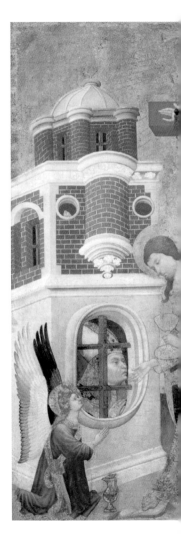

STORIES OF SAINT DENIS
(detail)
Henri Bellechose
1416
Louvre, Paris

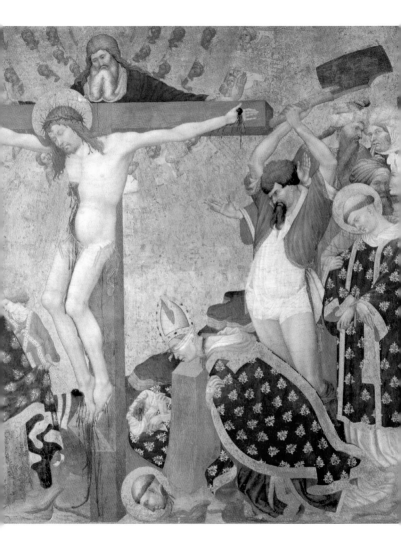

Saints Sarah and Abraham

SAINT ABRAHAM, PATRIARCH, AND SAINT SARAH, WIFE OF ABRAHAM

The patriarch Abraham, to whom God promised descendents as numerous as the stars in the sky or the grains of sand, and his wife Sarah are recalled together. When advanced in years they became the parents, as promised, to Isaac. Rarely depicted as separate figures, they are often inserted in biblical narrations as protagonists.

PROTECTOR: Abraham is the protector of hosts.

NAMES: Both names are of Hebrew origin. Abraham means "great father," and Sarah means "princess."

ABRAHAM AND THE ANGELS
(detail)
5th century
Santa Maria Maggiore, Rome

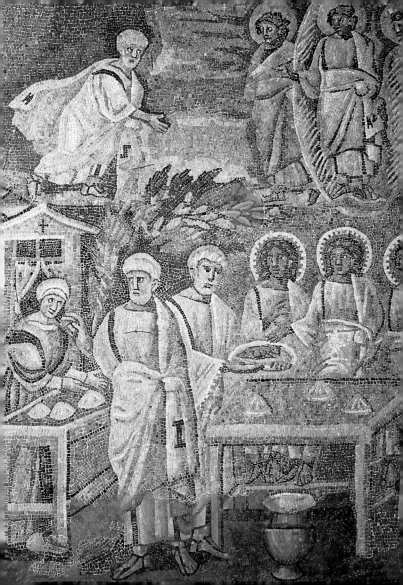

Saint Francis Borgia

PRIEST

Born in Spain in 1510, Francis was a member of the famous Borgia family. At the death of his wife, he resigned his duchy and joined the Jesuits. The "duke turned Jesuit," he was a popular preacher and wrote texts on spirituality. Elected general of the order, he promoted the first missions to the New World. He died in 1572 and was canonized in 1671.

He is depicted in a priest's cassock or in the dress of the regular clergy and is invoked against earthquakes.

PATRON: Francis Borgia is the patron of Spain and Portugal.

NAME: Francis *(Frank)* is of German origin, from the name of the people who settled in France; it has come to mean "forthright, sincere."

SAINT FRANCIS BORGIA AND
THE DYING IMPENITENT
Francisco Goya
1788
Valencia Cathedral

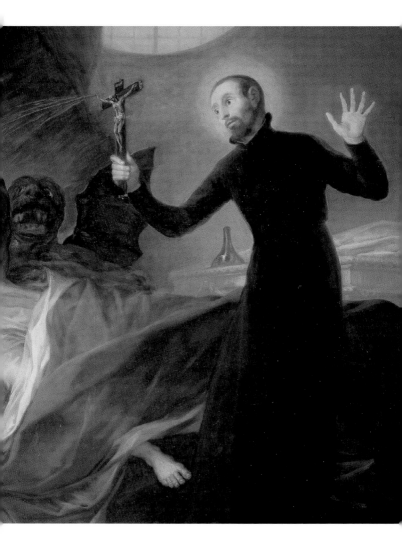

Blessed John XXIII

POPE

Angelo Giuseppe Roncalli was born at Sotto il Monte, near Bergamo, Italy, in 1881. Ordained priest at twenty-two, he spent a decade as secretary to the bishop of Bergamo. In 1925, he was sent as apostolic visitor to Bulgaria and remained there ten years. He then served as apostolic delegate in Turkey and Greece until 1944. At the end of the Second World War he was papal nuncio in Paris and later patriarch of Venice. In 1958, he was elected pope. He labored for peace and to hold the Second Vatican Council, the purpose of which was to find the best ways to fit traditional doctrine to modern realities. He died on June 3, 1963, and was beatified in 2000. NAME: John is from a Hebrew name meaning "Yahweh is gracious."

POPE JOHN
Giacomo Manzù
1963
Museo Artistico "G. Manzù," Ardea

Our Lady of the Pillar

Feast

This Spanish feast celebrates the appearance of the Virgin Mary to Saint James the Greater. According to tradition supported by 12th-century literature, the apostle who evangelized Spain was at the Ebro River, near Saragossa, when Mary appeared to him above a pillar or column and asked him to build a church atop the pillar. Thus rose, at the initiation of Saint James, the first Marian sanctuary on the Iberian peninsula.

In art, the scene presents Mary seated on a pillar in front of the apostle James.

THE VIRGIN APPEARS TO JAMES THE GREATER
(detail)
Nicolas Poussin
1629
Louvre, Paris

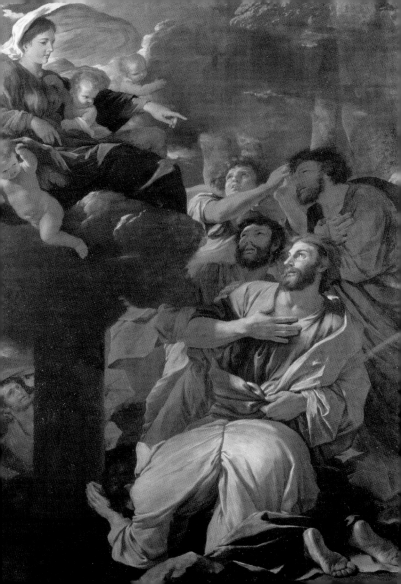

Saint Petka

HERMIT

Petka (Paraskeva) is especially venerated in Slavic lands. She probably lived in the 10th century. Her birthplace was Epibata, near Constantinople. She spent a period in a convent, but soon left it, yearning for the life of a hermit. After several years she experienced a revelation and left the hermitage to return to Epibata and live as a penitent. Miraculous events occurred following her death, and when her body was discovered it emanated a sweet perfume. The later translation of her relics gave origin to her cult.

She is depicted holding a jar of perfume and the cross.

NAME: Petka is of Greek origin and means "preparation."

SAINT PETKA
Popular sacred image
20th century

Saint Calixtus I

POPE • Optional memorial

Calixtus was born a Christian slave, the property of a man named Carpophorus, also a Christian. For certain crimes, he was sentenced to hard labor in Sardinia, but was later freed and ransomed by the Christian community. Pope Zephyrinus called him to Rome to look after the Christian cemetery near the catacombs, later known as the Calixtus Cemetery. He became deacon and was elected pope in 217. He made important contributions to doctrinal matters but was accused of laxity. He died a martyr, probably during a popular uprising, in 222.

He is depicted in papal robes.

NAME: Calixtus is from the Greek and means "beautiful."

INNOCENT II, SAINT LAURENCE, AND SAINT CALIXTUS
(detail)
Anonymous
12th century
Santa Maria in Trastevere, Rome
(Saint Calixtus I is on the right)

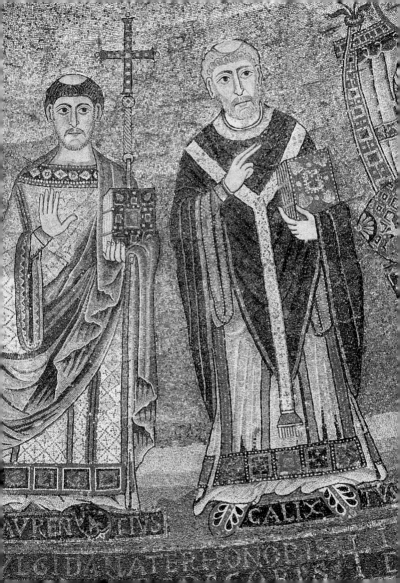

AVRENTIVS CALIX
ALGIDAPATER HONOBIS

Saint Theresa of Avila

**VIRGIN AND DOCTOR OF
THE CHURCH • Memorial**

Teresa de Cepeda y Ahumada was born in Avila in 1515. Educated by Augustinian nuns, at twenty she entered the Carmelite convent of her native city. Her writings tell of her mystical experiences and ecstatic visions. She reformed the Carmelite order and died in 1582. She was named a Doctor of the Church in 1970 by Pope Paul VII, the first woman so honored.

She is depicted in the habit of the Carmelites, with an arrow in her chest, a heart with the name of Jesus (IHS), and a dove. She is invoked to bring relief to souls in Purgatory and against heart diseases.

PROTECTOR: The Carmelites.
PATRON: Theresa of Avila is the patron saint of Spain.
NAME: Theresa is of Greek or German origin. In the first case it means "huntress," in the second "strong and amiable woman."

MADONNA AND CHILD,
SAINT ANDREW CORSINI, SAINT
THERESA OF AVILA, AND SAINT MARY
MAGDALEN DEI PAZZI
(detail)
Guido Cagnacci
1630
San Giovanni Battista, Rimini

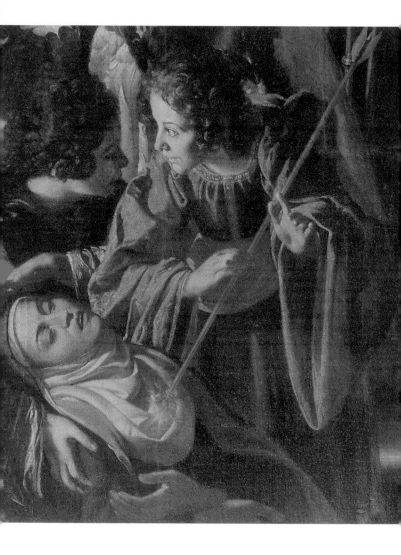

Saint Hedwig

DUCHESS

Born in 1174, daughter of Berthold IV, duke of Carinthia, in 1186, only twelve, Hedwig married Henry I, duke of Silesia. She sought peace in all ways, dealing fairly with both her family (she was forced to mitigate the rivalry among her sons) and her subjects. The poor and the imprisoned received her special care. She lived as a penitent, in poverty, with prayer, fasts, and mortifications. In 1209, she retired to the Cistercian abbey of Trebnitz, which she had founded, and after the death of her husband (1238) she took the Cistercian habit. She died in 1243 and was canonized by Pope Clement IV in 1267.

She is depicted with royal attributes and the habit of a nun.

NAME: Hedwig is of Germanic origin and means "holy battle."

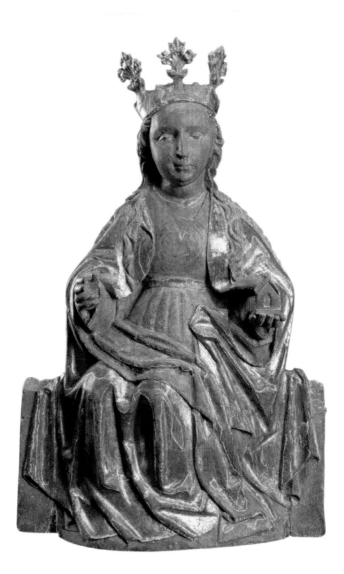

Saint Ignatius of Antioch

BISHOP AND MARTYR • Memorial

Of Syrian origin, Ignatius probably converted to Christianity when an adult. He became bishop of Antioch. During the persecution under Trajan he was arrested and condemned to die at Rome. During the long journey from Antioch to Rome he wrote seven letters to the Christian communities he passed, advising and encouraging them. In Rome, he was thrown to the lions in the Colosseum and torn to pieces.

He is depicted in episcopal vestments with a wounded heart.

NAME: Ignatius is from the Roman family name Egnatius, perhaps from the Latin word for "fire."

MADONNA AND CHILD, IGNATIUS OF ANTIOCH, AND SAINT ONUPHRIUS
(detail)
Lorenzo Lotto
1508
Galleria Borghese, Rome

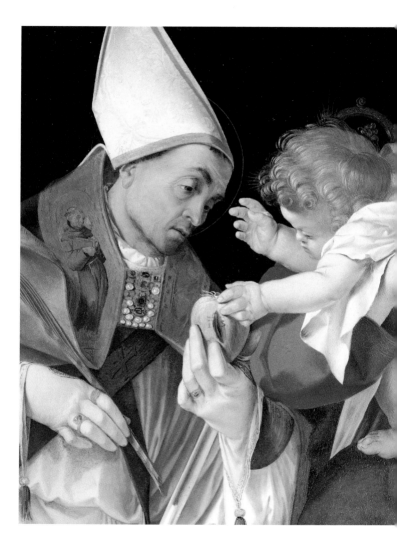

Saint Luke Evangelist

Feast

Luke wrote the third Gospel as well as the Acts of the Apostles. A Greek physician who converted to christianity, he was part of the community at Antioch and accompanied Saint Paul on some of his missionary journeys. In his Gospel, characterized by parables of charity, much attention is given to the infancy of Jesus, perhaps as the result of direct testimony from Mary.

Luke is depicted while writing his Gospel or painting the portrait of the Virgin Mary; his attribute is the winged ox.

PROTECTOR: Physicians, surgeons, gilders, glaziers, illuminators, notaries, writers, and artists.

NAME: Luke is from the Latin and means "from Lucania."

SAINT LUKE DRAWING THE VIRGIN
(detail)
Rogier van der Weyden
1435–38
Museum of Fine Arts, Boston

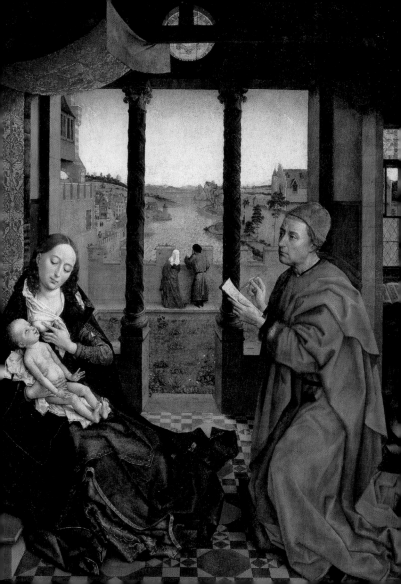

Saint Peter of Alcántara

FRANCISCAN REFORMER

Peter was born in Spain in the small town of Alcántara in 1499. During studies at the University of Salamanca, he was drawn to the religious life and entered the Franciscan order. He lived the rule with great austerity and founded a reform branch of strict observance, later called the Alcantarines, approved by the pope in 1562.

He knew and supported Saint Theresa of Avila. He died at Las Arenas, in 1562, and was canonized in 1669. He is depicted in a Franciscan habit and is invoked against malignant fevers.

PROTECTOR: Nightwatchmen.

NAME: Peter is from the Greek and means "rock, stone."

SAINT PETER OF ALCÁNTARA, SAINT JEROME WITH THE ANGEL, AND ANOTHER FRANCISCAN SAINT
Giovan Battista Pittoni
1725–27
National Gallery of Scotland, Edinburgh
(Saint Peter of Alcántara is at lower left)

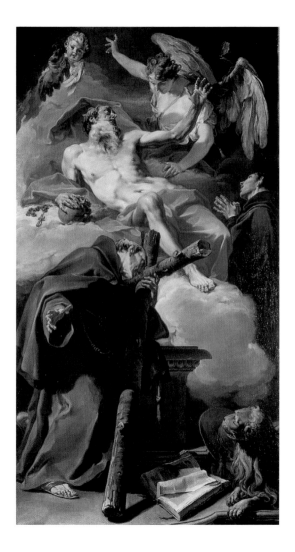

Saint Cornelius

CENTURION

Cornelius lived in the 1st century, is cited in the Acts of the Apostles, and was traditionally the first bishop of Caesarea in Palestine. A Roman centurion, a pious and devout man, he was living at Caesarea when he had a vision: while praying, an angel told him to send some of his men to find a certain Simon called Peter. He did so, and the apostle Peter came to his home to pray. Cornelius and his family experienced a new Pentecost with Peter; the Holy Spirit descended on them, and they were baptized with water. Here began the conversion of the Gentiles, the pagans who did not belong to the Hebrew people but were welcome in the Christian Church. Cornelius in turn became an evangelizer and suffered much for his faith.

NAME: Cornelius is from the Latin family name Cornelia.

SAINT PETER BAPTIZES THE
CENTURION CORNELIUS
(detail)
Francesco Trevisani
1709
Pinacoteca Civica, Jesi

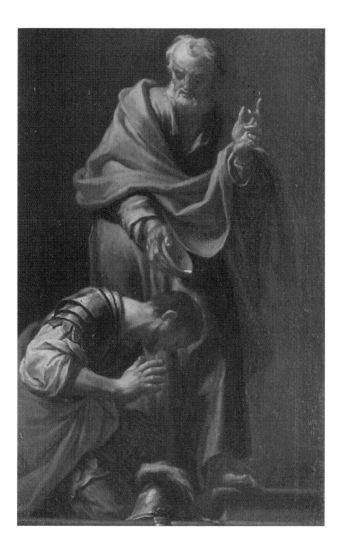

Saint Ursula

MARTYR

The Breton princess Ursula lived in the 4th century. Although sworn to God, she accepted marriage with a pagan prince on condition that he convert. *The Golden Legend* relates that she was killed by Huns at Cologne together with the eleven thousand virgins who had accompanied her on a pilgrimage to Rome. Her cult was particularly popular during the Middle Ages.

She is depicted in royal robes, with such attributes as the palm, the arrow that killed her, a standard, and a boat. She is often depicted with a broad cloak under which she protects her companions. She is invoked for a happy marriage, a good death, and against burns.
PROTECTOR: Girls and students.
NAME: Ursula is from the Latin and means "strong."

URSULA AND HER COMPANIONS
Moretto da Brescia
16th century
Civiche Raccolte d'Arte Antica, Castello Sforzesco, Milan

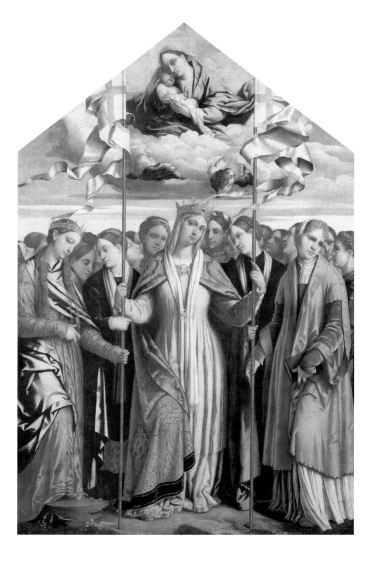

Saint Mary Salome

MOTHER OF THE APOSTLES JAMES AND JOHN

Mary Salome was one of the women that followed Jesus. The wife of Zebedee, she may have been a cousin of Mary and was the mother of James the Greater and John. The evangelist Matthew recalls that Mary Salome asked Jesus to have her sons sit to his right and left in Paradise. Mark cites her twice during the Passion: she was among the women who witnessed the crucifixion from a distance and was also among those who, on the morning of the day of Easter, went to the tomb with perfumed unguents. She is depicted in scenes of the Deposition and the Resurrection.

NAMES: Mary is from the Egyptian and means "beloved"; in Hebrew (from Miriam) it means "lady." Salome is Aramaic and means "happy."

SAINT MARY SALOME
(detail of the *Lamentation on the Dead Christ*)
Nicolò dell'Arca
1485
Santa Maria della Vita, Bologna

Saint John of Capestrano

PRIEST • Optional memorial

John was born at Capestrano, Italy, in 1386. He began a brilliant legal career but was shut in prison for political reasons. This sad experience at least gave him time in which to meditate, and he decided to enter the Friars Minor, which he did in 1415. He proved a great preacher, most especially among university students. He organized the Franciscan Observant Friars and was called "the apostle of Europe" thanks to his constant preaching in Italy, the Holy Land, the Low Countries, Austria, Germany, Poland, Hungary, and Moravia. He died in 1456 and was canonized in 1690.

He is depicted in a Franciscan habit with a small cross and usually carries a standard.

PROTECTOR: Jurists.

NAME: John is from a Hebrew name meaning "Yahweh is gracious."

SAINT JOHN OF CAPESTRANO
AND STORIES OF HIS LIFE
(detail)
Master of Saint John of Capestrano
Circa 1465
Museo d'Arte Nazionale d'Abruzzo, Aquila

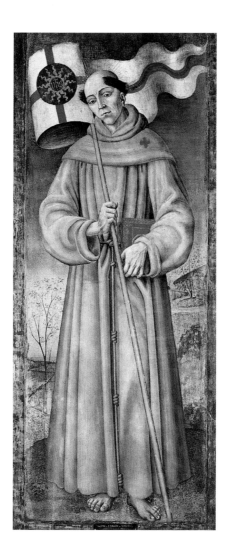

Saint Anthony Mary Claret

BISHOP • Optional memorial

Anthony was born at Sallent in northern Spain in 1807. As a child he helped his father in his trade as a weaver. The local priest taught him Latin. He entered a seminary in 1829 and was ordained priest in 1835. Health problems prevented him from choosing the missionary life, but he founded a congregation of preachers for popular missions, the Missionary Sons of the Immaculate Heart of Mary, commonly called the Claretians. In 1849, he was made archbishop of Santiago in Cuba, where he was opposed by the slave owners and suffered numerous attempts on his life. He returned to Spain and became the confessor of Queen Isabella II, following her into exile after the revolution of 1868. He died two years later in France, at Fontroide. He was canonized in 1950. **NAME:** Anthony is from the Roman family name Antonius.

SAINT ANTHONY MARY CLARET
(detail)
Luis Madrazo y Kuntz
19th century
Museo Romántico, Madrid

Saint Crispin

MARTYR

Together with Crispinian, Crispin is recalled in the ancient martyrologies among the martyrs who died at Augusta Suessionum (modern-day Soissons), at the end of the 3rd century. This martyrdom may have occurred in the year 285, during the persecution of Maximian. Legendary versions claim that both Crispin and Crispinian were shoemakers. Crispin is depicted as a shoemaker or soldier.

PROTECTOR: Shoemakers, saddlers, glovers, and leather workers.

NAME: Crispin is from the Latin and means "with curly hair."

SAINT CRISPIN
Anonymous
1523
Musée Carnavalet, Paris

SAINCT · CRESPIN

Saint Evaristus

POPE AND MARTYR

Evaristus took the throne of Saint Peter from 97 to 105, succeeding Pope Clement I. Very little is known of him. According to tradition, he was born at Bethlehem or at Antioch in a Jewish family. Between the 1st and 2nd centuries, the period of his pontificate, the Roman Empire was ruled by Nerva and Trajan: the climate of peace toward Christians made it possible for work to be done on the organization of the Roman Church. Evaristus is credited with the division of Rome into twenty-five parishes and the designation of the seven deacons who from then on were to follow the pope and transcribe his homilies. According to legend, Evaristus died under Trajan.

NAME: Evaristus is of Greek origin and means "he that is welcome."

POPE EVARISTUS
Sandro Botticelli (attrib.)
1481–82
Sistine Chapel, Vatican

OCTOBER 27

Saint Frumentius

BISHOP

Frumentius, who lived in the 4th century, is venerated as the evangelizer of Ethiopia. As a boy, he had traveled to India in the company of another youth, Aedesius, along with a philosopher named Meropius. They were kidnapped by pirates who took pity on their young age and gave them as slaves to the king of Ethiopia at Aksum. Frumentius became the king's cupbearer, Aedesius his secretary. Frumentius was given permission to build Christian churches for the traveling merchants and to evangelize the Ethiopian population. Freed, he was ordained by Saint Athanasius and was the first bishop of Aksum.

He is depicted in episcopal vestments.

NAME: Frumentius is of Latin origin and means "who delights."

SAINT FRUMENTIUS
Popular sacred image
19th century

Saint Simon

APOSTLE • Feast

The Apostle Simon is called the Canaanite or Cananean by the evangelists and also Zelotes, referring to his association with the fanatical sect of the Zealots, who had created a resistance movement against the Roman occupation of Palestine. Apocryphal sources make him the brother of Judas Thaddaeus and James the Less, sons of Alpheus and of Mary of Cleophas, and also state that Simon and Jude preached in Persia, where they were killed by pagan priests.

Saint Simon is depicted in a tunic and pallium; his attribute is a saw, believed to have been the instrument of his martyrdom, and he may also hold a halberd.

PROTECTOR: Fishermen, marble cutters, and woodcutters.

NAME: Simon is from the Hebrew and means "God has answered."

MADONNA AND CHILD AND SAINTS
STEPHEN, JOHN THE EVANGELIST,
SIMON ZELOTES, AND LAURENCE
(detail)
Lorenzo Lotto
1539
Pinacoteca Civica "F. Podesti," Ancona

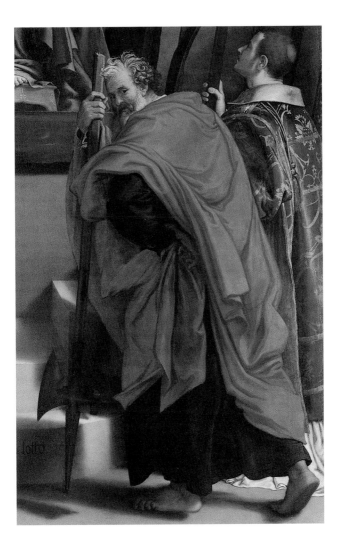

Saint Jude

APOSTLE • Feast

Jude (Thaddaeus) was the brother of James the Less. The Gospel of John refers to his presence at the Last Supper, when he asked Jesus, "Lord, how is it that thou wilt manifest thyself unto us, and not unto the world?" And Jesus answered, "If a man love me, he will keep my words: and my Father will love him and we will come unto him, and make our abode with him." Apocryphal tradition holds that he was active in preaching the Gospel and was martyred, clubbed to death, together with Simon in Persia. He is therefore often depicted with a club. He is invoked for help in hopeless situations.

NAME: Jude is from the Aramaic and means "support of God."

THE APOSTLE JUDE
(detail of the *Maestà*)
Duccio di Buoninsegna
1308–11
Museo dell'Opera del Duomo, Siena

Saint Narcissus of Jerusalem

BISHOP

Narcissus lived in the 3rd century and was the twentieth bishop of Jerusalem, nominated for his virtue at the advanced age of 100. He led the Church with decision and fortitude and presided over the council that established that Easter must always fall on a Sunday. He instituted the figure of the coadjutor for the bishop, entrusting this role to Saint Alexander. He died at age 116. He is depicted in episcopal vestments.

NAME: Narcissus is from the Greek and means "flavor."

SAINT NARCISSUS IN GLORY
Franz Anton Maulbertsch
1750
Gemäldegalerie der Akademie der Bildenden Künste, Vienna

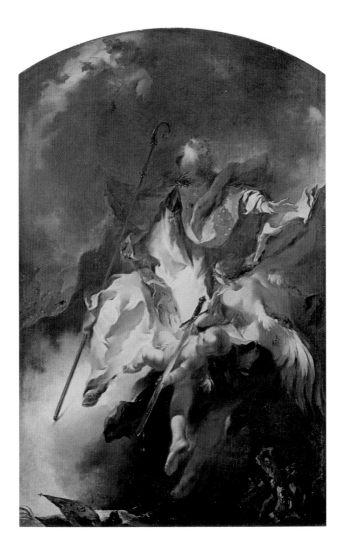

Blessed Angelo of Acri

CAPUCHIN FRIAR

Born at Acri, Italy, in 1669, he was called Lucantonio Falcone. He changed his name to Angelo when he entered the order of the Capuchin friars, after having twice abandoned the novitiate. He was ordained priest in 1700. He was a tireless and beloved preaching friar, nicknamed the "angel of peace." He led an active mission, also becoming a provincial father. He died in 1739 and was declared blessed in 1825. He is depicted in the habit of a Capuchin friar.

NAME: Angelo *(angel)* is of Greek origin and means "messenger."

BLESSED ANGELO OF ACRI
Popular sacred image
First half 19th century
Civica Raccolta delle Stampe Bertarelli, Milan

Saint Alphonsus Rodriguez

JESUIT

He was born in 1533 at Segovia, Spain. Following the death of his father, he became a merchant, married, and had two children. In 1571, overcome by the premature deaths of his wife and children and the failure of his business, he entered the Jesuits. He was sent to the monastery on the island of Majorca and became the hall porter in the Jesuit monastery there, from which missionaries departed for the New World. He was an invaluable spiritual adviser to many of the faithful. He died in 1617 and was declared a saint in 1888.

He is depicted with the habit of the regular clergy, with the occasional attribute of keys.

PROTECTOR: Porters.

NAME: Alphonsus is of German origin and means "valorous."

THE VISION OF ALPHONSUS RODRIGUEZ
Francisco de Zurbarán
1630
Real Acadèmia de Bellas Artes
de San Fernando, Madrid

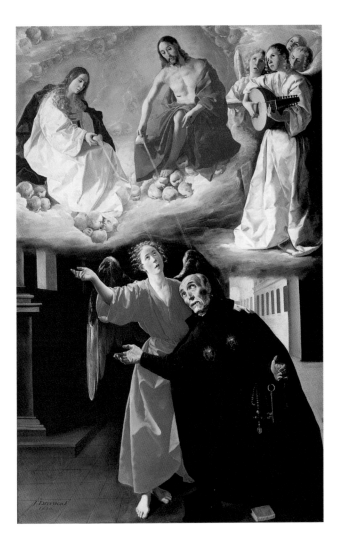

All Saints' Day

Solemnity

As early as the 4th century, the Eastern Church commemorated all the confessors, but the first such collective celebration in the West dates to the 5th century and was not related to a precise day. Only in 609, when Pope Boniface IV dedicated the pagan temple of the Pantheon to Santa Maria dei Martiri, was the first commemoration to honor all the martyrs inserted in the calendar, for May 13. In 835, Pope Gregory IV extended the feast to the entire Church and moved it to November 1. This solemnity celebrates the Church Triumphant. Together with the canonized saints, all the just of every language, race, and nation are recalled, all those whose names are written in the book of life.

SAINTS AND APOSTLES
(detail of the *Maestà*)
Simone Martini
1315
Palazzo Pubblico, Siena

All Souls' Day

Solemnity

The commemoration of the faithful dead, following the November 1 solemnity dedicated to all the saints, originated at the end of the 10th century in the Benedictine monastery of Cluny, on the initiative of the abbot Odilon. From there it spread to all the Cluniac monasteries, which were located over a large part of northern Europe. The Church of Rome officially adopted it in 1311. Pope Benedict XV, in 1915, granted all priests the privilege of celebrating up to three Masses on this day, one for the celebrant, one for the pope, and one for all the faithful dead.

RESURRECTION OF THE FLESH
Luca Signorelli
1499
San Brizio Chapel, Orvieto Cathedral

NOVEMBER 3

Saint Hubert

BISHOP

Born into a noble family, Hubert was named bishop of Tongres-Maestricht in 705 and later became the first bishop of Liège. He showed great passion in bringing the Gospel to the Belgian district of the Ardennes. He died in 727. His cult rose to great popularity during the 9th century, at which time the legend of his conversion came into being: during a hunt he encountered a stag that bore a crucifix between its antlers. Hubert is depicted as a bishop, often accompanied by the stag, and is invoked against rabies and the bites of reptiles.

PROTECTOR: Hunters and hunting dogs, forest rangers, workers of hides, and butchers.

NAME: Hubert is from the German and means "brilliant spirit."

SAINT HUBERT AND THE STAG
1450
British Library, London

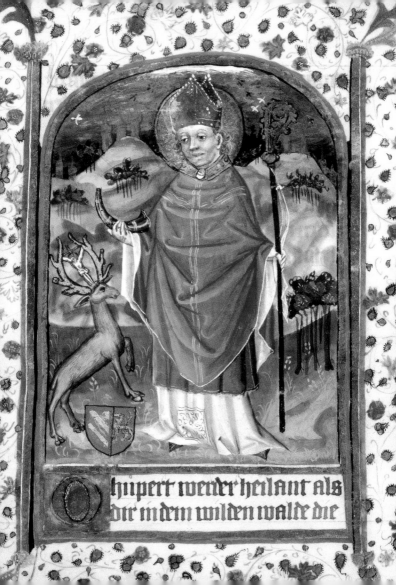

hupert wer der heilant als
dir in dem wilden walde die

Saint Charles Borromeo

BISHOP • Memorial

Born at Arona, Italy, in 1538, into a family of Lombard aristocracy, Charles was bishop and cardinal of Milan during the period of the Counter-Reformation. He was active in carrying out the reform dictates of the Council of Trent in his dioceses and is remembered for his intense pastoral activity and his works of charity, most especially during the terrible plague of 1576.

He died in 1584 in Milan and was canonized in 1610.

He is depicted in cardinal's robes, sometimes with a cord around his neck, the sign of the penitent. He is invoked against the plague.

PROTECTOR: Seminarians, catechists, teachers, and starch-makers.

NAME: Charles is of German origin and means "man, or free man."

SAINT CHARLES IN GLORY
Cerano
Circa 1610
Museo Diocesano, Milan

Saints Elizabeth and Zacharias

**PARENTS OF
JOHN THE BAPTIST**

Elizabeth was the cousin of the Virgin Mary; she was already on in years when she conceived, and during her sixth month she was visited by her young cousin; when the two women came near each other, John leapt in his mother's womb. Zacharias, struck dumb at not believing the announcement of the coming birth of John, regained his speech only when it came time to name the child.

The two saints are depicted as elderly, with the small Baptist. Zacharias is invoked against mutism.
PROTECTOR: Elizabeth is the protector of sterile women and those giving birth.
PATRON: Zacharias is a patron saint of Venice.
NAMES: Elizabeth is from the Hebrew and means "God is abundance"; Zacharias is of Aramaic origin and means "God remembers."

**THE NAMING OF THE BAPTIST
(detail)**
Fra Angelico
1433
Museo di San Marco, Florence

Saint Leonard of Noblac

HERMIT

A Frankish noble, Leonard was converted by Remigius, bishop of Rheims, in the 6th century. By way of King Clovis I, Leonard was able to obtain the liberation of many prisoners. He then became a hermit at Noblac in the forest of Limousin, where he made a cell for himself. Clovis was out hunting one day with his pregnant wife, and with the help and prayers of Leonard she gave birth in his cell. The grateful king gave Leonard all the surrounding land on which to found a monastery. His cult, and also his legend, spread mostly in the 11th century.

He is depicted in the cloak of a monk or the robes of a deacon, with shackles as his attribute. He is invoked to ease the pains of childbirth and by sterile women.

PROTECTOR: Farmers, blacksmiths, fruit vendors, prisoners, and the insane.

NAME: Leonard is of German origin and means "strong as a lion."

FOUR SAINTS
(detail)
Correggio
1517
Metropolitan Museum of Art, New York
(Saint Leonard is on the right)

Saint Prosdocimus of Padua

PROTOBISHOP

Prosdocimus, born in Greece, lived between the 1st and 2nd centuries. He may have been sent by the apostle Peter himself to evangelize the Veneto region of northern Italy. He was the first bishop of Padua. He survived the persecutions under Emperor Nero and died an old man. His cult spread immediately after his death.

He is depicted in episcopal vestments, with a pitcher in his hand, a reference to the great number of baptisms he celebrated.

PATRON: Prosdocimus is the patron saint of Padua.

NAME: Prosdocimus is from the Greek and means "the awaited."

SAINT PROSDOCIMUS
BAPTIZES A NOTABLE WITH
SAINTS NICHOLAS OF BARI AND
CATHERINE OF ALEXANDRIA
Pietro Damini
1625
Santa Maria Assunta, Asolo

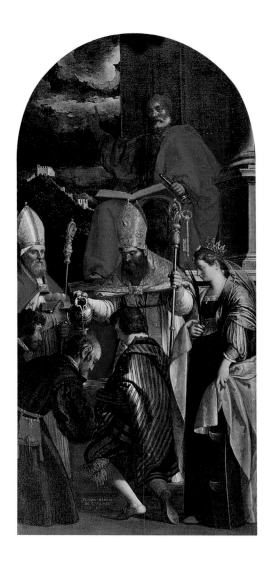

The Four Crowned Ones

MARTYRS

The story of these martyrs, who lived in the 4th century, has legendary tones. Perhaps brothers, Claudius, Nicostratus, Simpronian, and Castorius were stonecutters originally from Pannonia (Hungary) who, because of their exceptional skills, had been summoned to work for Diocletian. They were martyred when they refused to carve a statue in honor of Aesculapius, pagan god of health.

They are depicted as stonecutters, with sculptor's tools as their attributes, along with the palm branches and crowns of martyrs. Confusion of the crowns for crowns of royalty led them to be referred to as "crowned."

PROTECTORS: Stonecutters, sculptors, and masons.

NAMES: Claudius, from Latin, means "lame"; Nicostratus, from Greek, means "victorious"; Castorius, from Latin, means "to shine"; the origin and meaning of Simpronian are unknown.

MARTYRDOM OF THE
FOUR CROWNED ONES
Filippo Abbiati
Late 18th century
Palazzo Branda Castiglioni, Castiglione Olona

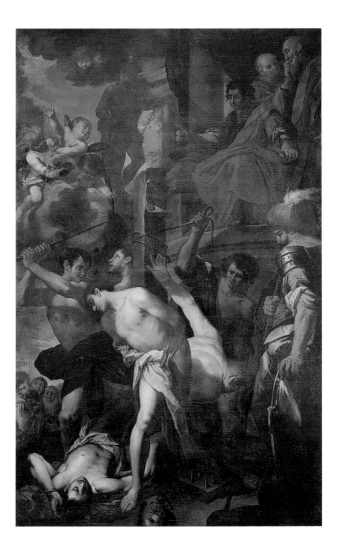

Dedication of the Lateran Basilica

Feast

This day recalls the dedication of the world's first cathedral. The sacred building, located near the Lateran palace, became the official residence of the popes in the 4th century. It had originally been dedicated to the Divine Savior. Building began in 315 under the emperor Constantine, and it was consecrated by Pope Sylvester in 324. After the fires of the 14th century and its abandonment following the Great Schism, the basilica was rebuilt and dedicated to Saints John the Baptist and John the Evangelist. As the Mother Church of Rome, it hosted the sessions of the five great ecumenical councils.

THE DREAM OF INNOCENT III:
SAINT FRANCIS SUPPORTS THE
COLLAPSING LATERAN BASILICA
Giotto
1297–99
Upper Basilica, Church of St. Francis, Assisi

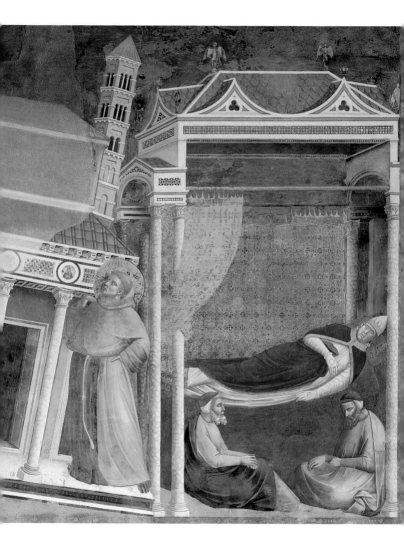

Saint Leo the Great

POPE AND DOCTOR OF
THE CHURCH • Memorial

Leo I was elected pope in 440 and
served twenty years. He made con-
tributions to theological and political
matters, demonstrating firm resolve
in both. In the theological, his most
notable act took place during the
Council of Chalcedon (451), when he
stated the doctrine of the Incarnation
of Christ. He is traditionally credited
with meeting with Attila the Hun and
stopping his advance on Rome after
sacking Milan (452). Leo died in 461.
In 1754, he was declared a Doctor of
the Church.
He is depicted in papal robes with
the triregnum (papal tiara).
PROTECTOR: Sacred music,
musicians, and singers.
NAME: Leo is from the Latin and
is related to the name "Lion."

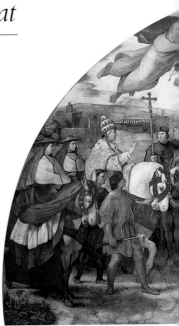

MEETING OF LEO THE GREAT AND ATTILA
Raphael
1512
Stanza di Eliodoro, Vatican

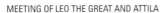

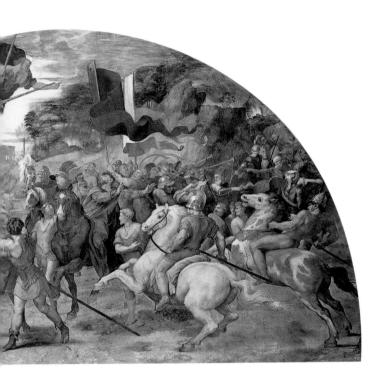

Saint Andrew Avellino

PRIEST

When he was born, in 1521 in Basilicata, Italy, he was baptized with the name Lancillotto. Ordained priest at twenty-four, he studied law at the university of Naples, intending to become an ecclesiastical lawyer. His encounter with the Jesuits turned him in a far more spiritual direction, and in 1556 he entered the order of the Theatines, changing his name to Andrew. He performed important roles during the delicate period of the Counter-Reformation and died at Naples, while celebrating Mass, in 1608. He was canonized in 1712. He is depicted in priest's robes near an altar. He is invoked against apoplexy and sudden death.

NAME: Andrew is from the Greek and means "male virility, courage."

DEATH OF SAINT ANDREW AVELLINO
Domenico Fiasella
Circa 1630–40
San Siro, Genoa

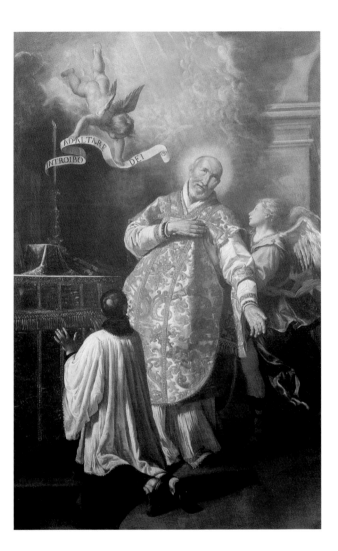

Saint Martin of Tours

BISHOP • Memorial

Martin was born around 315 in the Roman province of Pannonia (modern-day Hungary). The son of a Roman soldier, he too followed a military career and was drawn to Christianity. While stationed near Amiens, he gave half of his cloak to a nearly naked beggar and the next night dreamed Jesus wore it. This vision convinced him to request release from military service and to seek baptism. He became bishop of Tours, acclaimed by the clergy and the people alike. He died at Candes, near Tours, in 397.

He is depicted as a soldier on horseback while cutting his cloak in half. (The French word for that cloak gives us the word *chapel*.)

PROTECTOR: Soldiers, tailors, restaurant owners, beggars, and hotel directors.

NAME: Martin is from the Latin and means "dedicated to Mars."

SAINT MARTIN DIVIDES HIS CLOAK WITH THE BEGGAR
Simone Martini
1315–16
St. Martin Chapel, Lower Basilica, Church of Saint Francis, Assisi

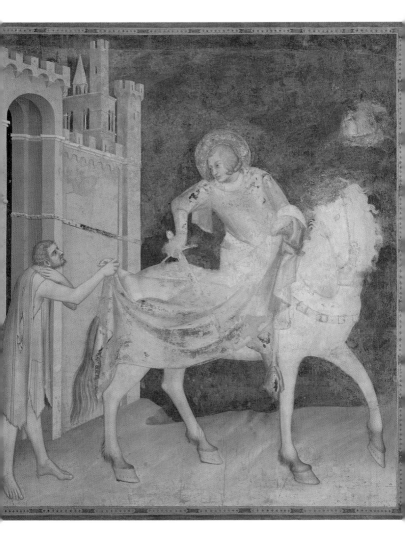

Saint Josaphat Kuncewicz

BISHOP AND MARTYR • Memorial

Born in Ukraine in 1580 in an orthodox family, Josaphat first became a member of the Ruthenian Union (the Catholic Church with Oriental rite) and then, in 1604, he entered in the Ukrainian Order of Saint Basil (Basilians) at Vilna. He was later made a Church official and, in 1618, became bishop of Polotsk. He worked tirelessly for the unity of the Church. His passion attracted the anger and hatred of certain orthodox believers, and in 1623 he was killed. Beatified in 1643, he was canonized in 1867.

He is depicted in the cloak of a monk with an ax stuck in his head.

NAME: Josaphat is from the Hebrew and means "the Lord judges."

Saint Livinius

MARTYR

Livinius (or Lebuinus, as he is listed in the recent Roman Martyrology) is said to have been bishop in Scotland and to have died a martyr at Houtem, in Belgium, in the 7th century. The information about him is scarce and confused with the events of another Livinius, the patron saint of Deventer, who died in 775. His cult began spreading in the 11th century, greatly supported by the monks of Saint Bavo in Ghent who possessed his relics, brought there in 1007.

He is depicted in episcopal vestments, while suffering the martyrdom of having his tongue extracted.

NAME: The origin and meaning of Livinius are unknown.

MARTYRDOM OF SAINT LIVINIUS (detail)
Peter Paul Rubens
1633
Musées Royaux d'Art et d'Histoire, Brussels

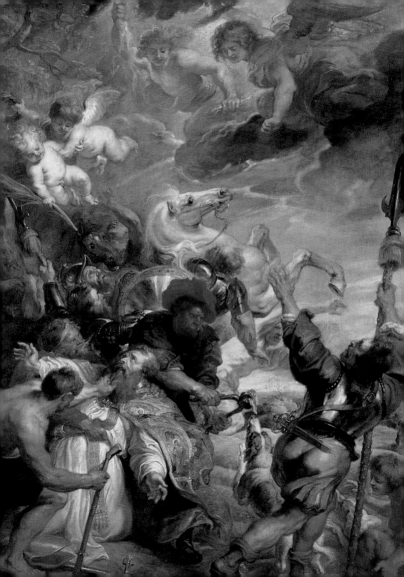

NOVEMBER 13

Saint Diego of Alcalá

FRANCISCAN

Born in Andalusia around 1400, Diego chose the religious life while still young, joining the Franciscans. He was a layfather, dedicated to the assistance of the sick and pilgrims, assigned the role of cook. He died at Alcalá in 1463. His cult spread primarily in Spain. King Philip II of Spain promoted his canonization, which took place in 1588.
Saint Diego is represented as a youth, with the Franciscan habit, often while displaying flowers in the folds of his habit. He is invoked against infirmities.
NAME: Diego is from the Greek *didaco* and means "instructed."

SAINT DIEGO OF ALCALÁ
HEALS THE SICK
(detail)
Jacopo Ligozzi
Circa 1620
Church of Ognissanti, Florence

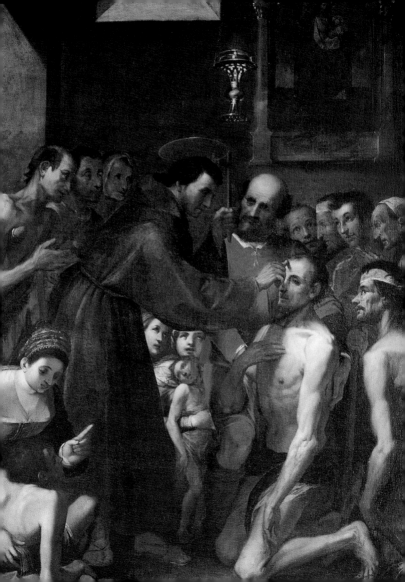

NOVEMBER 14

Saint Serapius

MERCEDARIAN MARTYR

Serapius was born at London in 1179, son of a noble captain at the court of Henry II. His life was quite adventurous: he participated in the Crusades, survived a shipwreck, and was taken hostage. He made his living in the service of princes and kings until he met Peter Nolasco, in 1221. He joined the order of Our Lady of the Ransom and worked vigorously to obtain the release of many Christian slaves and to spread the values of the order. He was tortured and killed at Algeria in 1240. Canonized in 1625, he is depicted in the white habit of the Mercedarians, tied to the scaffold. He is invoked against arthritis.

NAME: Serapius is of Latin origin, by way of the Egyptian, and means "sun."

SAINT SERAPIUS
Francisco de Zurbarán
1628
Wadsworth Atheneum, Hartford

Saint Albert the Great

BISHOP AND DOCTOR OF THE CHURCH • Optional memorial

Born into a noble family in Swabia (Germany) in 1206, Albert entered the Dominican order at Padua when he was seventeen. He taught at Hildesheim, Regensburg, and Cologne before teaching theology at Paris. Provincial prior between 1254 and 1257, three years later he was elected bishop of Regensburg. He died in 1280. Beatified in 1622, he was canonized in 1931.

Albert the Great is depicted in the Dominican habit with the hat of a doctor or in episcopal vestments with the miter.

PROTECTOR: Scientists, students of natural sciences, and naturalists.

NAME: Albert is of German origin and means "all clear." It can also be a diminutive of Adalbert, which means "of clear nobility."

PREACHING OF SAINT ALBERT THE GREAT WITH SAINTS THOMAS AQUINAS, BONAVENTURE, GILES, AND OTHER DOCTORS
Alvise de Donati
15th century
Beata Vergine Annunciata, Vignola
(Saint Albert is seated at the center)

Saint Margaret of Scotland

QUEEN AND WIDOW

Margaret was born around 1046 in Hungary, the daughter of Edward the Atheling, at the time in exile to flee the Danish kings who had usurped the throne of England. At age nine she returned to her home-land, but in 1066, following the Norman Conquest and the death of her uncle Edward the Confessor, she was forced to seek refuge in Scotland. In 1070, she married King Malcolm III. In her roles as queen, wife, and mother she proved herself discreet, loving, and devout; she was active in the reform of the Scottish Church and promoted and supported works of charity. She died in 1093 at Edinburgh.

In art, she is depicted in royal robes.

PATRON: Margaret is the patron saint of Scotland.

NAME: Margaret is from the Greek and means "pearl."

QUEEN MARGARET OF SCOTLAND
Henry Shaw
19th century
Private collection

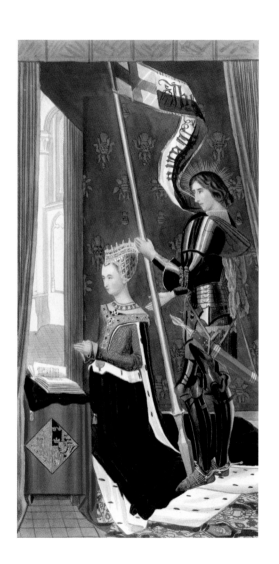

Saint Elizabeth of Hungary

QUEEN • Memorial

Daughter of King Andrew II of Hungary, Elizabeth was born in 1207 and was educated as a Thuringian princess. She married the landgrave Louis IV in 1221 and was the mother of three children. She was famously generous in her care for the poor and sick, most of all after the death of her husband, when she entered the Franciscan tertiaries. She died at only twenty-four and was canonized in 1235.

She is depicted in princely robes with a crown or in the Franciscan habit. Sometimes she holds coins for charity, a pitcher, a basket of bread, fruit, or fish; sometimes she bears a basket or apron full of roses.

PROTECTOR: Bakers.

NAME: Elizabeth is of Hebrew origin and means "God is abundance."

ELIZABETH WITH THREE BEGGARS
Hans Holbein the Elder
1516
Alte Pinakothek, Munich

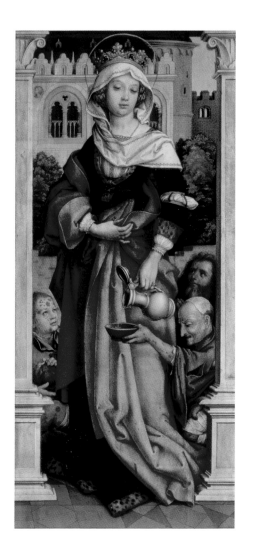

Saint Frediano of Lucca

BISHOP

It remains unclear whether Frigidian, Finnian, and Frediano are one saint or three. According to Gregory the Great, Frediano (despite the name) was an Irishman of royal lineage who became a monk and set off on a pilgrimage to Rome. A Frediano was certainly bishop of Lucca around 560, acclaimed by the clergy and people alike. He was active in his diocese in pastoral work and also as a hydraulic engineer, doing his utmost to bring an end to the nightmare floodings of the Serchio River. According to legend, Frediano used a rake to scratch a new, safer course for the river to follow, and it obeyed. He seems to have died around 588.

He is depicted in episcopal vestments, sometimes with the rake, and is invoked against floods.

NAME: Frediano is from the German and means "bearer of peace."

SAINTS PAUL AND FREDIANO
Filippino Lippi
1482
Norton Simon Museum, Pasadena
(Saint Frediano is on the right)

Saint Obadiah

PROPHET

Fourth of the Minor Prophets, Obadiah probably lived after the conquest of Jerusalem by Nebuchadnezzar II, sometime after 587–86 B.C. According to what can be gleaned from his text, which at twenty-one verses is the shortest of the prophetic writings, he was highly knowledgeable concerning the liturgical traditions of the Temple. His prophecy bears a message of hope for Israel, interpreted as a messianic announcement, and a hard condemnation of the people of Edom who had supported the Babylonian invaders of Jerusalem. **NAME:** Obadiah is of Hebrew origin and means "servant of the Lord."

OBADIAH AND THE LIBYAN SIBYL
(detail)
Workshop of Pinturicchio
1492–94
Borgia Apartments, Vatican

Saint Benignus

BISHOP

Benignus occupied the bishop's see of Milan from 465 to 472. He came from the noble Bossi family of Milan, and not the Bensi of Como, as was established after a debate that dragged on nearly 1,200 years. He may have studied at Rome; what is certain is that he directed the Milanese Church with great charity and zeal, such that he was eulogized by the Latin poet and rhetorician Ennodius.

He is depicted in episcopal vestments.

NAME: Benignus is of Latin origin and means "what produces good."

SAINT BENIGNUS
Anonymous Lombard painter
First half 18th century
Museo Diocesano, Milan

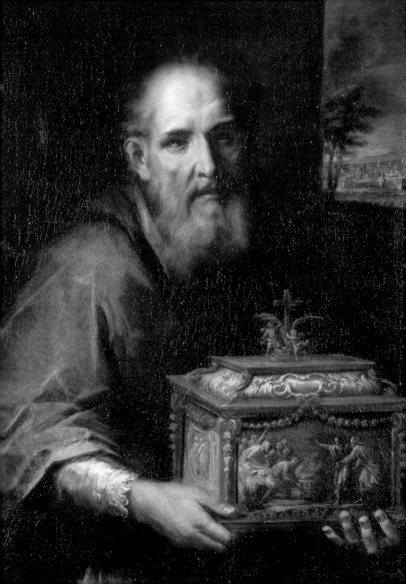

Presentation of the Blessed Virgin Mary

Memorial

According to the Protevangelium of James as well as *The Golden Legend*, Mary was presented in the Temple at the age of three. This feast came into being with the dedication of the New Church of Saint Mary in Jerusalem in 543 and has been celebrated in the East since the 6th century. It was introduced to the West only in the 14th century; it has been preserved as a memorial in the new calendar. In art, the scene shows Mary as a child climbing the steps of the Temple and being welcomed by the priest.

PRESENTATION OF THE VIRGIN
IN THE TEMPLE
(detail)
Titian
1534–38
Gallerie dell'Accademia, Venice

Saint Cecilia

VIRGIN AND MARTYR • Memorial

A young Christian patrician, Cecilia (Cecily) lived in the 3rd century and was betrothed to a pagan named Valerius. Maintaining her vow of virginity, she converted her husband, who accepted baptism and died a martyr. Cecilia refused to sacrifice to the idols and was beheaded. The figure of this saint is closely tied to music, perhaps because the *passio* that relates her story refers to how during her wedding "as the organs were playing, Cecilia sung in her heart to the Lord."

Since the 14th century it has been customary to depict her together with musical instruments, particularly an organ.

PROTECTOR: Music, musicians, makers of stringed instruments, poets, and singers.

NAME: Cecilia, of Latin origin, means "blind"; according to medieval etymology the name means "sky and lilies."

THE ECTASY OF SAINT CECILIA
Raphael
1514
Pinacoteca Nazionale, Bologna

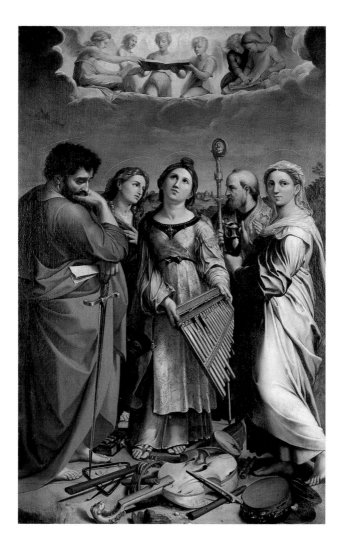

Saint Clement I

POPE AND MARTYR • Optional memorial

Clement lived in the 1st century and was the fourth bishop of Rome, from 88 to 97. The Epistle he wrote to the Corinthians to reestablish concord in the local Christian community affirms the unquestionable authority of the Church's ministers. According to apocryphal tradition, Clement was exiled to the Crimea, condemned to work in mines, and finally thrown from a ship with an anchor around his neck.

He is depicted in papal robes, and his primary attribute is the anchor. He is invoked against the diseases of children.

PROTECTOR: Children, hatters, boatmen, watermen, gondoliers, stone cutters, sailors, marble workers, and sculptors.

NAME: Clement is from the Latin and means "benevolent, tolerant."

THE MARTYRDOM OF SAINT CLEMENT
(detail)
Bernardino Fungai
Circa 1500
City Art Gallery, York

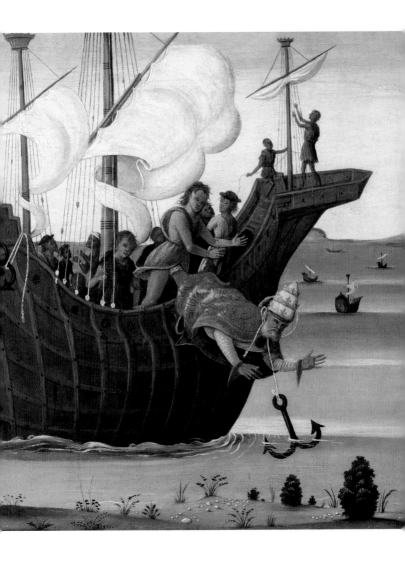

Saint Andrew Dung-Lac and Companions

MARTYRS • Memorial

Andrew Dung-Lac was born in today's Vietnam in 1795. His parents, extremely poor, were pagan and sold him to a catechist who educated him in the mission of Vinh-Tri. He received baptism and studied theology. In 1823, he was ordained priest and became the parish priest of various areas. During the persecutions of King Minh-Manh he was arrested several times, but the Christians were able to obtain his release. Imprisoned yet again in 1839, he was decapitated. Together with another 116 Vietnamese martyrs he was beatified in 1900 and canonized in 1988.

NAME: Andrew is from the Greek and means "male virility, courage."

Saint Chrysogonus

BISHOP AND MARTYR

Chrysogonus lived in the 4th century and is in the ancient *Roman Martyrology*, having been beheaded during the persecution of Emperor Diocletian. Information about him has been handed down in several ancient sources, but the stories are confused, sometimes conflict, and have certainly been enriched with legendary details. Although his origins are uncertain, it seems he was the bishop of Aquileia, Italy, and it was near that city, in a locality called Aquae Gradatae, that he was beheaded, around 304. His relics were preserved in the cathedral of Zara. His cult spread immediately after his death.

He is sometimes depicted as a knight.

NAME: Chrysogonus is of Greek origin and means "born of the gold."

SAINT CHRYSOGONUS
Michele Giambono
Middle 15th century
San Trovaso, Venice

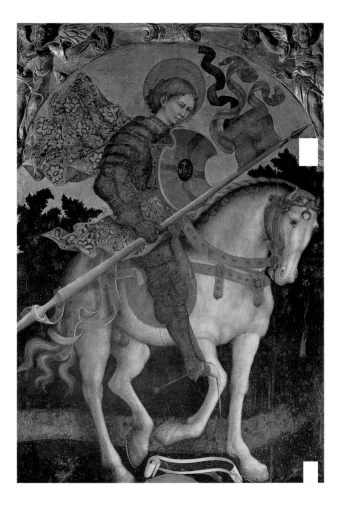

Saint Catherine of Alexandria

VIRGIN AND MARTYR • Optional memorial

Catherine lived between the 3rd and 4th centuries. Probably of noble lineage, she refused to marry Massimino Daia, governor of Egypt and Syria, because she had given herself to Christ. She protested against the persecutions ordered by Emperor Maxentius and for this reason was first tortured with a toothed wheel and then beheaded, perhaps in 305. According to legend, milk gushed forth from her severed neck.

She is depicted as a young woman in regal dress, and her attributes are the wheel, the palm, the sword, and the ring of mystical matrimony. She is invoked by nursing women, shipwreck victims, and against migraines.
PROTECTOR: Orators, philosophers, notaries, tailors, stylists, spinners, carters, nursing mothers, and wet nurses.
NAME: Catherine is of Greek origin and means "pure."

SAINT CATHERINE OF ALEXANDRIA
Caravaggio
1595–96
Museo Thyssen-Bornemisza, Madrid

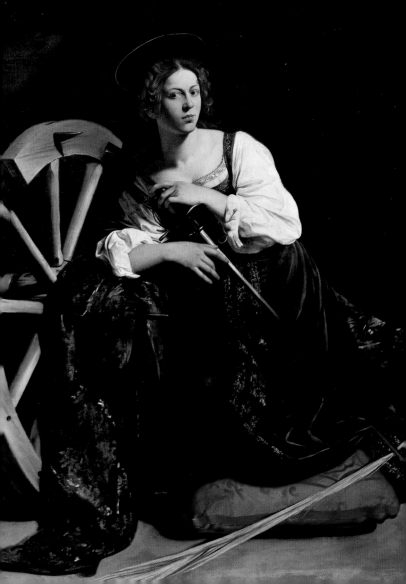

Saint Sylvester Guzzolini

ABBOT

Born at Osimo, Italy, in 1177, Sylvester began studying law at the University of Bologna but then changed over to theology, which he studied at the University of Padua. This decision did not meet with parental approval, and in fact his parents called him back home. Even so he was ordained priest (1217) and became canon of the cathedral. In 1227, he decided to live in solitude in the Gola della Rossa, near Frasassi. In 1228, he was visited by two papal legates, Fra Riccardo and Fra Bonaparte, and he was later joined by numerous disciples. In 1231, he founded the monastery of Montefano, for which he obtained papal approval in 1248. By the time he died, in 1267, he had founded numerous monasteries.

He is depicted in the dress of an abbot.

NAME: Sylvester is of Latin origin and means "inhabitant of the woods."

SAINT SYLVESTER GUZZOLINI
Popular sacred image
19th century

Saint Virgil of Salzburg

BISHOP

Virgil was born early in the 8th century in Ireland. He became a monk there and was probably educated at Colbroney by the abbess Samthann. He traveled to Gaul and the monastery of Quierzy-sur-Oise, where he met King Pippin the Short, who sent him to Bavaria, entrusting him with the diocese of Salzburg. At first Virgil met opposition, in part because Irish missionaries awakened a certain distrust. Even so, on the basis of the king's mandate he performed as a bishop even before his consecration as such, which occurred in 755. He dedicated himself to the poor, to teaching, and to the evangelization of the Slavs. He died at Salzburg in 784 and was buried in the cathedral that he had had built. He was canonized in 1233.

He is depicted in episcopal vestments, often holding a model of the cathedral of Salzburg.

PATRON: Virgil is the patron saint of Salzburg.

NAME: Virgil is of Etruscan origin, and its meaning is unknown.

SAINTS VIRGIL AND RUPERT
Popular sacred image
20th century
(Saint Virgil is on the left)

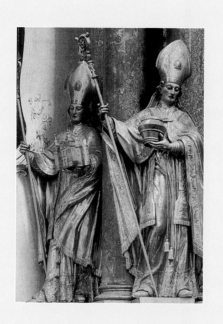

Saint James of the Marches

PRIEST

James was born at Monteprandone, Italy, in 1391, and entered the order of Friars Minor at the age of twenty. He was a preaching friar and disciple of Saint Bernardino of Siena. Like him, he spread devotion for the Holy Name of Jesus. He did a great deal of preaching in Bosnia, Hungary, and Austria. He founded the institution of the Monti di Pietà (pawnshops) to combat usury and favor the poor with low-interest loans. He died in Naples in 1476 and was canonized in 1726.

He is depicted in the Franciscan habit with a monstrance or chalice.

NAME: James is from the Aramaic and means "follower of God."

SAINT JAMES OF THE MARCHES
Carlo Crivelli
1477
Louvre, Paris

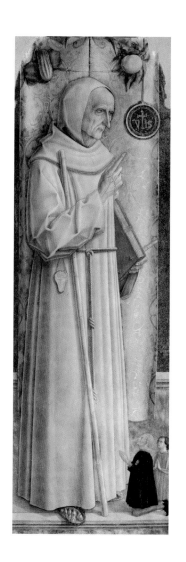

Saint Saturnius of Toulouse

BISHOP AND MARTYR

According to a 5th-century discourse written in his praise, Saturnius came from the East, arrived in Toulouse, and became its first bishop. This was around 250, during the period when the consuls of Rome were Decius and Gratus. He worked to spread the Gospels in that region until the strong pagan community rose against him, accusing him of having angered the gods, who had interrupted the oracles. When he refused to sacrifice to the idols, he was tied to a bull that dragged him, tearing his body apart.

PROTECTOR: Bullfights.

NAME: Saturnius is of Latin origin and means "of melancholy character."

STORIES OF SATURNIUS OF TOULOUSE (detail)
Master Roque de Artajona
14th century
Navarre Museum, Pamplona
(Saint Saturnius is on the left)

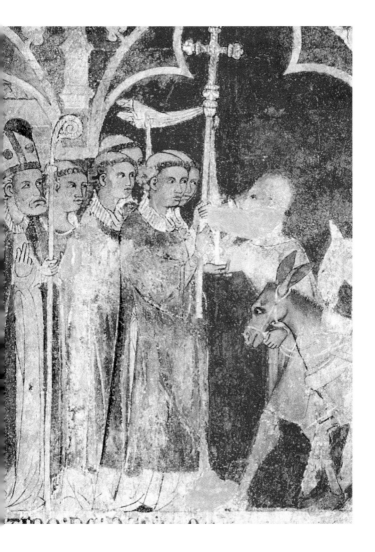

Saint Andrew

APOSTLE • Feast

Brother of Simon Peter, and like him a fisherman at Capernaum, Andrew was a disciple of John the Baptist and was also among the first to follow Jesus. He seems to have died a martyr around 60. His cult was especially popular during the Middle Ages. Since he was given the traits of a warrior saint, the symbol of his cross was chosen by various chivalric orders.

Since the 10th century he has been depicted with an X-shaped cross and sometimes the fishing net with fish. He is invoked against injustice, sterility, gout, dysentery, and wryneck.

PROTECTOR: Fishermen, fishmongers, and paralytics.

NAME: Andrew is from the Greek and means "male virility, courage."

SAINT ANDREW THE APOSTLE
François Duquesnoy
1640
St. Peter's, Rome

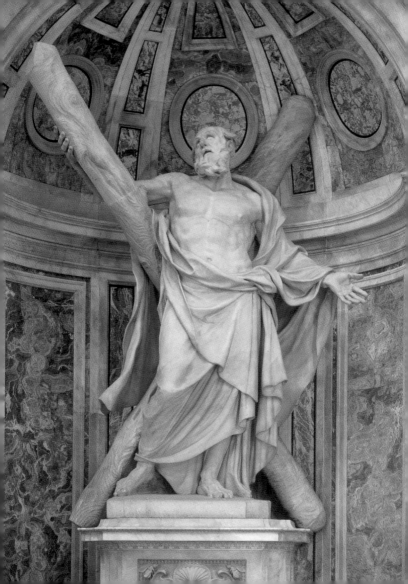

DECEMBER 1

Saint Eligius

BISHOP

Born around 588 near Limoges, Eligius (Eloi) was a blacksmith and goldworker. He served both King Clotaire II and his successor, Dagobert. He became a priest and was named bishop of Noyon in 641; he worked tirelessly among the pagans. He died in 660. His cult was popular in the Middle Ages.

He is depicted in the dress of a goldsmith or blacksmith or in episcopal vestments, often with a horseshoe or horse, for according to legend he found it easier to shoe horses by removing a leg and then reattaching it. He is invoked against ulcers, earaches, and enteritis.

PROTECTOR: Goldsmiths, blacksmiths, and garage workers.

NAME: Eligius is from Latin and means "elected by God."

SAINT ELIGIUS SHOEING THE HORSE
Master of the Tree of Life
14th century
Santa Maria Maggiore, Bergamo

DECEMBER 2

Saint Bibiana

MARTYR

A Roman saint who lived in the 4th
century, Bibiana (Viviana) is said to
have fallen victim during the late
persecutions of the emperor Julian
the Apostate (360–63). The story
of her life and martyrdom are
legendary. The emperor is said to
have had all the members of her
family killed and then had her
tortured, scourged, and killed. Her
cult was popular, primarily in Rome,
beginning in the 5th century.
She is depicted near a column
with a palm branch and is invoked
against headaches and intestinal
ailments.
NAME: Bibiana is of Etruscan
origin and means "who has life."

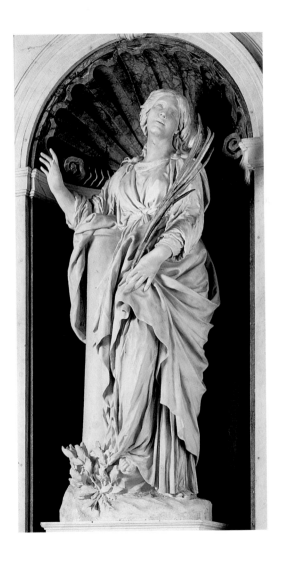

Saint Francis Xavier

PRIEST • Memorial

Of aristocratic origins, Francis Jassu y Xavier was born in 1506 in Navarre. With Ignatius of Loyola he founded the order of the Jesuits and passionately dedicated himself to the apostolate in India and Japan. He died on Saint John Island, before reaching China, in 1552. He was canonized in 1622.

He is depicted in a priest's robes with the crucifix and the baptismal bowl, accompanied by Indians; sometimes he has a flaming heart, lily, hat, or shoulder cape. He is invoked against the plague, storms, and hurricanes.

PROTECTOR: Missionaries, sailors, and tourists.

NAME: Francis *(Frank)* is of German origin, from the name of the people who settled in France; it has come to mean "forthright, sincere."

THE MIRACLE OF
SAINT FRANCIS XAVIER
Peter Paul Rubens
1616–17
Kunsthistorisches Museum, Vienna

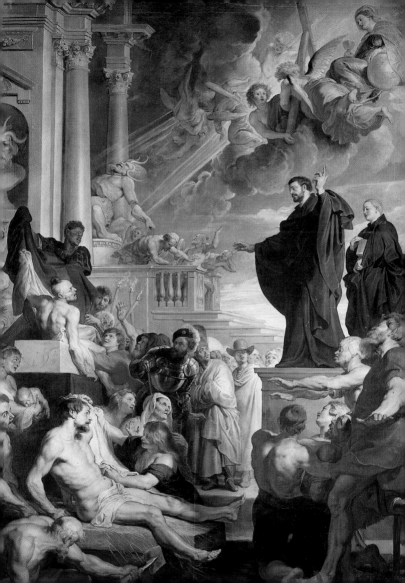

Saint John Damascene

PRIEST AND DOCTOR OF THE CHURCH • Optional memorial

Son of an important Christian functionary, John was born at Damascus around 650. He worked as a highly valued counselor in the service of the Muslim governor and, around 700, retired to the abbey of Saint Saba, near Jerusalem, where he was ordained priest. He wrote hymns and important theological works, including *The Fountain of Wisdom*. He was a defender of religious images against the iconoclasts. He died at age one hundred at Saint Saba. He was declared a Doctor of the Church in 1890.

He is depicted in a monk's habit and bears a scroll.

PROTECTOR: Sick children and icon painters.

NAME: John is from a Hebrew name meaning "Yahweh is gracious."

SAINT JOHN CLIMACUS,
SAINT JOHN DAMASCENE,
AND SAINT ARSENIUS
School of Novgorod
15th century
Art Museum, Novgorod
(Saint John Damascene is at the center)

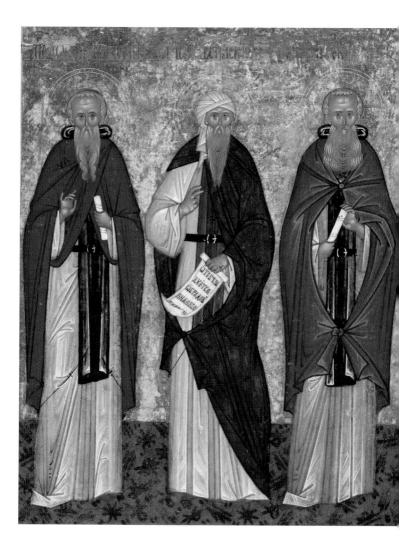

Saint Barbara

VIRGIN AND MARTYR

Barbara lived between the 3rd and 4th centuries. According to apocryphal sources, she was the daughter of Dioscorus, king of Nicomedia, who locked her away in a tower so that no man could have her. She became a Christian and decided to live as a hermit, but when the king learned of this he denounced her to the prefect, who condemned her to death. She was beheaded with her own father's sword, and he in fact then perished, incinerated by a bolt of lightning. Barbara has been worshiped since the 7th century.

She is depicted as a young girl with a palm branch or peacock feathers. Her attribute is the tower; she is invoked against lightning.

PROTECTOR: Architects, gunners, weapons makers, miners, masons, firemen, bell-founders, and those at risk of sudden death.

NAME: Barbara is from the Greek and means "foreigner."

SAINT BARBARA
Jan van Eyck
1437
Koninklijk Museum voor Schone Kunsten, Antwerp

DECEMBER 5

Saint Dalmatius of Pavia

MARTYR

This holy martyr is listed in *The Roman Martyrology* as the bishop of Pavia, Italy. There was once a church dedicated to him in that city, but his cult was far more heavily documented in Piedmont, in the diocese of Asti, beginning in the 6th century. Probably originally from Germany, he carried on active work between Emilia, Piedmont, and Gaul. The most recent scholarship relates to his martyrdom, which took place in 254.

NAME: Dalmatius is from the Latin and means "from Dalmatia."

SAINT DALMATIUS OF PAVIA
Popular sacred image
20th century

Saint Nicholas

BISHOP • Optional memorial

Nicholas was born in Lycia (in modern-day Turkey) in the 3rd century and while still a layperson was acclaimed bishop of Myra. Ordained a priest, he led the diocese with charity, dedication, and full respect for orthodoxy. He died in the opening decades of the 4th century. His cult spread first in the Byzantine Empire beginning in the 6th century and then to Europe following the translation of his relics to Bari in 1087. The miracles attributed to him include that of having saved three girls from prostitution by giving each a bag of gold as dowry and having brought back to life three boys who had been murdered by a butcher and placed in a brine tub.

He is depicted in episcopal vestments; his attributes are three golden balls, and he is sometimes accompanied by the boys and the tub.

PROTECTOR: Sailors, pilgrims, fishermen, perfume-makers, the poor, and scholars.

PATRON: Nicholas is the patron saint of Russia and Greece as well as the Italian city of Bari.

NAME: Nicholas is of Greek origin and means "victorious among the people."

SAINT NICHOLAS OF BARI
AND SAINT JOHN GUALBERTO
Lorenzo di Niccolò Gerini
1410
Basilica of Saint Francis, Assisi
(Saint Nicholas is on the left)

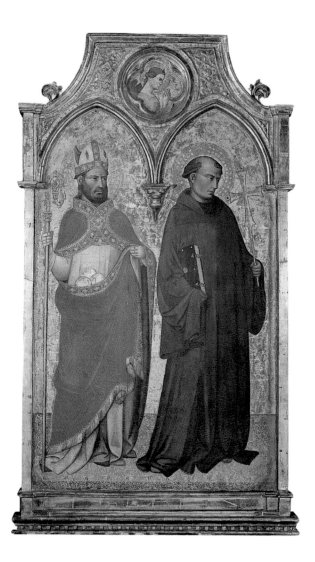

Saint Ambrose

**BISHOP AND DOCTOR
OF THE CHURCH • Memorial**

Born between 337 and 339 at Trier, Germany, into a Christian family, Ambrose studied at Rome and became a brilliant lawyer. Nominated bishop of Milan by acclamation in 374, he was baptized and consecrated in a week. He battled the Arian heresy and completed important liturgical and pastoral reforms in the diocese of Milan. His cult spread immediately after his death, in Milan in 397. He is depicted in episcopal vestments with staff and scourge; he is sometimes presented horseback.

PROTECTOR: Bees, beekeepers, and those who work with wax.

PATRON: Ambrose is the patron saint of Milan.

NAME: Ambrose is of Greek origin and means "immortal."

SAINT AMBROSE
(detail)
5th century
San Vittore in Ciel d'Oro, Basilica
of Sant'Ambrogio, Milan

The Immaculate Conception of the Blessed Virgin Mary

Solemnity

The Immaculate Conception of the Blessed Virgin Mary has been dogma in the Catholic Church since 1854 and confirms the election of Mary by God even before her birth. In fact, the Church holds that, alone among humans, the Virgin Mary was conceived without Original Sin in keeping with her future role as Mother of the Savior. This mystery has been the subject of enormous popular involvement over the course of the history of the Church. As early as the 11th century, the feast of the Conception of Mary was celebrated in England and Normandy, and the Council of Basil declared it an article of faith in 1439.

In art, Mary is depicted following the description given in the twelfth chapter of the book of Revelation: the woman, identified as Mary, is clothed with the sun and crowned by twelve stars; she stands on the moon and crushes a snake under her heel.

THE IMMACULATE CONCEPTION
(detail)
Giambattista Tiepolo
1767–69
Prado, Madrid

720

Saint Syrus of Pavia

BISHOP AND MARTYR

Syrus was the first bishop of Pavia and evangelized various cities of northern Italy. The events of his life are legendary and date to a late period; they were probably written to support the primacy of the Church of Pavia over that of Milan, on which it had come to depend. A tradition identifies Syrus with the boy who offered bread and fish to Jesus for the miracle of the loaves and the fishes; following Pentecost he arrived in Italy, traveling with Saint Peter. According to another tradition, he was a disciple of Hermagora, the first bishop of Aquileia. He is depicted in episcopal vestments.

NAME: Syrus is of Greek origin and means "from Syria."

HOLY FAMILY AND SAINT SYRUS
(detail)
Bernardino Campi
1569
San Marco, Milan

DECEMBER 10

The Blessed Virgin of Loreto

Commemoration

The worship of the Blessed Virgin of Loreto is tied to the tradition of the miraculous transportation by angels of the home where Mary lived at Nazareth to the hill of Loreto, Italy. In reality, around the 4th century several devout Christians dismantled it, moved it, and reassembled it. The Marian sanctuary of Loreto is among the oldest sanctuaries and has always been a site for pilgrimages.
In art, the event is depicted as the Virgin sitting atop a house that is being borne through the air by angels.
PROTECTOR: Aeronautics.

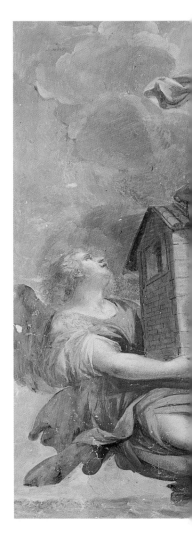

THE VIRGIN OF LORETO
(detail)
Francesco Allegroni
17th century
Gubbio Cathedral

724

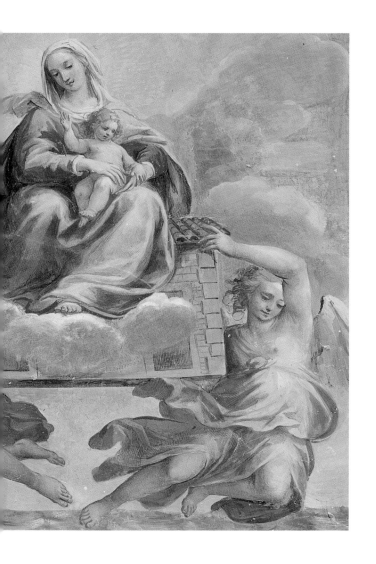

Saint Damasus I

POPE • Optional memorial

Probably of Spanish origin, the deacon Damasus was chosen as the successor to Pope Liberius in 366. His election was not without opposition, however, certain factions having elected another pope, and Damasus had to protect his claim. During his pontificate he dedicated himself to important doctrinal and theological questions, revived the cult of the martyrs, and promoted the restoration of the catacombs. He commissioned Saint Jerome to revise the Latin text of the Bible. Damasus died in 384 at seventy-nine years of age.

He is depicted in papal robes.

PROTECTOR: Archaeologists.

NAME: Damasus is of Greek origin and means "who knows how to tame."

POPE DAMASUS I
Giulio Romano
1525
Sala di Constantino, Vatican

DECEMBER 12

Saint Walaricus

ABBOT

Walaricus (Valéry) was born into a
family of shepherds in the Auvergne
region of France in 565. When still
very young, he taught himself to
read while caring for the family
flock and memorized the Psalter.
Overcoming his father's opposition,
he asked to be taken into the
nearby Benedictine monastery,
where he proved his calling and
distinguished himself for humility
and goodness. Because of these
traits, he was often called on to
move from monastery to monastery,
since the fame of sanctity that
followed him attracted many of the
devout. He died in 622, and his cult
was approved in 1598 by Pope
Clement VII.
NAME: Walaricus is from old
German and means "powerful lord."

SAINT WALARICUS
Popular sacred image
19th century

Saint Lucy

VIRGIN AND MARTYR
Memorial

The martyr Lucy died at Syracuse, Sicily, around 304, during the persecution of Diocletian. Born into a noble family, she consecrated herself to Christ, renounced matrimony, and gave all her belongings to the poor. For this she was denounced by her betrothed: she was imprisoned and tortured. According to legend, when the torturer dug out her eyes she herself put them back in place.

In the end she was decapitated. Her cult spread immediately after her death.

She is depicted holding a plate with eyes, the palm, or a sword and is invoked against opthalmia and hemorrhages.

PROTECTOR: Electricians, eye doctors, and the blind.

NAME: Lucy is from the Latin and means "light."

SAINT PAULINUS OF LUCCA
AND SAINT LUCY
Filippo Lippi
Circa 1480–90
Massarosa Collection, Lucca

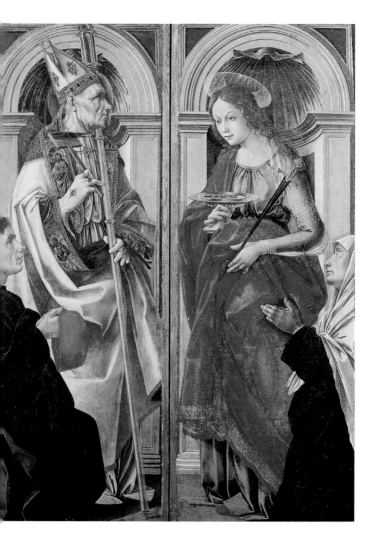

DECEMBER 14

Saint John of the Cross

PRIEST AND DOCTOR OF
THE CHURCH • Memorial

Born in Spain in 1542, Juan de Yepes entered the Carmelite order in 1563. He was attracted to the life of the Carthusians and was about to leave the Carmelites when Theresa of Avila convinced him to reform it instead. So it was that the order of the Discalced Carmelite friars came into being, in 1568. A great mystic, John wrote numerous works, including *The Dark Night of the Soul* and *The Ascent of Mount Carmel*. Persecuted and isolated, he died in 1591. He was canonized in 1726 and declared a Doctor of the Church two hundred years later. He is depicted with the Carmelite habit in adoration of the cross.

PROTECTOR: Mystics, theologians, and poets.

NAME: Juan *(John)* is from a Hebrew name meaning "Yahweh is gracious."

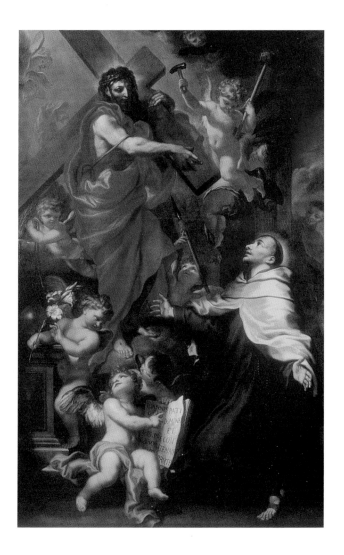

Saint Mary di Rosa

VIRGIN

Daughter of a businessman in Brescia, Italy, Paola Francesca di Rosa was born in 1813. Her mother died, and at eleven she entered a college and gave vows of chastity. She therefore did not consent to any of the marriage proposals presented to her by her father, but she did agree to his wish that she take care of the home and the other children. At the same time, she dedicated even more effort to the training of girls and the care of the sick and poor, creating a religious congregation approved in 1851 with the name Handmaids of Charity. As a nun she took the name Mary Crucified (Mary di Rosa) and worked a few more years, until her death, in 1855. She was canonized in 1954.

She is depicted in a nun's black habit.
NAME: Mary is from the Egyptian and means "beloved"; in the Hebrew (from Miriam) it means "lady."

SAINT MARY DI ROSA
Popular sacred image
20th century

Saint Adelaide of Burgundy

EMPRESS

Daughter of King Rudolph II of Burgundy, Adelaide was born around 931. After a brief marriage to Lothair II, nominal king of Italy, who died of poison, she was pursued by the new king, Berengarius II. She took refuge with Otto I of Germany, who married her in 951, and beside him in 962 she was crowned empress of the Holy Roman Empire. She was always attentive to political events and was active in assistance to the poor and needy. After the death of Otto she faced serious intrigues at court and retired to Alsace, to the monastery at Seltz that she had herself founded. She died there in 999 and was immediately venerated as a saint. She was canonized in 1097.

She is depicted in royal robes.

NAME: Adelaide is from the German and means "of noble aspect."

SAINT ADELAIDE
Master of Naumburg
1275
Naumburg Cathedral

Saint John of Matha

PRIEST

Born in Provence around 1155, John became a priest and teacher of theology at Paris. He learned in a vision that his true mission in life was that of freeing the Christian slaves in Africa. He therefore gave up teaching and founded a religious order dedicated to the Holy Trinity, hence its name of Trinitarian. He obtained papal approval in 1198. John died at Rome in 1213, and his cult was approved in 1666.
He is depicted in the white habit and cross of the Trinitarians.
NAME: John is from a Hebrew name meaning "Yahweh is gracious."

FOUNDING OF THE TRINITARIAN ORDER
Juan Carreño de Miranda
1666
Louvre, Paris

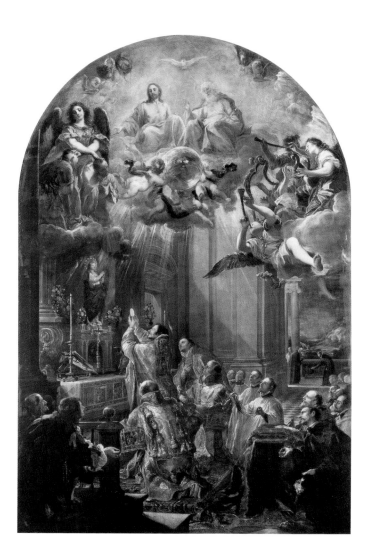

Saint Gratian

BISHOP

Gratian lived between the end of the 3rd century and the beginning of the 4th century. What little is known of him—in antiquity he was known as Grasinus—comes from the testimony of Gregory of Tours, according to whom he was among the seven bishops sent to evangelize Gaul in 250. When he arrived in Tours he became that city's first bishop, and he occupied the episcopal see nearly fifty years. At his death he was buried in a suburban cemetery.
NAME: Gratian is of Latin origin and means "thankful," or "son of Gratus."

STAINED-GLASS WINDOW
OF SAINT GRATIAN
(detail)
1250
Cathedral of St. Gratian, Tours

Blessed William of Fenoglio

CARTHUSIAN LAYBROTHER

Born in the diocese of Mondovì, Italy, in 1065 and attracted to the religious life, for a certain period William lived as a hermit not far from his birthplace. He later joined the Carthusian monks of Casotto, living as a laybrother, observing the rule of obedience, piety, and charity. He died around 1120, and his tomb was immediately the object of veneration. His body remained intact for nearly three centuries. The cult of the blessed William was approved in 1860.

He is depicted in the white habit of the Carthusians holding the leg of a mule which he would remove from the animal and use to scare off brigands and then reattach.

NAME: William is from the German and means "helmet of freedom."

BLESSED WILLIAM OF FENOGLIO
AND BLESSED BEATRICE OF ORNACIEU
(detail)
Daniele Crespi
1618
Certosa di Garegnano, Milan

Saint Dominic of Silos

ABBOT

Born early in the 11th century in the Spanish province of La Rioja, Dominic was a shepherd and then, seeking solitude and contemplation, entered the Benedictine monastery of San Milán de la Cogolla, of which he became abbot. Having come into conflict with the king of Navarre, who claimed Church possessions, Dominic was driven out, but in recompense King Ferdinand I of Old Castile gave him the abandoned monastery of Saint Sebastian at Silos. Within a short time he had made it a lively center of Christian and monastic activity. He was also active in the liberation of slaves. He died in 1073 and is depicted in the robes of an abbot.

PROTECTOR: Women in childbirth.

NAME: Dominic is from the Latin and means "sacred to the Lord."

SAINT DOMINIC OF SILOS IN GLORY (detail)
Bartolomé Bermejo
1474–77
Prado, Madrid

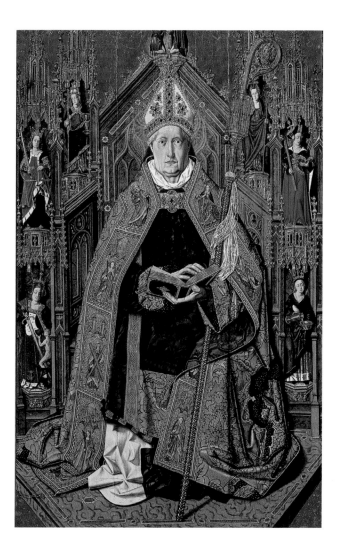

Saint Peter Canisius

JESUIT AND DOCTOR OF THE CHURCH • Optional memorial

Peter Kanijis, Latinized Canisius, was born in Holland in 1521. While studying at Cologne he sensed his religious calling and consulted Saint Ignatius. He entered the Jesuits and was ordained priest. He carried forth an assiduous mission in defense of the Catholic Church. He participated in the Council of Trent and was sent to Sicily, Germany, and Switzerland. Theologian and preacher, he wrote important works, including the *Catechism, or Summary of Christian Doctrine*. He died at Fribourg in 1597 and was canonized in 1925.

He is depicted in the robes of a Jesuit.

NAME: Peter is from the Greek and means "rock, stone."

PETER CANISIUS PREACHER
Pierre Wuilleret
1635
College of Saint-Michel, Fribourg

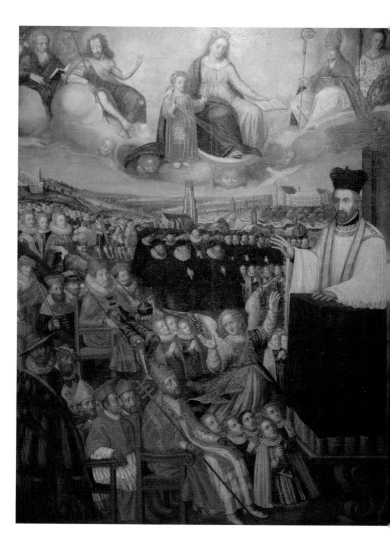

Saint Frances Xavier Cabrini

FOUNDRESS

Frances was born in 1850, the thirteenth daughter of a poor family of peasants near Pavia, Italy. Following the deaths of both her parents she hoped to embrace the religious life and asked to become a nun at a convent school but was refused because of poor health. She earned a diploma in teaching and dedicated herself to the education of orphaned children, founding a religious institute that she put under the protection of Saint Francis Xavier. She then took vows as a nun, becoming Frances Xavier Cabrini. Concerned for the spiritual and material health of the Italian immigrants in America, she decided to take her mission there, organizing assistance for Italian immigrants, beginning with orphans and the poor. Famous as Mother Cabrini, she built homes, schools, and hospitals in New York and Chicago, California and Argentina. She died in Chicago in 1917 and was canonized in 1946.

PROTECTOR: Immigrants.

NAME: Frances *(Frank)* is of German origin, from the name of the people who settled in France; it has come to mean "forthright, sincere."

SAINT FRANCES CABRINI
20th century
Saint Joan of Arc, Orleans (Mass.)

Saint John of Kanti

PRIEST

Born in Kanti, Poland, in 1390, the son of rich landowners, John studied at the University of Krakow. At twenty-seven he was teaching philosophy; he also undertook studies of theology and became a priest in 1424. He was highly valued as a professor and preacher and was a parish priest for a short period in the small town of Olkusz. On his return to Krakow he lived with austerity, proving himself generous and charitable to the poor and needy, and teaching that behavior to his students. He died on Christmas Eve, 1473, and was canonized in 1767.

He is depicted in priestly robes accompanied by the poor.

PROTECTOR: Seminarists and scholarly ecclesiastics.

NAME: John is from a Hebrew name meaning "Yahweh is gracious."

SAINT JOHN OF KANTI
Popular sacred image
Early 20th century

Saints Adam and Eve

PROGENITORS

Celebrated by the Eastern Church on December 19, the progenitors Adam and Eve were inserted together in the new Catholic martyrology. They are saints because they were saved by redemption. Adam was created by God, who made him in his image and gave him dominion over every other living thing. Eve was his companion, generated from Adam so that he would not be alone. Their error was disobedience, the cause of Original Sin, and they were driven from Paradise. Even so, the progenitors did not speak ill of God but on the contrary worshiped and served him.

They are depicted nude in Earthly Paradise, often at the moment of temptation.

NAMES: Both Adam and Eve are from the Hebrew; Adam means "man," Eve means "living" or "that sustains life."

ADAM AND EVE
Lucas Cranach the Elder
1528
Galleria degli Uffizi, Florence

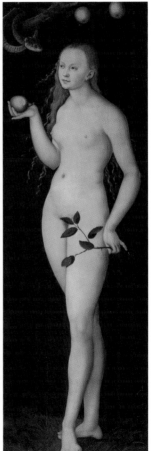

The Birth of the Lord

Solemnity

The solemnity of the birth of Jesus Christ was celebrated on December 25 as early as the time of Pope Liberius, in 354. The date chosen had been that of a very popular and important pagan festival, the conclusion of the Saturnalia celebrations in honor of Saturn and the winter solstice. Thus the celebration of *"sol invictus,"* the sun that returns to shine again, became the feast of the "true sun." Christmas is the manifestation to the world of God become human; it is recognized by both the Western and Eastern Churches. Scenes of the Nativity have been of central importance to the history of Western art since the 5th century.

NATIVITY
(detail)
Marcello Fogolino
1525
Museo di Castelvecchio, Verona

754

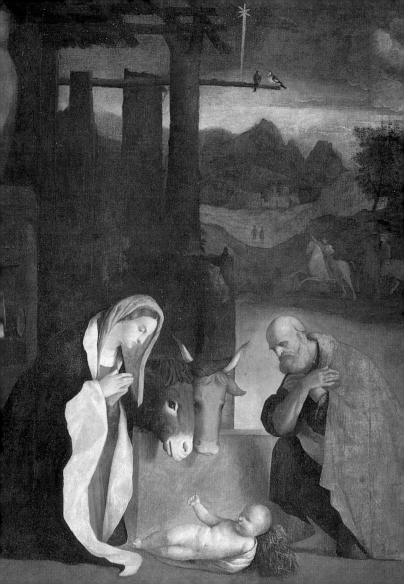

DECEMBER 26

Saint Stephen

PROTOMARTYR • Feast

Stephen was one of the seven deacons of Jerusalem named by the apostles. Accused of blasphemy against Moses and God, he was taken to the Sanhedrin. With his scriptural knowledge, he argued that the Jews were being resistant to the Holy Spirit and did not want to recognize the Messiah. He was stoned to death. His cult spread between the 4th and 5th centuries.

He is depicted as a young deacon, with the stones, martyr's palm, and book and is invoked against migraines and for a good death.

PROTECTOR: Deacons, bricklayers, stonemasons, stonecutters, pavers, and sculptors.

NAME: Stephen is of Greek origin and means "crowned."

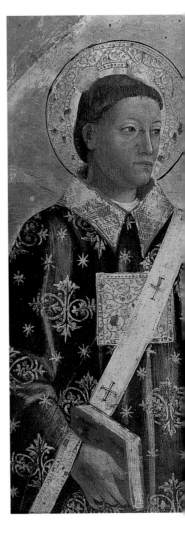

SAINTS STEPHEN AND JOHN THE BAPTIST (detail)
Stefano de' Fedeli
15th century
Monza Cathedral
(Saint Stephen is on the left)

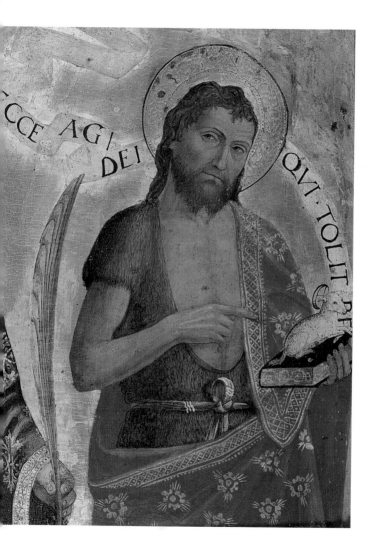

Saint John the Evangelist

APOSTLE • Feast

Son of Zebedee, John was among the first disciples of Jesus and was perhaps the youngest. He was the only one who did not abandon Jesus at the moment of crucifixion, remaining near the cross. Jesus entrusted his mother to him, asking him to take care of her. Toward the end of his life he wrote his Gospel, narrating the events he had himself witnessed. He is also the author of the Book of Revelation, which relates his visions on the island of Patmos.

He is depicted as a youth with an eagle and a book. He may also have a cup with a viper in it (he had been challenged by a priest of Diana to drink a poisoned cup). He is invoked against false friends.

PROTECTOR: Booksellers, writers, theologians, artists, templars, stationers, and typographers.

NAME: John is from a Hebrew name meaning "Yahweh is gracious."

SAINT JOHN THE EVANGELIST
(detail)
Pedro Berruguete
1485
Convent of Saint Thomas, Avila

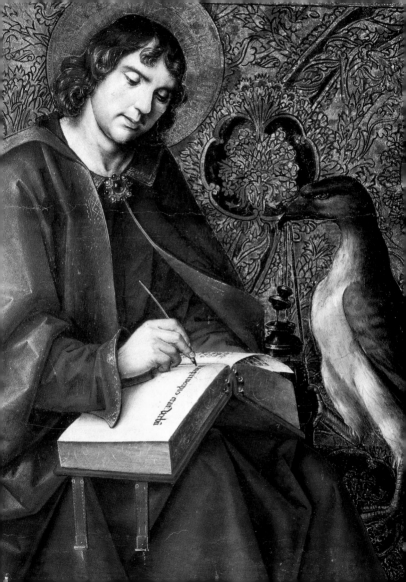

DECEMBER 28

The Holy Innocents

Feast

Because they died for Jesus Christ, the children of Bethlehem killed on the orders of Herod the Great were declared martyrs. The Gospel of Matthew (2:16) recounts how Herod, having learned from the Magi of the birth of the king of the Jews and fearing the loss of his power, ordered the killing of all the children of Bethlehem up to two years of age in order to be certain to eliminate him. The cult of these murdered children became popular in the West in the 4th century.

They are depicted as small children being violently killed and have the palm of martyrdom.

PROTECTORS: Foundlings.

THE SLAUGHTER OF THE INNOCENTS
Andrea Delitio
1481
Atri Cathedral

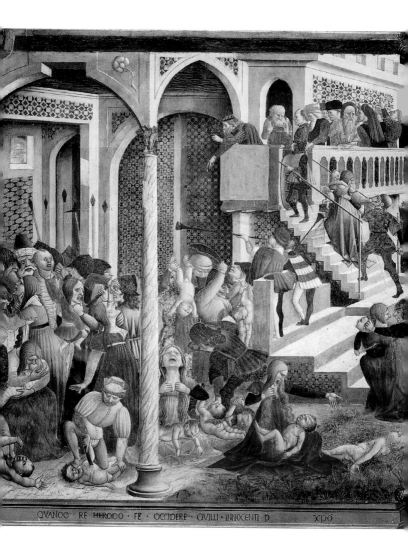

QVANDO · RE · HERODO · FE · OCCIDERE · OVILLI · INNOCENTI · D · · · XPO

Saint Thomas Becket

BISHOP AND MARTYR • Optional memorial

Born in London around 1117, Thomas studied theology and Church law and was collaborator of the bishop of Canterbury. Henry II wanted him as chancellor and personal councillor and in 1161 elected him archbishop and primate of England with the aim of exercising control, through him, on the local Church. However, Thomas increasingly set spiritual interests against political and came into conflict with the king, who in 1170 had him killed by four knights. He was canonized in 1173.

He is depicted in episcopal vestments with miter, pastoral staff, and sword.

PROTECTOR: The English College in Rome, coopers, and makers of brooms.

NAME: Thomas is from the Aramaic and means "twin."

KING HENRY II SPEAKING WITH SAINT THOMAS BECKET
(detail of an illuminated page from the *Chronicle of England*)
Peter Langtoft
Circa 1300–25
British Library, London

Henricus natus Matildis regna tenebat
Sub quo sacratus Thomas mitgore cadebat

Henricus Rex filius Matildis Imperatris genui

henr'
hauene
rege qui
obiit

DECEMBER 30

Saint Felix I

POPE

Member of a Roman family, Felix led the Catholic Church from 269 to 274. During his pontificate he had to confront the question of Paul of Samostata, the heretical patriarch of Antioch, deposed and excommunicated because he did not recognize the legitimate bishop. He also carried on the struggle against Monarchianism, already condemned by his predecessor, Pope Dionysius, and made provision for the celebration of the Mass over the tombs of martyrs.
He is depicted in papal robes.
NAME: Felix is from the Latin and means "happy, content."

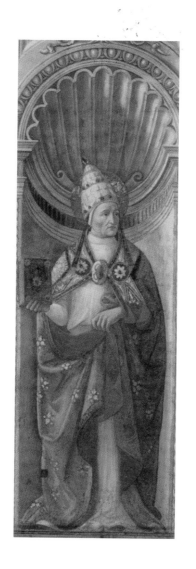

Saint Sylvester I

POPE • Optional memorial

Sylvester (Silvester) was the first pope after Constantine's Edict of Milan granting a degree of toleration to Christian worship (313). His pontificate lasted twenty years and included the famous Council of Nicea against the Arian heresy (325). He died December 31, 335. He is depicted in papal robes, and his attributes are the bull (because he revived one that had been killed by a magician) and the dragon that, according to legend, he tamed.

PROTECTOR: Masons, stonecutters, domestic animals, and bovines.

NAME: Sylvester is from the Latin and means "inhabitant of the woods."

STORIES OF THE LIFE OF POPE SYLVESTER: THE BAPTISM OF CONSTANTINE
(detail)
Maso di Banco
1337
San Silvestro Chapel, Santa Croce, Florence

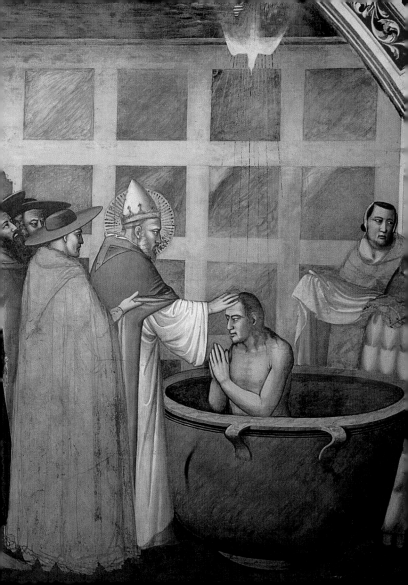

INDEX OF NAMES

769

INDEX OF SYMBOLS AND ATTRIBUTES

Abbess: Brigid of Ireland, Clare of Assisi, Walburga
Abbot: Dominic of Silos, Ildephonsus of Toledo, Robert, Robert of Newminster, Sylvester Guzzolini
Agricultural tools: Isidore the Farmer
Alms box: Laurence
Alpino uniform: Carlo Gnocchi
Anchor: Clement I
Angel: Bonaventure, Gabriel, Matthew Michael, Raphael, Roch
Arrows: Christina of Bolsena, Sebastian, Ursula
Aspergillum: Martha
Augustinian: Hildegard of Bingen, Monica, Nicholas of Tolentino, Rita of Cascia
Ax: Josaphat Kuncewicz
Baptismal bowl: Francis Xavier
Barrel of salt: Rupert
Basket of bread: Elizabeth of Hungary, Julian of Toledo
Beehive: Bernard
Beggar's wallet: Felix of Cantalice
Bell: Anthony Abbot
Belt: Thomas
Benedictine (white for reformed): Romuald
Benedictine (black): Bede, Benedict, Frances of Rome, Giles, Maurus, Placid, Scholastica
Bible: Jerome, Romuald
Bible pierced by a sword: Boniface
Bishop: Abundius of Como, Agapitus of Ravenna, Augustine, Augustine of Canterbury, Albert the Great, Albinus of Vercelli, Alphonsus de' Liguori, Ambrose, Anselm, Apollinaris, Athanasius, Basil the Great, Bassian of Lodi, Benignus, Blaise, Boniface, Cyprian, Cyril, Cyril of Alexandria, Cyril of Jerusalem, Denis, Eleuterius, Eligius, Erasmus, Erhard, Francis de Sales, Frediano of Lucca, Frumentius, Galdinus, Gerard of Csanad, Germanus of Paris, Giustiniano of Vercelli, Gothard of Hildesheim, Gratus of Aosta, Gregory Nazianzen, Hilary of Poitiers, Hubert, Hugh of Grenoble, Irenaeus of Lyons, Isidore of Seville, Januarius, John Chrysostom, John the Good, Julian of Toledo, Leander of Seville, Livinius, Lorenzo Giustiniani, Louis of Anjou, Mansuetus, Maternus, Médard, Methodius, Narcissus of Jerusalem, Nestor of Magydos, Nicholas, Patrick, Peter Damian, Polycarp, Prosdocimus of Padua, Prosper of Reggio, Quirinus, Rupert, Stanislaus, Syrus of Pavia, Titian, Thomas Becket, Turibius of Mogrovejo, Valentine, Virgil of Salzburg, Zeno
Black habit: Mary di Rosa, Jane Frances de Chantal
Blacksmith's tools: Eligius
Boat: Peter
Book: Anthony of Padua, Athanasius, Basil, Benedict, Bernard, Bonaventure, Bridget of Sweden, Catherine of Siena, Gregory Great, Ives, Jerome, John, Laurence, Luke, Mark, Matthew, Matthias, Paul, Peter, Prosper of Reggio, Stephen, Vincent Ferrer
Book of the rule: Monica, Nicholas of Tolentino, Scholastica
Boys (three) in a tub: Nicholas
Bread: Anthony of Padua, Frances of Rome
Breasts cut off: Agatha
Brown habit: Francis of Paola
Bucket: Florian
Bullock: Felicity, Perpetua

Camaldolese: Peter Damian
Candle: Blaise, Bridget of Sweden
Cape: Francis Xavier
Capuchin: Bernard of Corleone, Diego Joseph of Cádiz, Felix of Cantalice, Fidelis of Sigmaringen, Ignatius of Laconi, Pius of Pietreclina
Carders' combs: Blaise
Cardinal: Bonaventure, Charles Borromeo, Jerome, Gregory Barbarigo
Carmelite: John of the Cross, Andrew Corsini, Teresa Benedicta of the Cross, Theresa of Avila
Carpenter's tools: Joseph
Carthusian: Bruno, Odo of Novara
Cassock: Aloysius Gonzaga, Anthony Zaccaria, Carlo Gnocchi, Jerome Emiliani, John Baptist de la Salle, John Bosco, John of God, John Nepomucene, John Ogilvie, Peter Canisius, Peter Claver, Philip Neri
Chalice: James of the Marches
"Charitas": Francis of Paola
Child: Raphael
Christ Child: Anthony of Padua, Christopher, Rose of Lima
Cistercian habit: Bernard
Clergy: Alphonsus Rodriguez, Cajetan, Ives
Cloak: Martin
Clog: Vigilius
Clover: Patrick
Club: Jude
Cock: Peter
Cock, white: Vitus
Column: Bibiana
Cord around neck: Charles Borromeo
Cow: Brigid of Ireland
Cowl: Ignatius of Laconi
Crosier: Albinus of Vercelli, Gregory the Great
Cross: Helen, Liberata, Nestor of Magydos, Paul Miki
Cross with green leaves: Bruno
Crown: Casimir, Margaret of Hungary
Crown of flowers: Maximus, Four

Crowned Ones, Tiburtius, Valerius
Crown of thorns: Louis of France, Veronica Giuliani
Crucifix: Acacius, Agnes of Montepulciano, Aloysius Gonzaga, Anthony Zaccaria, Bonaventure, Catherine of Siena, Clare of Assisi, Eustache, Francis of Assisi, Francis Xavier, Jerome, John of the Cross, Margaret of Cortona, Margaret of Hungary, Mary Magdalen, Monica, Nicholas of Tolentino, Petka, Philip, Rita of Cascia, Rosalia, Theodore, Theresa of Avila
Crutch: Maurus
Cup, broken: Benedict
Cup with viper: John the Evangelist
Cyrillic writing: Cyril, Methodius
Dagger: Peter of Verona
Deacon: Alexander, Daniel of Padua, Jovita, Laurence, Martyrius, Sisinnius, Stephen, Vincent of Saragossa
Deer: Giles, Julian the Hospitaller
Devil (demon): Juliana of Nicomedia, Michael, Romuald
Devil (demon), chained: Bartholomew, Bernard
Dog: Dominic, Margaret of Cortona, Roch
Dog, white: Bernard
Dog with torch: Dominic
Dominican: Agnes of Montepulciano, Albert the Great, Fra Giovanni Angelico, Catherine of Siena, Clare of Montefalco, Constantius of Fabriano, Dominic, Margaret of Hungary, Peter of Verona, Peter González, Raymund of Peñafort, Rose of Lima, Thomas Aquinas, Vincent Ferrer
Dove: Scholastica, Theresa of Avila,
Dove of inspiration: Basil the Great, Gregory the Great, Thomas Aquinas
Dragon: Philip, George, Michael
Eagle: John
Epileptic child: Valentine
Eyes: Lucy
Falcon: Bavo of Ghent, Julian the Hospitaller

776

Palm branch: Abdon, Acacius, Achilleus, Adrian, Agatha, Agnes, Amelia, Apollonia, Aquilinus, Barbara, Bibiana, Catherine of Alexandria, Cecilia, Cyprian, Dorothy, Faustinus, Felix, Fidelis of Sigmaringen, Flavia Domitilla, Four Crowned Ones, Hermengild, Holy Innocents, Januarius, John Nepomucene, Jovita, Justin, Longinus Laurence, Lucy, Martinian, Maurice, Maximus, Nabor, Nereus, Peter of Verona, Placid, Polycarp, Processus, Procopius, Roderigo of Córdoba, Rufina, Secunda, Sennen, Stephen, Terence, Thecla of Iconium, Tiburtius, Ursula, Valentine, Valerius, Vincent of Saragossa, Vitalis, Vitus

Papal robes: Caius, Celestine I, Celestine V, Clement, Cornelius, Damasus, Felix I, Gregory X, Gregory the Great, Hilary, Leo IX, Leo the Great, Marcellinus, Paschal I, Pius X, Stephen I

Pastoral staff: Benedict, Gregory Nazianzen Valentine, Walburga

Peacock feathers: Barbara

Peasant: Angela of Merici

Pen: Thomas Aquinas

Pen and ink: Bridget of Sweden

Pig: Anthony Abbot

Pilgrim: Alexis, James the Greater, Roch

Pincer: Agatha

Pitcher: Elizabeth of Hungary, Prosdocimus of Padua

Poor Clares: Clare of Assisi, Veronica Giuliani

Priest: Alphonsus de' Liguori, Andrew Avellino, Andrew Corsini, Aquilinus, Faustinus, Francis Borgia, Francis Xavier, John of Kanti, John Vianney, Joseph Cafasso, Ignatius of Loyola, Philip Neri, Roderigo of Córdoba, Vincent de Paul

Rake: Frediano of Lucca

Raven: Benedict, Paul the Hermit

Red cross on black robe: Camillus de Lellis

Ring: Catherine of Alexandria, Edward the Confessor

Rods in a bundle: Benedict

Roses: Rita of Cascia, Rose of Lima, Rose of Viterbo, Rosalia

Royal dress: Adelaide, Casilda of Toledo, Casimir, Catherine of Alexandria, Clotilda, Constantine, Cunegund, Edward the Confessor, Elizabeth of Hungary, Elizabeth of Portugal, Hedwig, Helen, Henry II, Hermengild, Louis of Anjou, Ludwig IX, Margaret of Hungary, Margaret of Scotland, Matilda, Sigismund, Stephen of Hungary, Ursula

Saw: Simon

Scales: Maurus, Michael

Scapular: Hugh of Grenoble, Simon Stock

Scholar: Ives

Scourge: Ambrose, Aloysius Gonzaga, Mary Magdalen

Scroll: Amos, Daniel, Elisha, Ephrem, Ezekiel, Isaiah, Ives, Zechariah

Sculptor's tools: Four Crowned Ones

Servants of the Blessed Virgin Mary: Seven Servite Founders

Shackles: Leonard of Noblac

Shepherdess: Bernadette Soubirous

Ship: Peter González

Shoemaker: Crispin, Crispinian

Skull: Jerome, Aloysius Gonzaga, Margaret of Cortona, Mary Magdalen, Rosalia

Slaves: Peter Claver

Soldier: Aacius, Achilleus, Alexander, Crispin, Faustinus, Felix, Florian, Hippolytus, Joan of Arc, Jovita, Longinus, Martin, Maurice, Michael, Nabor, Nereus, Procopius, Secundus, Theodore

Sores: Job

Spade: Maurus

Square: Thomas

Staff: Christopher, James the Less, Odo of Novara

Stag: Eustace, Hubert

Stairs: Alexis

Standard: Alexander, Joan of Arc, John of

Capestrano, Maurice, Ursula
Star on chest: Nicholas of Tolentino
Star on forehead: Dominic
Stars: Bruno (seven), John Nepomucene (five)
Stigmata: Catherine of Siena, Francis of Assisi, Pius of Pietreclina
Stole: John Vianney
Stone: Jerome
Stones: Stephen
Sun on chest: Thomas Aquinas
Sword: Abdon, Aquilinus, Bavo of Ghent, Catherine of Alexandria, Fidelis of Sigmaringen, Julian the Hospitaller, Lucy, Maurice, Sennen, Thomas Becket

Teeth: Apollonia
Tower: Barbara
Triregnum: Leo the Great
T-shaped staff: Anthony Abbot
Vials: Januarius
Wheel: Catherine of Alexandria
Wheel, winged: Ezekiel
White cape: John Baptist de La Salle
White habit: John of Matha, Norbert, Peter Nolasco, Serapius
Windlass: Erasmus
Winged ox: Luke
Wound on forehead: Rita of Cascia
Wound on thigh: Roch
X-shaped cross: Andrew

PHOTOGRAPHIC REFERENCES

Accademia dei Concordi Pinacoteca, Rovigo, 458-59

AKG-Images, Berlin, 49, 69, 90-91, 126-27, 141, 161, 163, 313, 337, 339, 389, 405, 415, 417, 449, 497, 536-37, 565, 570-71, 584-85, 601, 646, 677, 703, 721, 727, 737, 741, 747, 759

Fratelli Alinari Photographic Archives, Florence, 143 and 243 (Archivio Finsiel), 169, 257, 287 (D. Cammilli), 351, 723

Alte Pinakothek, Munich, 559

Ancona Pinacoteca Civica, 633

Archivio Museo Diocesano, Milan, 27, 113, 235, 425, 446-47, 649, 683

Archivio Museo Diocesano Tridentino, Trent, 321

Archivio Salesiani Don Bosco, Rome, 71

Archivio Storico Parrocchia Santa Maria Assunta in Certosa, Milan, 35, 199, 743

Banca Intesa, Vicenza, Archivio Beni Culturali, 11

Bassano del Grappa Museo Civico, 103

Bellu, Sandro, Perugia, 453

Belluschi, Enrico, Milan, 189, 275

Biblioteca Universitaria Estense, Modena, 85

Bibliothèque Nationale, Paris, 24-25

Boston Museum of Fine Arts, 613

Bridgeman Art Library, London, 101, 358-59 (© Samuel Courtauld Trust, Courtauld Institute of Art Gallery, London), 577, 596-97, 609, 689 (© York Museum Trust, York Art Gallery), 711, 713

Cameraphoto Arte, Venice, 445

Capitoline Museums, Rome, 327

Carrara Accademia di Belle Arti, Bergamo, 147

Castelvecchio Museum, Verona, 755

Castignani, Sante, Spello, 427

Cento Pinacoteca Civica, 119

Civica Raccolta delle Stampe A. Bertarelli, Milan, 67, 213, 285, 343, 347, 361, 367, 399, 455, 461, 477, 529, 533

Como Ufficio Inventariazione Beni Artistici, 515

Corbis/Contrasto, Milan, 43, 291

Cortona Museo dell'Accademia Etrusca, 457

Da Re Studio Fotografico, 363

Fondazione don Carlo Gnocchi, Archivio, Milan, 133

Foto Biserni, Ravenna, 99

Fototeca Storica Nazionale, Milan, 171, 237, 513, 749

Gemäldegalerie der Akademie der Bildenden Künste, Vienna, 637

J.P. Getty Museum, Los Angeles, 153, 434-35

Hermitage Museum, St. Petersburg, 193

Jesi Pinacoteca Civica, 617

Kunsthistorisches Museum, Vienna, 55, 279, 523, 709

La Loggia, Angelo, San Cono, 191

Leemage, Paris, 115, 319, 333, 627

Erich Lessing/Contrasto, Milan, 13, 36-37, 245, 382-83, 397, 413, 431, 517, 557, 587, 592-93, 699, 763

Lisbon Museo Nacional de Arte Antiga, 509

Manzù, Giacomo, Museo Artistico, Ardea, 599

Metropolitian Museum of Art, New York, 653

Mondadori Electa, Archivio, with the permission of the Italian Fine Arts Commission: Paolo Airenti Fotografia, Genoa, 453; Sergio Anelli, Milan, 39, 61, 83, 88-89, 175, 184-85, 197, 227, 255, 259, 263, 295, 299, 303, 305, 331, 349, 353, 385, 402-03, 408-09, 419, 429, 433, 439, 443, 467, 501, 503, 505, 525, 534, 539, 542-43, 547, 561, 569, 575, 619, 644-45, 657, 761; Nuova Alfa Editoriale, Photographic Archive, Bologna, 201, 223, 247, 465 (Mario Berardi), 591, 687; Luigi Baldin, Treviso, 41, 437, 583; Bruno Balestrini, Milan, 184-85, 221, 271, 379; Bardazzi Photography, Sesto Fiorentino, 2, 325; Osvaldo Böhm, Venice, 239, 283, 421, 507, 562-63, 684-85; Cameraphoto